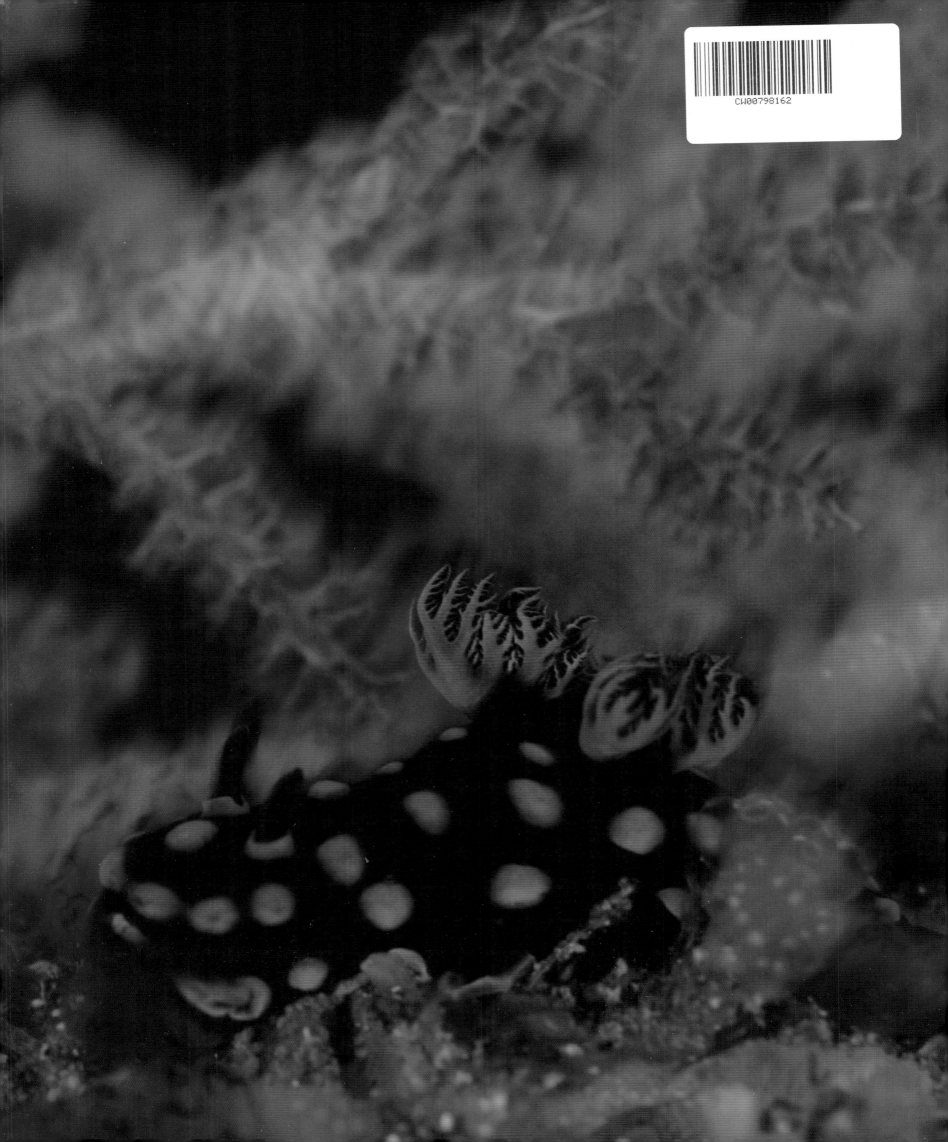

DEEP BLUE

THIS IS A GOODMAN BOOK

First published in 2008 by Goodman
An imprint of the Carlton Publishing Group
20 Mortimer Street
London W1T 3JW

A CIP catalogue record for this book is available from
the British Library.

ISBN 978 1 84796 002 3

Editor: Johanne Wort
Designer: Lucy Coley
Production: Kate Pimm

Printed in China

BELOW: A western clown anemonefish
in the undulating tentacles of its host
(Raja Ampat, Indonesia 2007)

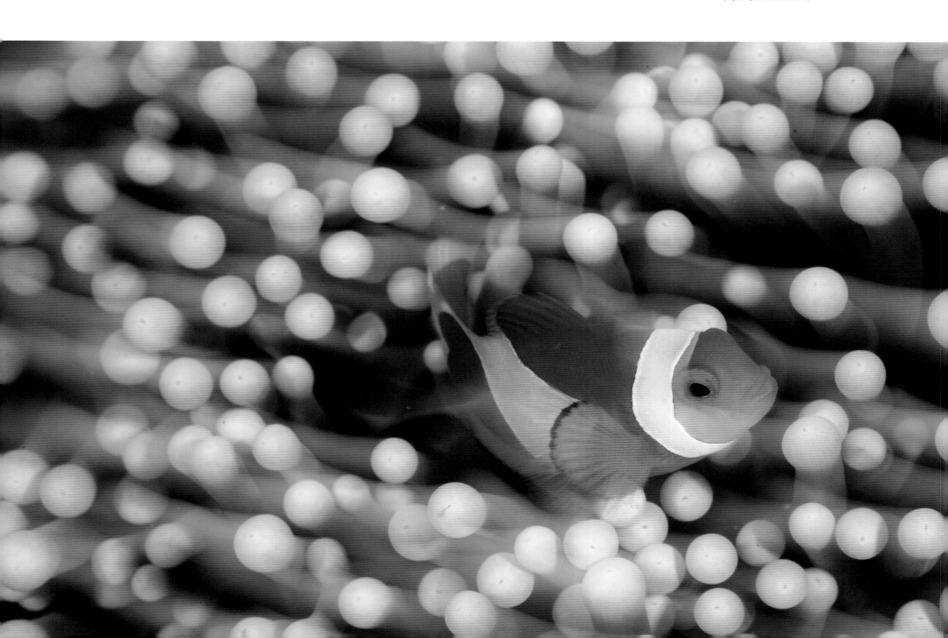

DEEP BLUE
THE EXTRAORDINARY
UNDERWATER PHOTOGRAPHY OF

YASUAKI KAGII

GOODMAN

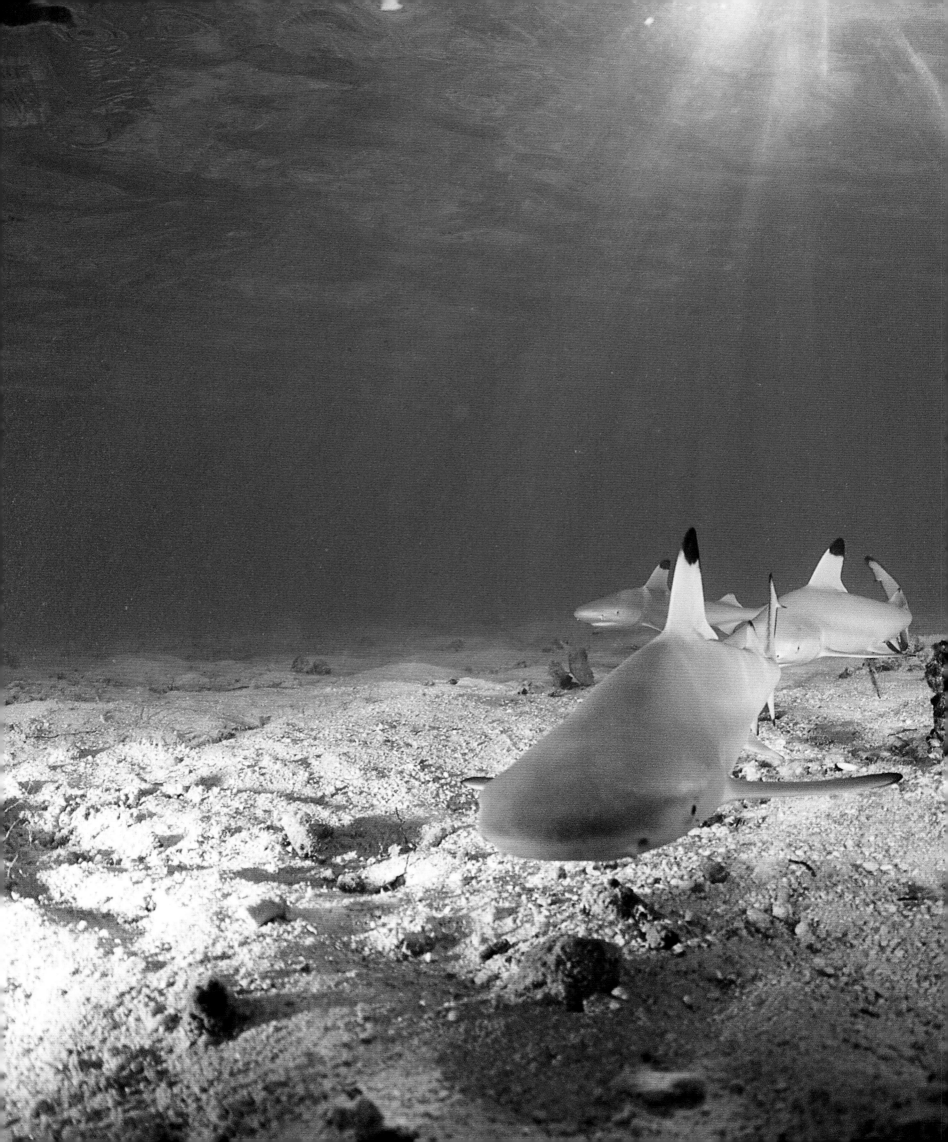

CONTENTS

LEFT: Blacktip reef sharks hunt
juvenile fish in a shallow lagoon
(South Male Atol, Maldives 1997)

INTRODUCTION

For many, the Maldives conjure up an image of paradise, islands edged in sandy white, topped green with palm trees, floating in a turquoise sea. That vague, unformed impression became a reality in 1995 when I first encountered the beauty and infinite wonder of those idyllic islands glittering like so many precious stones sprinkled in the warm Indian Ocean. For two years I lived and worked on Biyadoo, in the southeast of the South Male Atoll. Since you could walk round it in less than ten minutes, the island was soon familiar, but the clear waters and crowded reefs wrapped around its shore brought something new every day. The density and variety of life in that small drop of sea held fast my interest each moment I was in the water and held hostage my imagination each moment I was not. I was eager with anticipation each day to see, as if anew, the eternal drama played before me: the faces and stories subtly changing through the hours of the day and the passage of the year.

I was twenty and still at college when I set my heart on becoming an underwater photographer. With the money I earned working at a florist I bought my first camera — the same one professional underwater photographers used at the time: a Nikon F4 with a wide-angle action finder, set inside a Nexus housing. Though it was a considerable investment on my meagre wage, I knew it was what I needed for the best shots. For illumination I used a SEA&SEA YS-200 flash lamp, with its very cool yellow housing, also popular among marine photographers. I would drive down to Kushimoto in Wakayama Prefecture, feverishly taking photographs by day, and spending nights sleeping in my car.

I was pretty undiscerning in those days. The world under the sea was one of new and constant wonder and I wanted to capture it all on film — particularly the candy-coloured nudibranchs with their many extraordinary shapes and varieties.

In Japan there is still a strong tradition, in all trades and crafts, of apprenticeship to an established master. I pushed and elbowed my way into an opportunity to study under Katsutoshi Ito, a famous underwater photographer who finally accepted me as his *deshi*. In 2002 I had a chance to accompany him on an expedition to Exmouth, Western Australia, to photograph whale sharks and although I had never seen a whale shark until then, from the first breathtaking encounter, swimming with them felt completely natural. The mysterious creature was a microcosm of the possibilities open to me as a nature photographer, as if the ridges and troughs of its broad brown back were a huge map of the world, inviting me to explore.

A year later I was a guide for Japanese customers of the Exmouth Diving Service, giving me a precious opportunity to swim with whale sharks and photograph my favourite creatures. I used the compact Nikon V with a 15mm lens, whose size makes it perfect for situations where you need to be able to move relatively unencumbered, while being a precision instrument with very sharp definition. Every day I would swim far out in front of my companions, enthusiasm overcoming fatigue. While they would eventually leave the water exhausted, I was happy to be left alone to take photographs. When I look back now, I wonder if I didn't unnerve the creatures, swimming so close to them, but I feel these pictures capture the essence of whale sharks and it is among the most important work that I have ever done. The time spent with them taught me the significance and excitement of capturing the many different facets of the ocean's creatures. So began my career as a professional photographer, in my underwater journey around the world.

For the past 17 years, my passion to capture the essence of all things in the ocean has not waned. I was fortunate to have found a career in which I can pursue my artistic interests and strive toward my goals, but I am also humbled that these encounters with the unique creatures of the great oceans have informed my personal values and philosophies and contributed to my maturity as a human being. I sometimes wonder what would have happened if I hadn't found the sea. I think perhaps my mind would be less at peace in today's complicated world.

LEFT: Those big inquisitive eyes are almost unbearably cute... unforgettable encounters with Californian seals
(La Paz, Mexico 2006)

PAGES 8-9: Striped triplefin flitting above the coral
(Raja Ampat, Indonesia 2007)

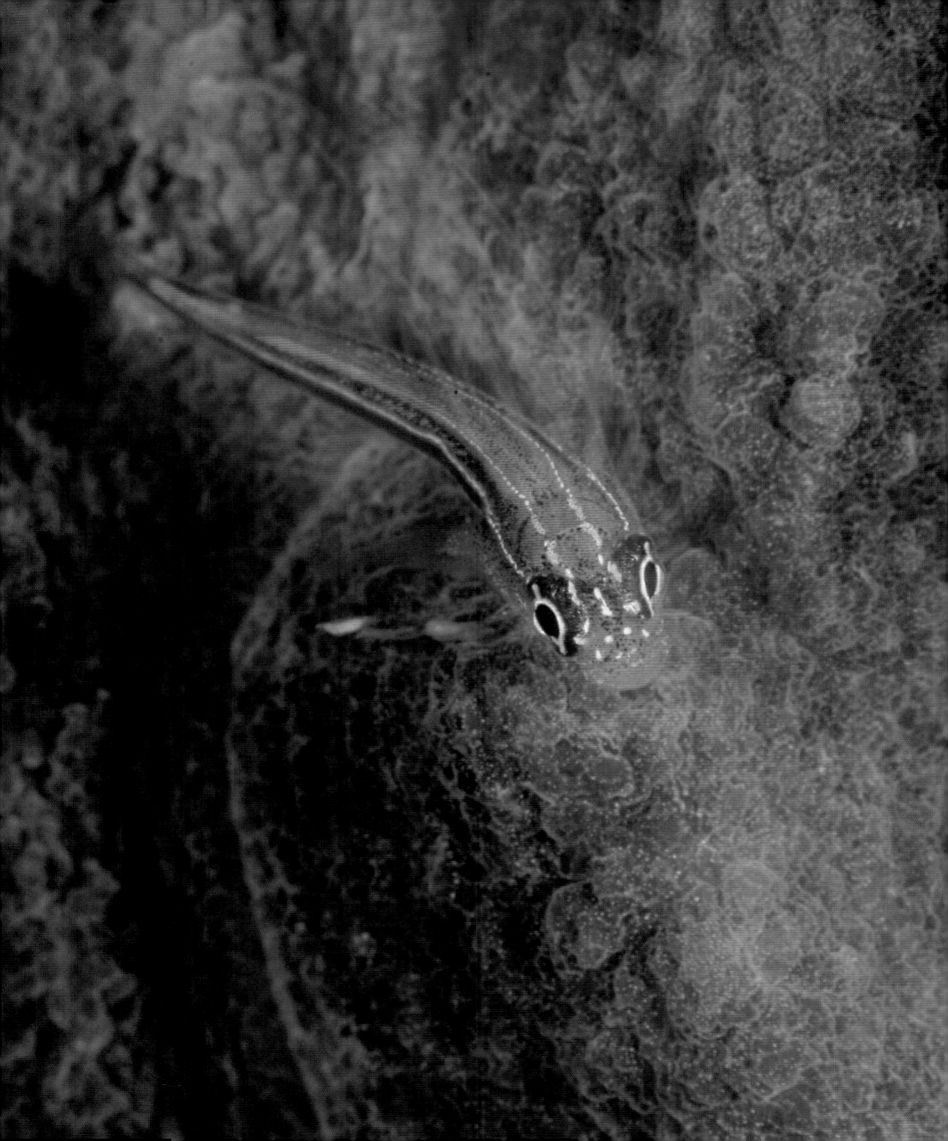

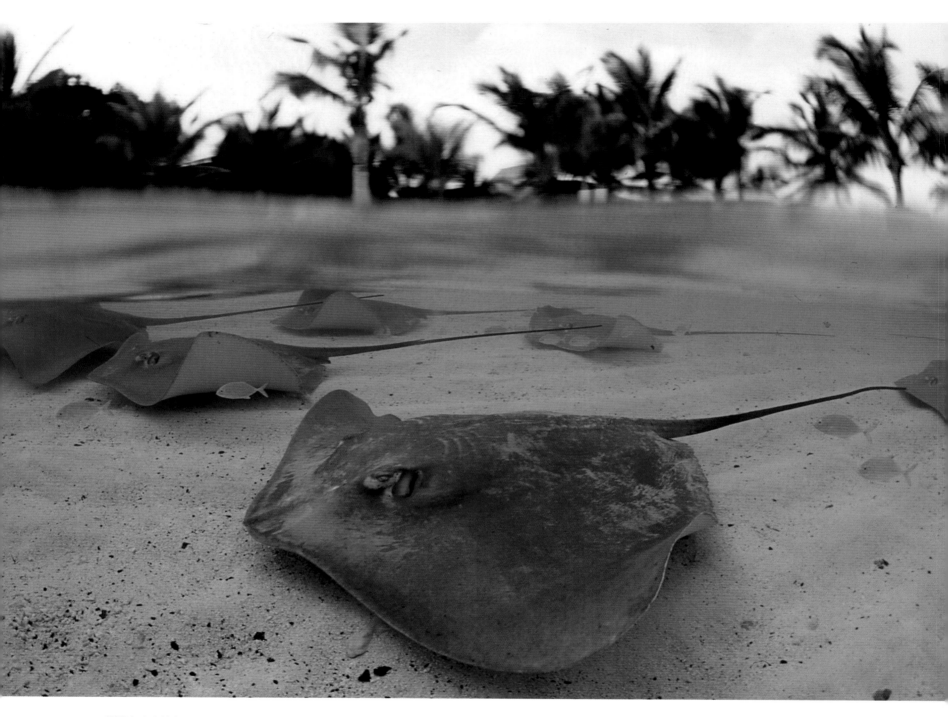

ABOVE: A school of Jenkins stingray, swimming like skaters in the shallows
(North Male Atoll, the Maldives 2002)

PAGES 12-13: Sun filtered though the leaves of an underwater forest of giant kelp
(Monterey, California, USA 1995)

PAGES 14-15: Jellyfish Lake, home to countless jellyfish
(Palau, Federated States of Micronesia 2004)

THE DESCENT

When you dive, you leave behind everything that is familiar. To enter the world beneath the sea is like being propelled through the sky and beyond, through outer space. Light succumbs to darkness, noise to silence. You become weightless, vulnerable and humbled, an infinitesimal human in a strange, vast, beautiful and endlessly varied other world. The deeper you go, the more alien in appearance the creatures you encounter become.

My first diving experience took place in a small port town in Wakayama Prefecture, Honshu Island, Japan. When I put my hand on the rocks of a tidal pool to put on my fins for the first time, I spotted a transparent shrimp. Being at that time completely ignorant of the marvels beneath the sea, this sight had a great impact on me. I put on my mask and let myself be overwhelmed by the expanse of blue water. Everything was different from the world on shore. The expanse of the waters gave me the feeling that I was floating in space. The world in which underwater creatures have evolved is weightless. Each is unique, and so different that they are like aliens from another planet. Even a school of small fish flashing brilliantly silver is, for me, as spectacular as a meteor shower. As I drifted at the entrance of this other world, I imagined all the wonderful experiences that awaited me. I guess you could say that a tolling bell of fate was ringing inside my head. Since then, I have experienced and learned a lot about the sea, but I have never again felt the excitement that overwhelmed me on that first day. The ocean is said to take up two-thirds of the earth; its impact on me has been equally substantial.

The sea is where life began, and it remains home to the most vivid abundance of life found anywhere on the planet; nonetheless it resists invasion by humans who can enter its realm only briefly. For this reason it remains for me a sacred place: I am but a traveller in this world of the Creator. From the microscopic to the immense, life teems on every scale, and I feel each and every one of those lives as if it were in itself a glittering planet.

Descending deeper into the sea, you enter a world of progressively singular blueness. The gentle bright blue near the surface surrenders to deeper and darker shades as the sunlight is scattered and absorbed, losing first red, then orange, and finally yellow, until at a depth of only thirty metres the world is pure blue. As a photographer, I travel under water carrying a camera, both day and night. I try to capture the beauty of this world of blue, but I also try, by use of artificial light, to retrieve the colours lost in that blue; to bring them back to shore for the world to enjoy.

However, my photographs are becoming records of history because the world captured in them is rapidly disappearing. Many of the sights I photographed only a few years ago no longer exist. Since 1998, when the first serious damage of coral bleaching became apparent, I have come to realise how easily these delicate ecosystems are destroyed by our pollution and neglect. The ocean has become the wastebasket of the world. If the real beauty I capture in my photographs no longer exists, I despair that my photos will become a meaningless echo of nature's lost magnificence.

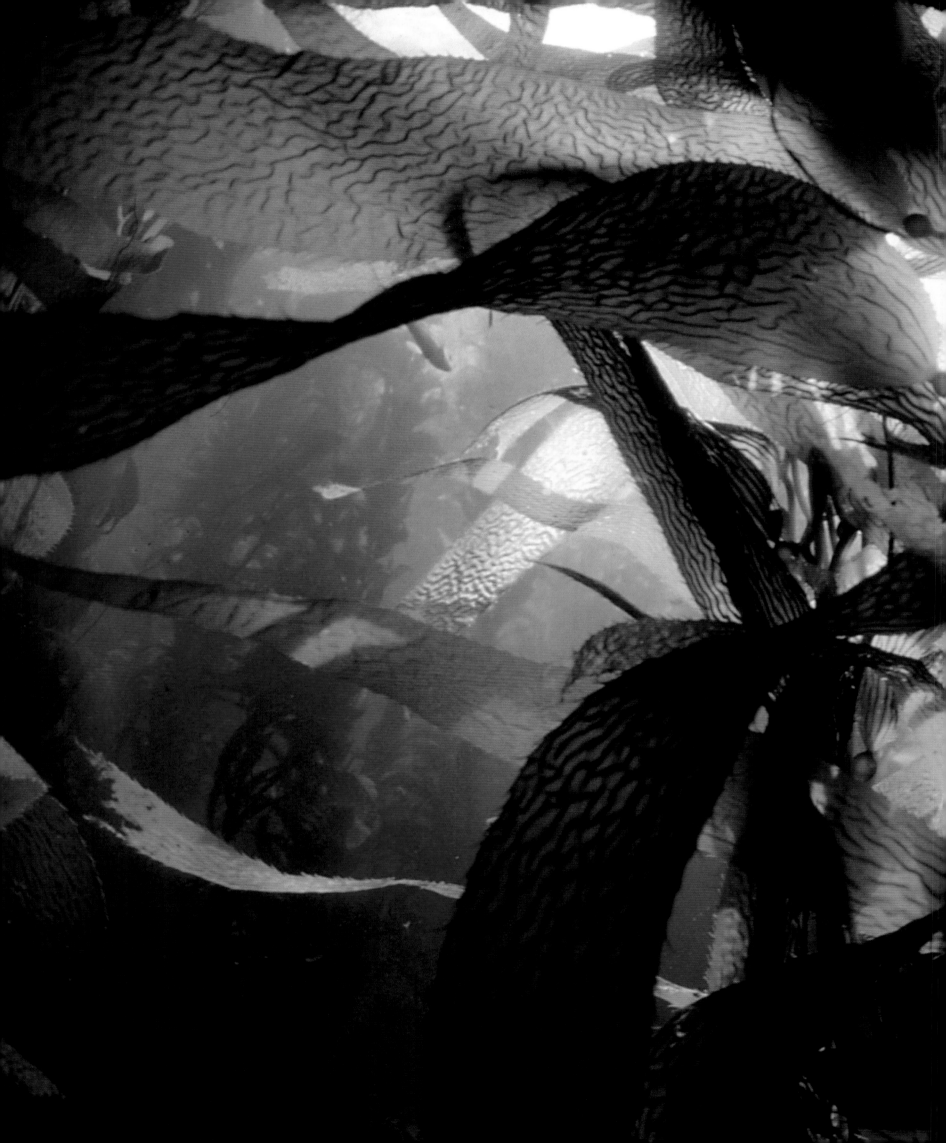

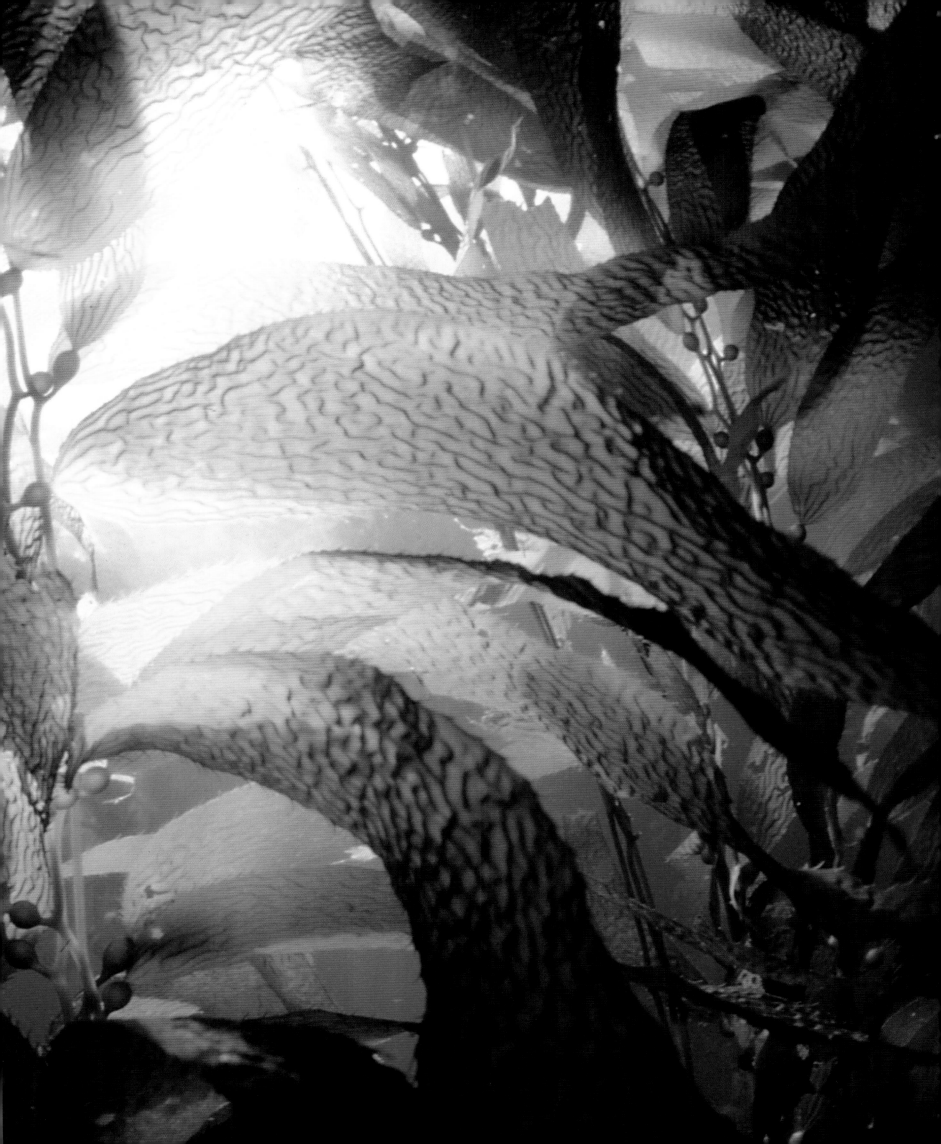

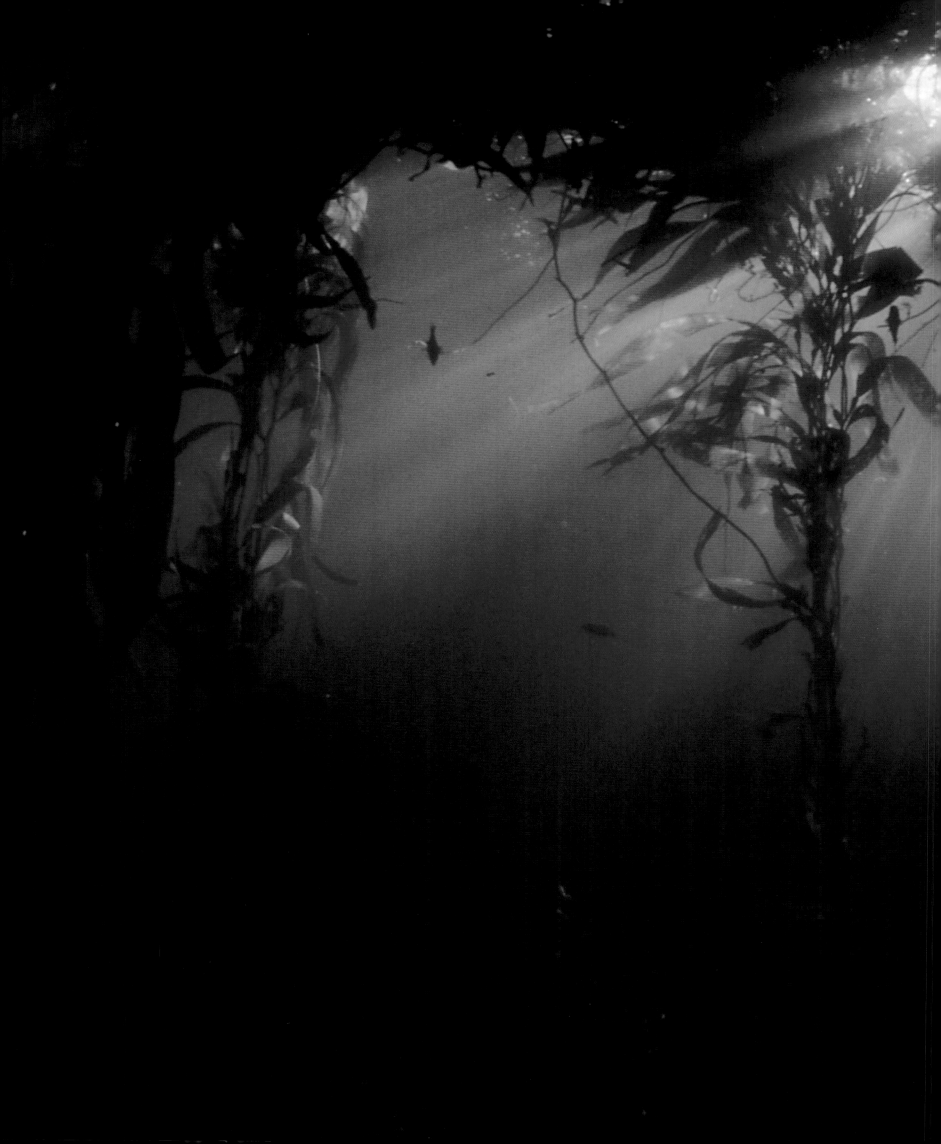

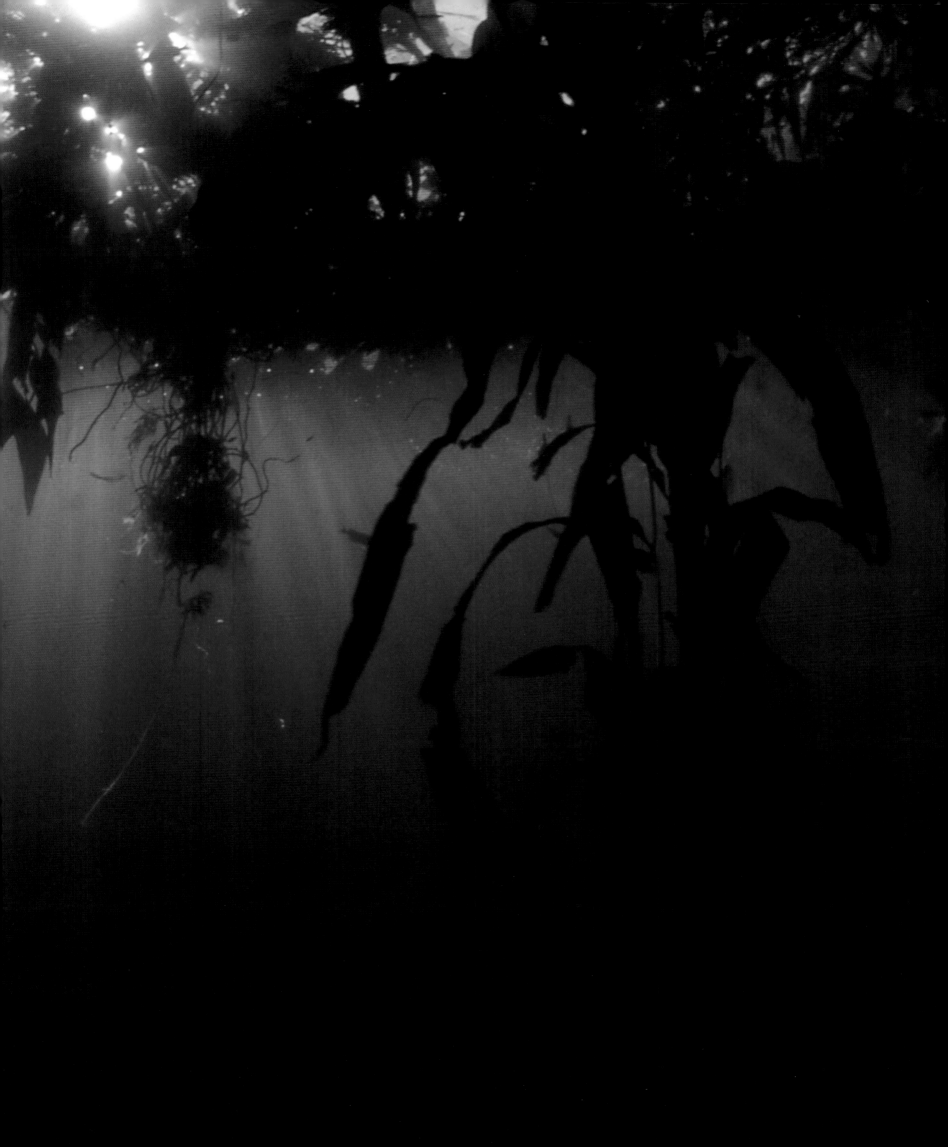

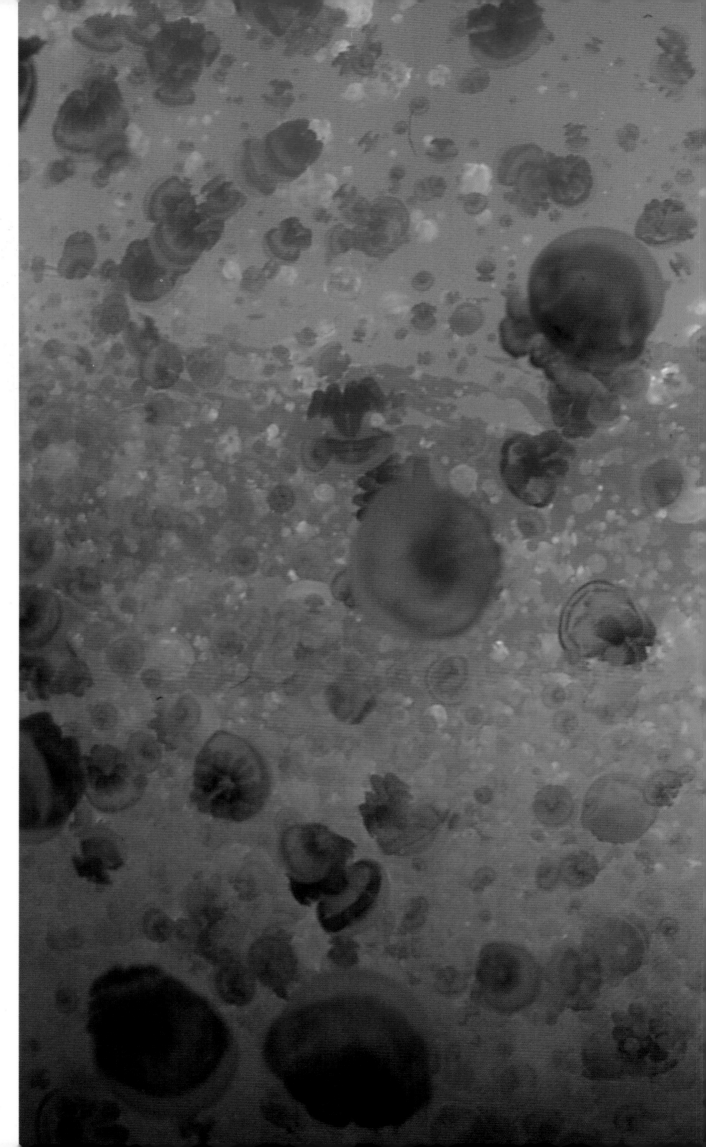

THE DESCENT

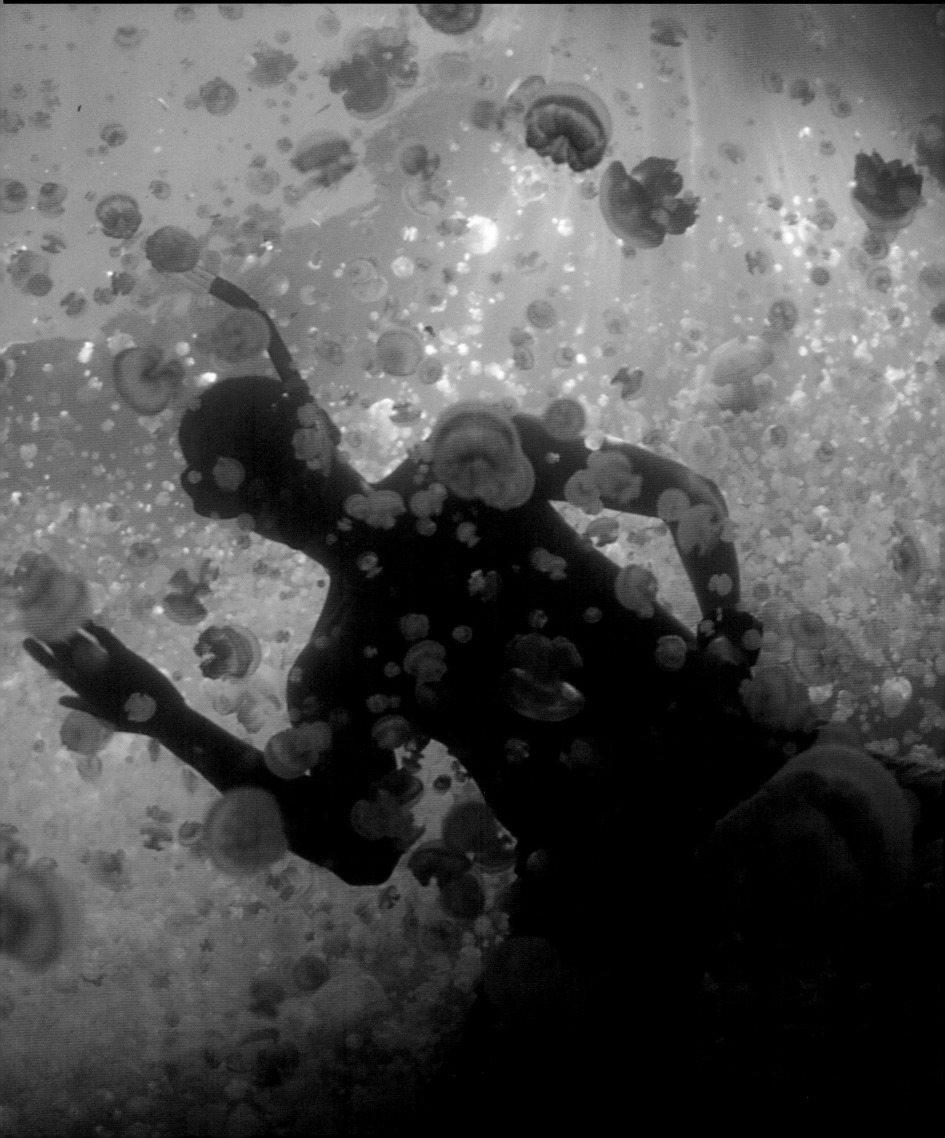

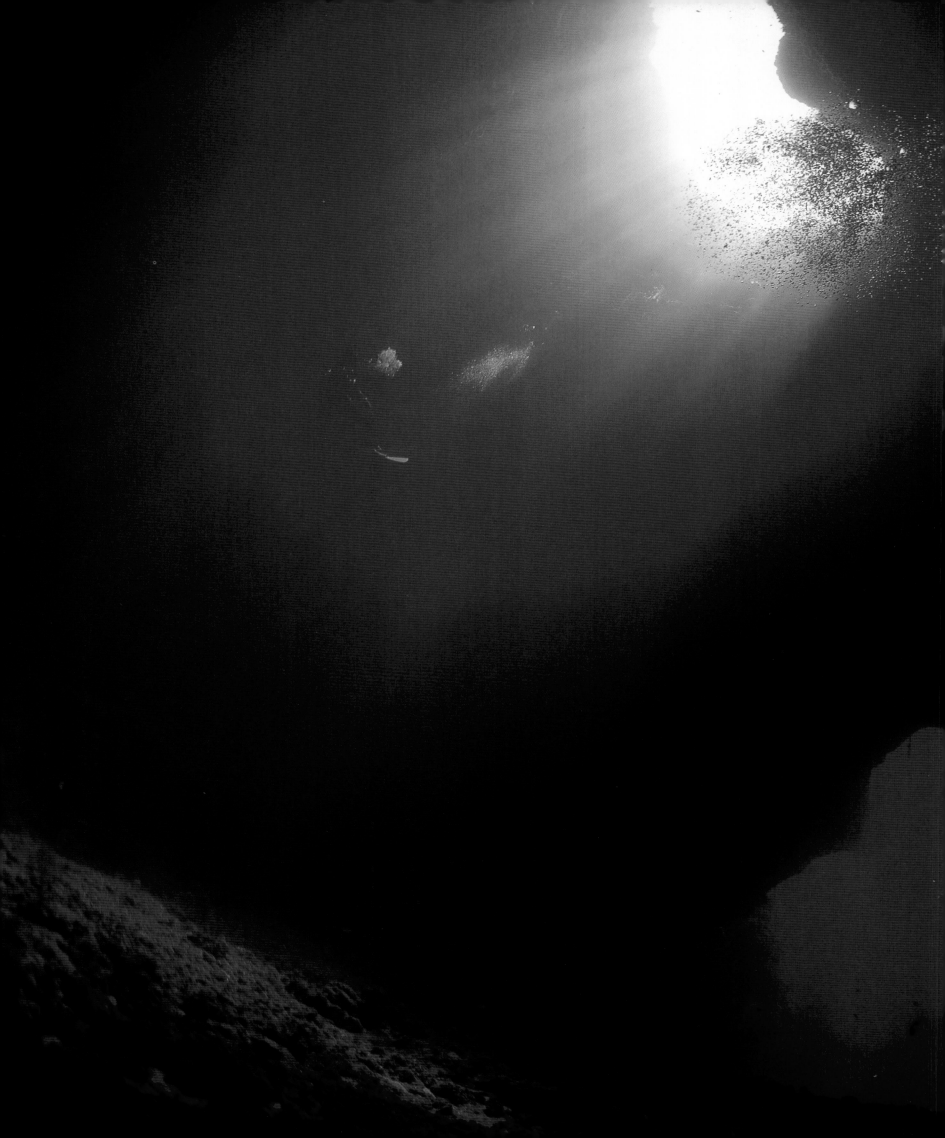

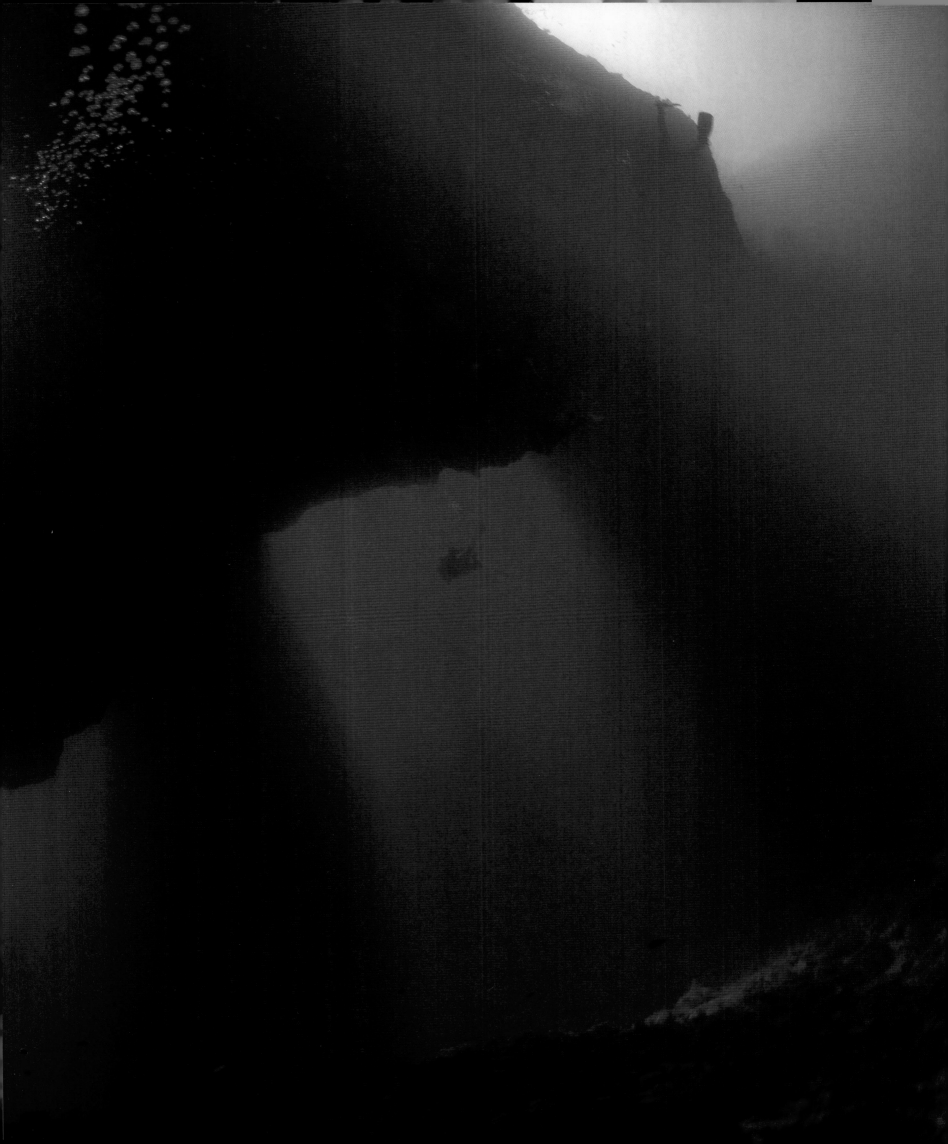

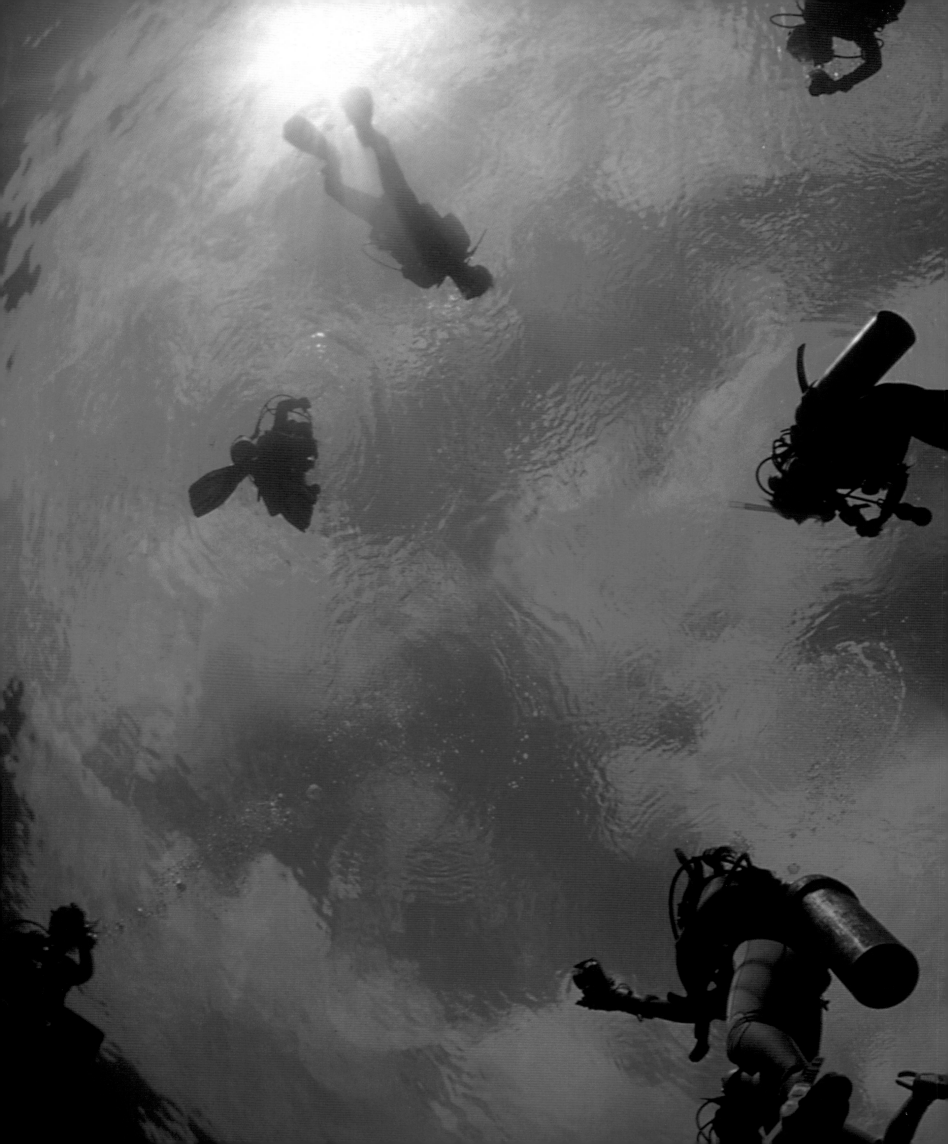

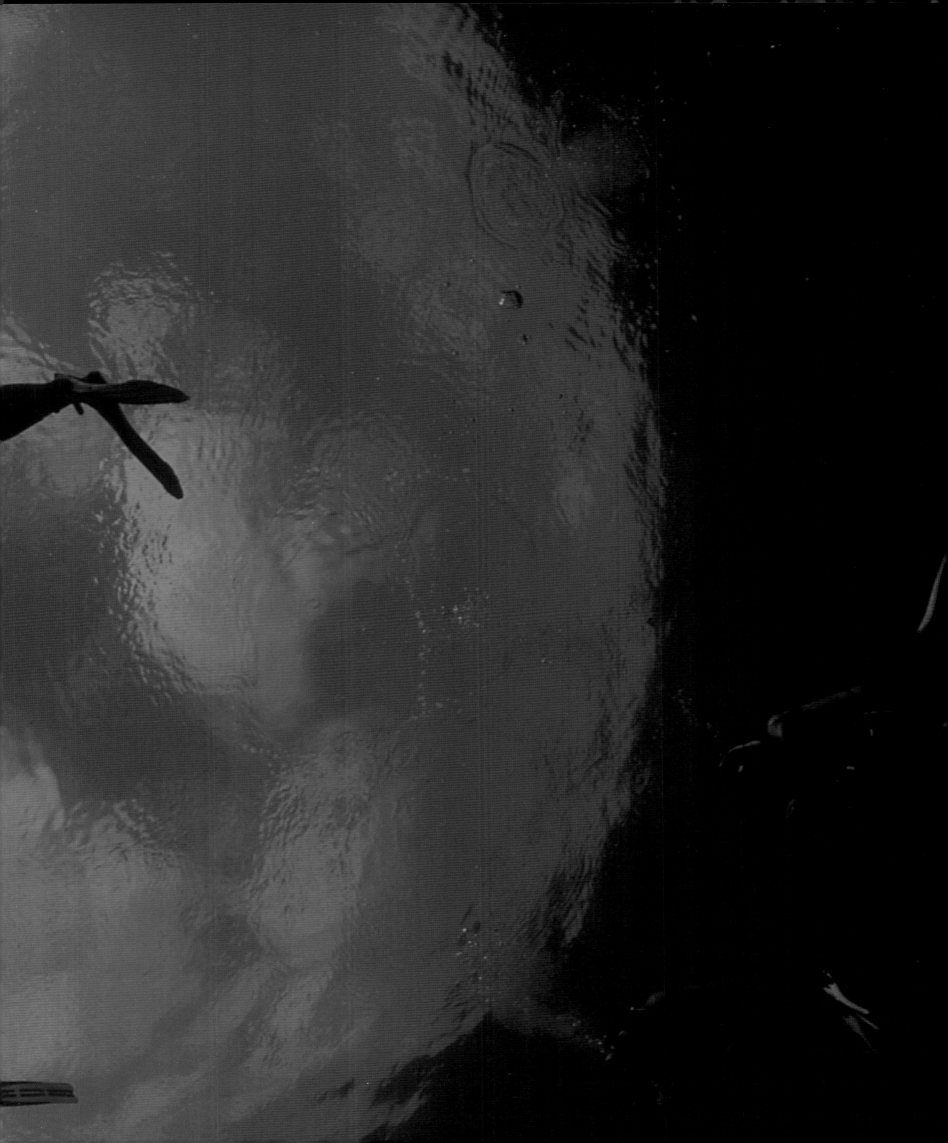

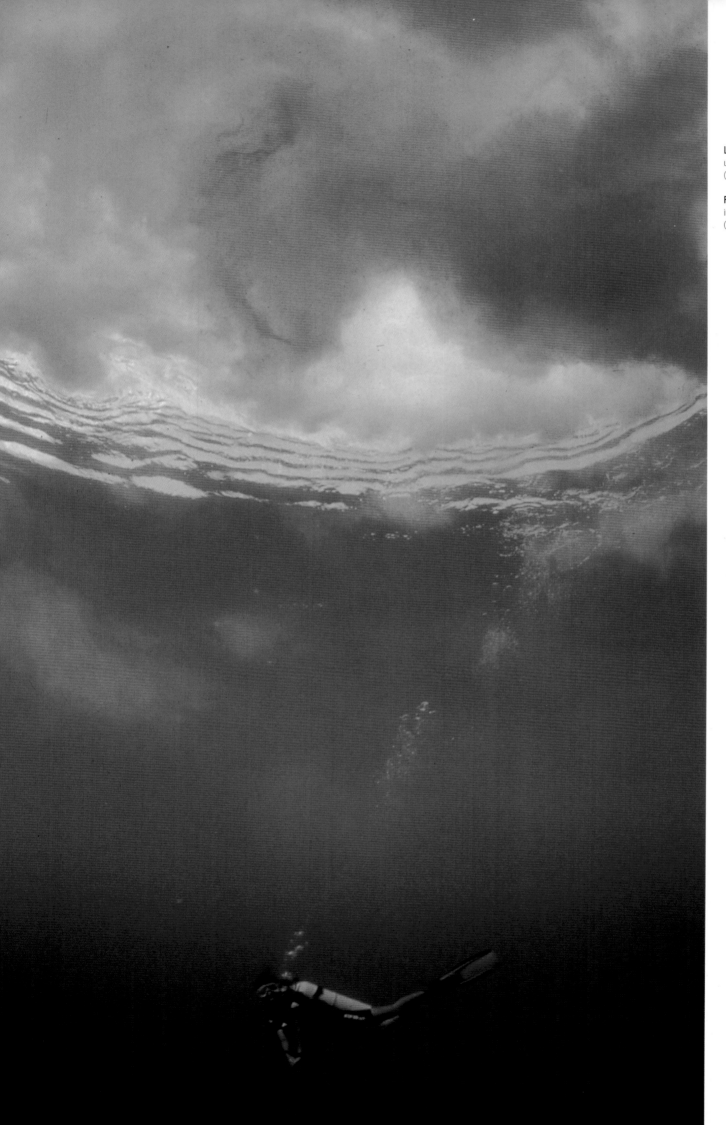

LEFT: The water introduces
us to a different world
(Andaman Sea, Thailand 2004)

RIGHT: A blessing of light
in the blue cavern, Rota Hole
(Rota, Federated States of Micronesia 2002)

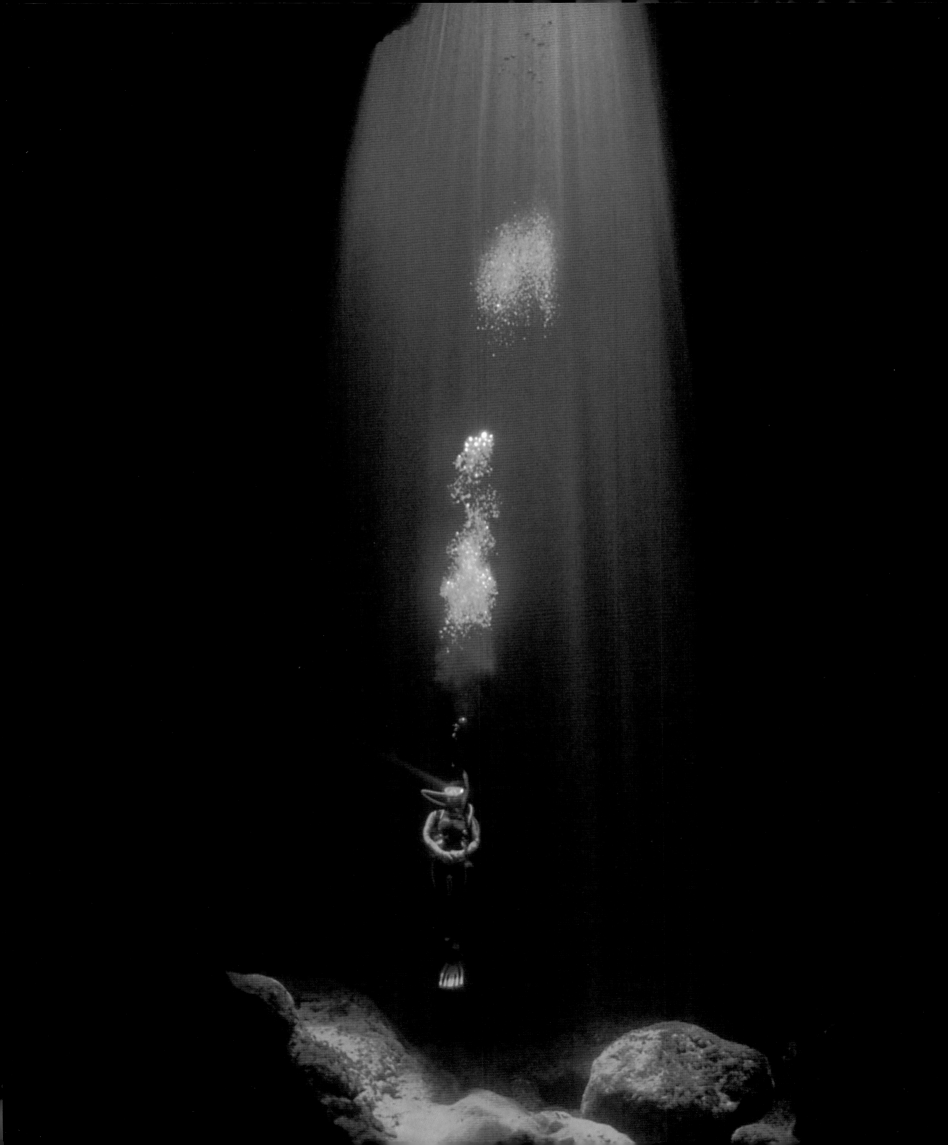

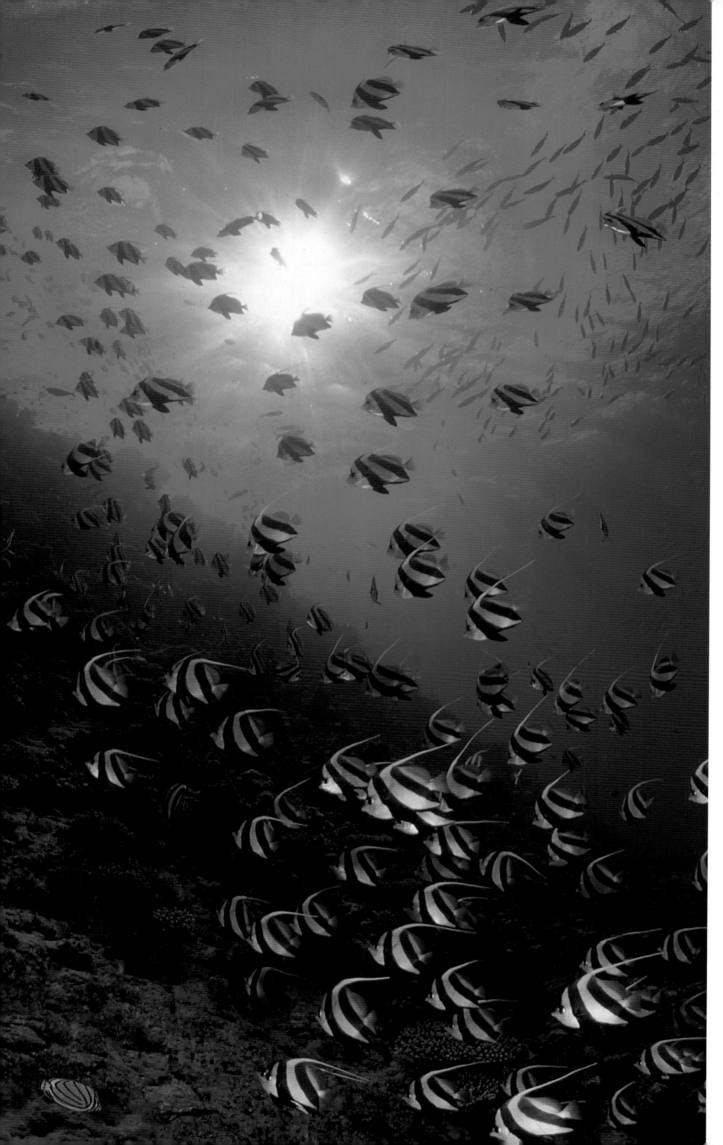

LEFT: A school of bannerfish, suspended from
the sea surface like chandeliers
(South Male Atoll, the Maldives 1997)

RIGHT: Wandering into the labyrinth
of fish while diving
(South Male Atoll, the Maldives 1997)

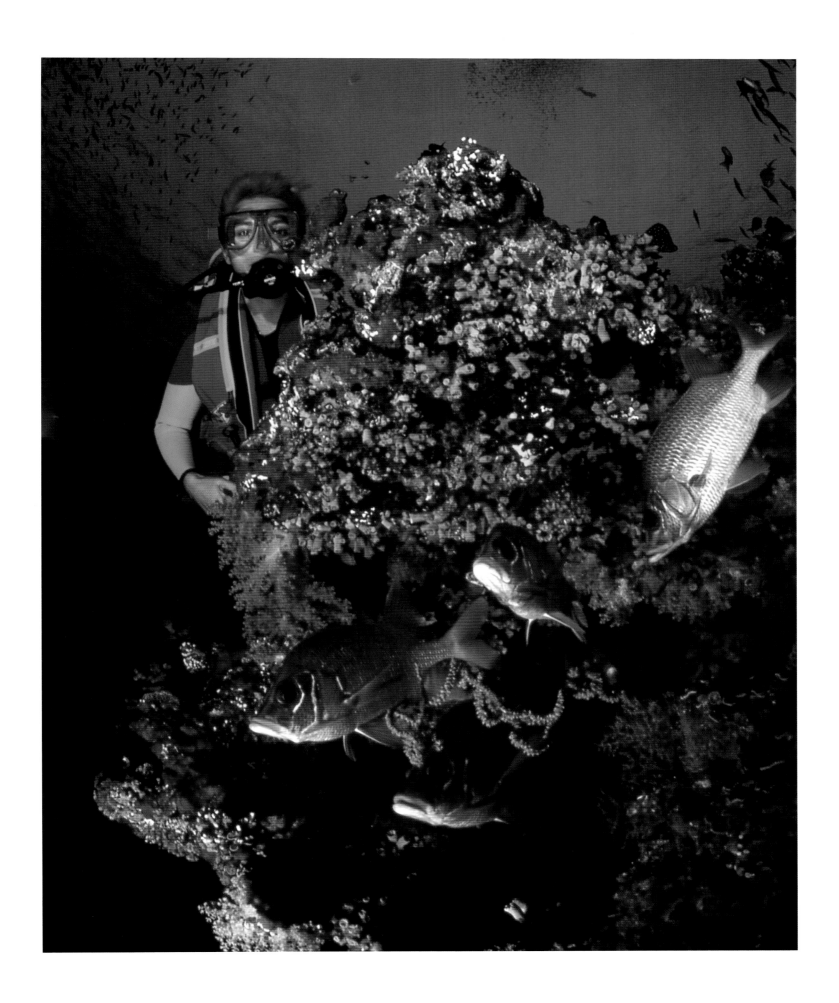

THE DESCENT

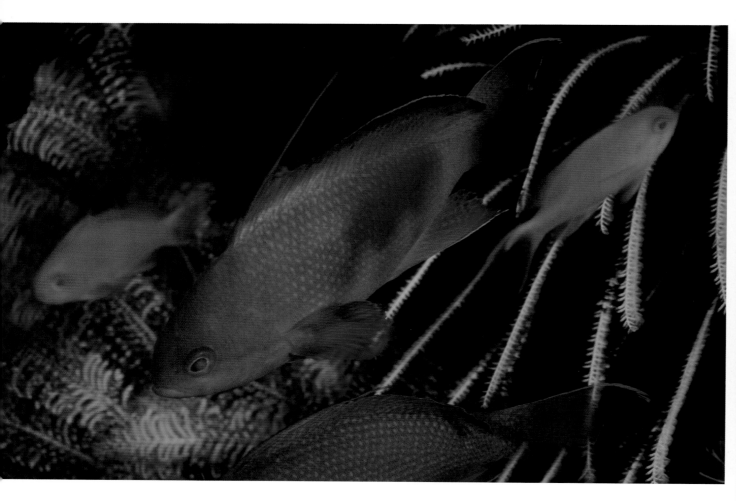

ABOVE: The uncanny charm
of a scalefin fairy basslet
(Komodo Island, Indonesia 2007)

RIGHT: Teira batfish; the lagoon is a safe cradle
for the young fish
(South Male Atoll, the Maldives 1997)

PAGES 28-29: Figures against the landscape:
a ripple of sand stretched out
(Yonaguni, Okinawa, Japan 2003)

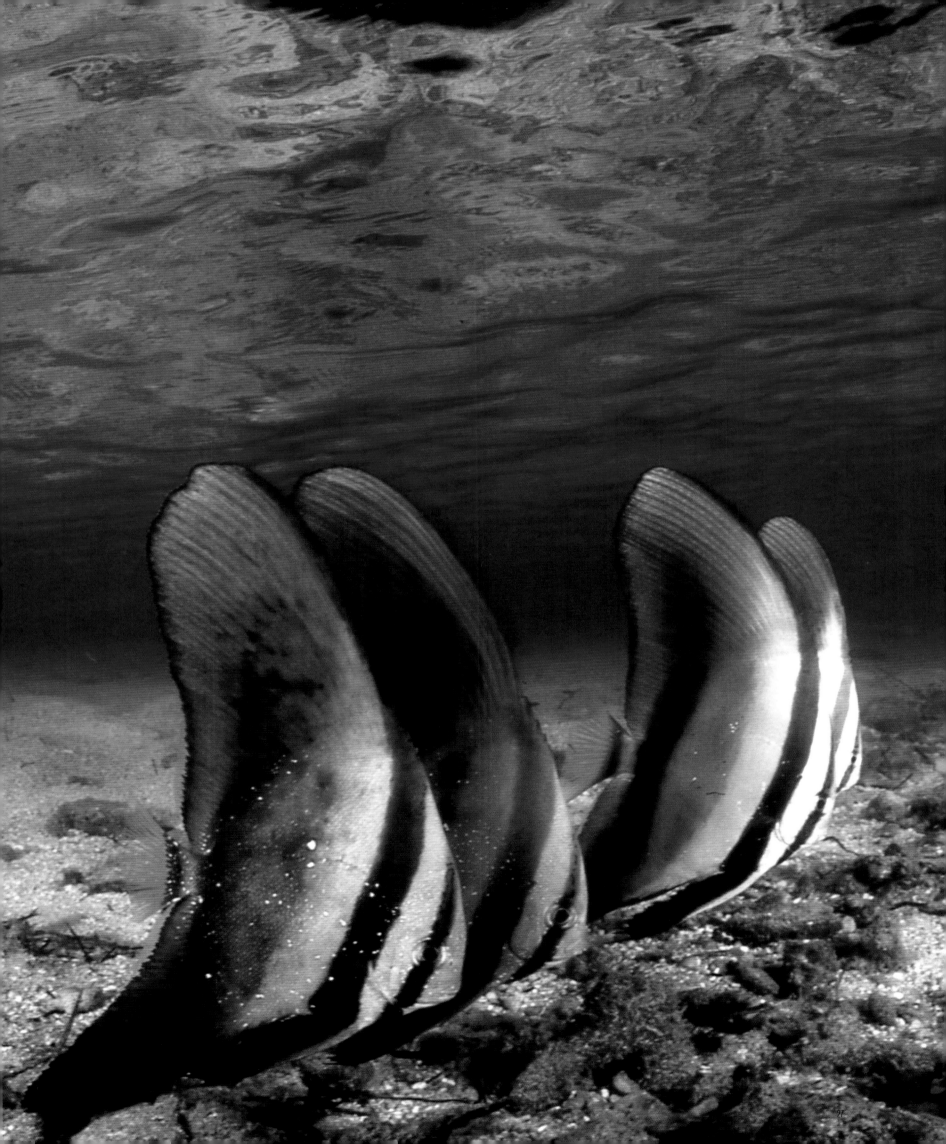

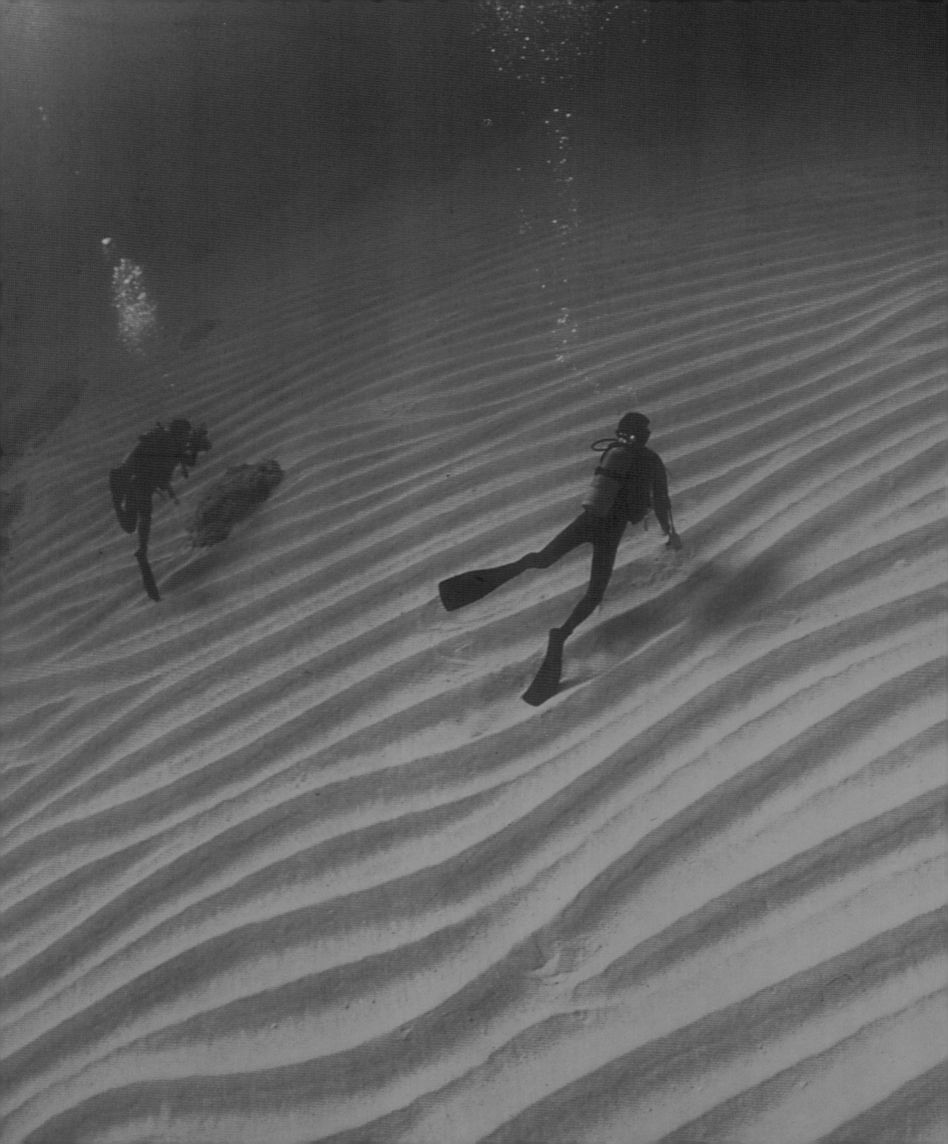

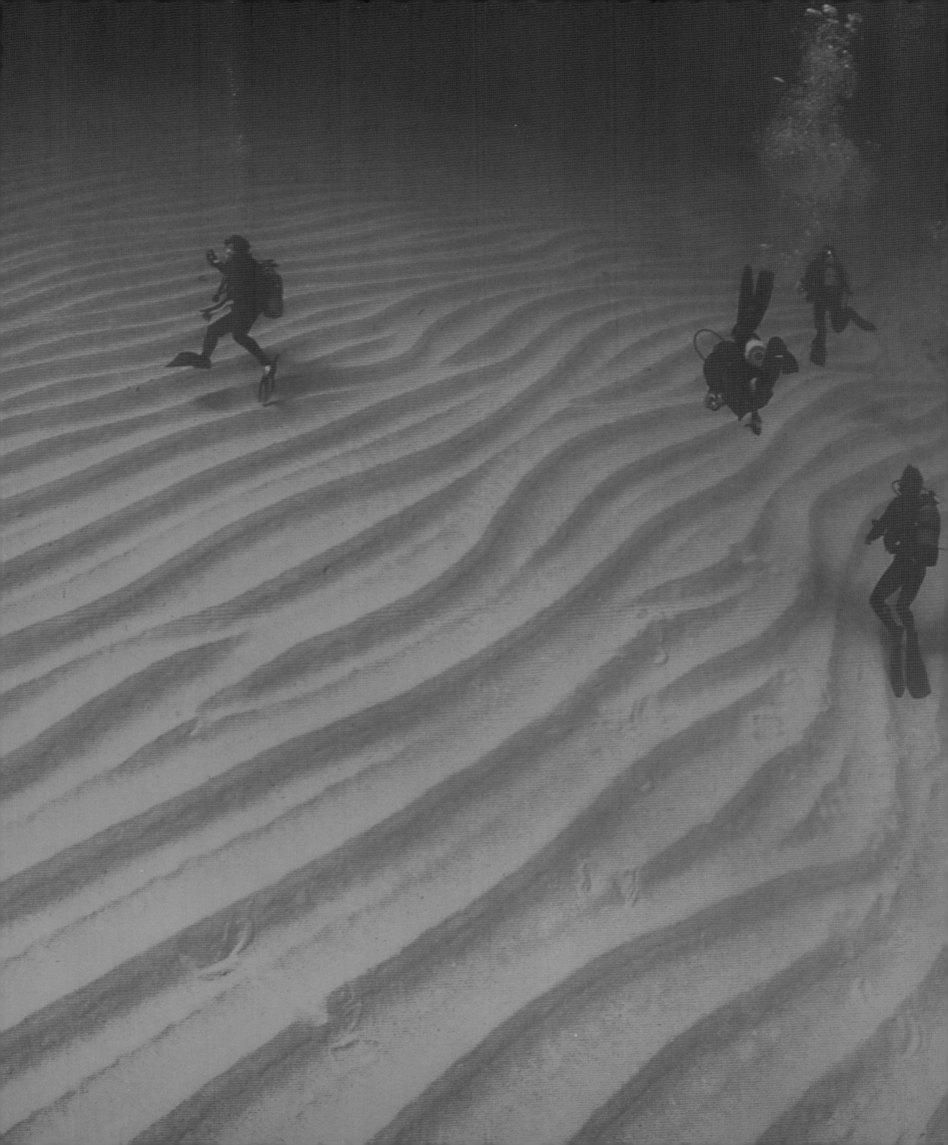

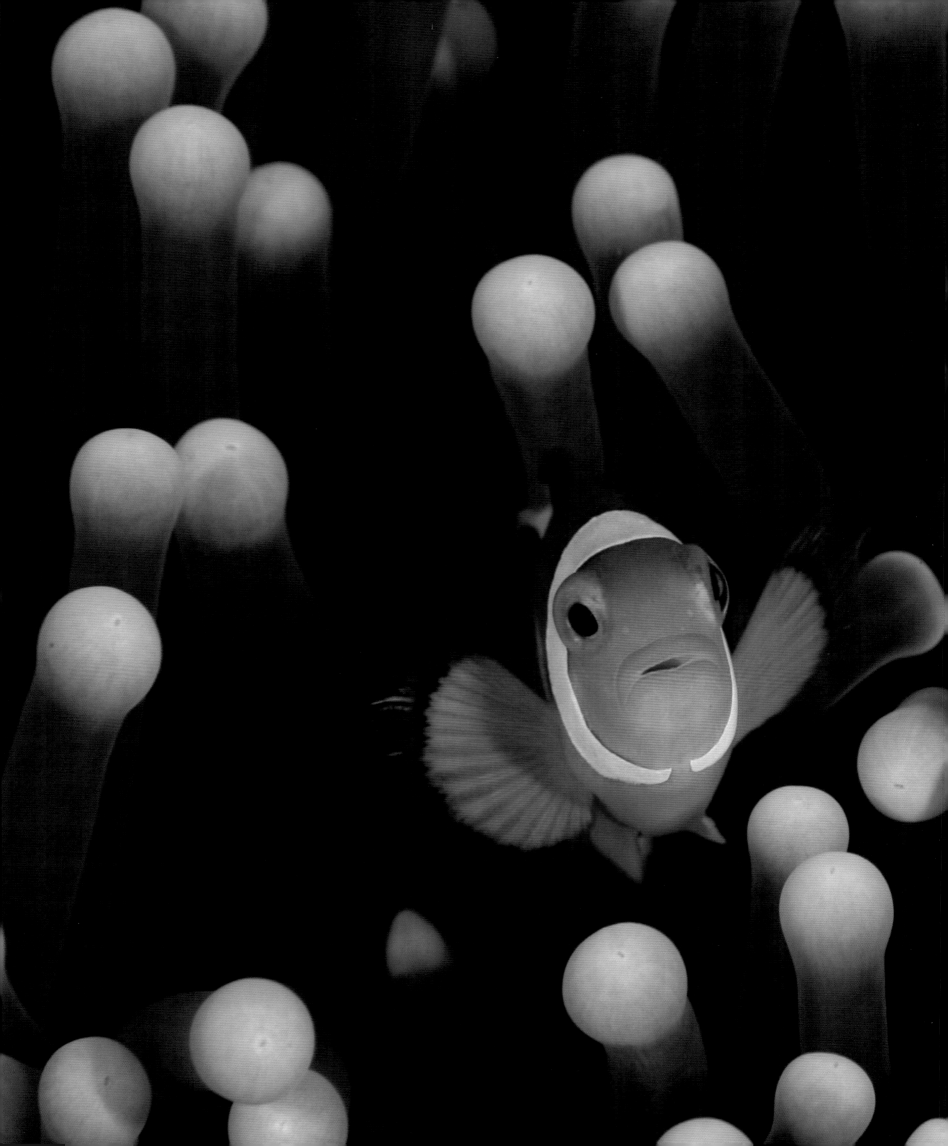

HABITAT

A stunning variety of creatures colonise every possible underwater habitat. Evolution finds opportunity everywhere: open ocean, murky, cold and deep; warm clear shallows bathed in sun; wide flat plains of gently undulating sand; tiny crevices in sheer rock walls; dark caves and brilliant coral gardens; even hydro-thermal chimneys spewing super-hot clouds of deadly chemicals, into the darkness three kilometres deep.

As the main concern of life in the sea is to eat without being eaten, habitat shapes strategies of attack and defence. Take the tendency of fish to swim together. There are about 26,000 varieties of fish, and approximately half of them form shoals for at least part of their life. The open ocean is a dangerous place, especially for small fish. Schooling increases the number of possible targets and so confuses an attacker. Thousands of eyes are better able to detect predators, and large numbers reduce the chances that any single fish will be taken.

Marine creatures even form habitats for smaller creatures in symbiotic and parasitic relationships. Anemonefish make their home in sea anemones, preferably plump and well-developed specimens. The tips of sea anemone tentacles contain stinging cells used to paralyse and capture small prey and as a defence against would-be predators. Although the mechanism is still not fully understood, anemonefish are covered in a mucous-like substance similar to that which protects the anemone from its own stinging cells. Thus nestled safely in the deadly tentacles, anemonefish are protected from larger predators. It is thought that the anemonefish may act as a shill, making the anemone appear harmless. Small fish are lured to their deaths, and anemonefish feed off the scraps. The anemonefish keeps its host free of parasites and debris and its territorial propensity to charge larger creatures may serve to protect the anemone against tentacle-biting predators.

Although comatulids appear to be colourful and intricate sea ferns, they are in fact animals related closely to starfish. One can find tiny shrimps, crabs and clingfish hiding in the feathery arms, their coloured exteriors blending in perfect camouflage with the brightly plumed host.

The coral reef is one of the more wonderfully exotic ecosystems in the sea, giving food, shelter and opportunity to a plethora of creatures. The reef itself is a living organism created by countless tiny coral polyps clinging together as they jostle to find a sunny space. The colours are not a property of the coral itself, but of a tenant that makes its home inside individual polyps: zooxanthella is a kind of algae living symbiotically within the polyp. The polyp protects the zooxanthella and provides it with nutrients, while the zooxanthella provides the polyp with much of its energy. The colour we see is a living decorative façade covering massive, ancient structures that have been growing slowly for millions of years, as generation upon generation of coral polyps build upon those that have gone before.

Although these massive structures are among the oldest ecosystems on the planet, they are also some of the most vulnerable to changes in the narrow range of environmental conditions in which they are able to thrive. Even small rises in water temperature stress polyps, causing them to expel the algae in a process called coral bleaching, leaving the reef a ghostly white. If conditions persist, the polyps soon die, and once vibrant reefs become dull skeletons covered in dirty brown weeds, left to be slowly worn and broken away by the constant surge of the tide until the crumbled remains resemble the wreckage of a bombed out city.

In the spring of 1998, a rise in water temperature in the sea around the Maldives resulted in a massive episode of coral bleaching in which ninety percent of the reefs were destroyed. Although I had been regularly visiting the Maldives between 1995 and 1998, I was not there to see the reefs turn white. When I first entered the water on my return I felt I was choking. I became disoriented, unable to recognise this familiar place. I could not recall what the reefs used to look like, only that they had been stunningly beautiful. Tears filled my eyes when I realised the treasure I had taken for granted was now entirely lost.

As with much human suffering, when the carnage is not visible, neither is it of consequence.

LEFT: Western clown anemonefish and cleaner shrimp; these two are close friends, sharing the same sea anemone (Raja Ampat, Indonesia 2007)

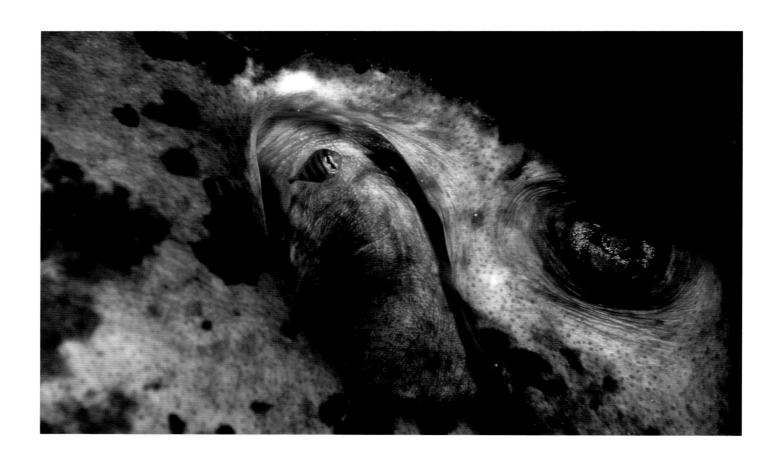

TOP LEFT: A field of flowers found in a corner of the sea; a wide variety of hues are found in coelenterates
(Koza, Wakayama, Japan 2006)

TOP RIGHT: Pepper-and-salt commensal shrimp living on the red upholstery of a sea anemone
(Manado, Indonesia 2006)

BOTTOM LEFT: This black-blotched stingray has a young golden trevally living in its ear
(Ari Atoll, the Maldives 2004)

BOTTOM RIGHT: Millions of tiny lives launched simultaneously into the darkness. To see table coral *(acropora hyacinthus)* spawning is a rare and moving experience
(Kushimoto, Wakayama, Japan 2001)

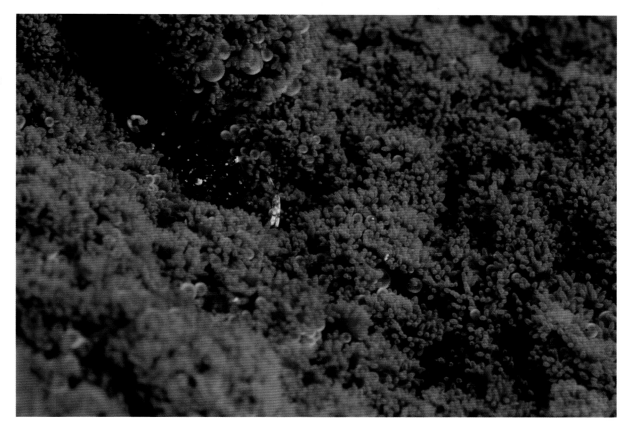

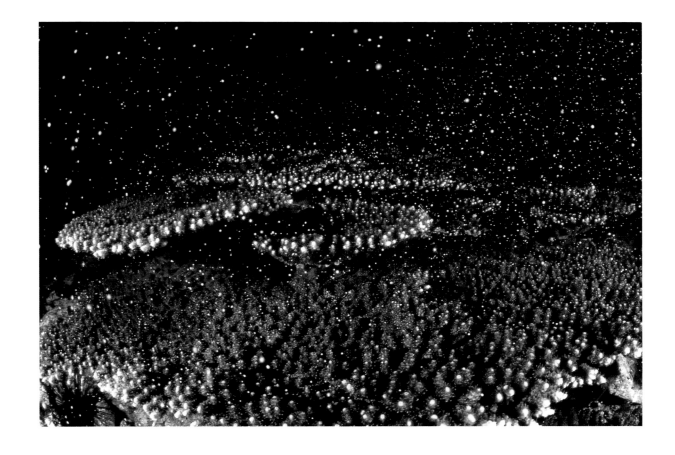

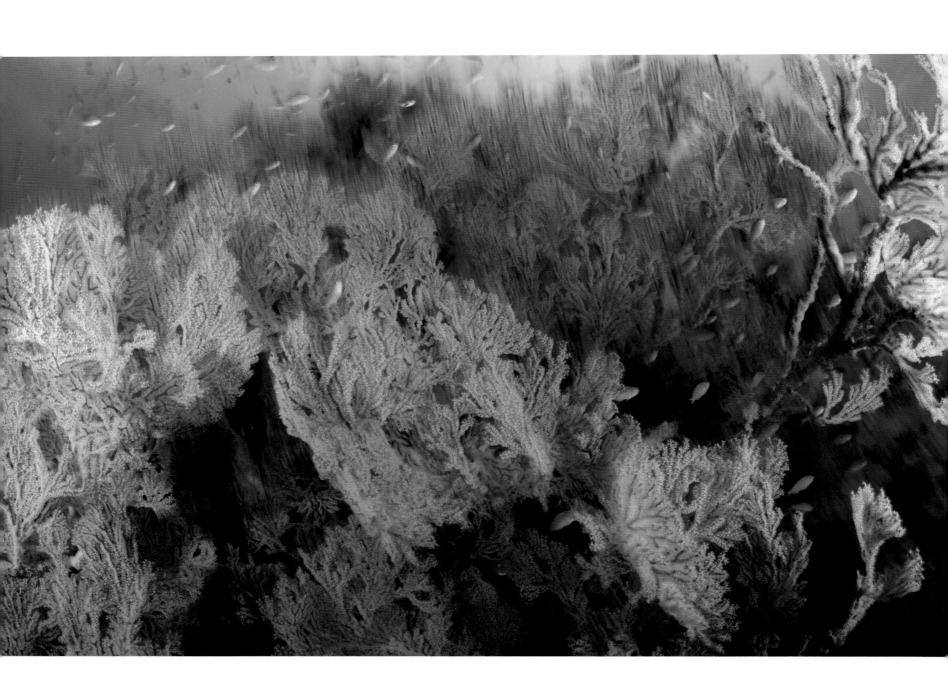

ABOVE: The sea fan looks lightly dusted with
snow. Scalefin fairy basslets flitter around
(Komodo Island, Indonesia 2007)

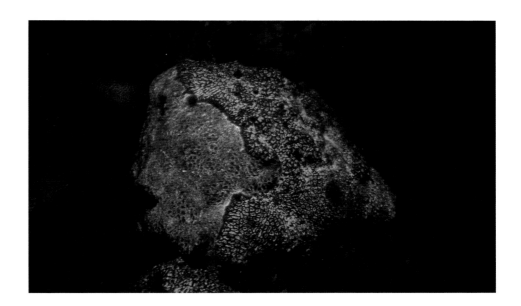

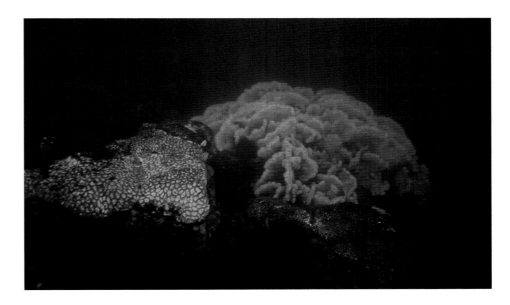

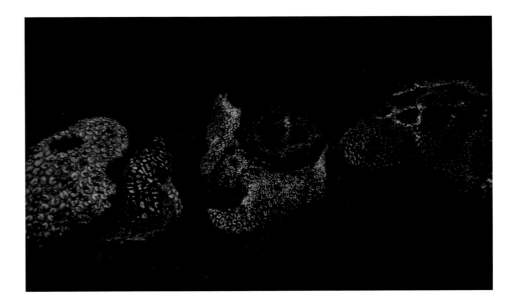

TOP RIGHT: Coral (*goniastrea australiensis*), luminescent under black light (Kushimoto, Wakayama, Japan 2007)

MIDDLE RIGHT: Coral (left, *goniastrea australiensis*; right, *pavona decussata*) (Kushimoto, Wakayama, Japan 2007)

BOTTOM RIGHT: Coral (*goniastrea australiensis*) (Kushimoto, Wakayama, Japan 2007)

PAGES 36-37: The innocent lives of pygmy sweepers, found under the reef (Komodo Island, Indonesia 2007)

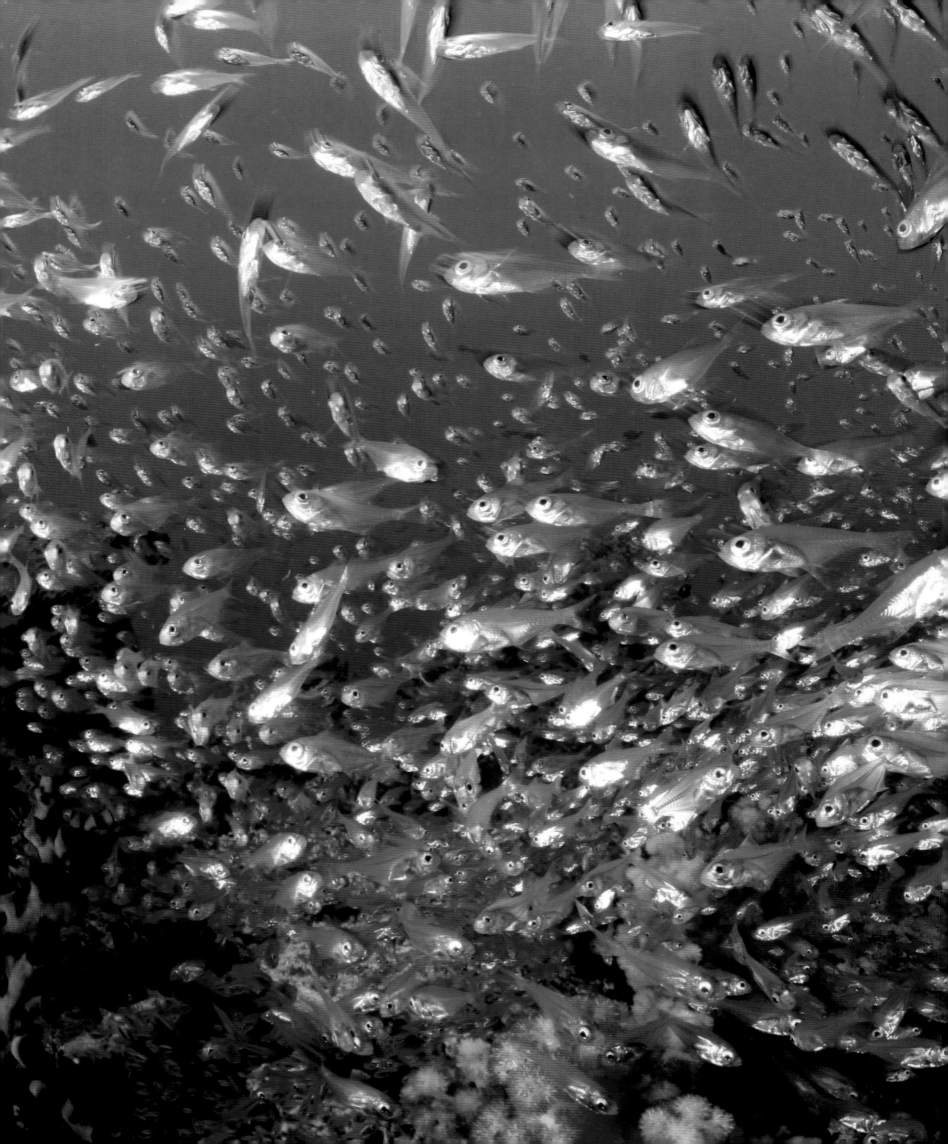

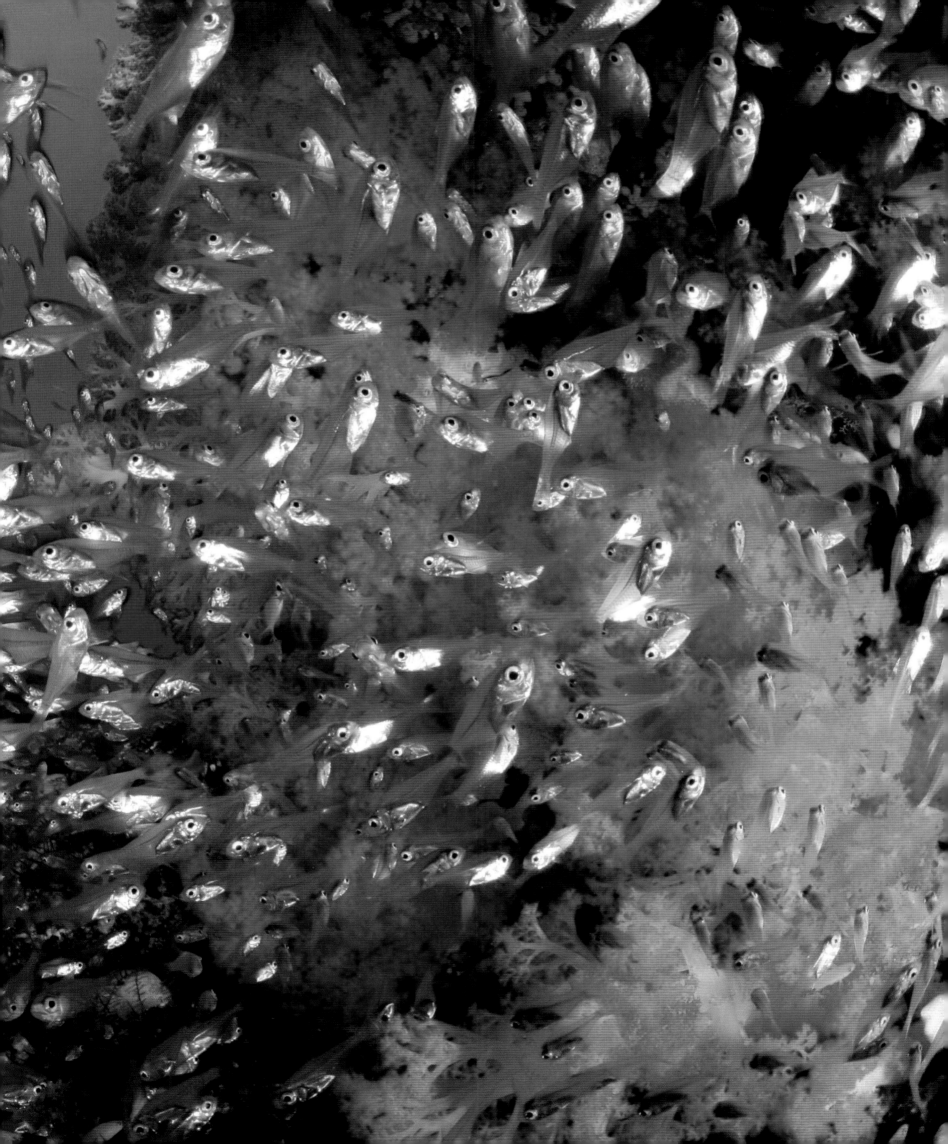

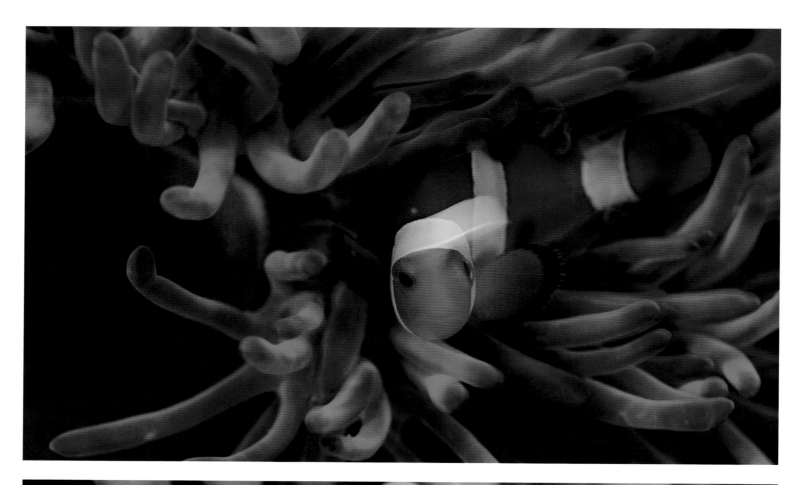

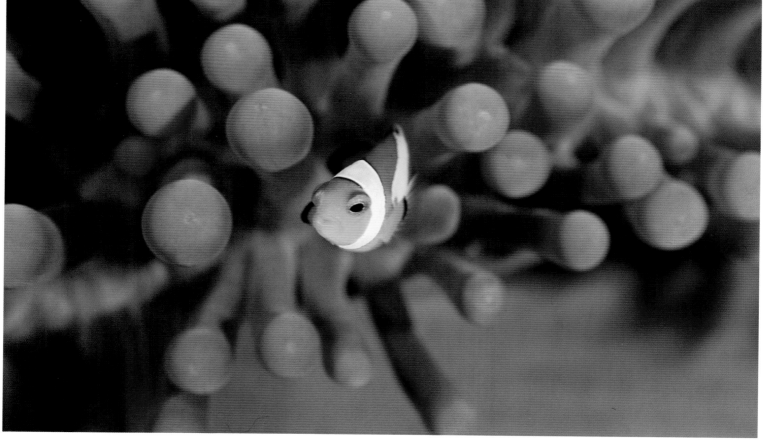

TOP LEFT: A western clown anemonefish hiding behind the poisonous sea anemone (Manado, Indonesia 2006)

BOTTOM LEFT: A young western clown anemonefish at home in a sea anemone with cherry pink tentacles (South Male Atoll, the Maldives 1997)

RIGHT: A Maldive anemonefish peeks from behind the soft, yellow tentacles of a sea anemone. (South Male Atoll, the Maldives 1998)

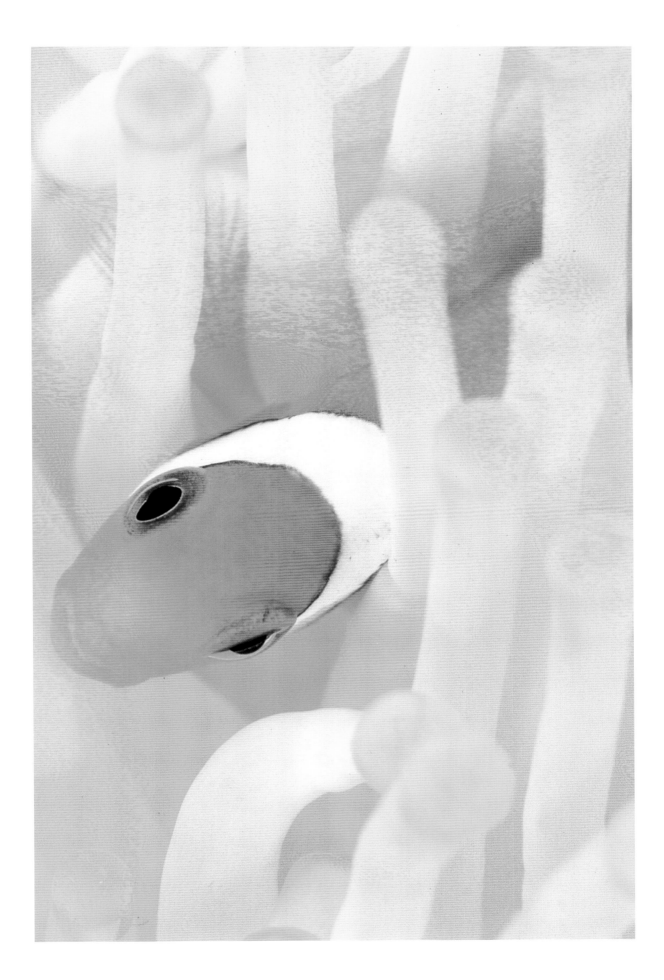

BOTTOM: 'Sea of Miracle' at Havodigalaa Thila, located in northern Gaaf Atoll, the beautiful coral has been left untouched (Gaaf Atoll, the Maldives 2004)

TOP RIGHT: Two spinecheek anemonefish striking a pose (Manado, Indonesia 2005)

BOTTOM RIGHT: Yellow pygmy-goby, black cardinalfish and striped frogfish, cohabiting in an old tin can (Sue, Wakayama, Japan 2006)

PAGES 42-43: An enormous number of convict blenny crowding around fluorescent soft corals (Manado, Indonesia 2006)

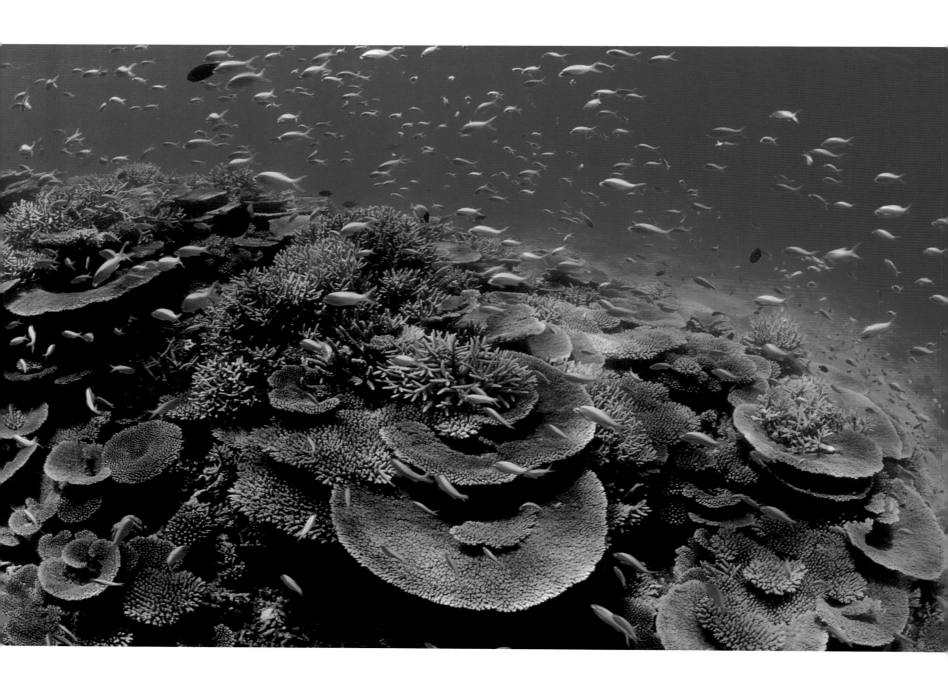

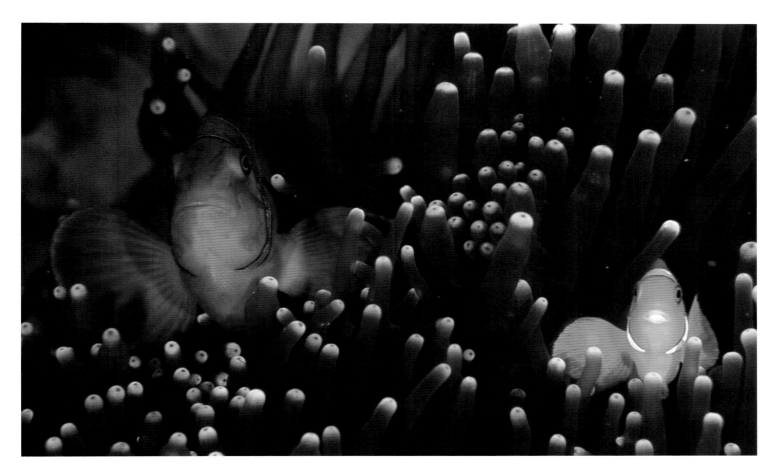

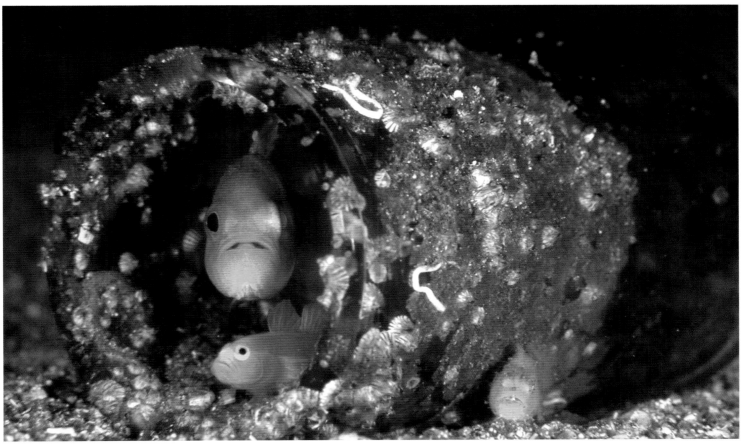

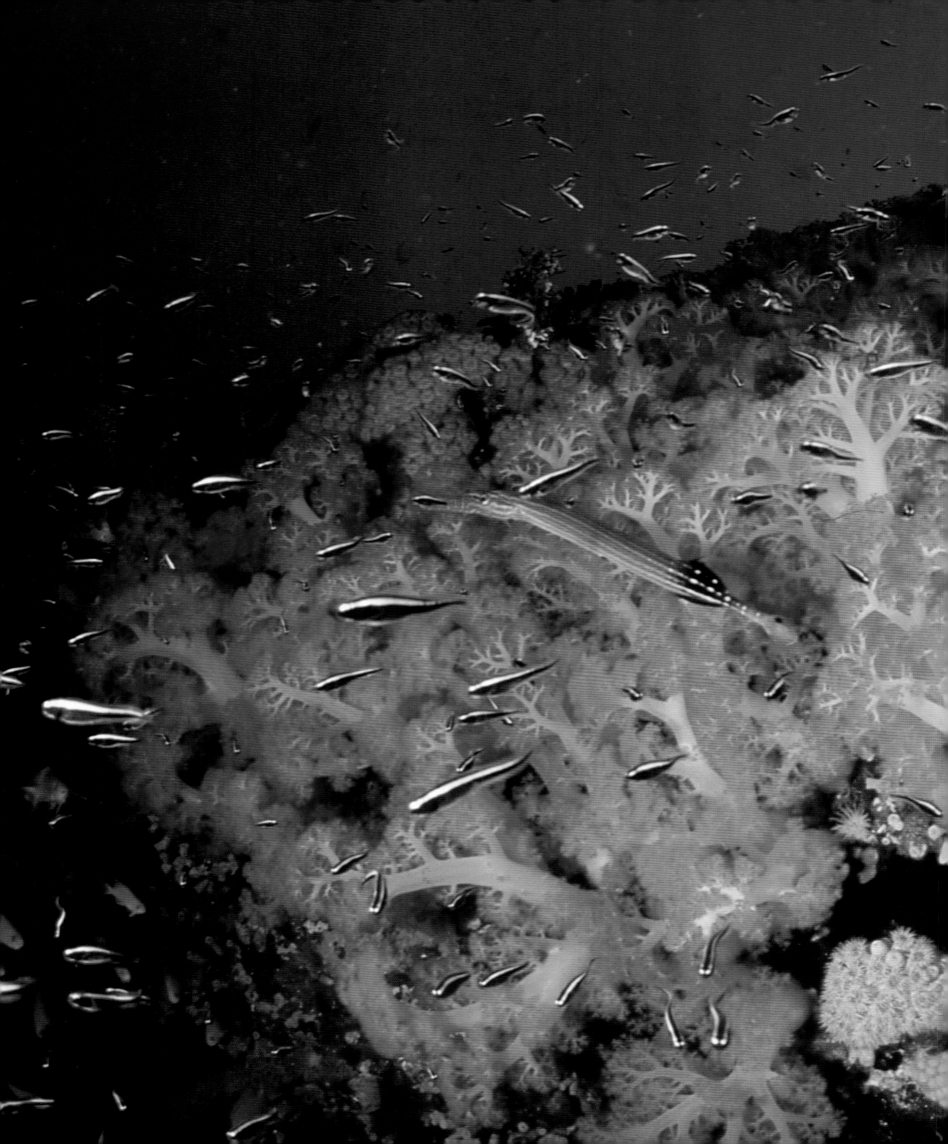

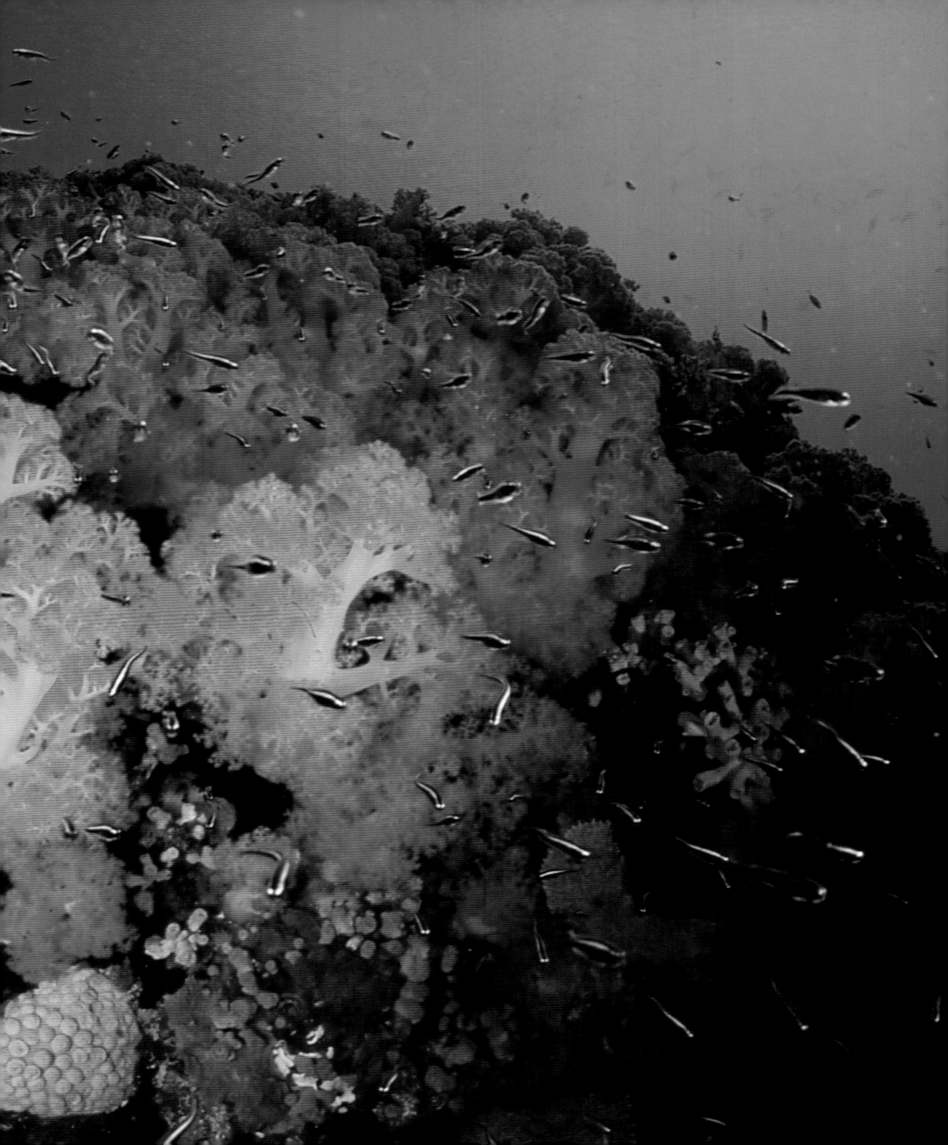

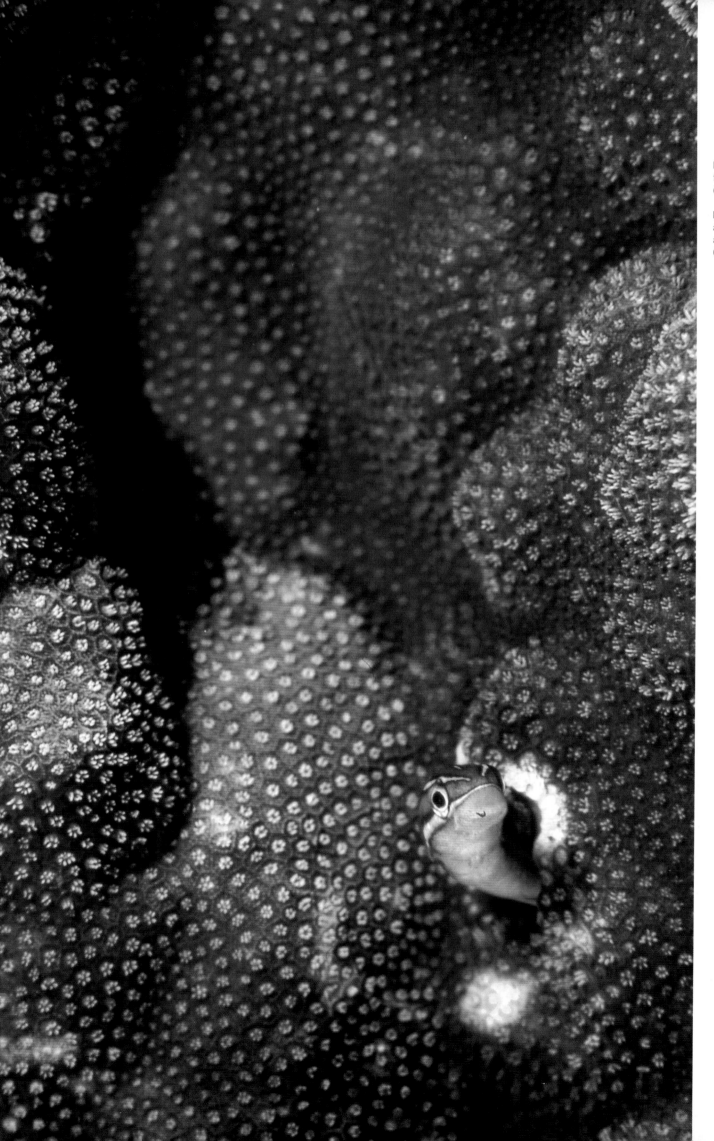

LEFT: A blue-lined blenny pops its head out from the coral and looks at the camera (South Male Atoll, the Maldives 1997)

RIGHT: Maldive anemonefish swim around a sea anemone that has become bleached and turned yellow (South Male Atoll, the Maldives 1998)

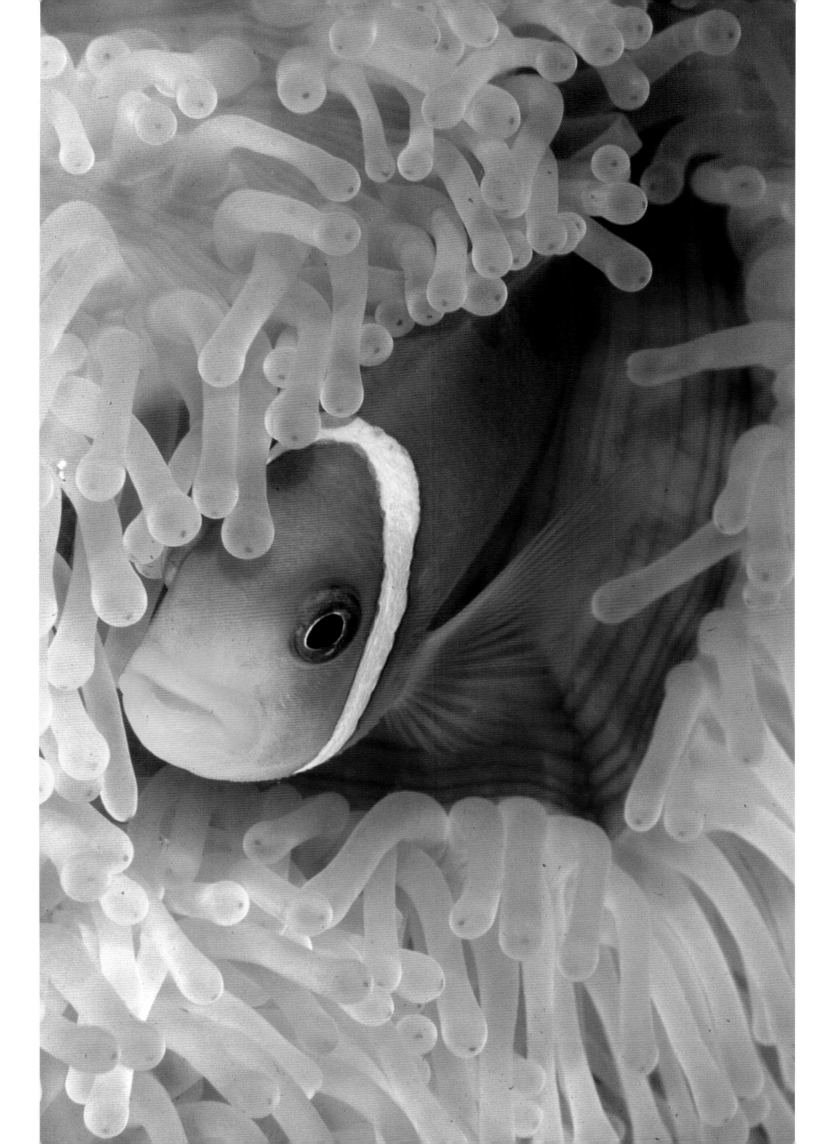

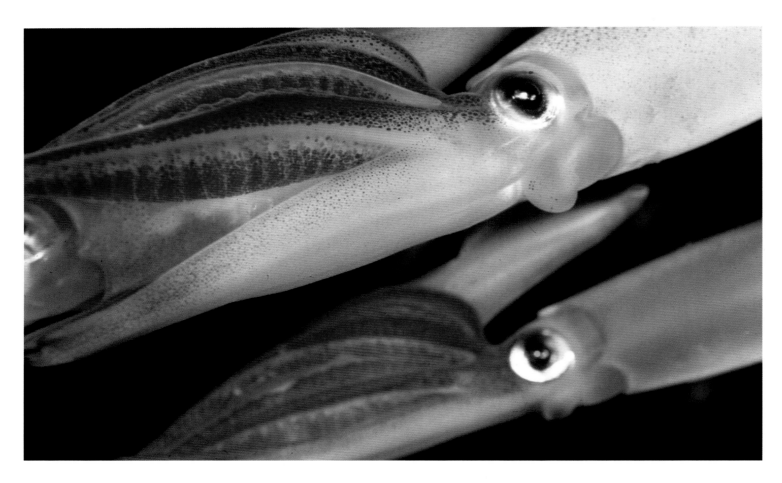

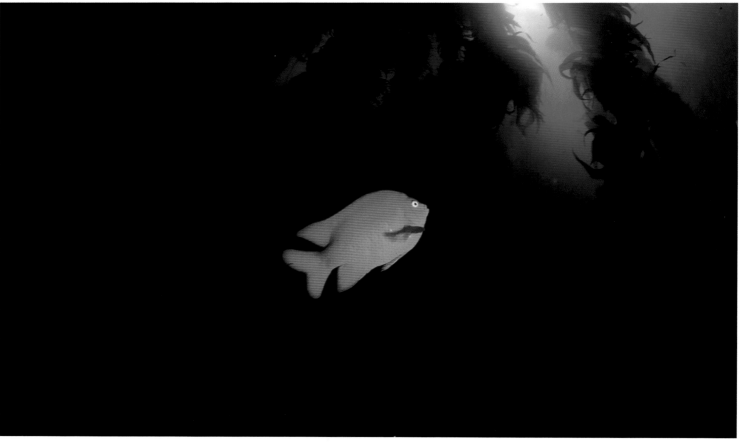

TOP LEFT: Opal squid mating
(California, USA 2000)

BOTTOM LEFT: Brilliant orange
garibaldi contrast brightly against
the dark forest of giant kelp
(California, USA 2000)

RIGHT: A cluster of lives: there are a variety
of different fish living in the Patch Reef
(Ishigaki Island, Okinawa, Japan 2004)

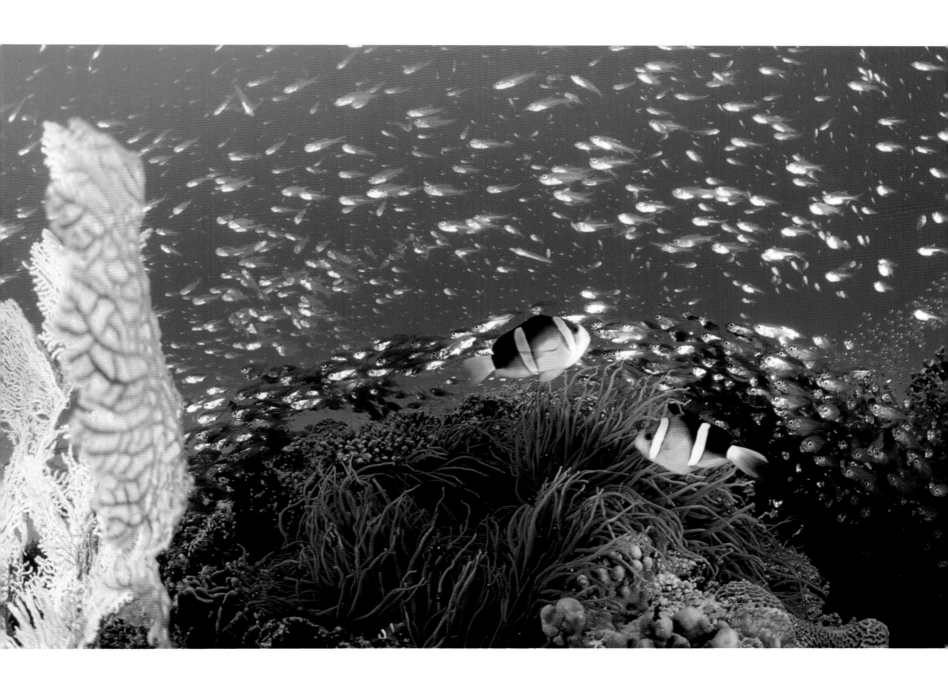

HABITAT

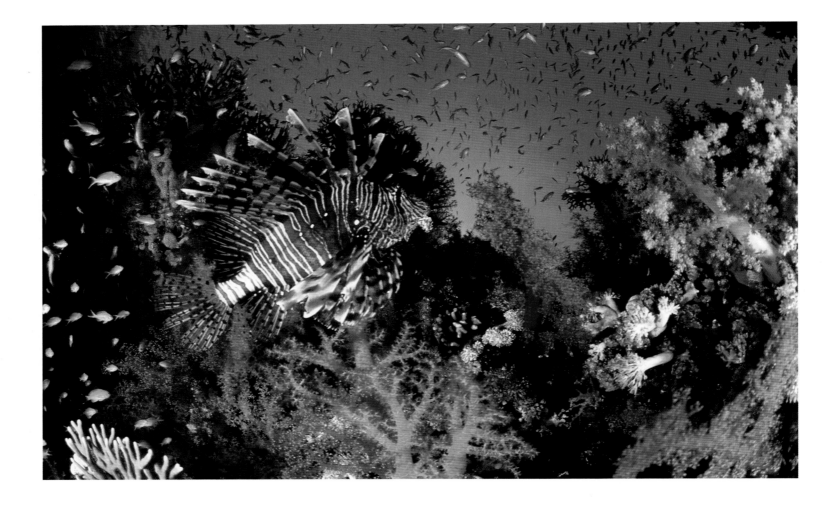

BELOW: A longnose filefish, the coral
eater, mimics the sea fan
(Andaman Sea, Thailand 2007)

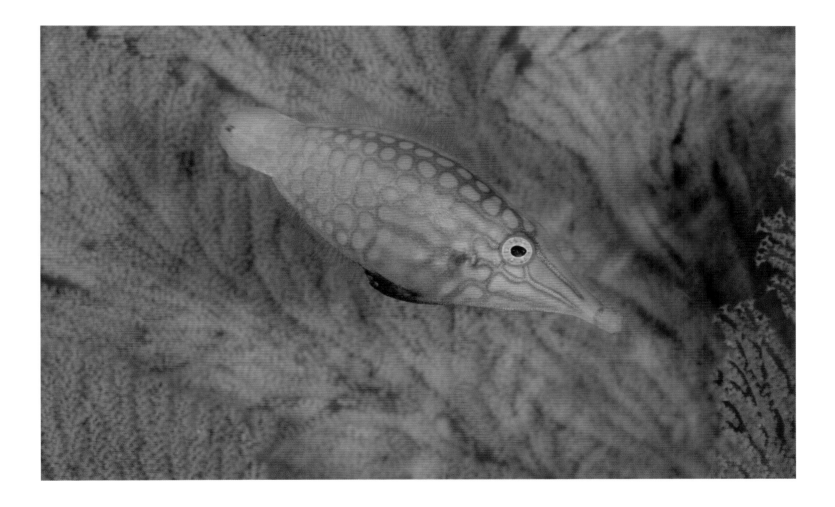

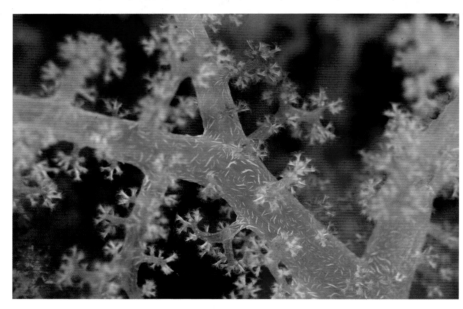

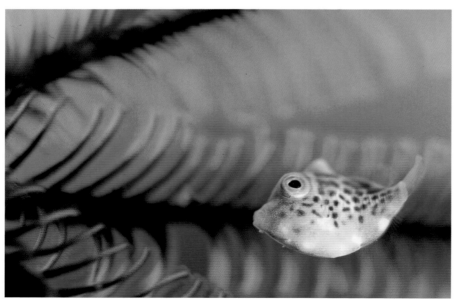

TOP LEFT: A lovely portrait of a pair of sea feathers (El Nido, Philippines 2004)

MIDDLE LEFT: Soft corals have the elegance of cherry blossoms (Andaman Sea, Thailand 2005)

BOTTOM LEFT: Sea feather is an ideal hiding place for Japanese filefish: they share the same body colour (Motobu, Okinawa, Japan 2003)

RIGHT: The ghost pipefish is a good mimic; it has completely eliminated its fish-like features (Andaman Sea, Thailand 2007)

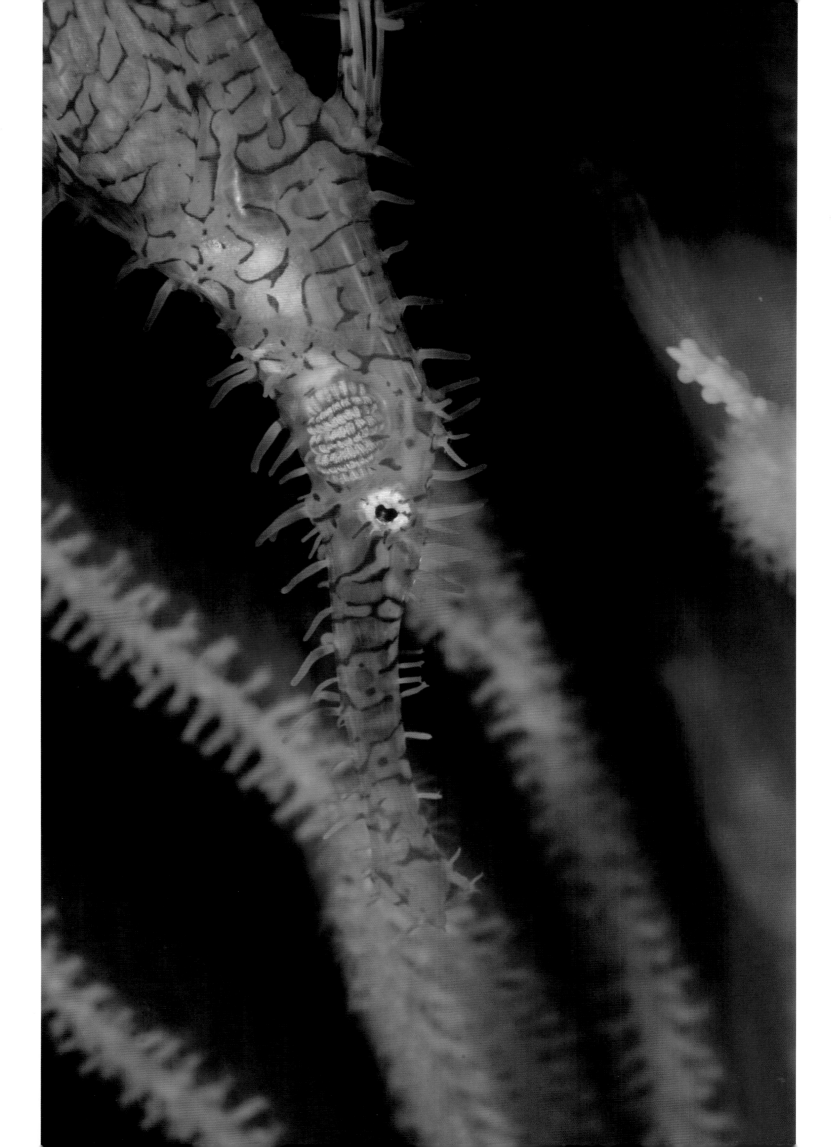

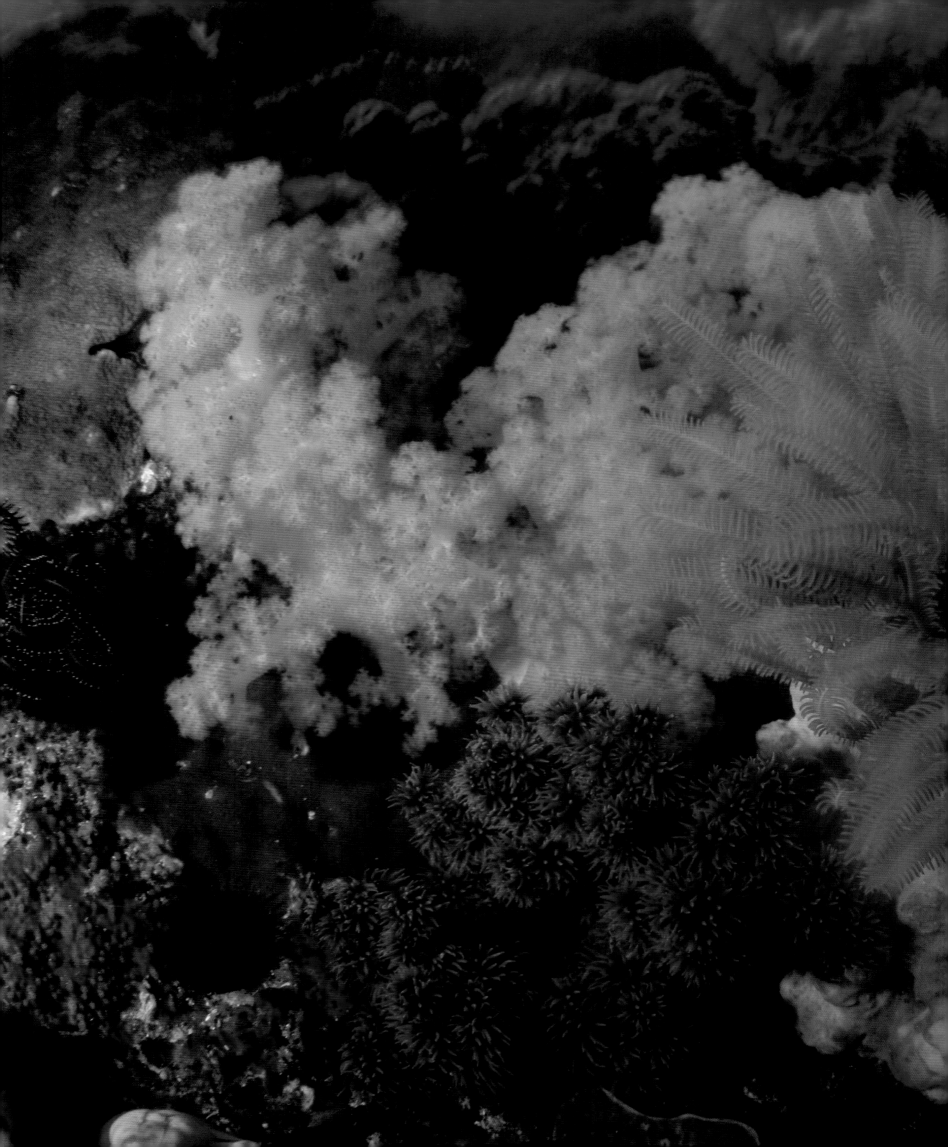

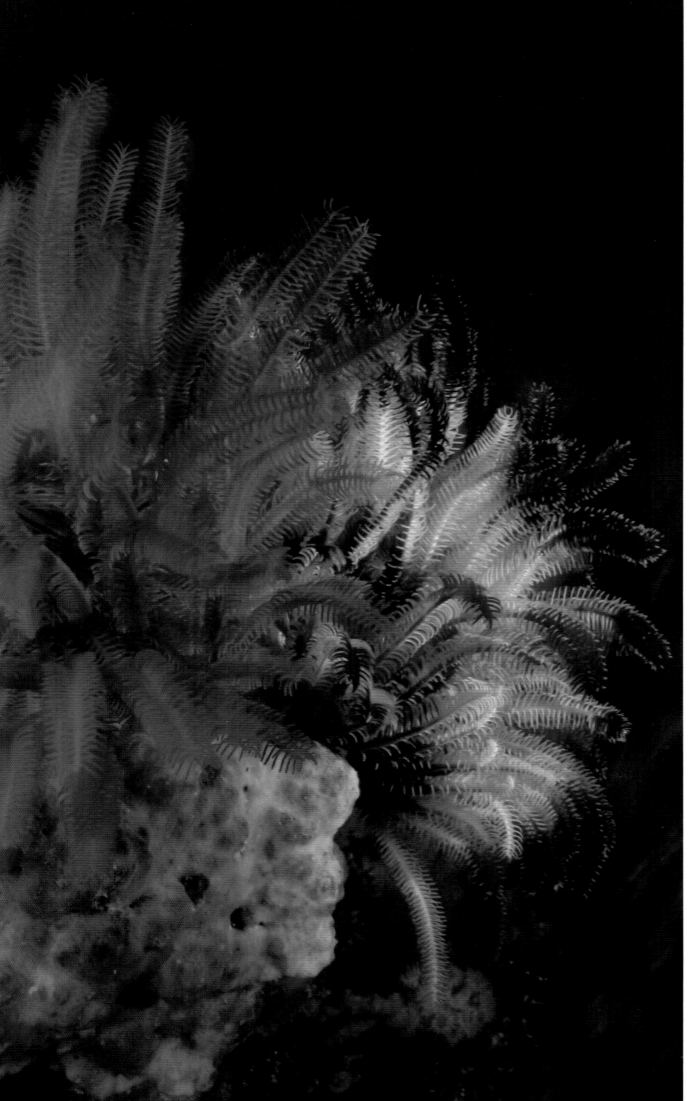

LEFT: Sea feather, coral and soft coral; they serve as shelter for fish, shrimps and crabs (Komodo Island, Indonesia 2007)

PAGES 54-55: A pair of yellow pygmy goby living in an empty can; human refuse, while providing homes for some, does more damage than good (Sue, Wakayama, Japan 2006)

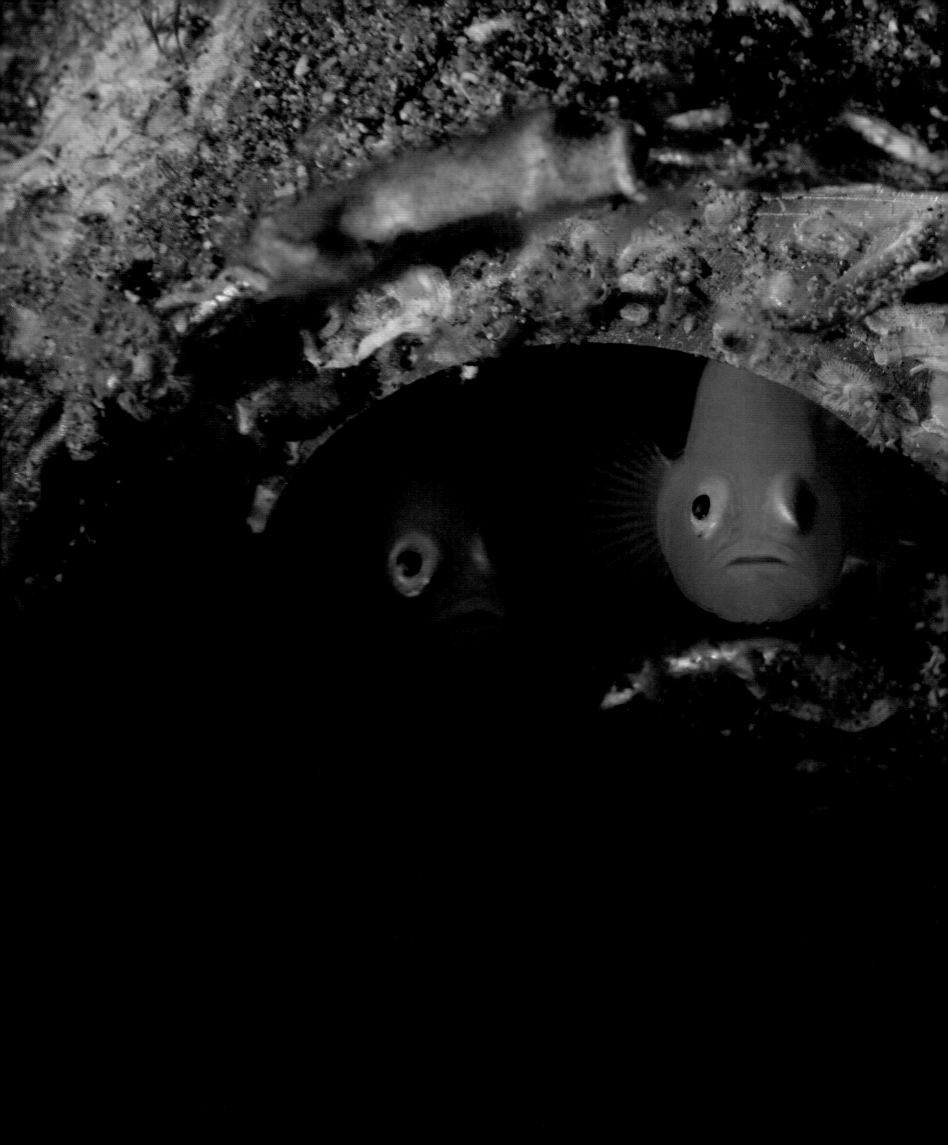

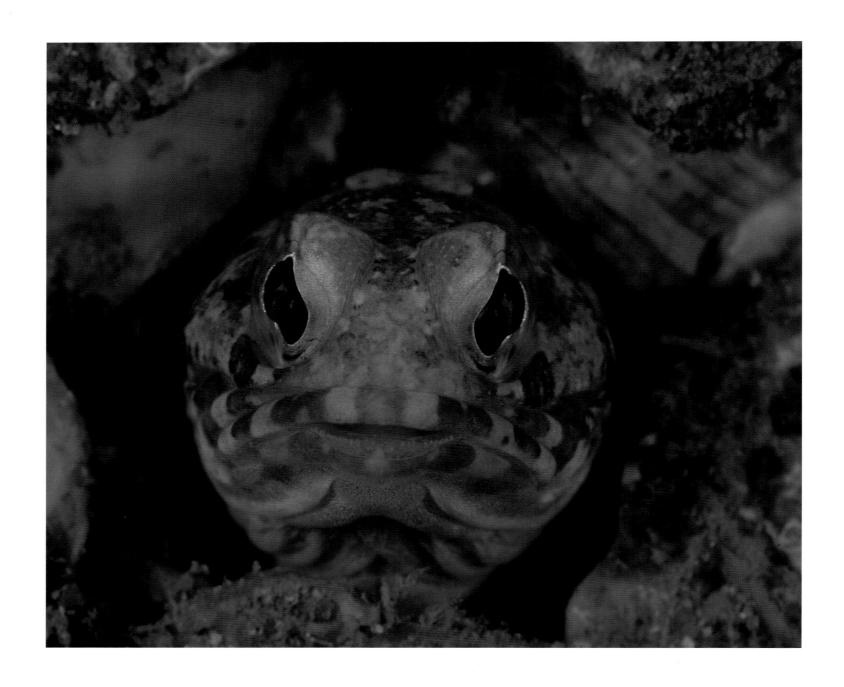

ABOVE: Annoyed at being disturbed,
a jawfish presents an angry face
(Andaman Sea, Thailand 2007)

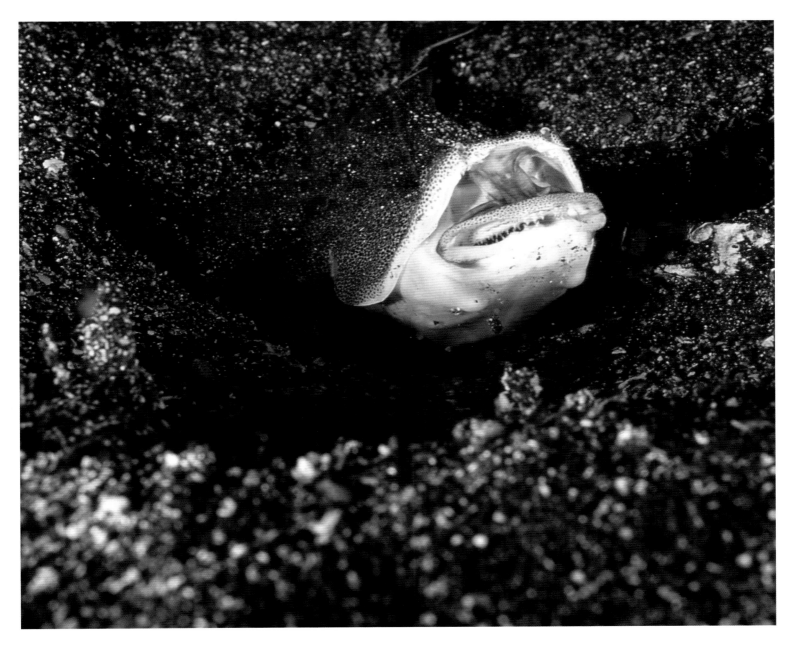

ABOVE: A Japanese angel shark stealthily
disappears into the sandy background,
waiting for prey
(Izu, Shizuoka, Japan 1998)

PAGES 58-59: Green sea turtles and other sea
creatures share a sunken ship as their home
(La Paz, Mexico 2005)

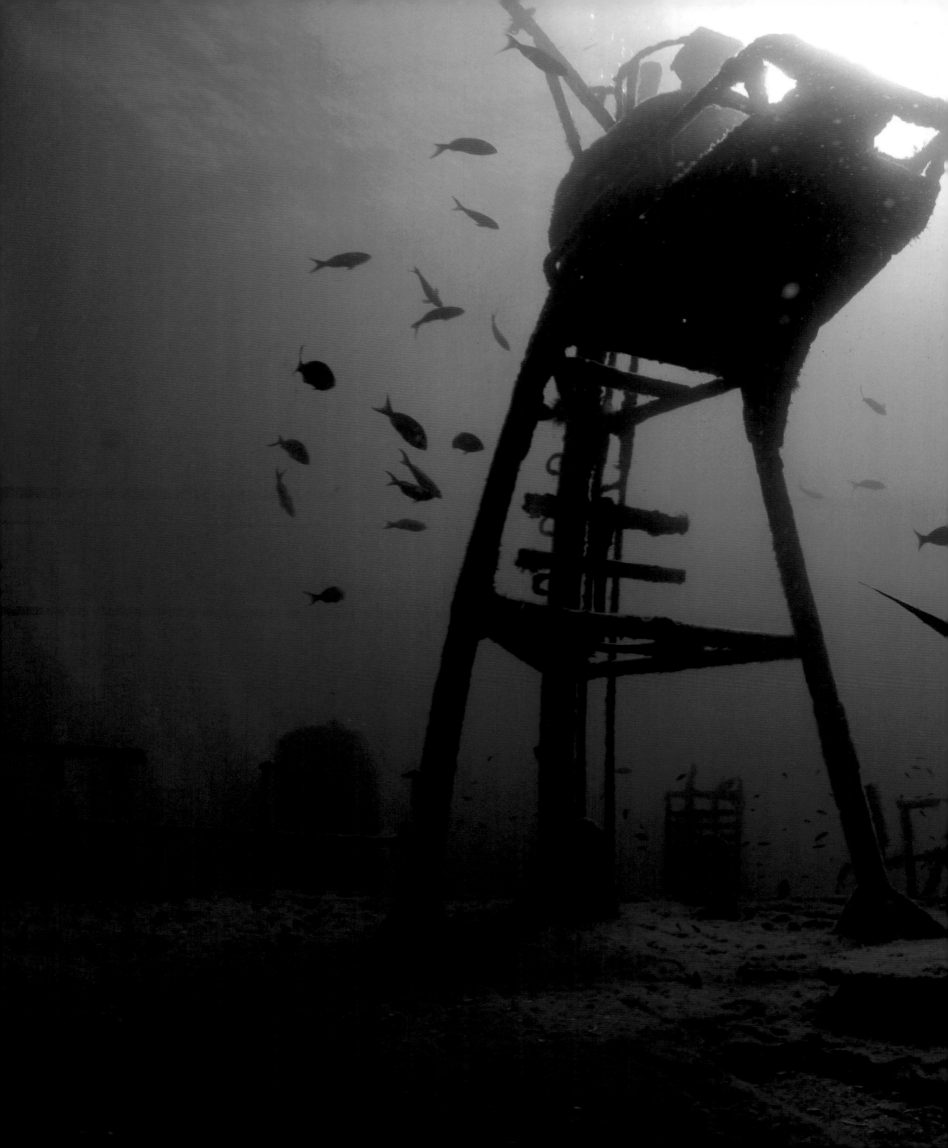

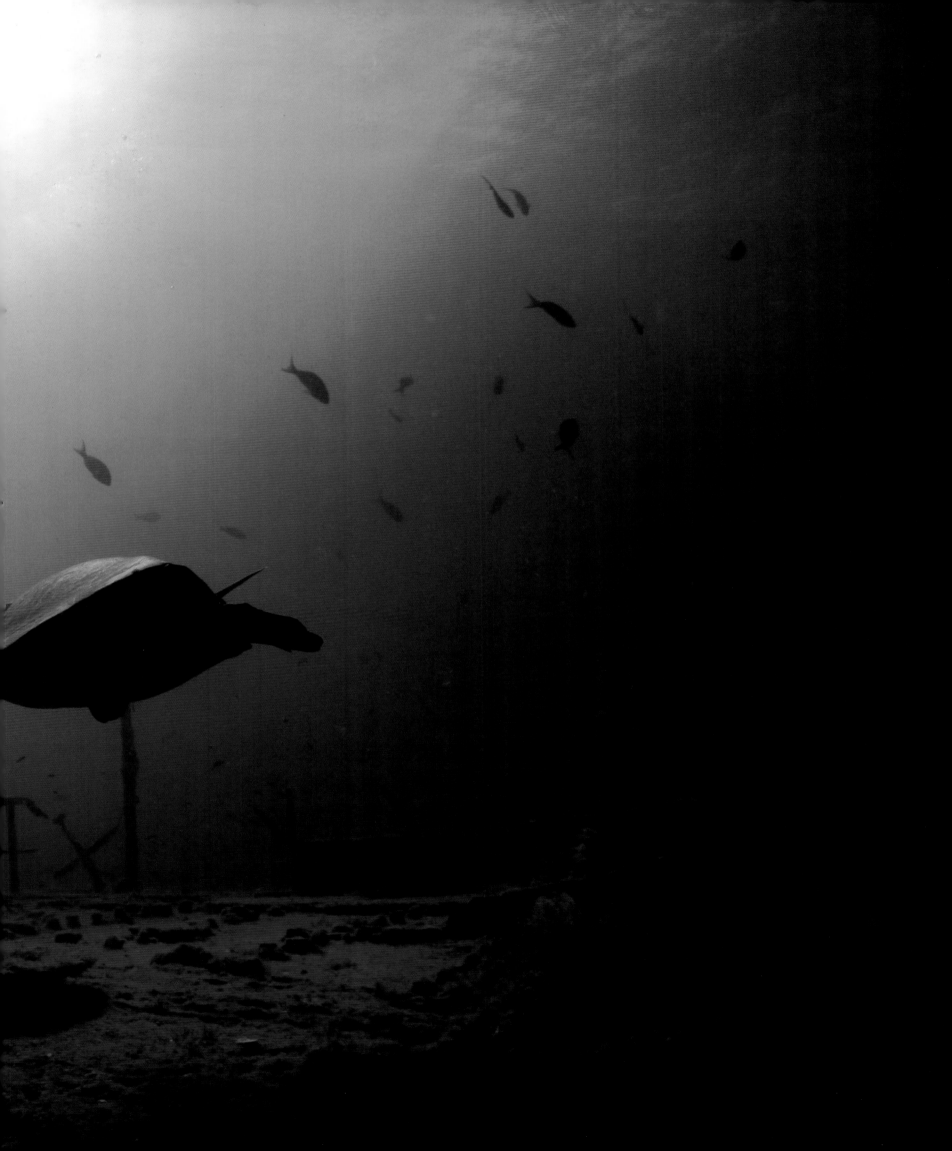

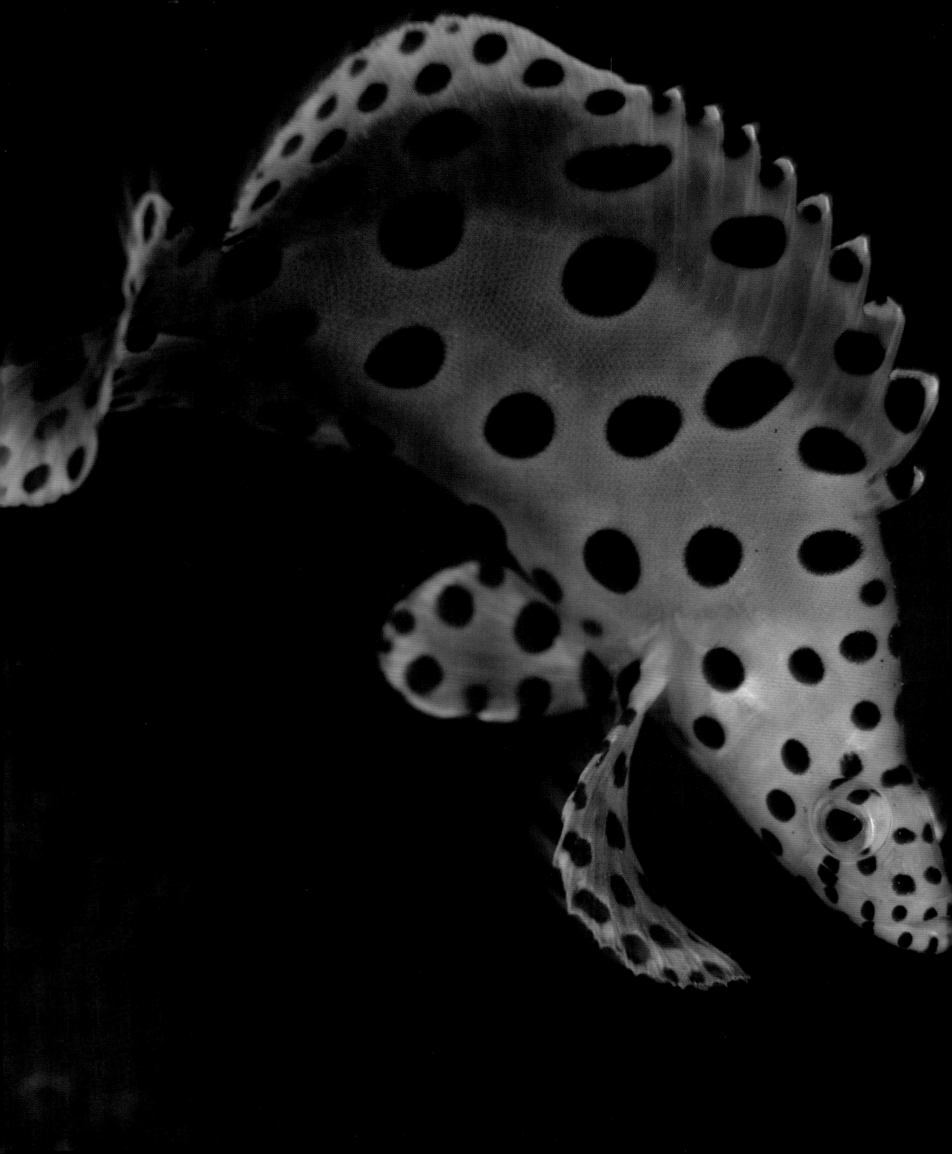

CREATURES

The ocean is like a colossal theatre. The waves conceal a teeming pageant, costumed in all possible colours, and cut in all manner of shapes. From microscopic plankton to huge marine mammals, the creatures of the deep are a cast as varied as any imagined for the stage: sometimes brave but more often timid, some are curious, others aloof, a few are friendly, others aggressive and occasionally lethal. There is drama: sneaking, swaggering, skulking and stalking; playfulness and friendships, communities and cooperation, betrayal, romance, rivalry, opportunism, extortion, comedy and spectacle…

The manta, a variety of ray, is the most graceful inhabitant of the open ocean. Divers are most likely to encounter these pelagic wanderers when they flock to freestanding nodules of reef, known as cleaning stations. Here, tiny striped cleaner wrasse peck away at the mantas' massive bodies, scouring them of cutaneous parasites. Sometimes four or more mantas will hover together over a cleaning station. They dip and turn to avoid collision, joined in a dance of indescribable grace.

I will never forget photographing a basking shark in the sea near the Isle of Man. The water was a brutally cold 10 degrees Celsius. I wore a very thick, semi-dry suit as I plunged from a little rubber boat into the Irish Sea, which was stained a deep green because of the abundance of phytoplankton. Even though I knew they were docile I was far from calm as a massive shark appeared suddenly in the cloudy water, its huge mouth gaping wide. They feed on the plankton that thrives in sunlight, and so basking sharks were named for their tendency to swim slowly close to the surface of the sea, as if basking in the sun. Despite the languor implicit in its name, the sharks I encountered were wary and nervous, quickly changing course as soon as they sensed my proximity. Finally, after many attempts, I was able to get close enough to see that its skin resembled that of an elephant.

I started photographing great whites in South Africa. I took my first shark sequence from a boat: a great white surging from deep below, snatching a small fur seal in its jaws as it breached the surface, its whole body emerging from the water and becoming airborne. This I call 'Air Jaws'. Then I began photographing them underwater, in the cold Atlantic. Through the bars of the steel cage, I could see a very large white pointer circling in the distance. I had finally come face to face with what had been lurking menacingly in my imagination ever since I saw the movie *Jaws* as a child. There were in fact as many as four sharks, all well above four metres long. The moment the chunks of tuna bait hit the water, the sharks would appear swiftly and stealthily from the depths and attack – the power coiled in their massive frames released in one explosive instant. Sometimes a shark would change course just short of the bait and swim directly towards my cage. Face latticed with ugly scars, the shark would pass me with coal-black eyes and in that stare I could see I was prey. Centuries of inherited learning, knowledge, science and culture were peeled away as I lay exposed to the most primal of fears: I was a part of the eat-or-be-eaten law of nature.

Of course my interests are not limited to large marine creatures; my models and muses include gobies, damselfish, anemonefish and wonderfully diverse, brightly coloured nudibranchs. Fish don't have eyelids, so it is difficult to read any expression. However, if one observes closely, moods and personalities are revealed in their behaviour. For example when a camera is pointed in its direction, a young humpback grouper approaches for a short inspection before swimming away. A lacy scorpionfish, its detailed camouflage mimicking the shapes and colours of sponges and coral that are its home, stubbornly refuses to move as if to say, I shall never be found. The bravely territorial anemonefish throws itself against me in attack after attack to defend its sea anemone home from my camera's incursions; sometimes the smallest and weakest display the most courage. Bobtail squid and cuttlefish flicker luminescent signals using the glowing bacteria that live within them. They expand, contract, and curl their tentacles as part of their communication. It is like a message from outer space, the sight of which never ceases to fascinate.

LEFT: A young humpback grouper looks like a girl wearing a white spotted dress (Manado, Indonesia 2006)

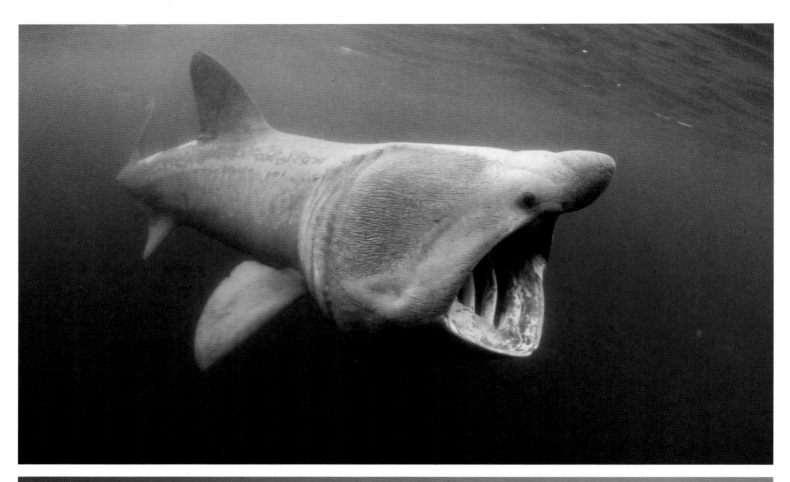

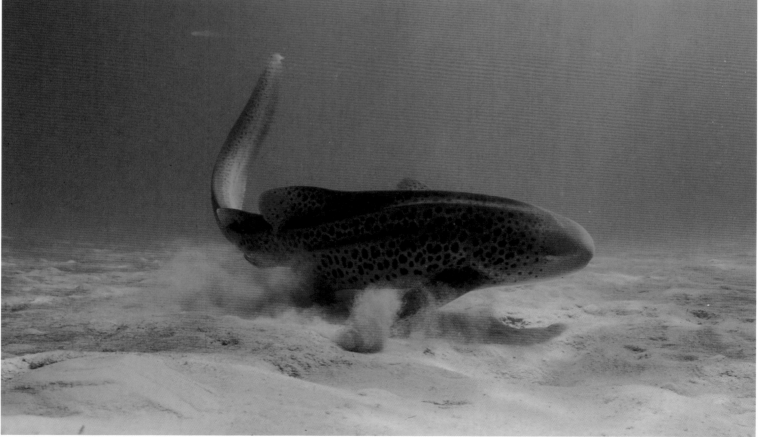

TOP LEFT: A basking shark swims with its mouth wide open in the rich sea. Contrary to its appearance, this shark was quite shy (Isle of Man, British Isles 2000)

BOTTOM LEFT: A leopard shark rolls in the sand (Exmouth, Western Australia 1994)

TOP RIGHT: Charged by a great white shark; fortunately I'm in a cage (South Australia 2000)

MIDDLE RIGHT: This great white shark is fully aware of my existence (South Australia 2000)

BOTTOM RIGHT: A great white shark circles, close enough to touch (South Australia 2000)

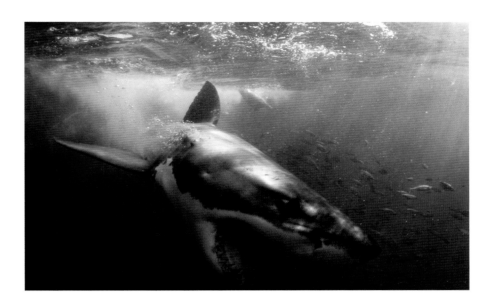

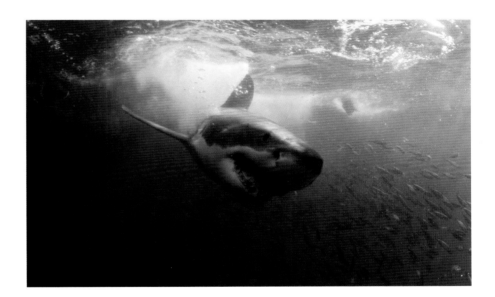

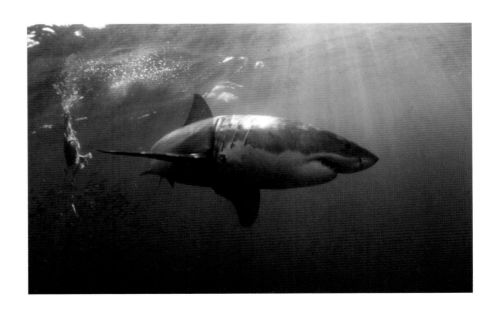

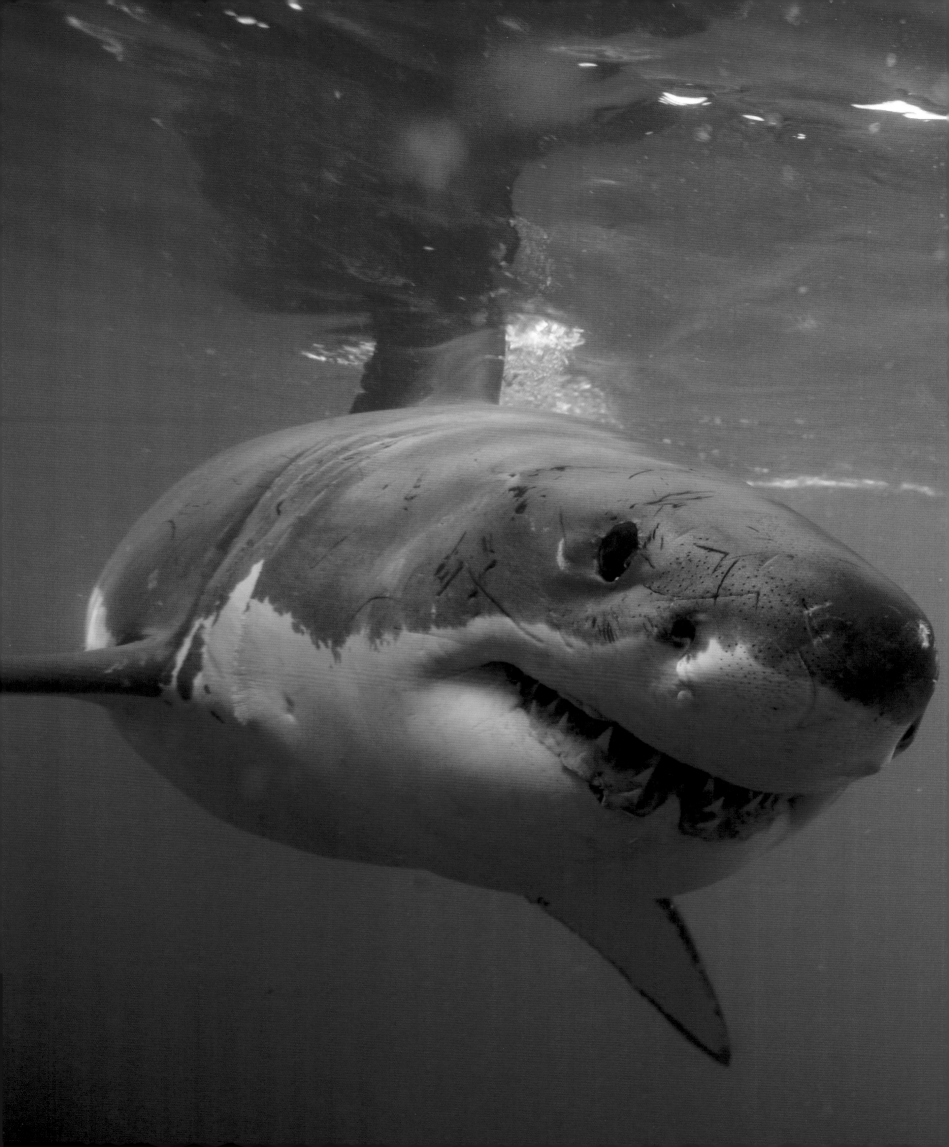

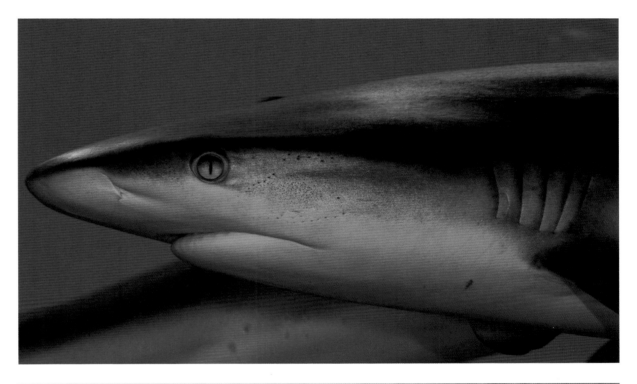

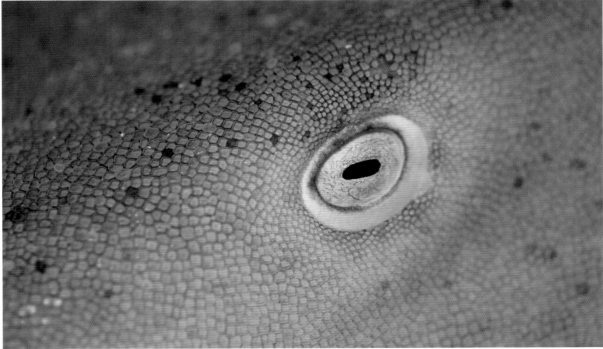

LEFT: Though severely scarred, this great white shark has the regal dignity that befits the King of the Sea (Simon's Town, South Africa 2006)

TOP RIGHT: The lustrous beauty of a grey reef shark (Manihi, Tahiti 2006)

RIGHT: Up close, the skin of the tawny nurse shark appears to be inlaid with precious stones (Marshall Islands, Micronesia 2006)

TOP: The sudden take-off of the very oddly-shaped tasselled wobbegong
(Raja Ampat, Indonesia 2007)

BOTTOM: A grey reef shark, swimming in slow circles
(Manihi, Tahiti 2006)

FAR RIGHT: The lovely zebra shark has a cute, undersized mouth
(South Male Atoll, the Maldives 2006)

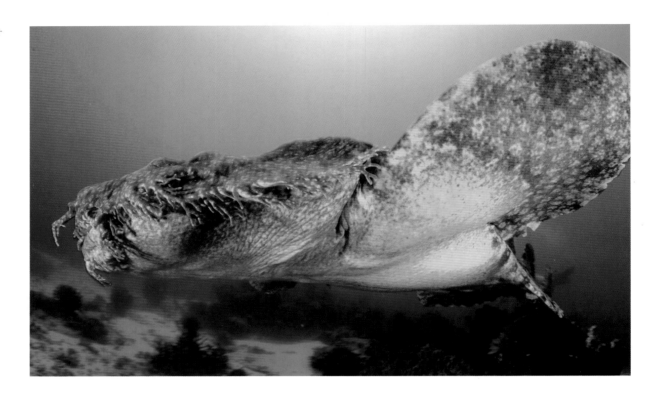

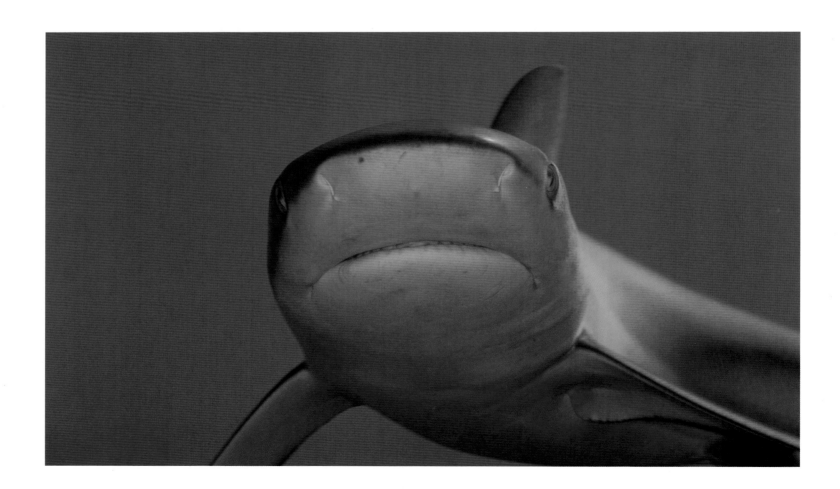

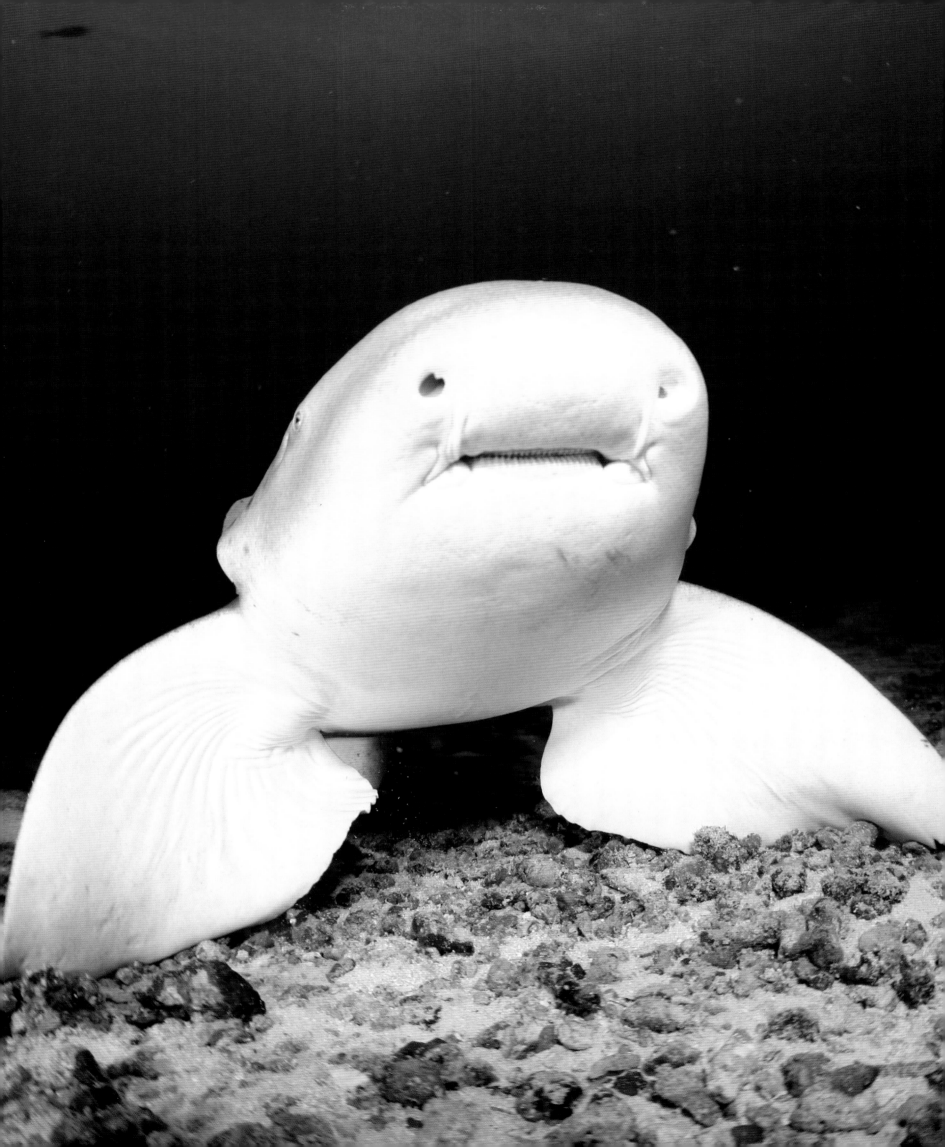

CREATURES

BELOW: Continuous shots of
'Air Jaws', a great white shark
(Simon's Town, South Africa 2006)

PAGES 70-71 : This hungry whale shark
has its mouth wide open for plankton
(Exmouth, Western Australia 1994)

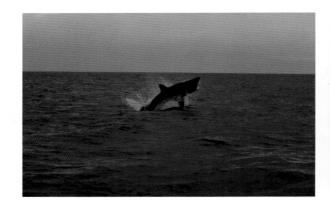 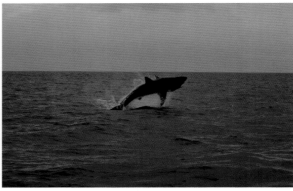 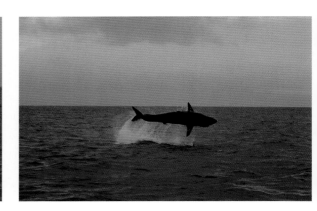

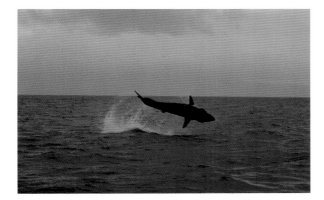 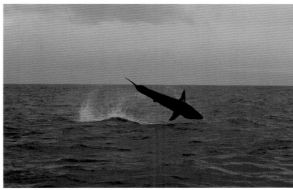 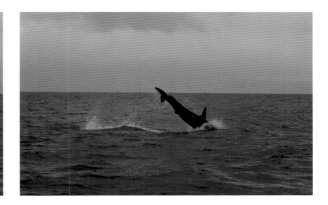

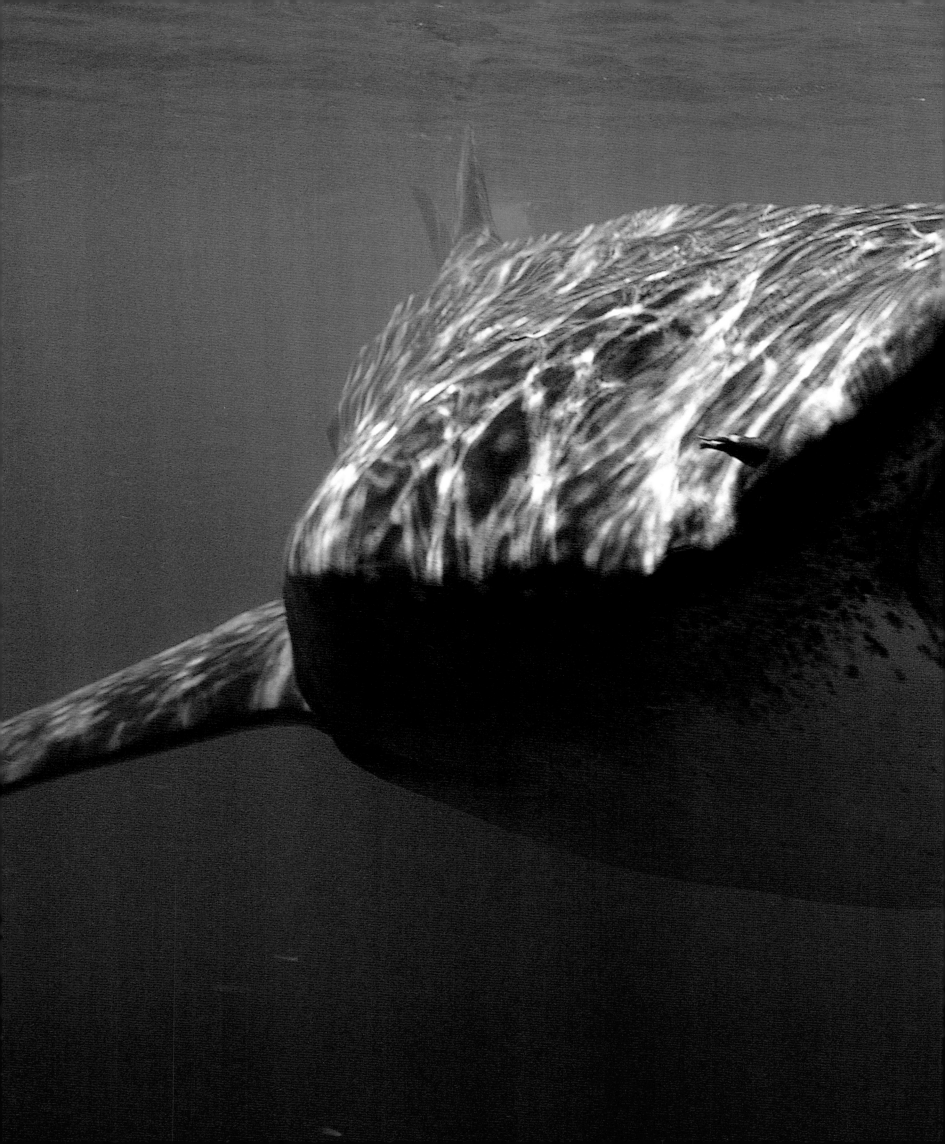

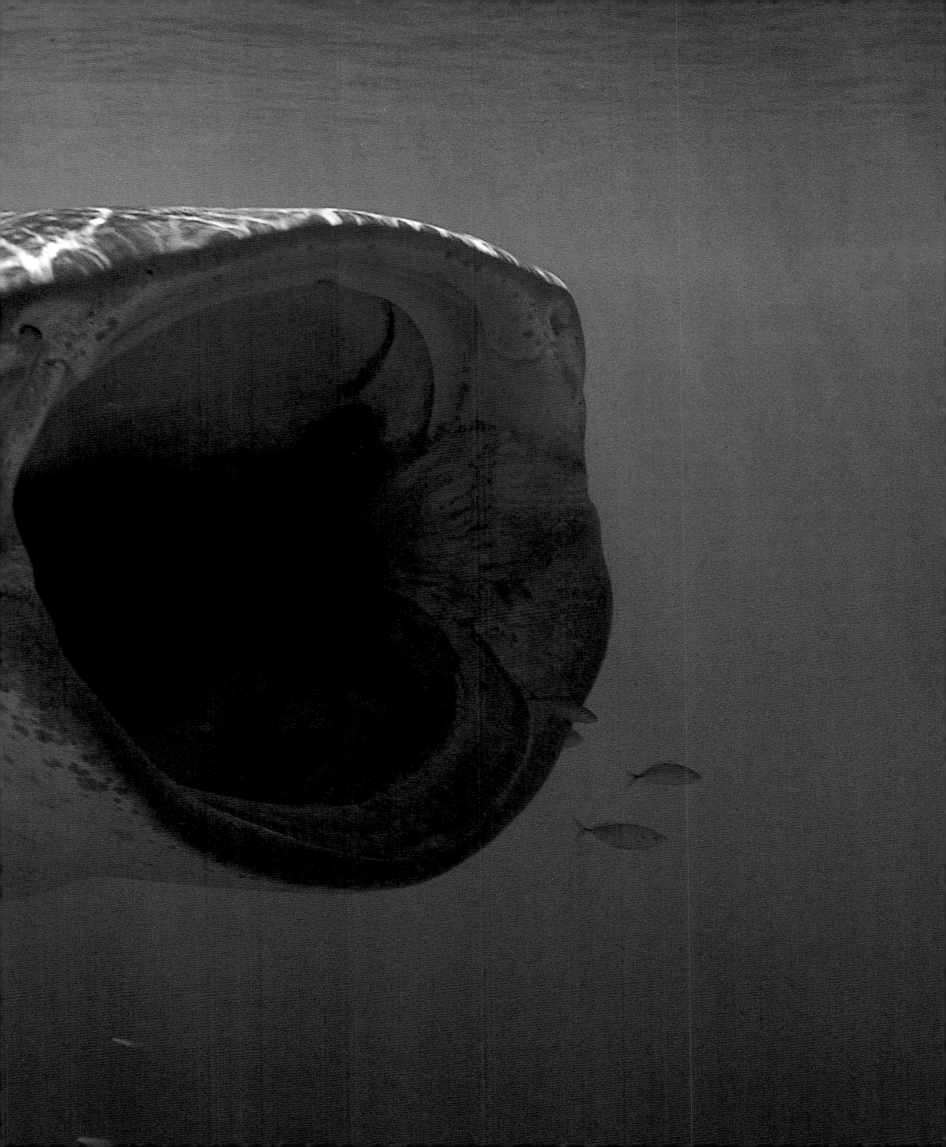

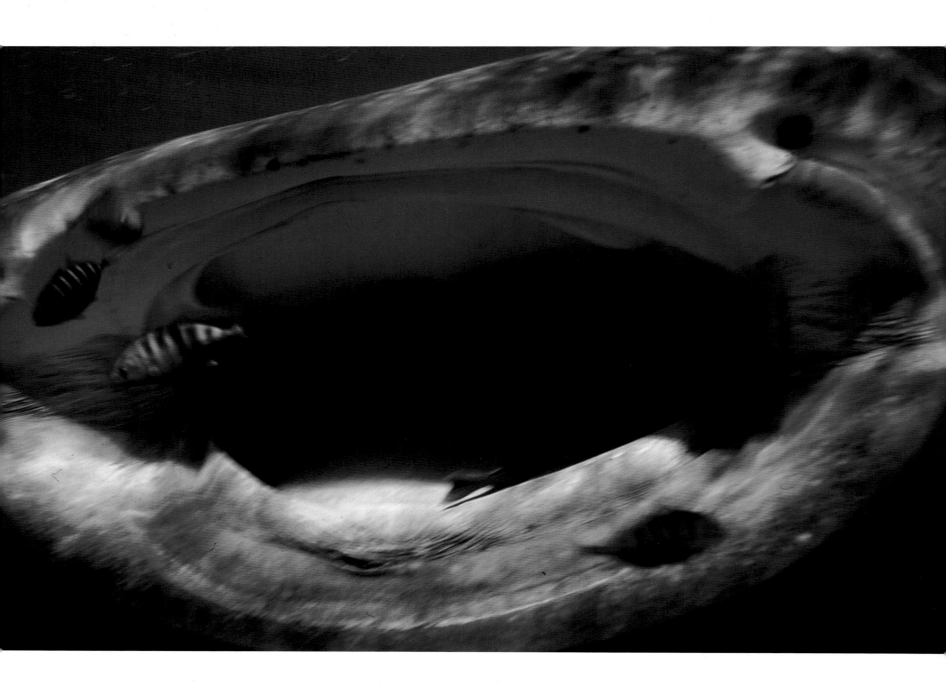

ABOVE: The whale shark opens its mouth
and rushes towards us at tremendous speed
(Exmouth, Western Australia 1994)

RIGHT: A whale shark gliding
gracefully into the blue
(Exmouth, Western Australia 1994)

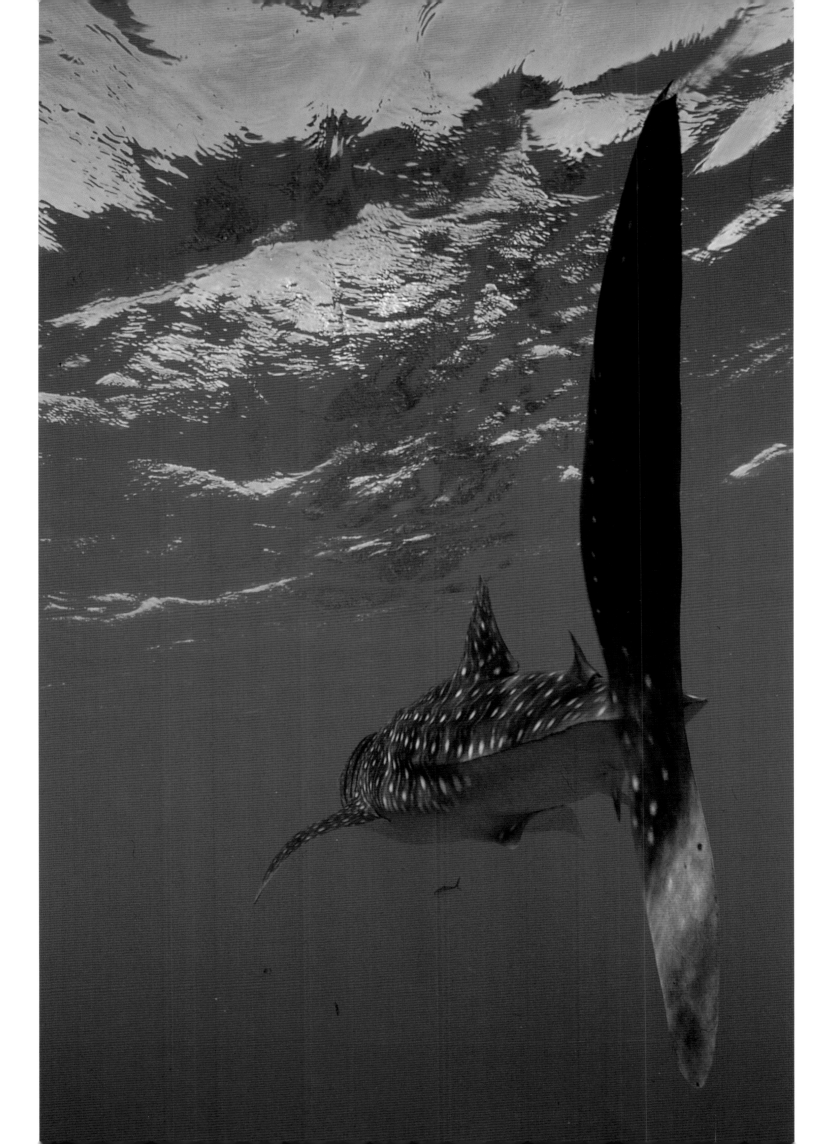

CREATURES

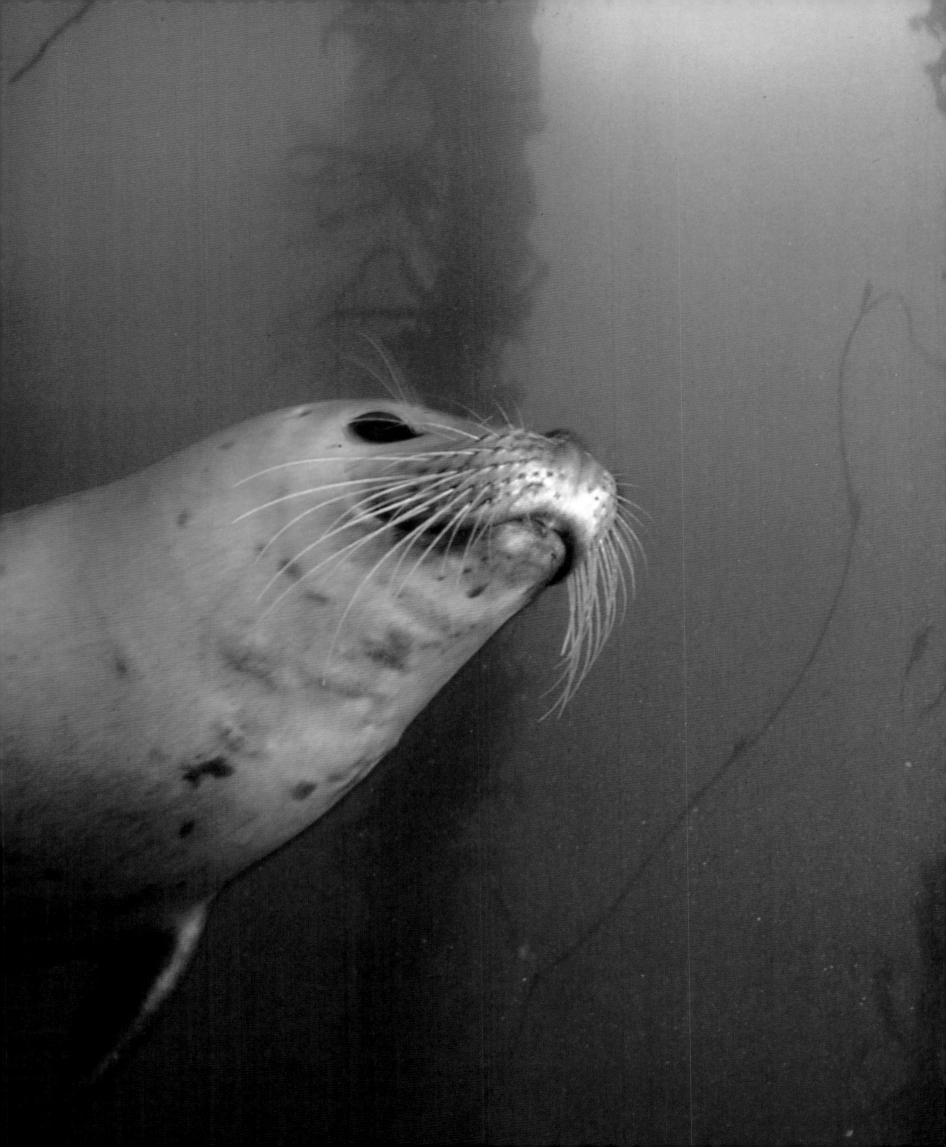

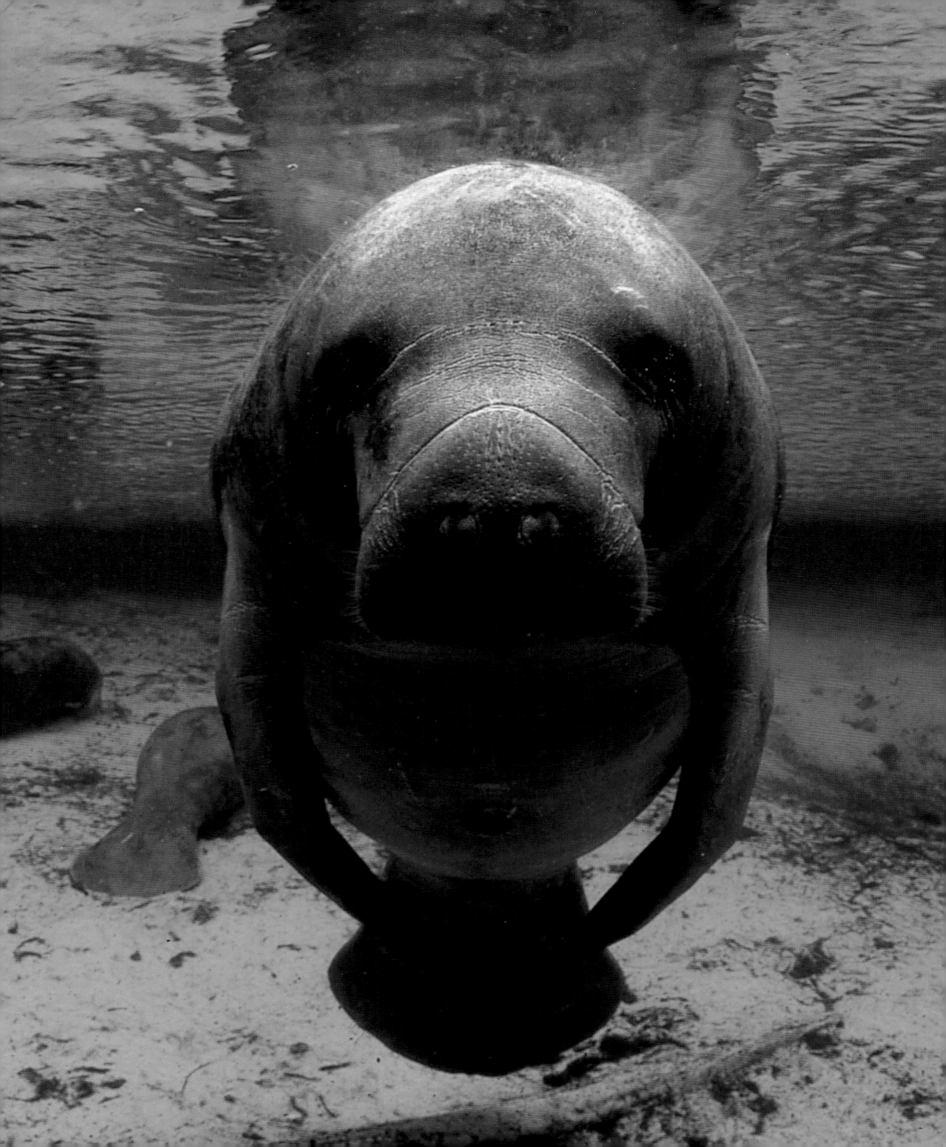

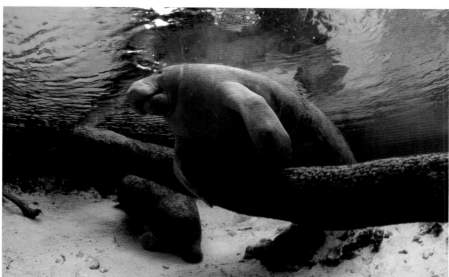

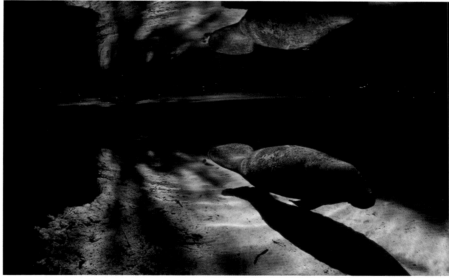

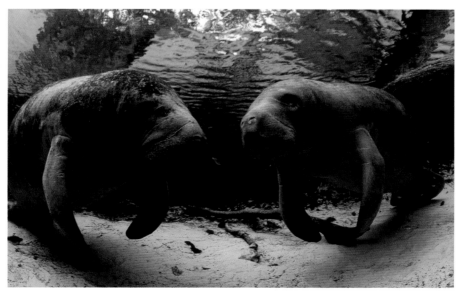

FAR LEFT: A manatee pauses to
say hello right in front of the camera
(Crystal River, Florida 2006)

TOP LEFT: A manatee plays with
a sunken branch as a panda might
(Crystal River, Florida 2006)

MIDDLE LEFT: Manatees come gathering
into the lake at the ebbing of the tide
(Crystal River, Florida 2006)

BOTTOM LEFT: These two
appear to be gossiping
(Crystal River, Florida 2006)

CREATURES

FAR RIGHT: A playful sea lion
toys with starfish on the seabed
(La Paz, Mexico 2000)

TOP RIGHT: Sea lions taking
a nap underwater
(La Paz, Mexico 2006)

MIDDLE RIGHT: A sea lion swimming
at a speed to match a jet aeroplane
(Monterey, California, USA 1995)

BOTTOM RIGHT: They decided to
dive underwater as I approached
(Monterey, California, USA 1995)

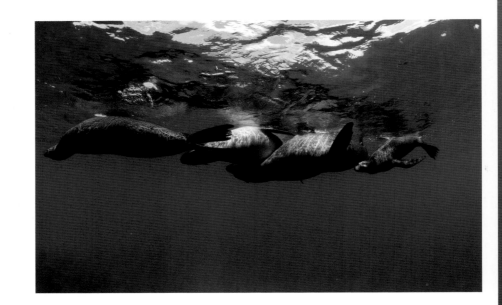

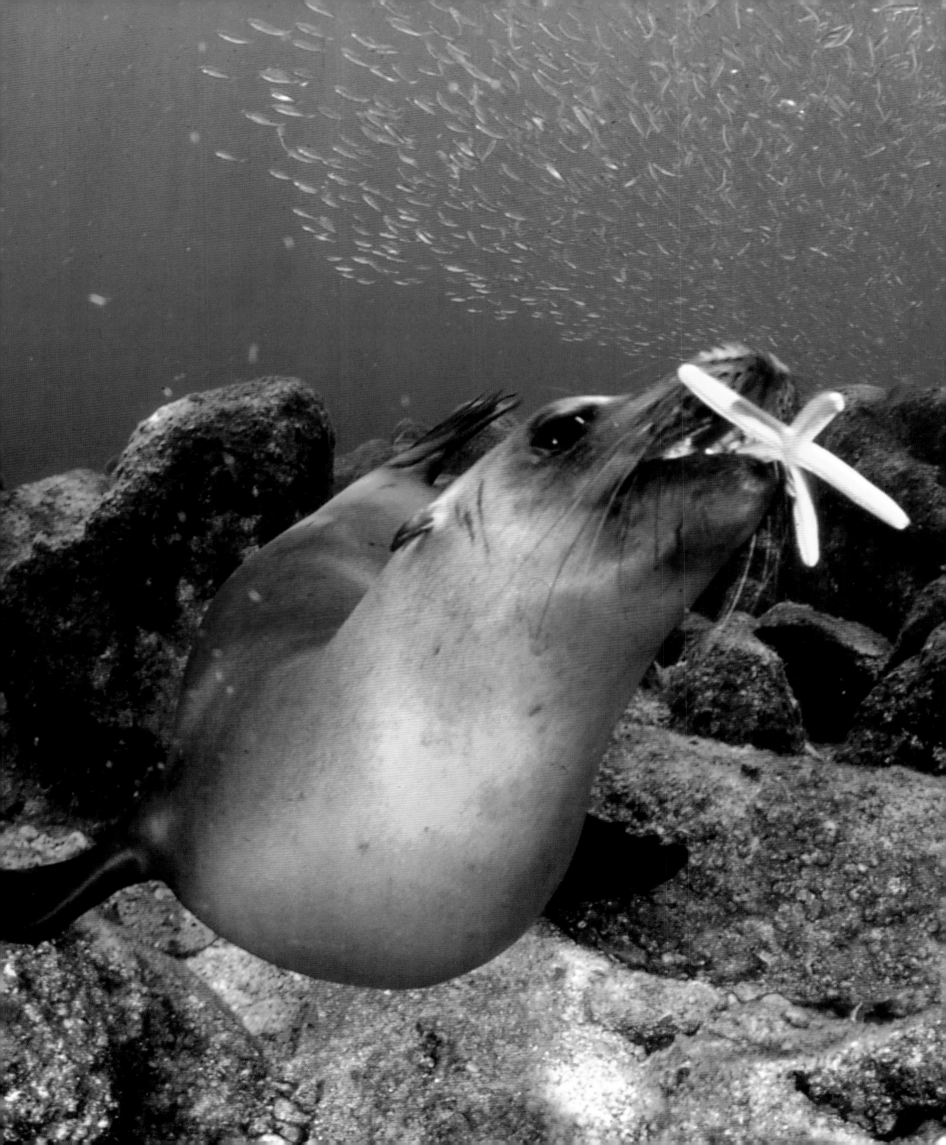

ABOVE: A curious California sea lion
looking into the lens
(La Paz, Mexico 2006)

RIGHT: A California sea lion looks
threatened, and lets out a strange noise
(La Paz, Mexico 2005)

PAGES 82-83: A baby California sea lion
I found under the rock; its round eyes
were memorable
(La Paz, Mexico 2006)

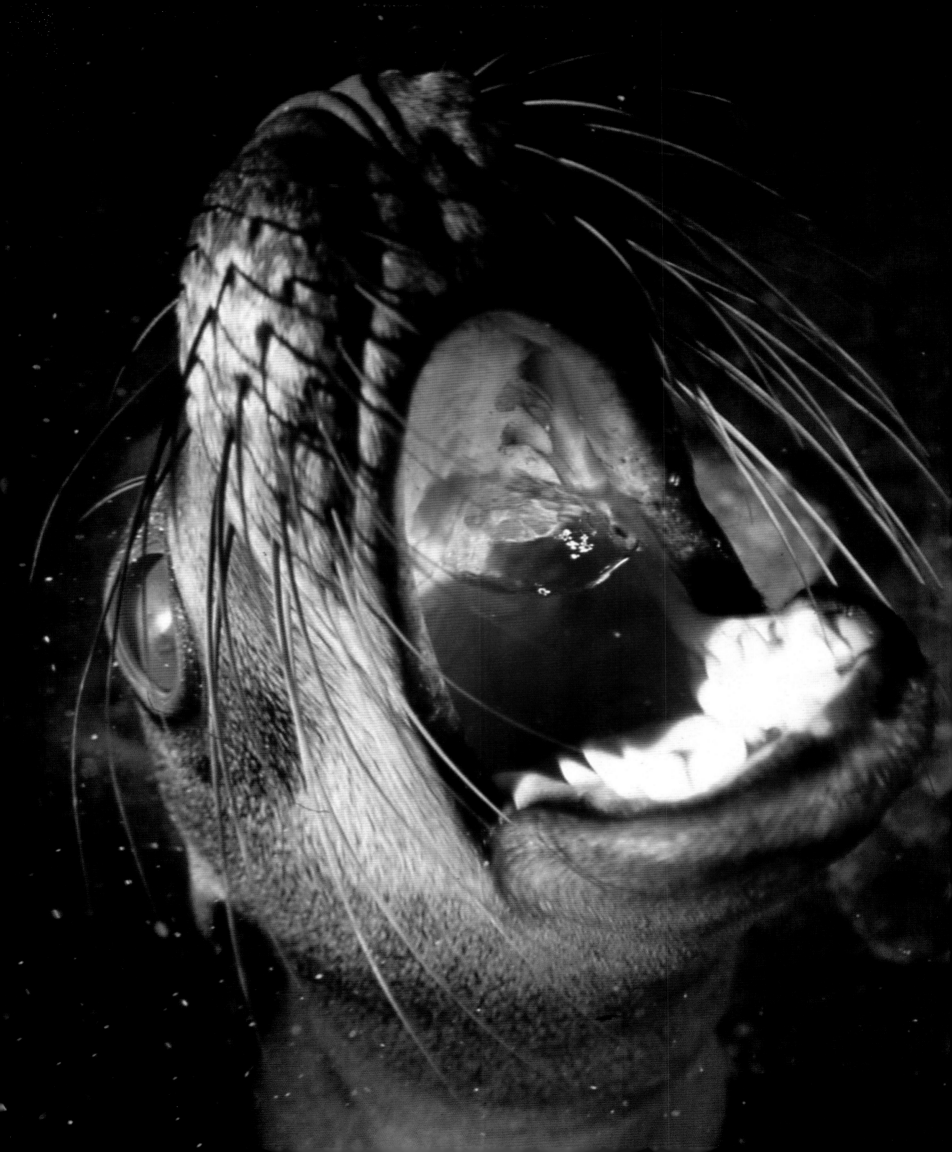

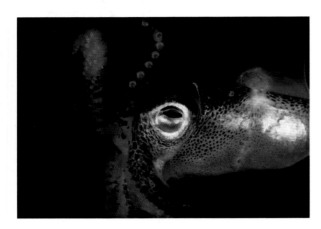

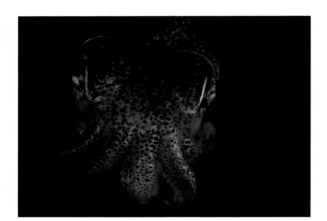

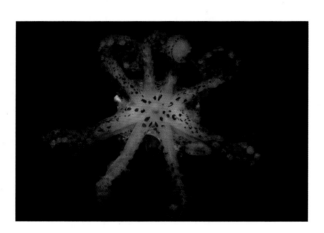

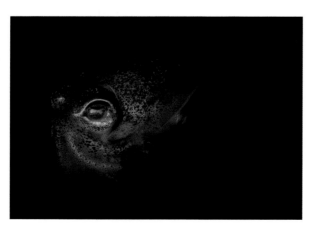

LEFT TOP TO BOTTOM & RIGHT: A small bobtail squid becomes visible under the light at night; threatened, it raises its tentacles (Shizugawa, Miyagi, Japan 2006)

PAGES 86-87: The giant cuttlefish looks like an alien, with its strange appearance. It allowed me to come very close; you can even see the texture of the skin (Komodo Island, Indonesia 2006)

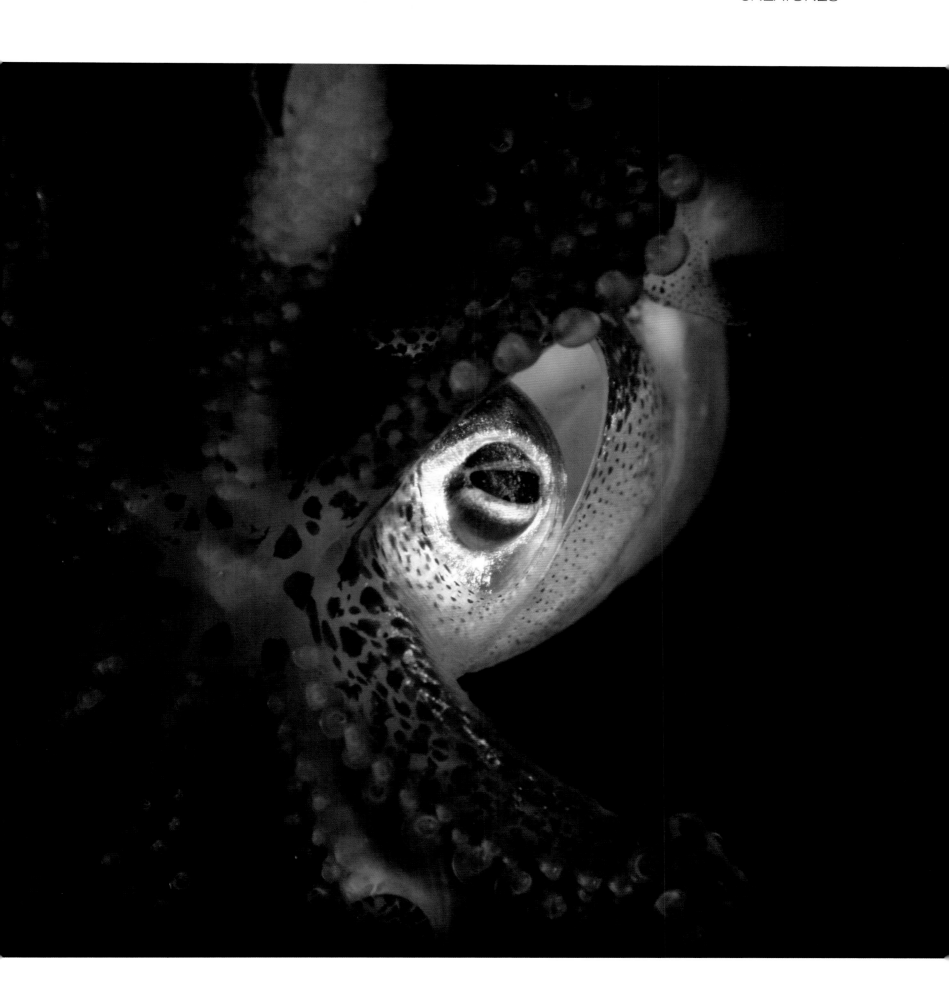

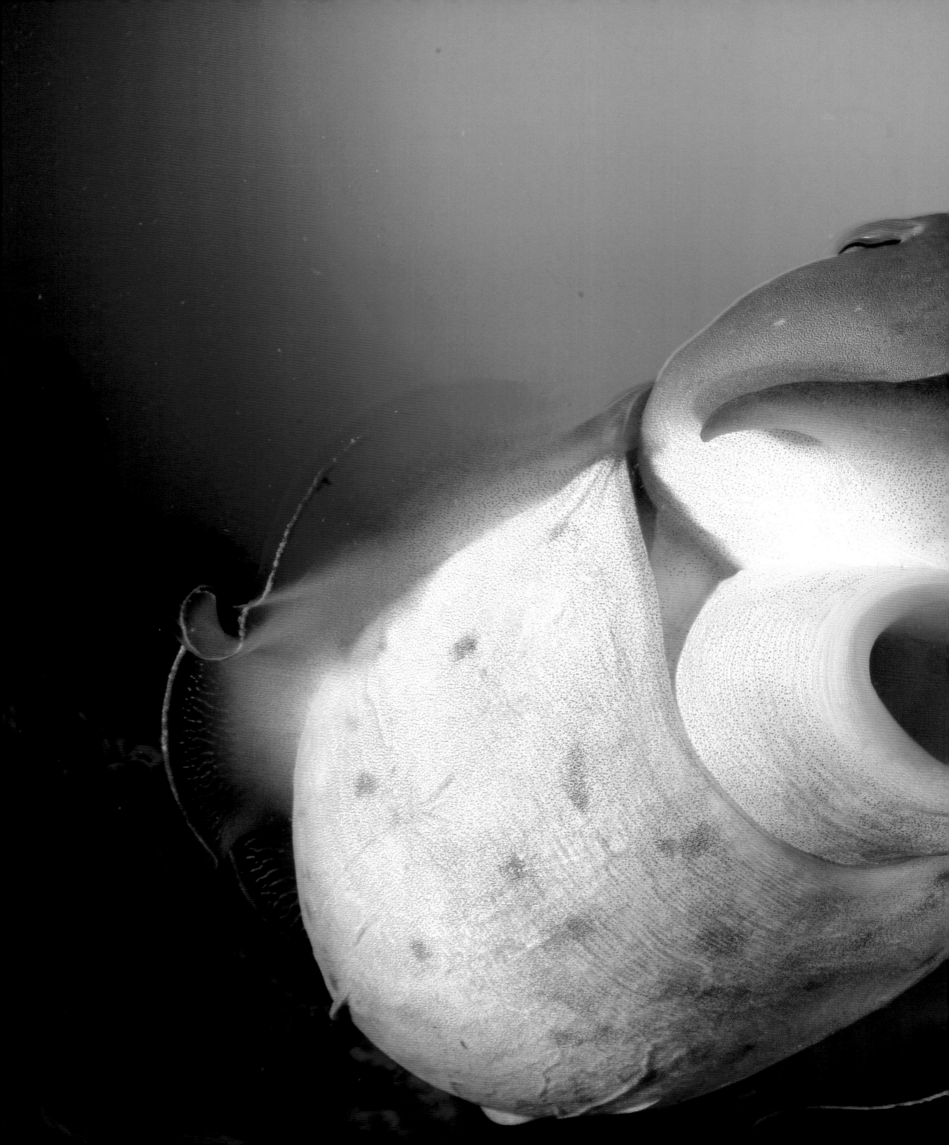

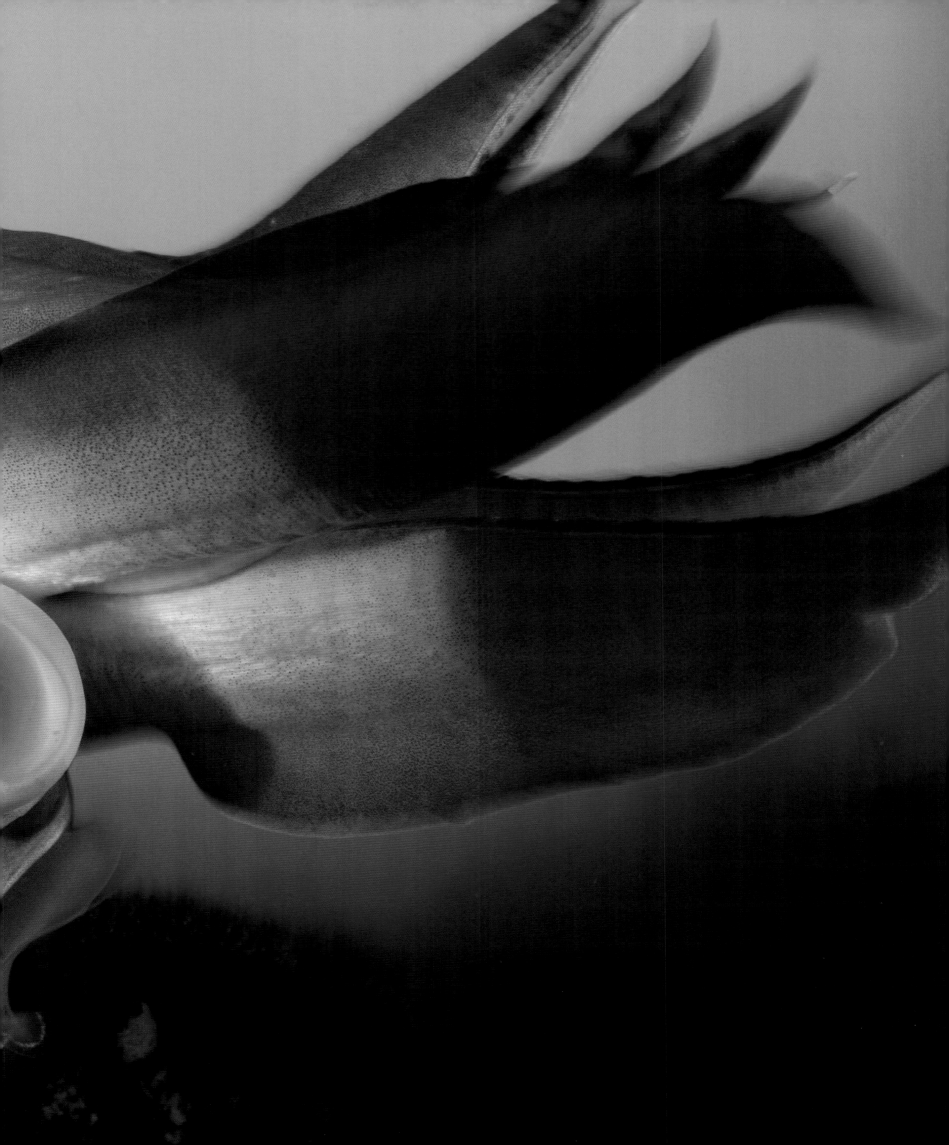

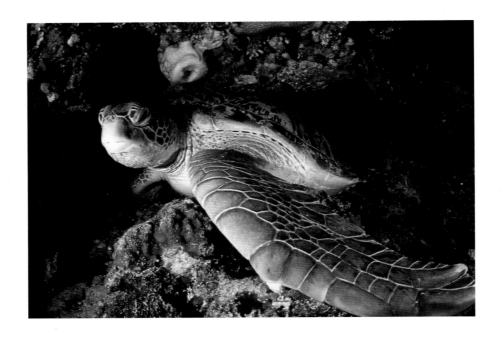

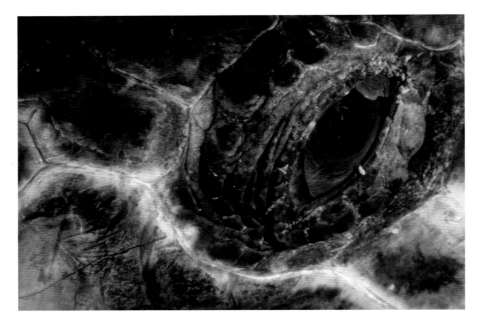

TOP: I met this green sea turtle
resting in a crevice of a sheer drop-off
(Manado, Indonesia 2006)

BOTTOM: Like the eye of a monster:
a loggerhead turtle
(Izu, Shizuoka, Japan 1999)

RIGHT: It must have felt really threatened;
you can even see its uvula
(Manado, Indonesia 2005)

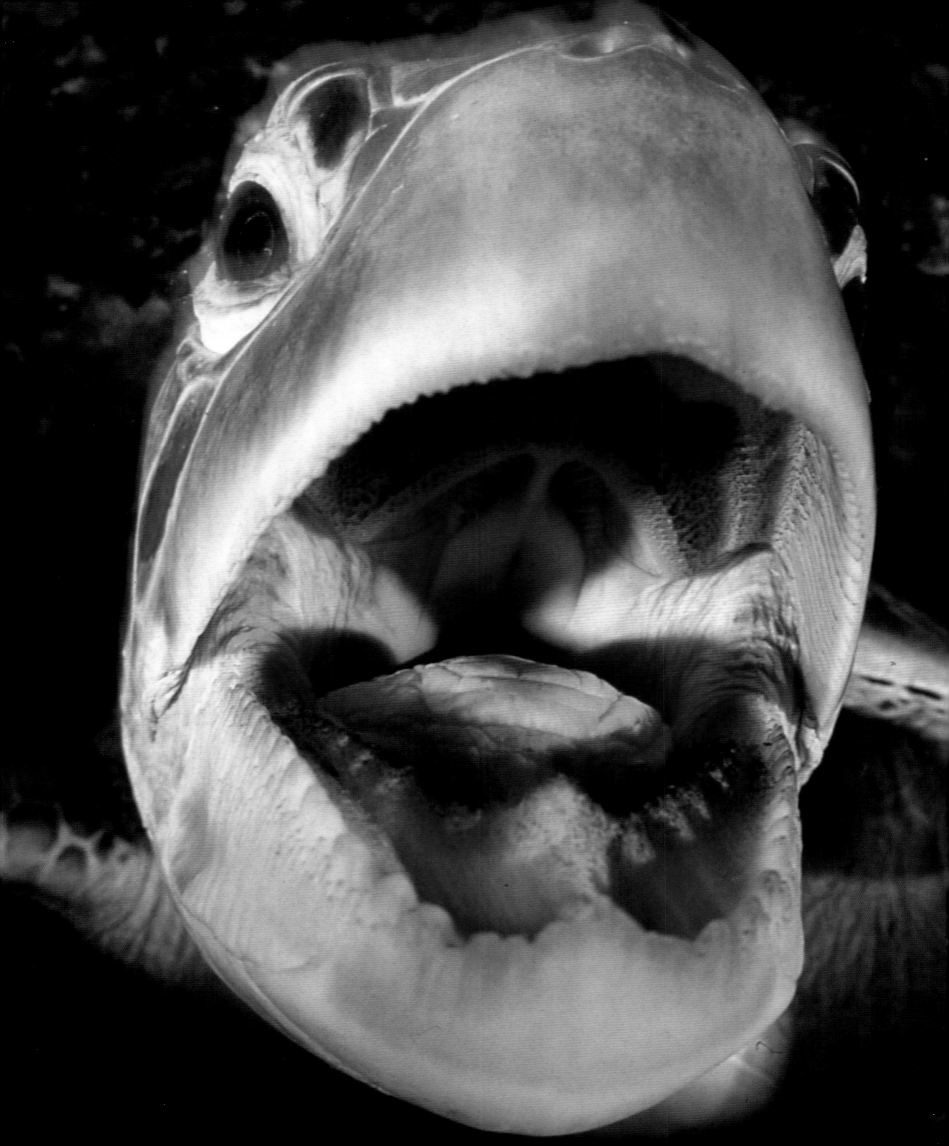

CREATURES

RIGHT: A hawksbill turtle waving its
flippers as though in invitation
(Raja Ampat, Indonesia 2007)

PAGES 92-93: The flamboyant cuttlefish is
strangely shaped; this one also seems alarmed
(Koza, Wakayama, Japan 2006)

PAGES 94-95: The giant cuttlefish has
tentacles like an elephant's legs; its body
has a unique pattern of dots and stripes
(Ishigaki Island, Okinawa, Japan 2007)

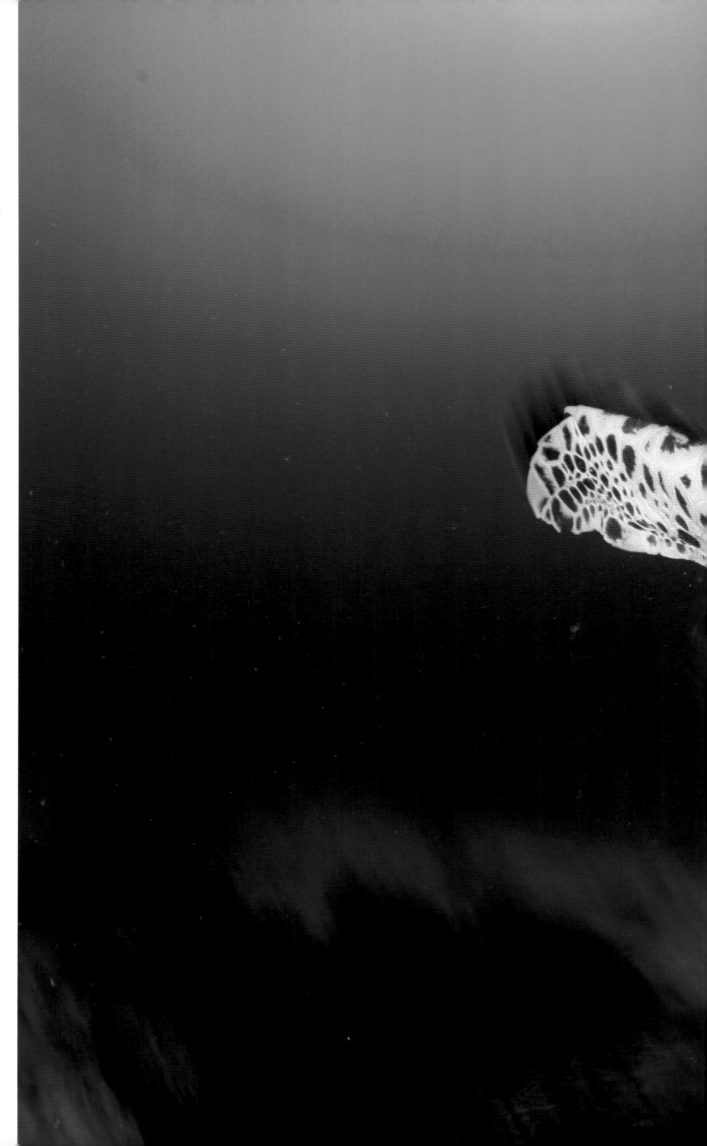

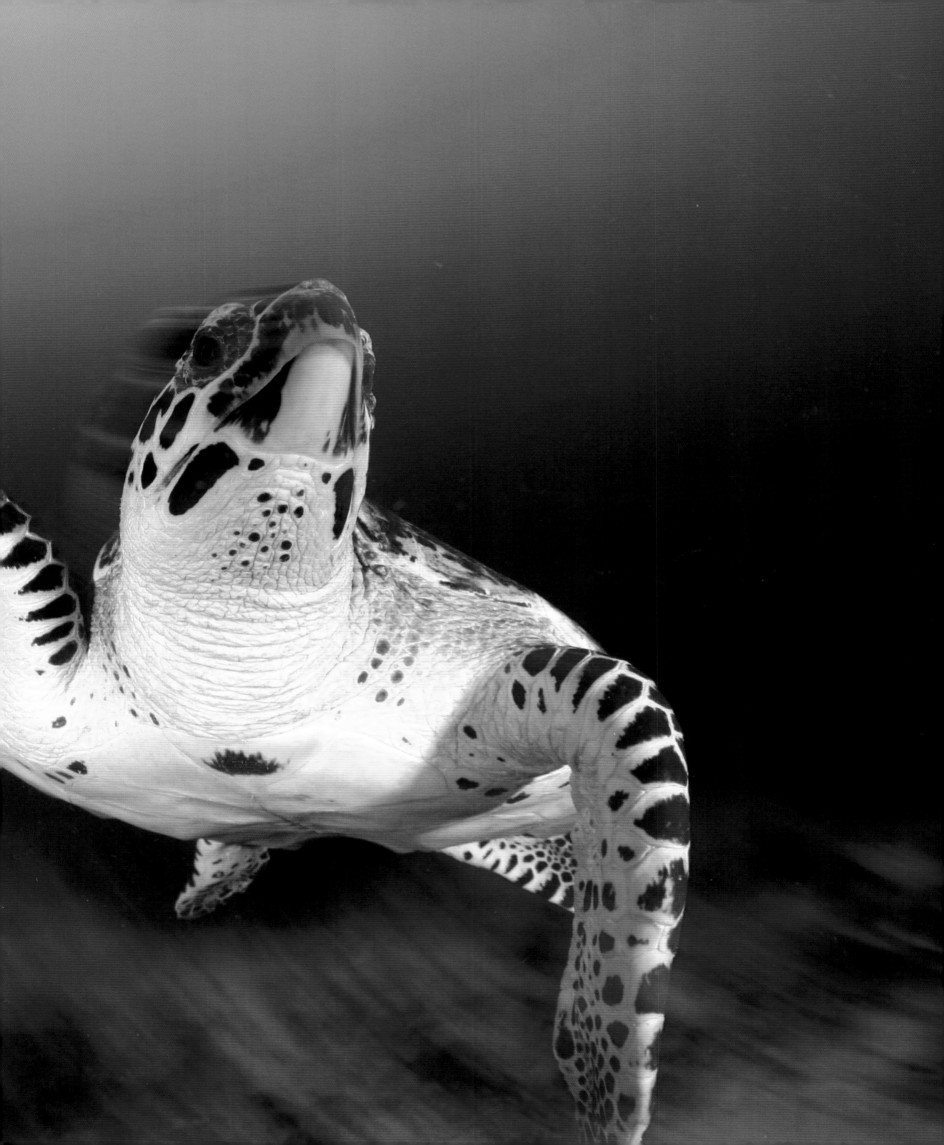

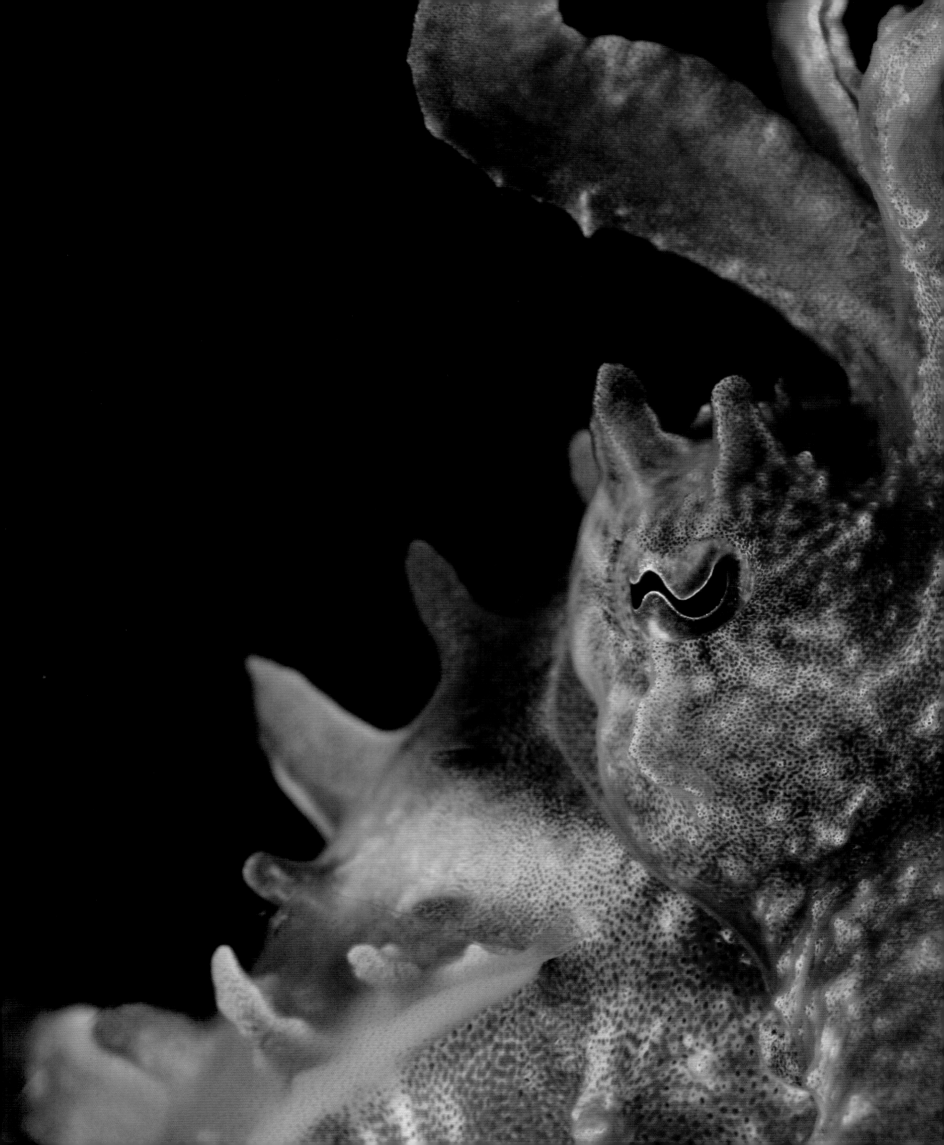

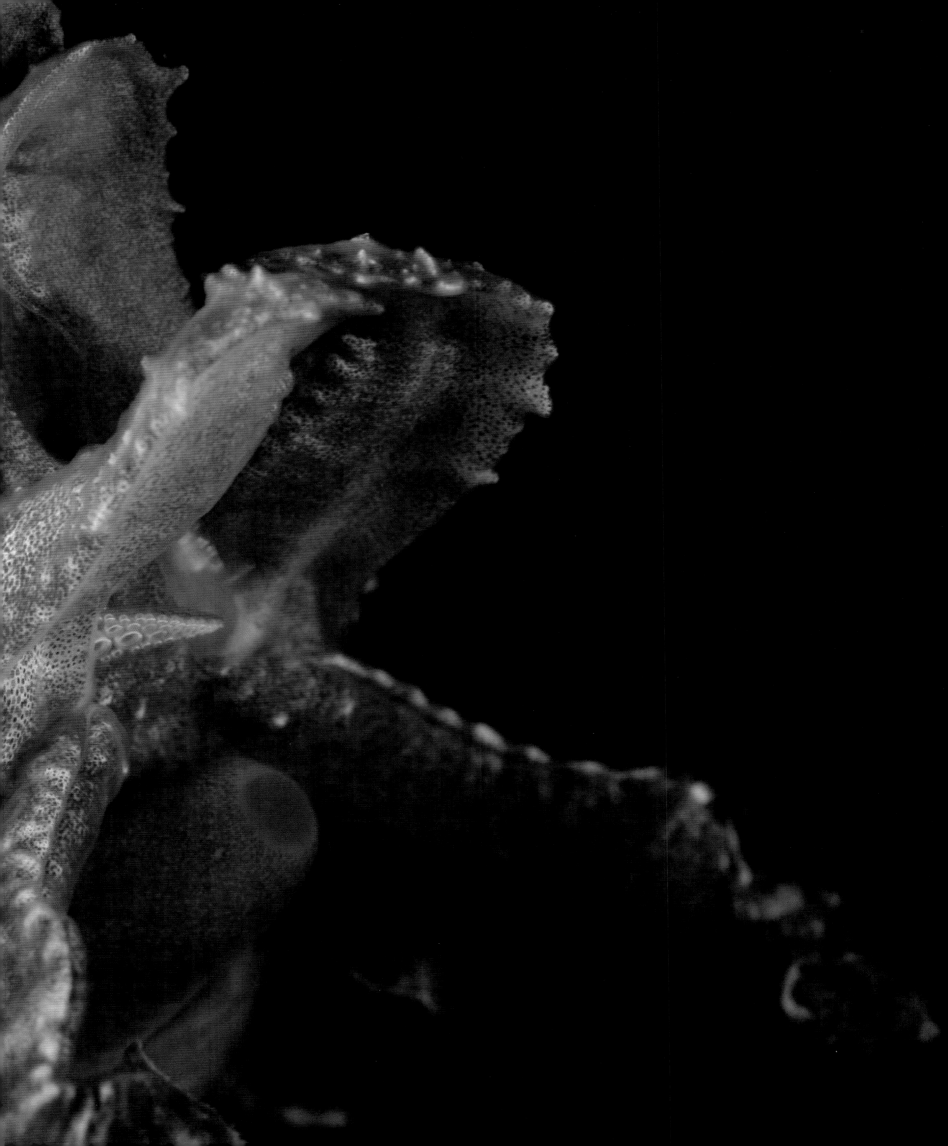

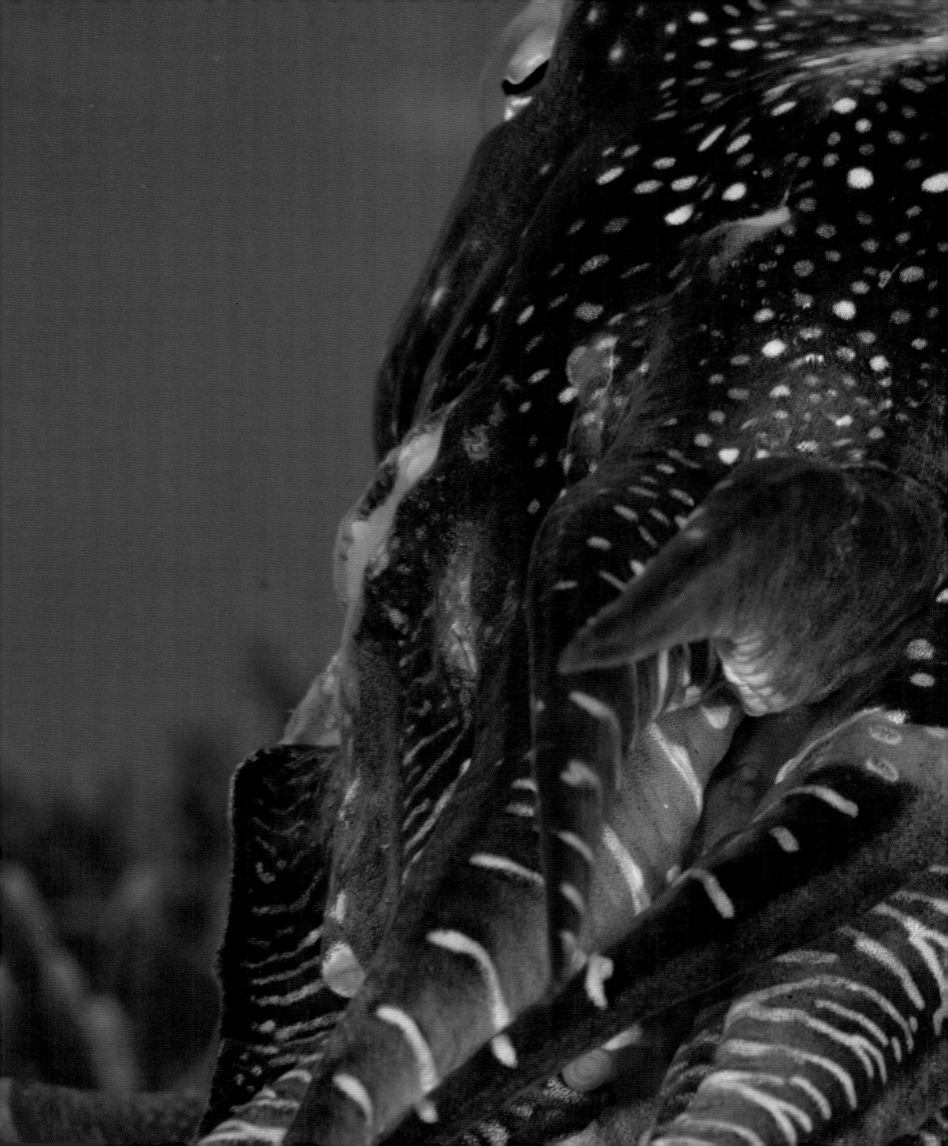

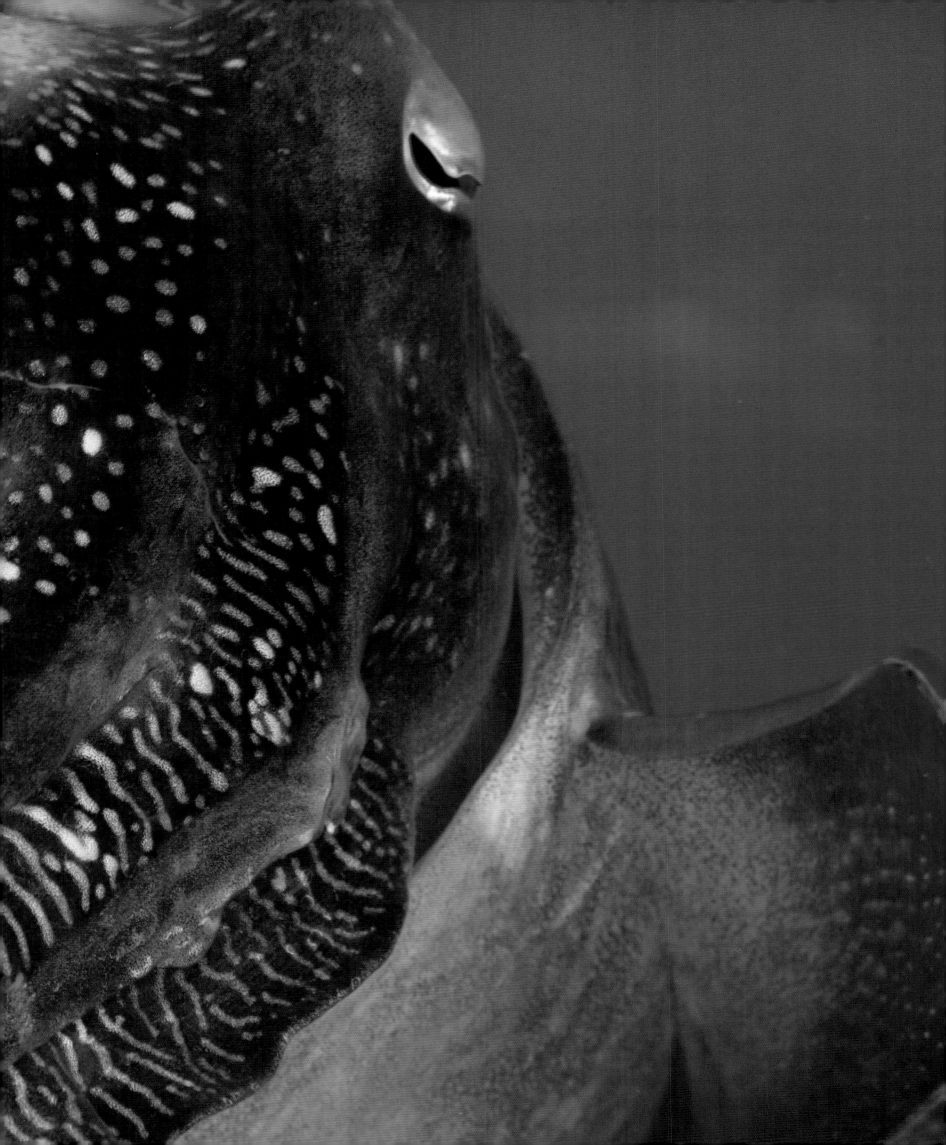

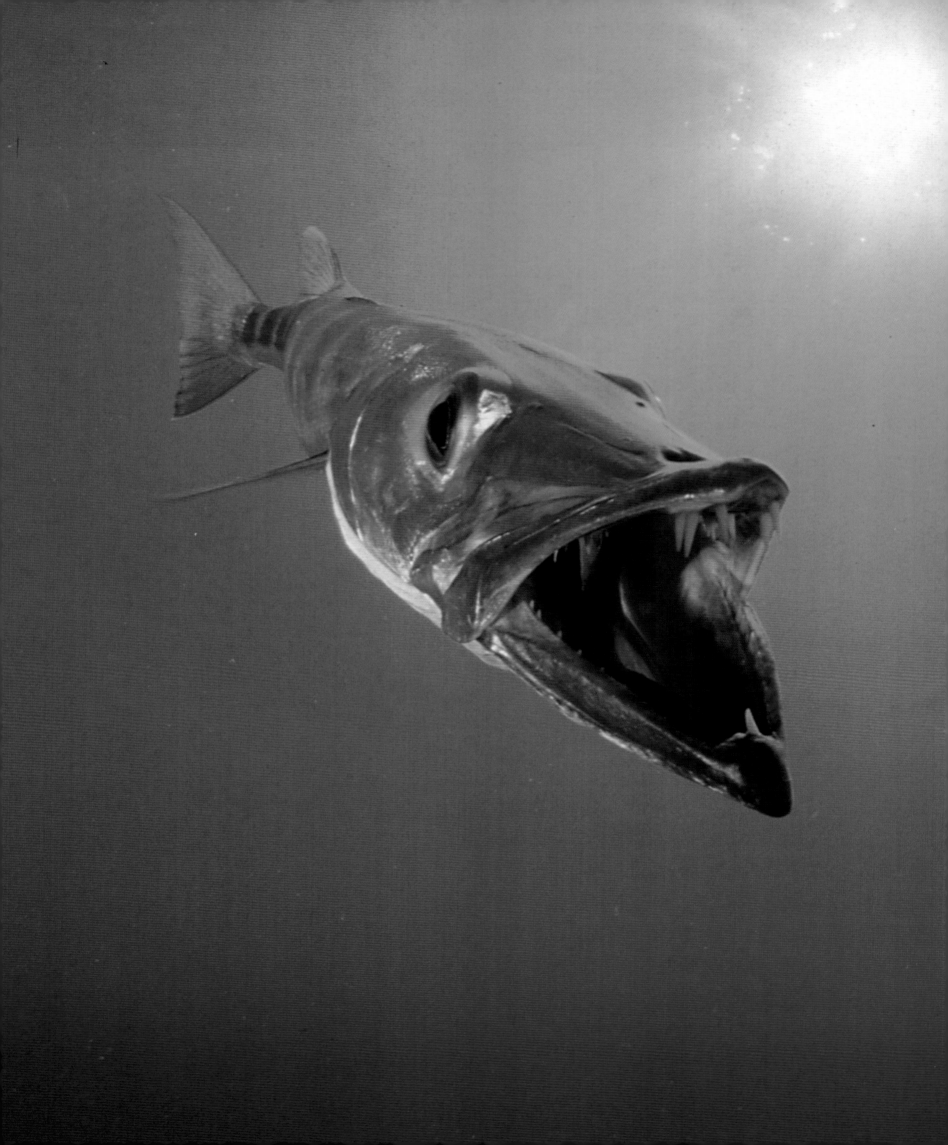

CREATURES

LEFT: Suddenly this yellow fin barracuda starts to open its mouth and takes up an attack position. It ends up falling onto the sea bed, and dies (Noumea, New Caledonia 2005)

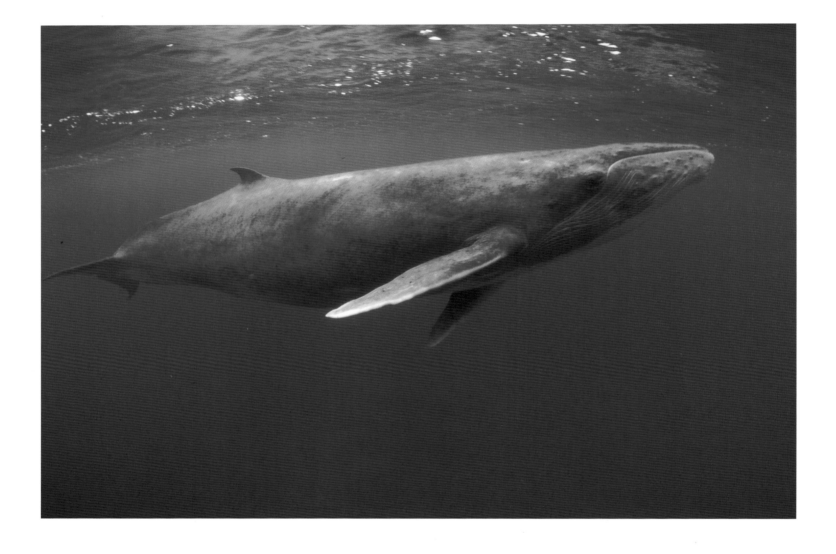

ABOVE: A humpback whale
(Rurutu Island, Tahiti 1998)

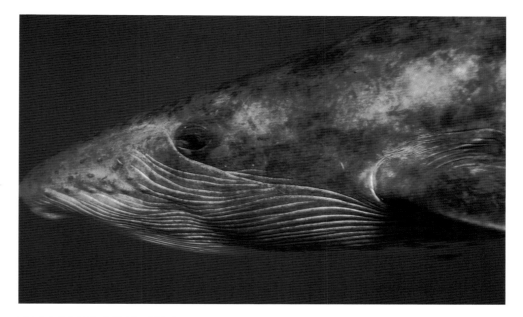

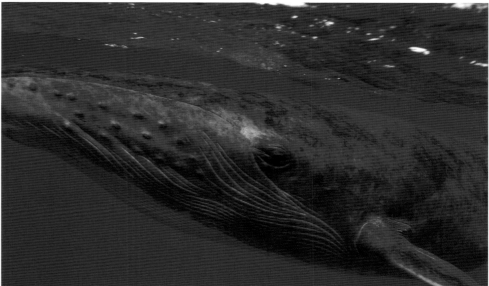

TOP RIGHT-BOTTOM RIGHT: A young humpback whale swims across in front of me. It is always a pleasure to swim with whales (Rurutu Island, Tahiti 1998)

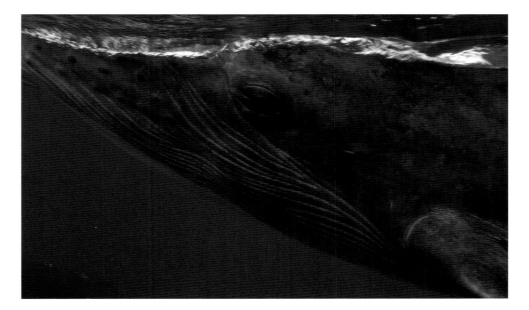

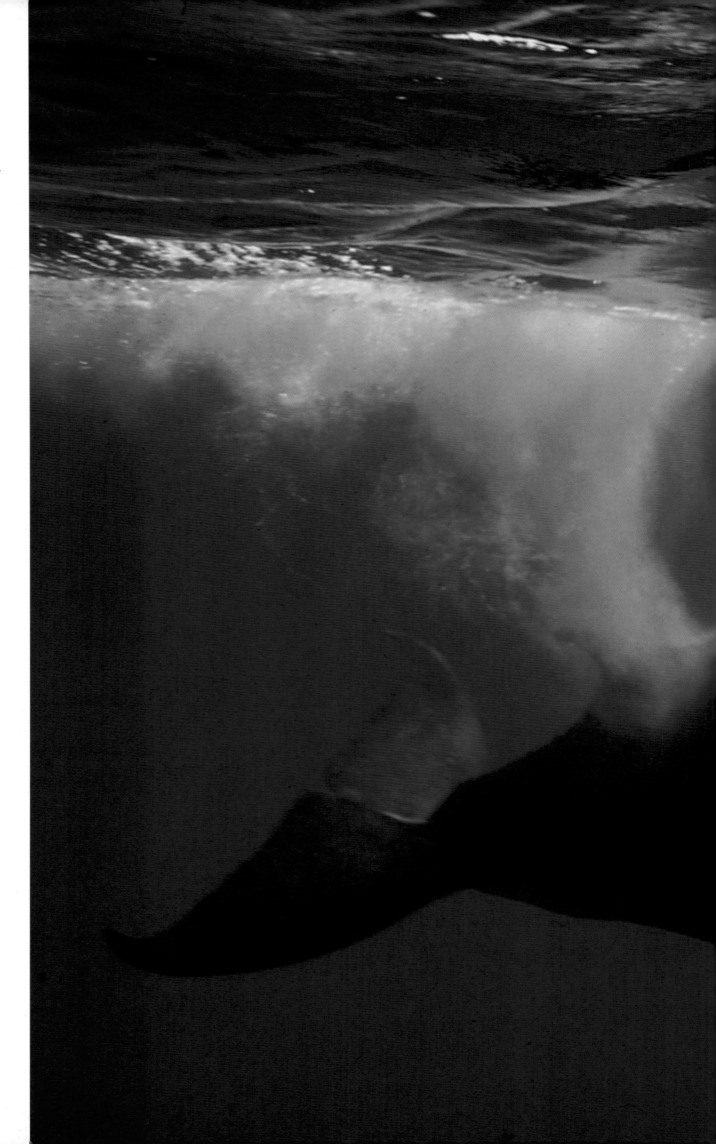

CREATURES

RIGHT: This young humpback whale is full of energy; every time it dances underwater, we are pushed back by the waves (Rurutu Island, Tahiti 1998)

PAGES 102-103: A banded dolphin swims quietly by; unexpected encounters are the most precious experiences of all (Red Sea, Egypt 2003)

PAGES 104-105: Bottle nosed dolphins swim freely in the water; they are natural born performers (Guam, Micronesia 2006)

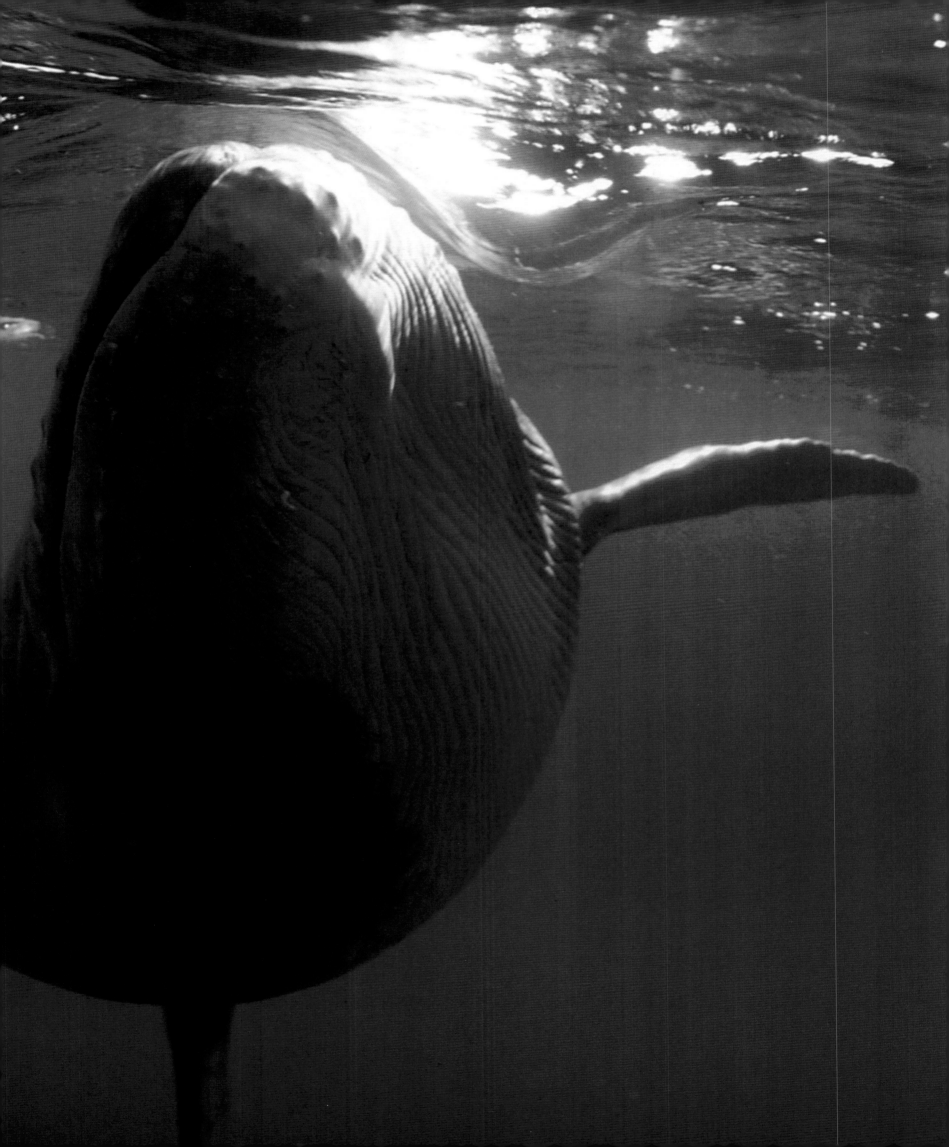

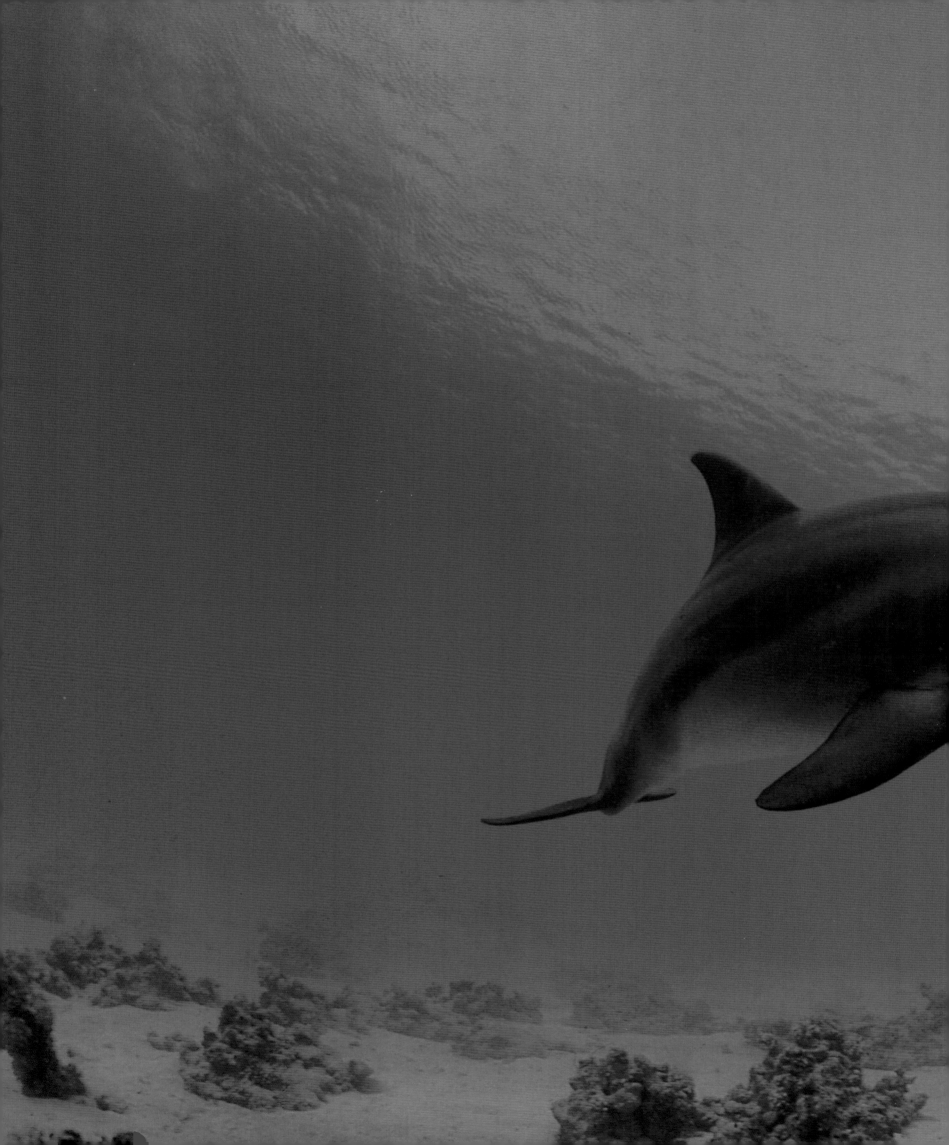

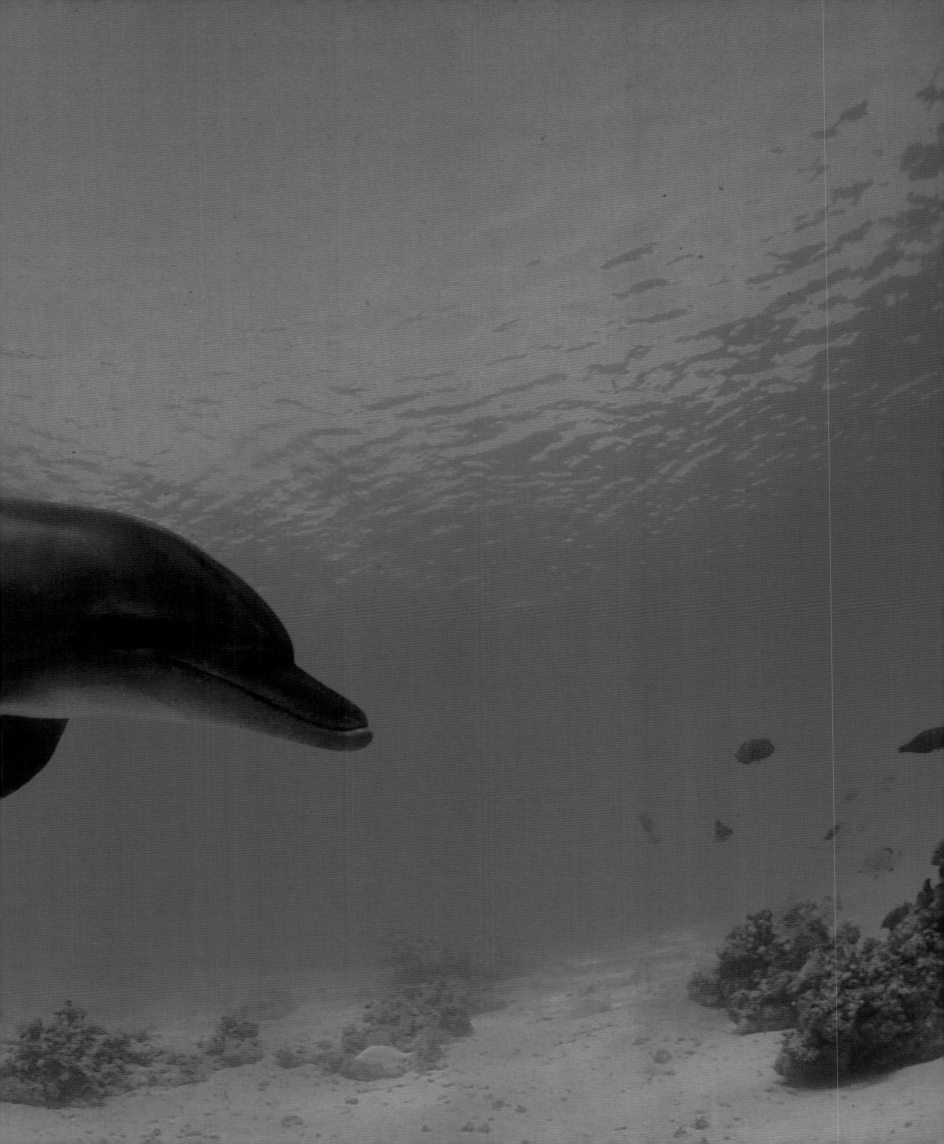

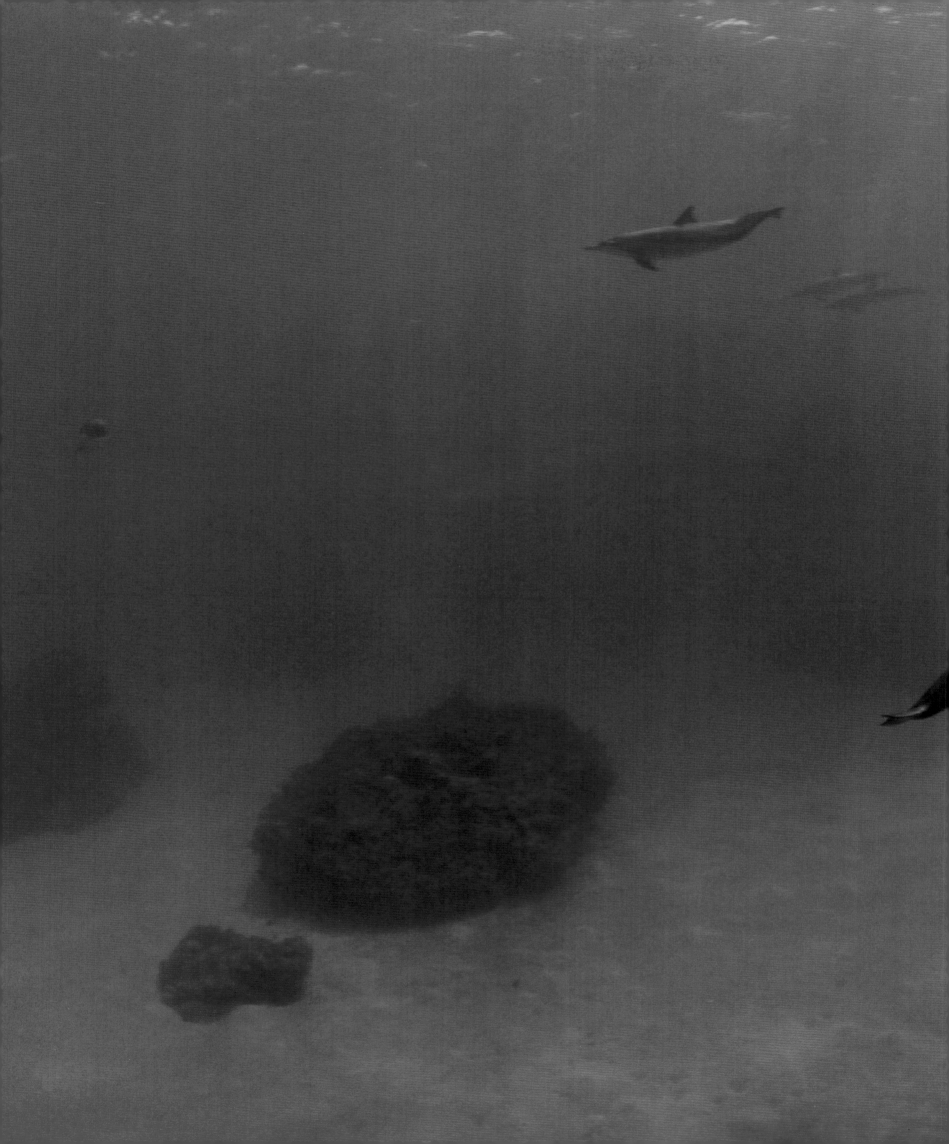

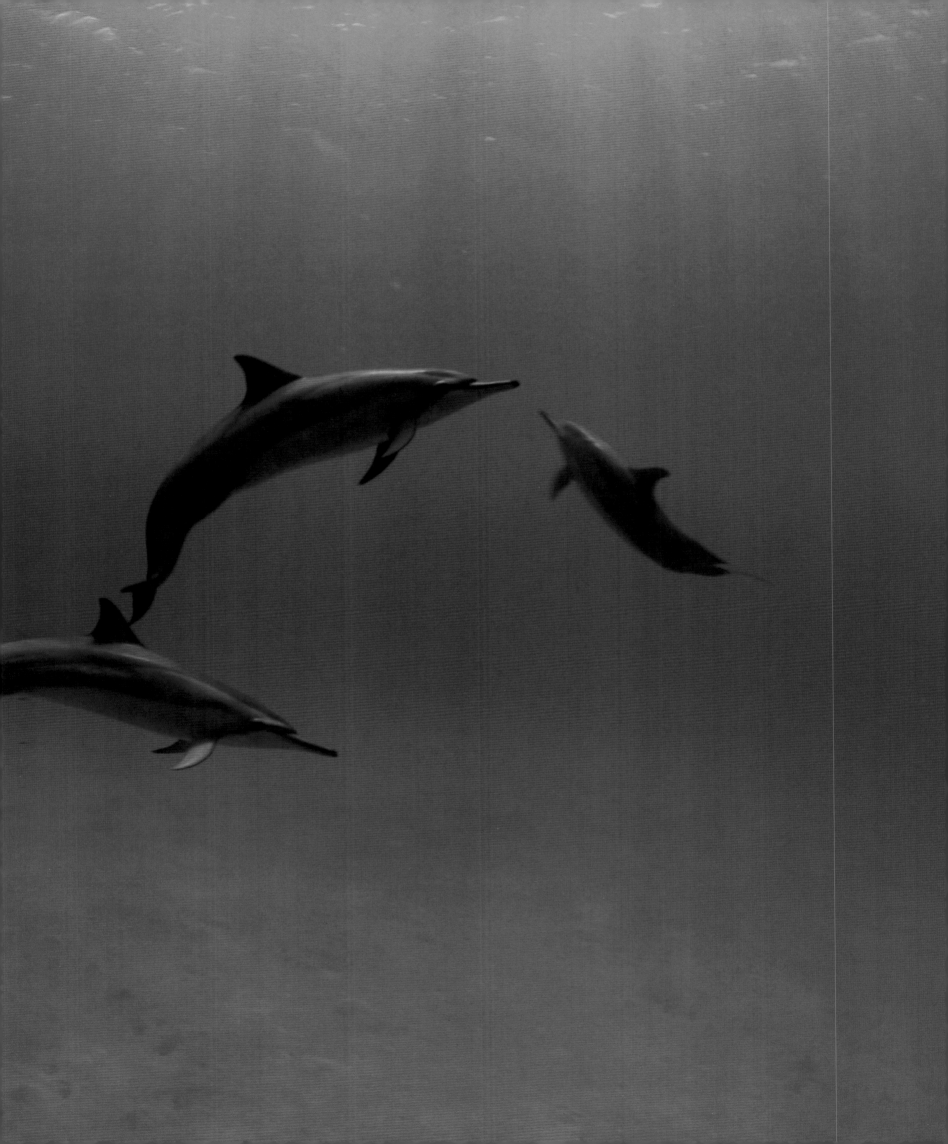

CREATURES

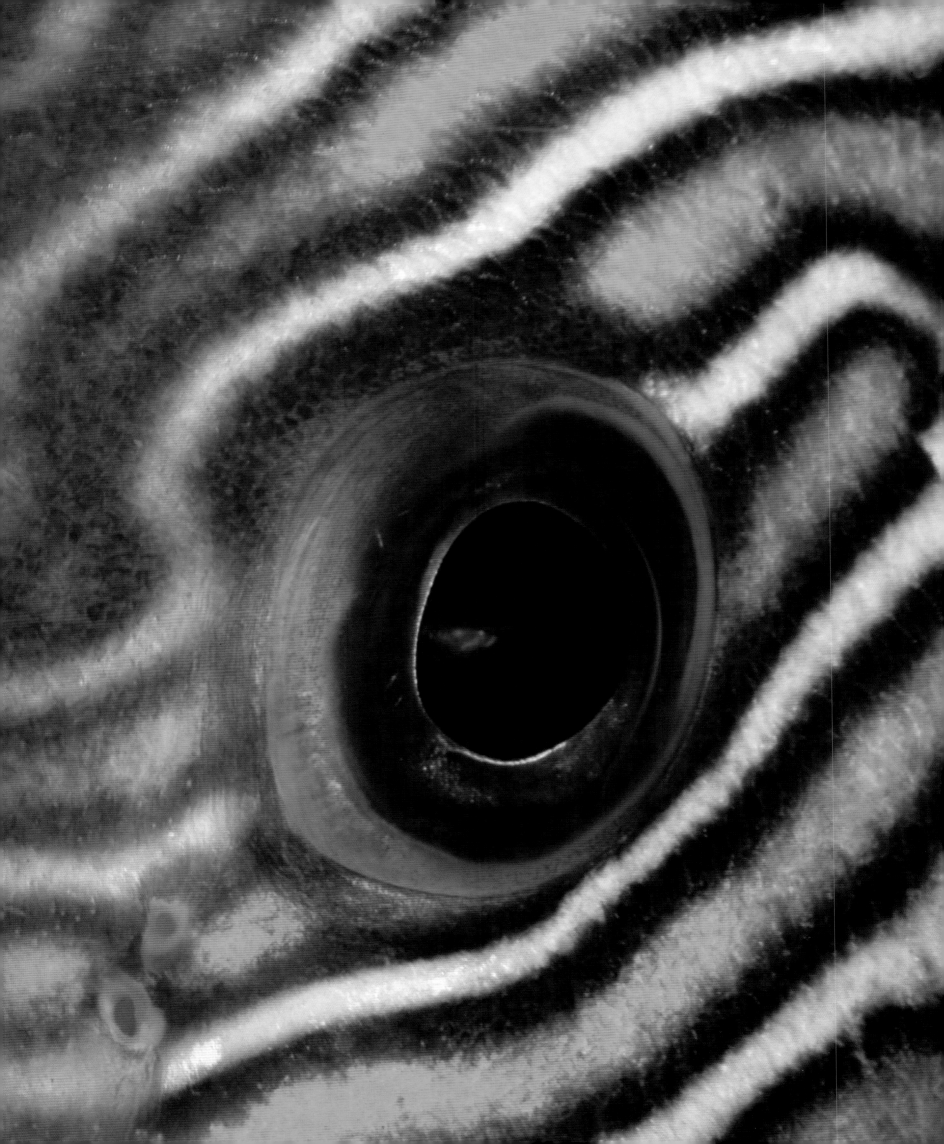

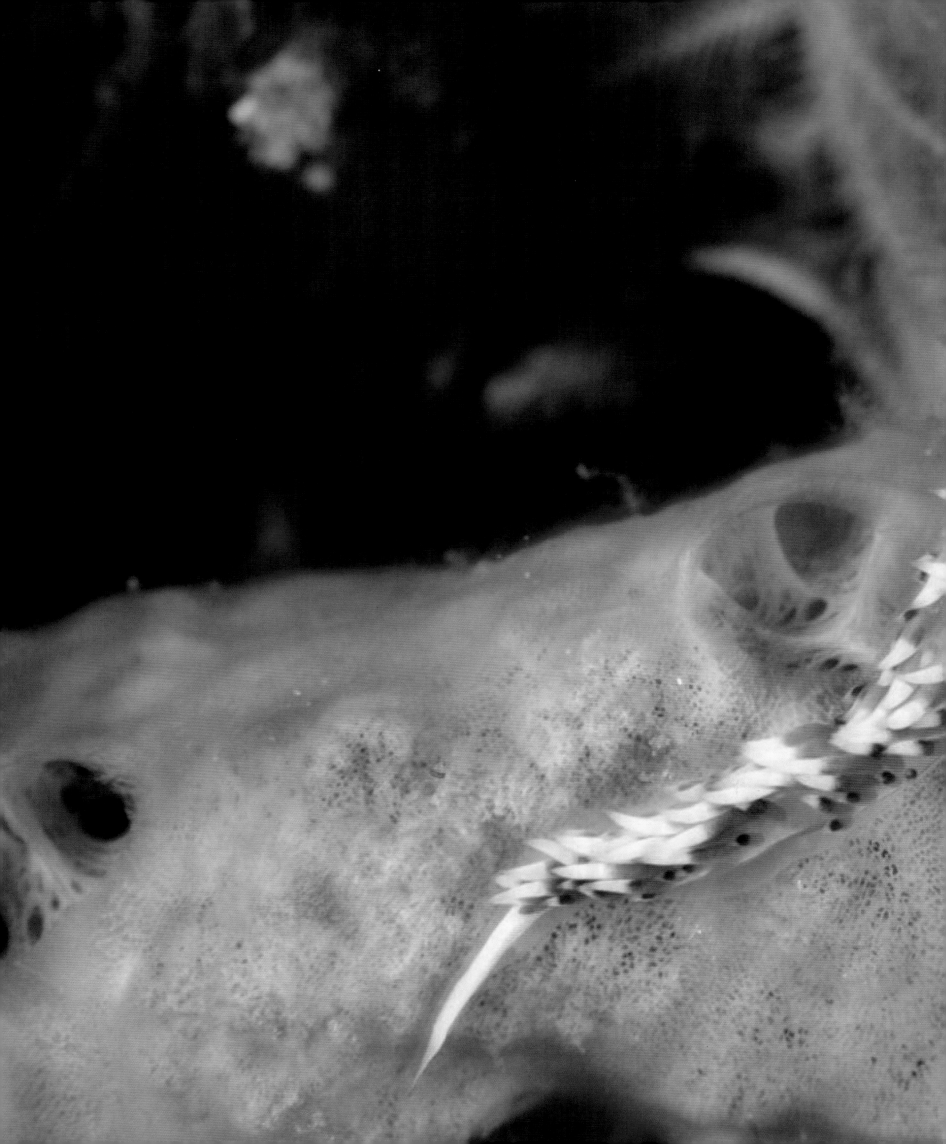

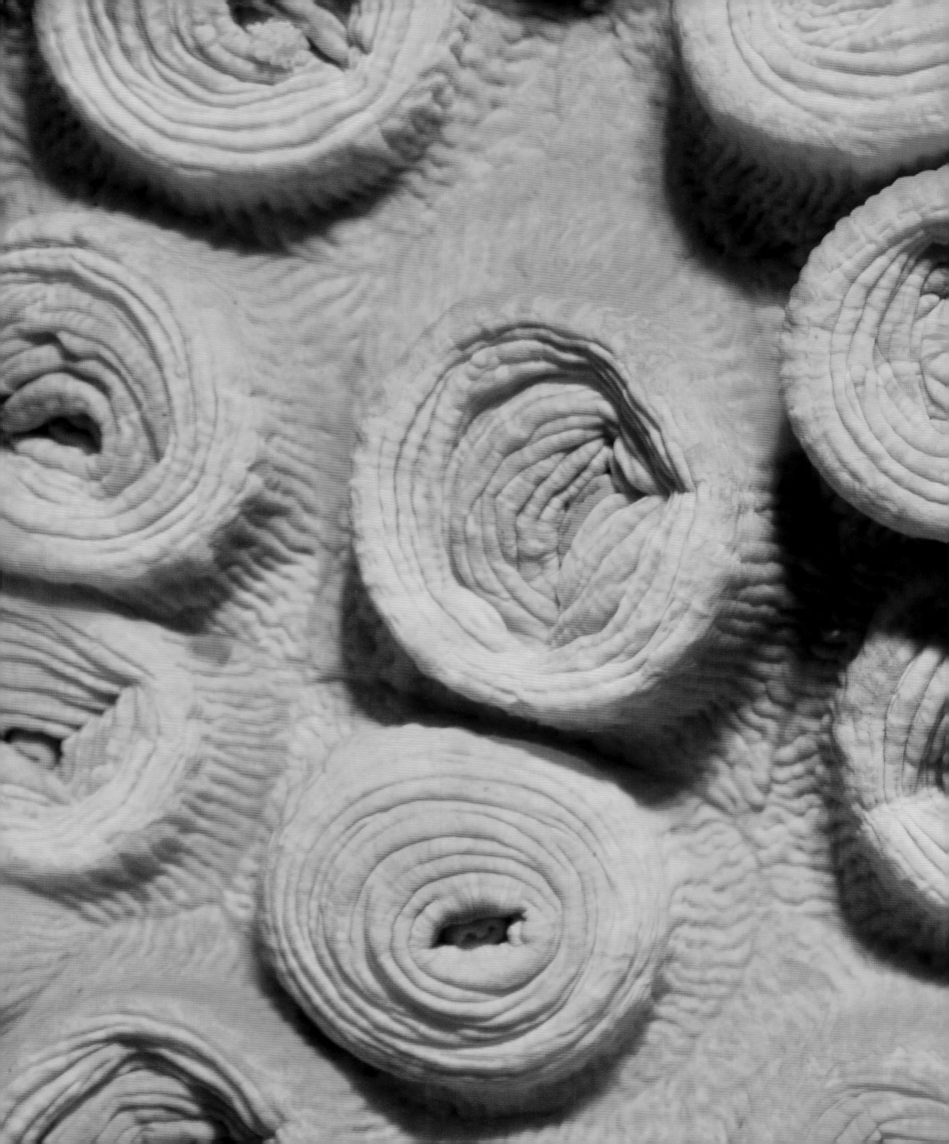

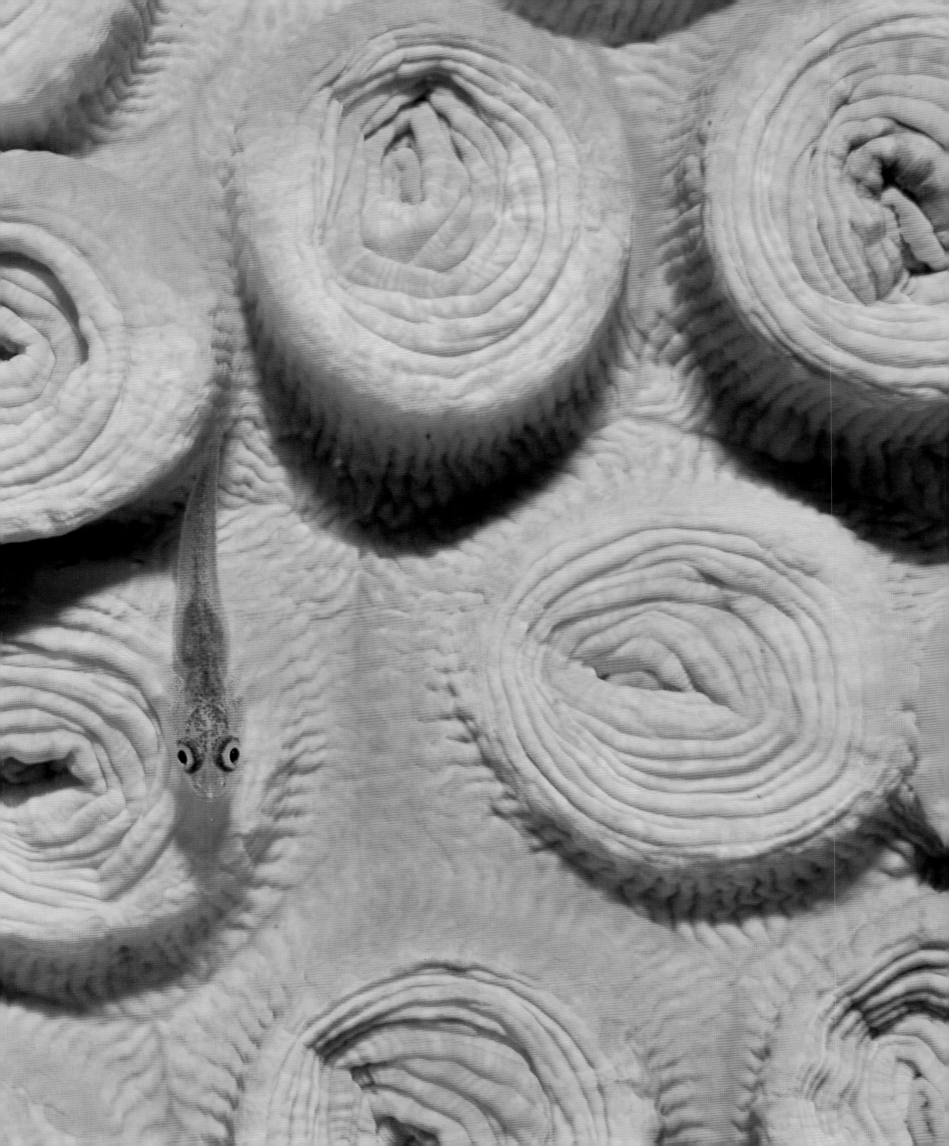

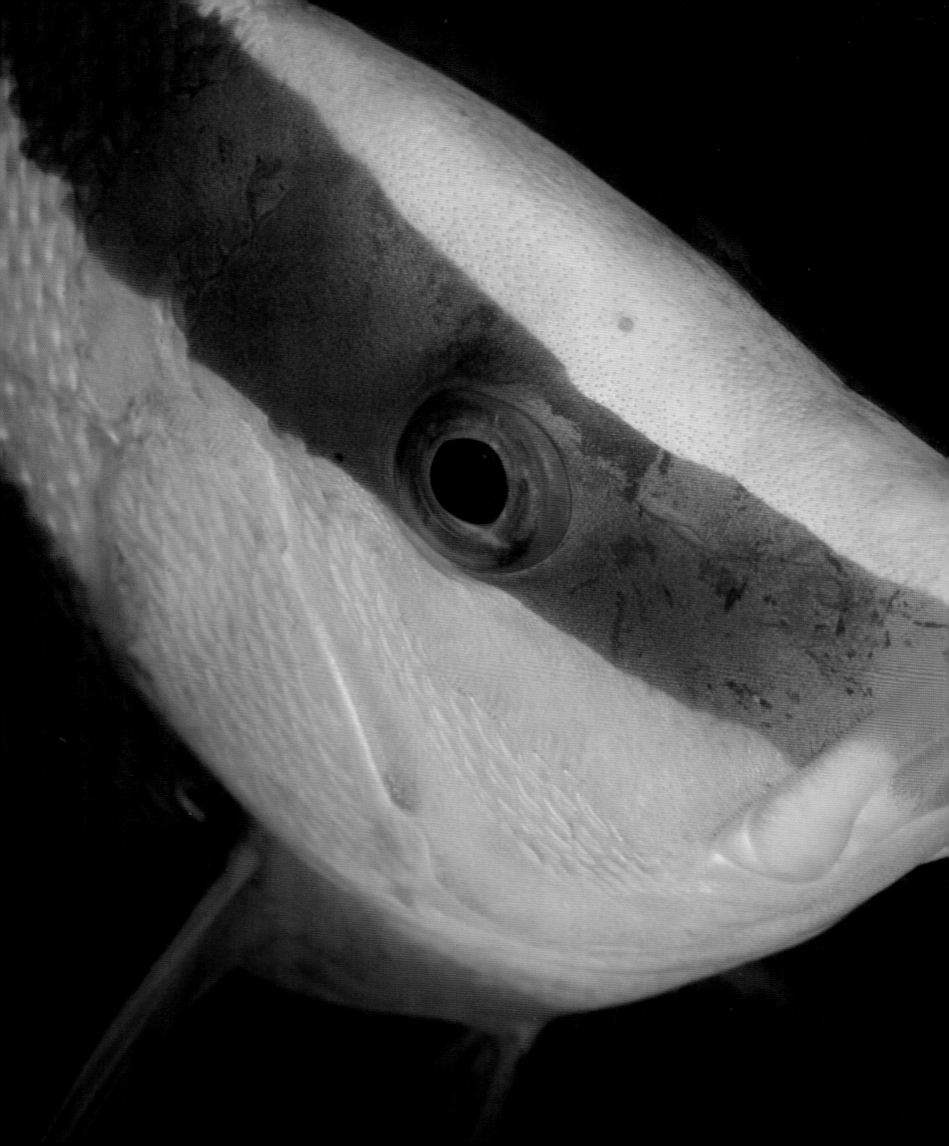

LEFT: Emperor red snapper; its red and white facial features resemble a Kabuki actor's make-up
(Andaman Sea, Thailand 2000)

RIGHT: At night, a school of shrimpfish gathers in the light just like a magnet picking up paper clips
(Manado, Indonesia 2006)

PAGES 114-115: A napoleonfish with mouth wide open
(South Male Atoll, the Maldives 2006)

PAGES 116-117: The scorpionfish flips over, leaving a ripple
(Komodo Island, Indonesia 2007)

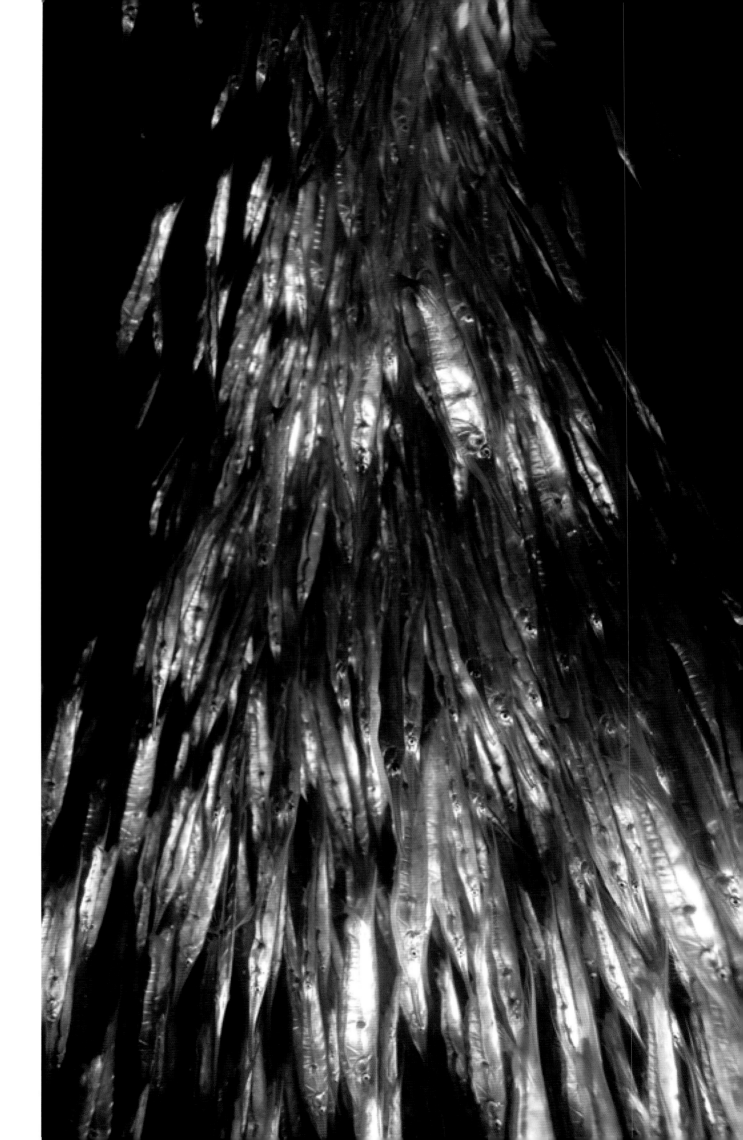

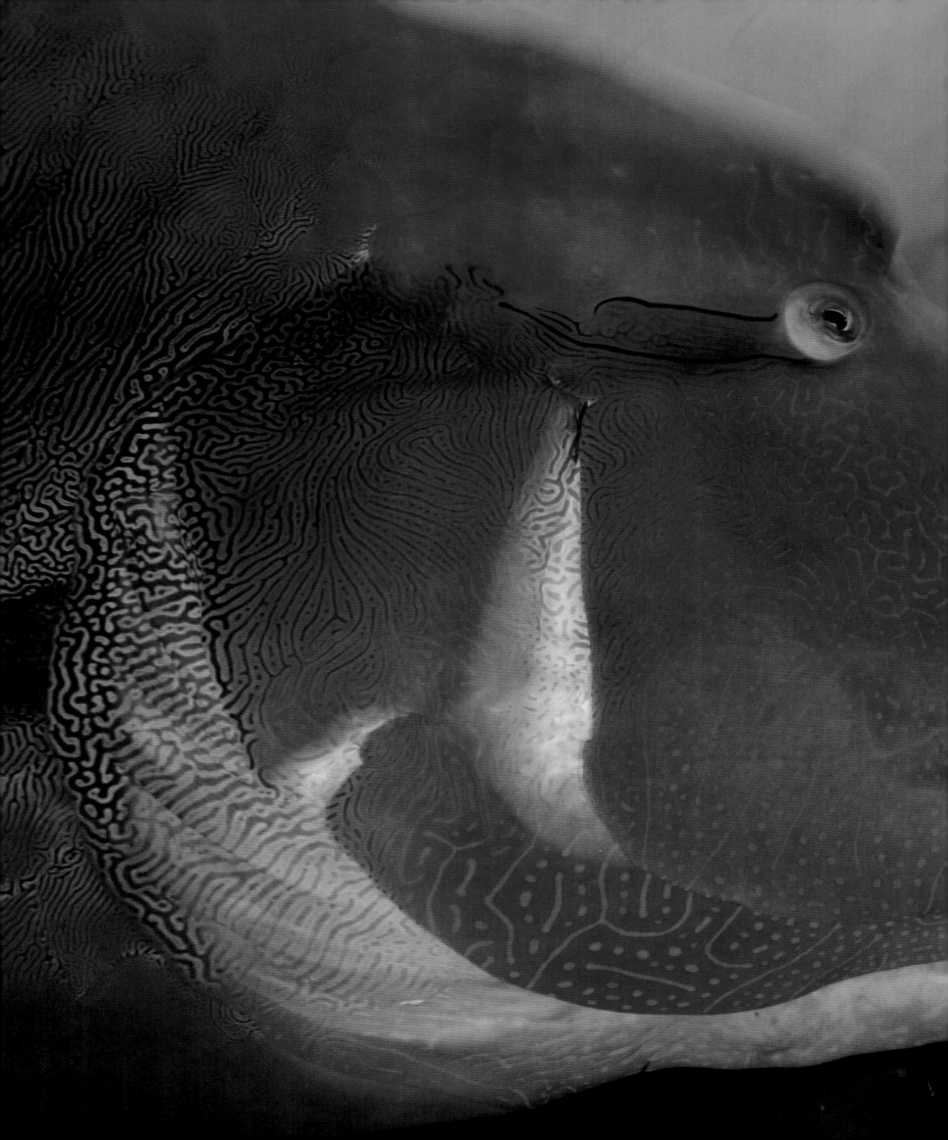

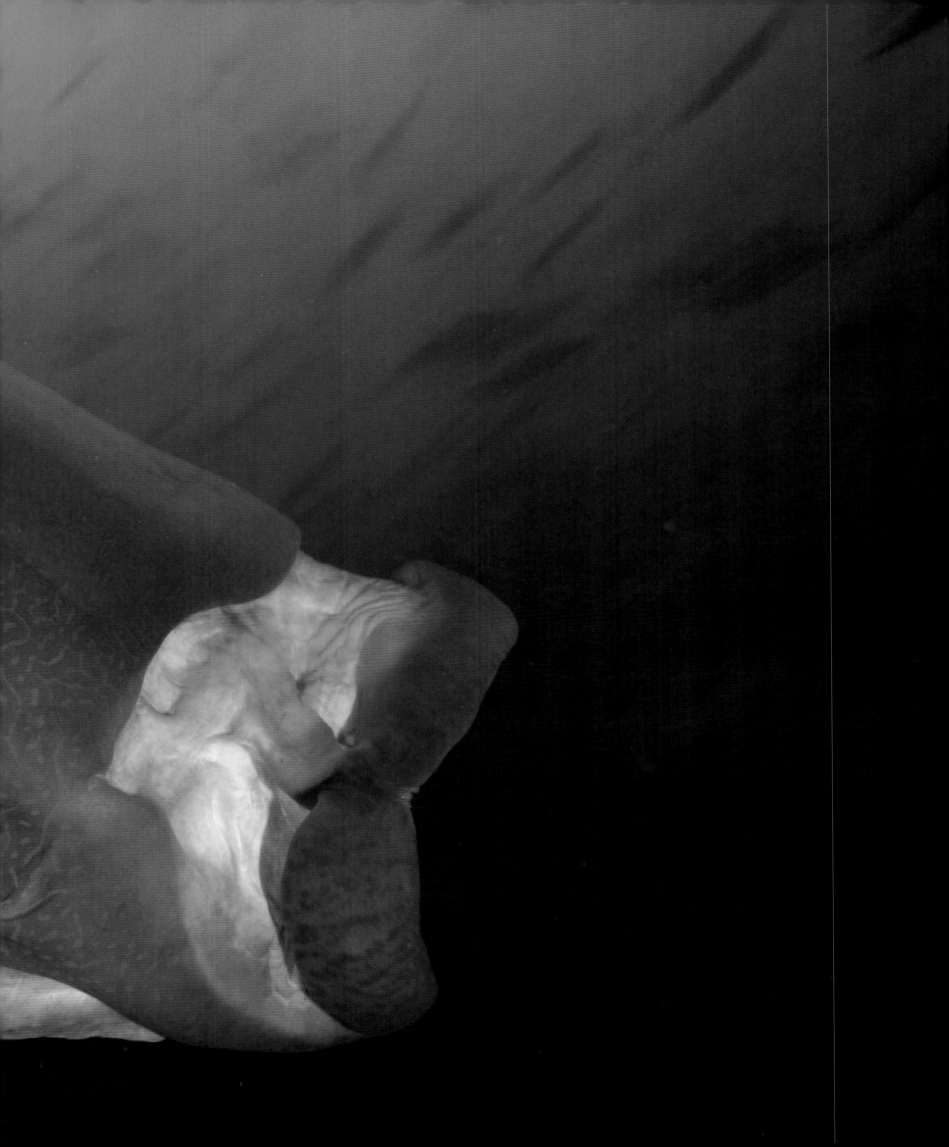

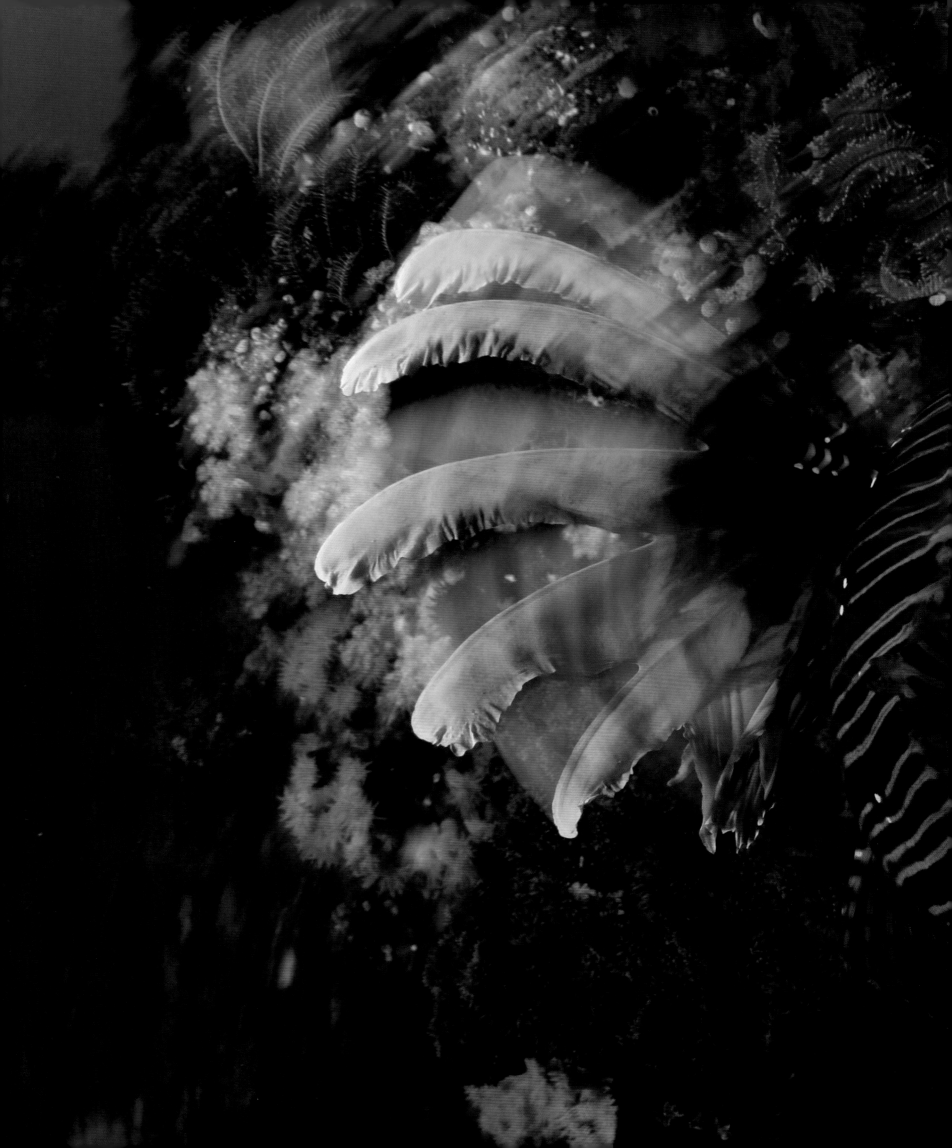

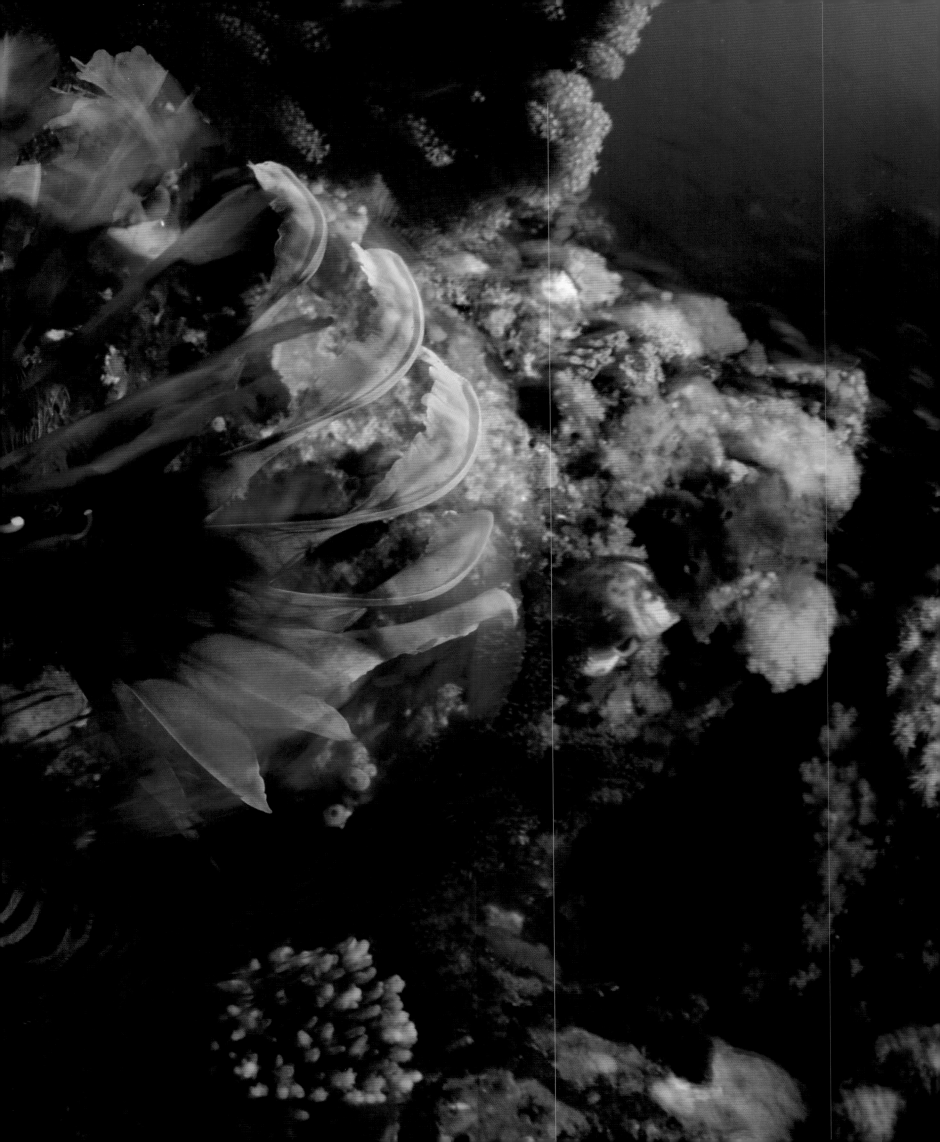

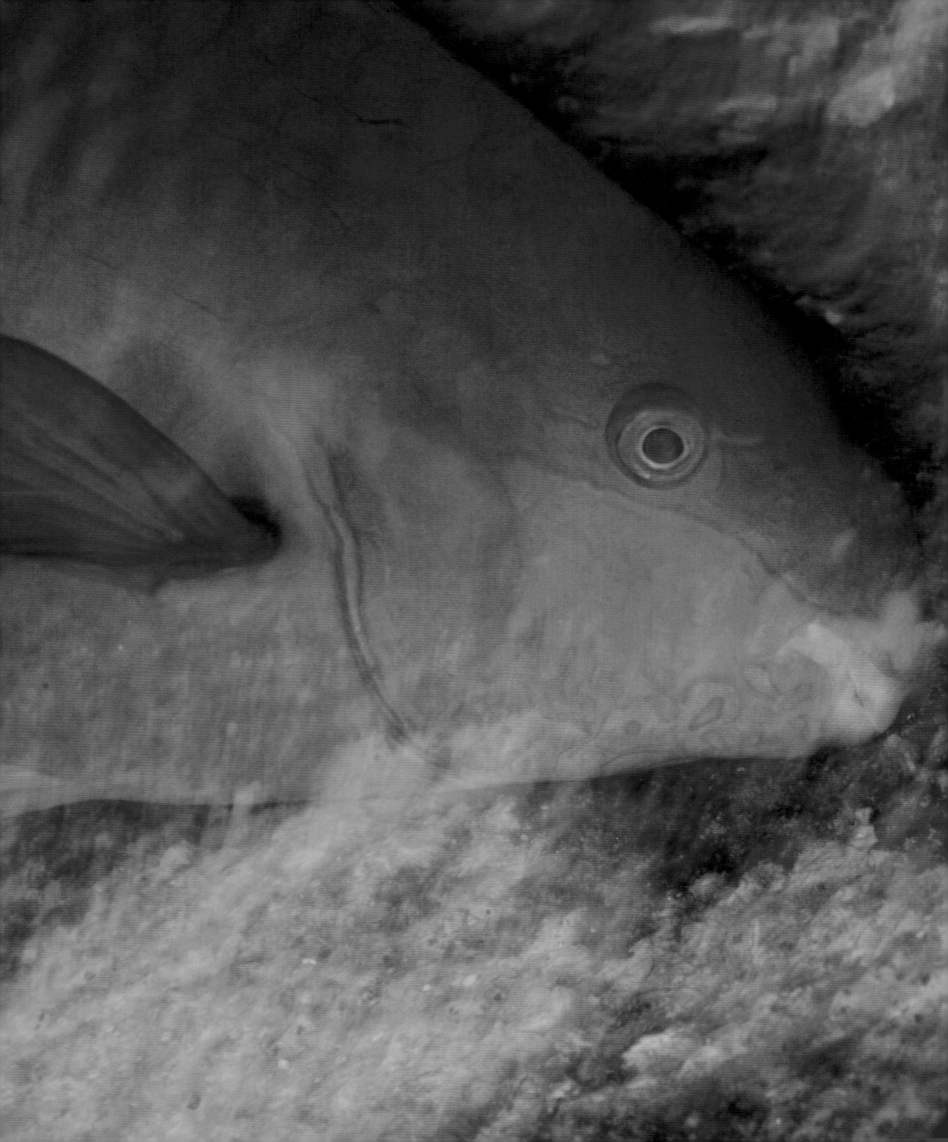

LEFT: A parrotfish bites off
the surface of the rock
(Andaman Sea, Thailand 2007)

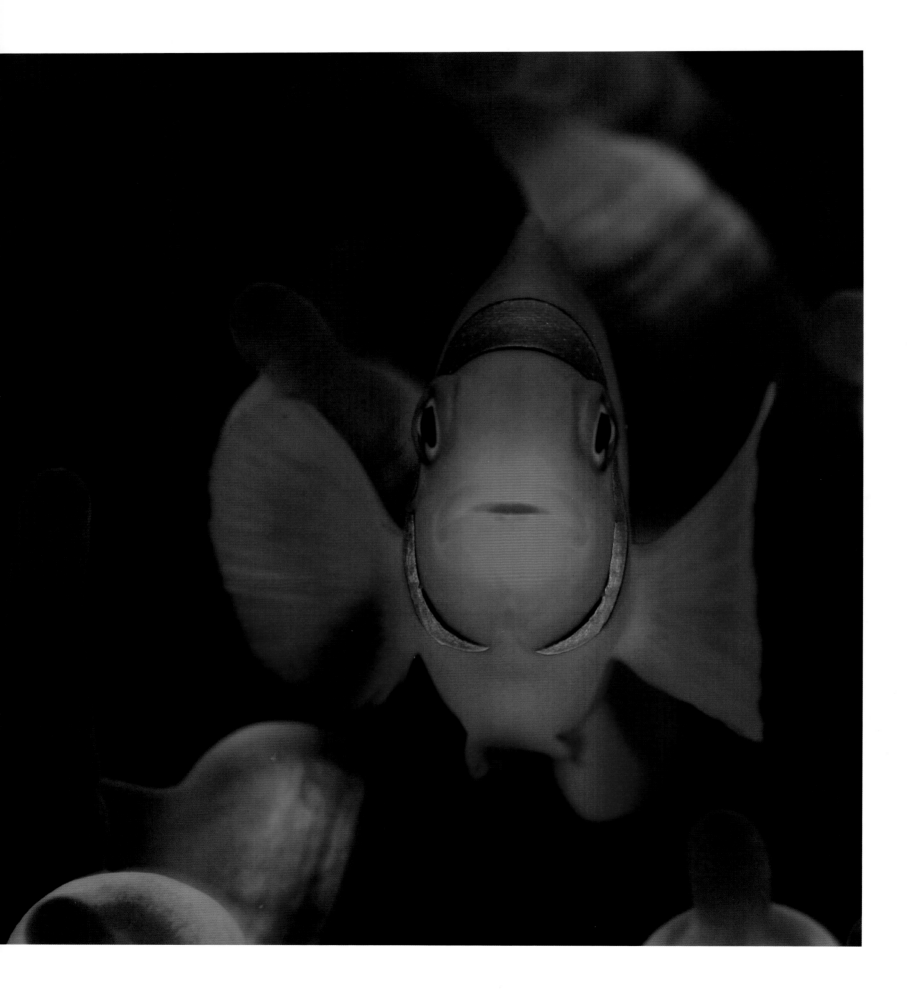

LEFT: Spiny anemonefish have
a bandage around the body
(Raja Ampat, Indonesia 2007)

TOP RIGHT: A little combtooth
blenny darts its eyes about
(South Male Atoll, the Maldives 1996)

BOTTOM: A big, merry family
of anemonefish
(Manado, Indonesia 2005)

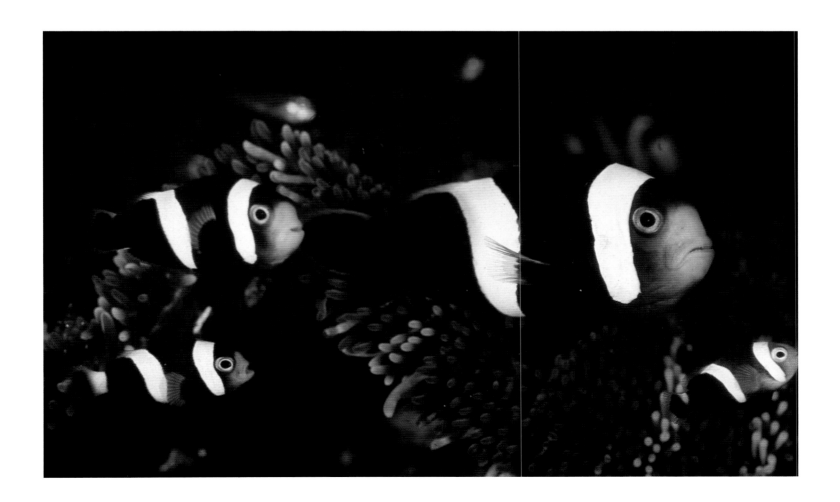

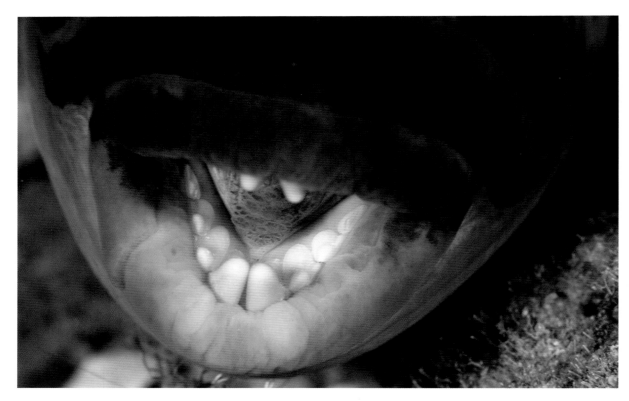

TOP:The formidable jaw of a titan triggerfish.
It pays not to get too close to these fish during
spawning season
(South Male Atoll, the Maldives 1997)

BOTTOM: The face of the
giant jawfish is about the size of a fist
(La Paz, Mexico 2000)

RIGHT: The unique facial features
of the lacy scorpionfish
(Manado, Indonesia 2005)

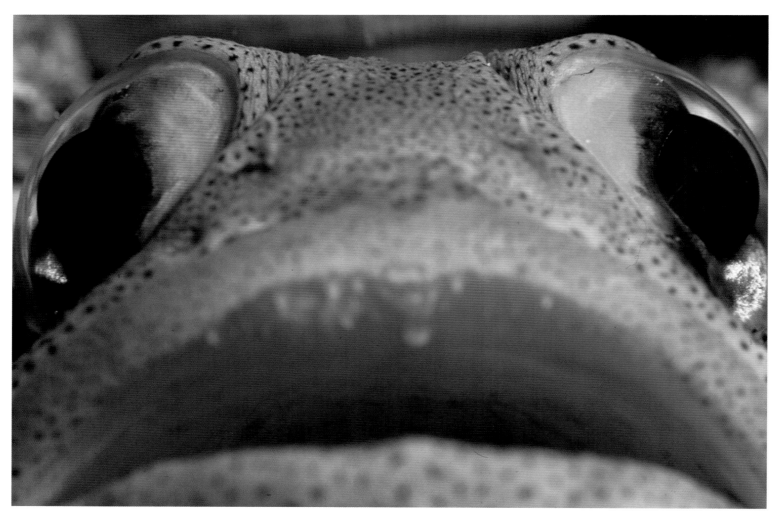

RIGHT: An orange-spine unicornfish
has an elegant swimming style
(South Male Atoll, the Maldives 1996)

FAR RIGHT: The thorny seahorse mimics
a sponge; their shapes are very similar
(Manado, Indonesia 2005)

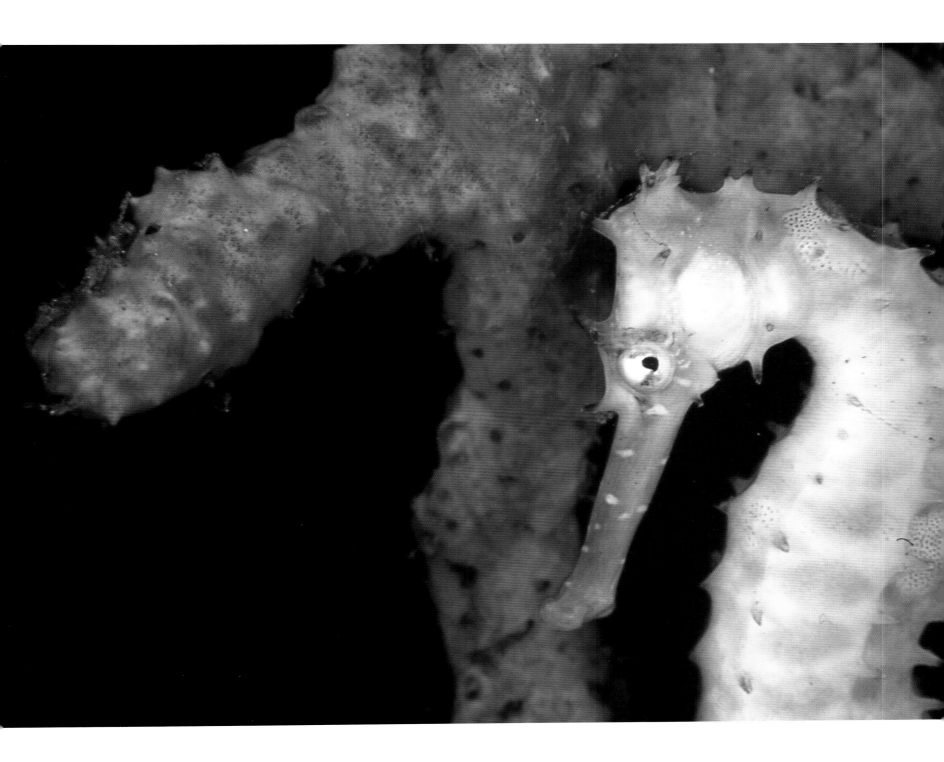

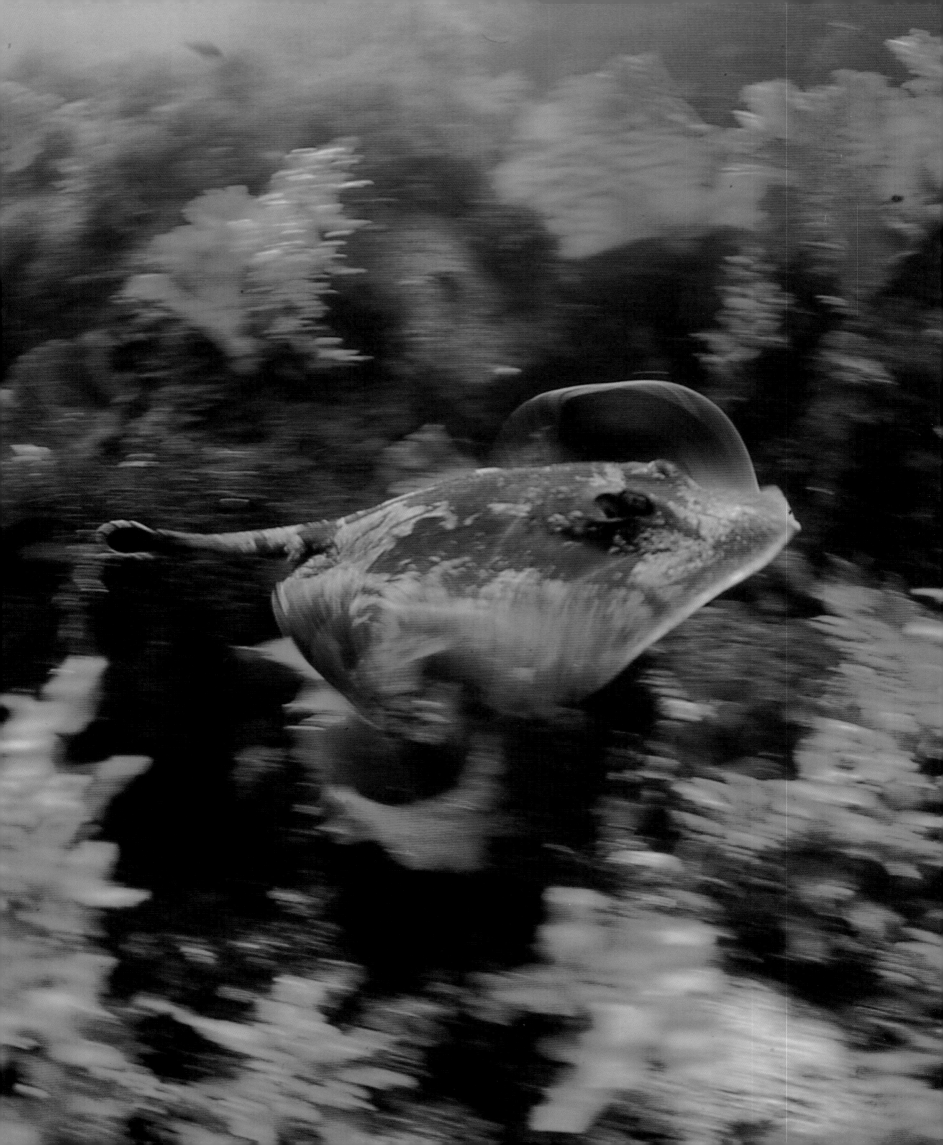

LEFT: A sepia stingray swims through a forest
of seaweed in spring
(Izu, Shizuoka, Japan 1995)

BELOW: An anemonefish presents an innocent
face in front of the bleached sea anemone
(South Male Atoll, the Maldives 1998)

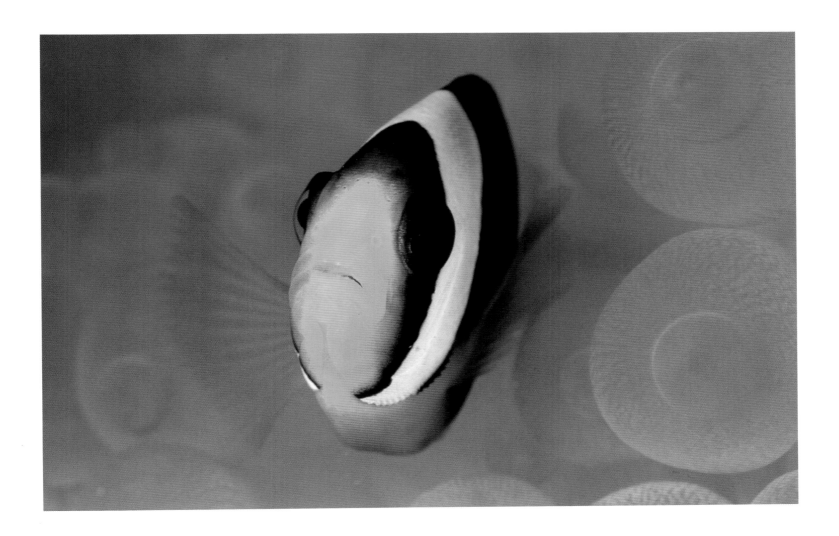

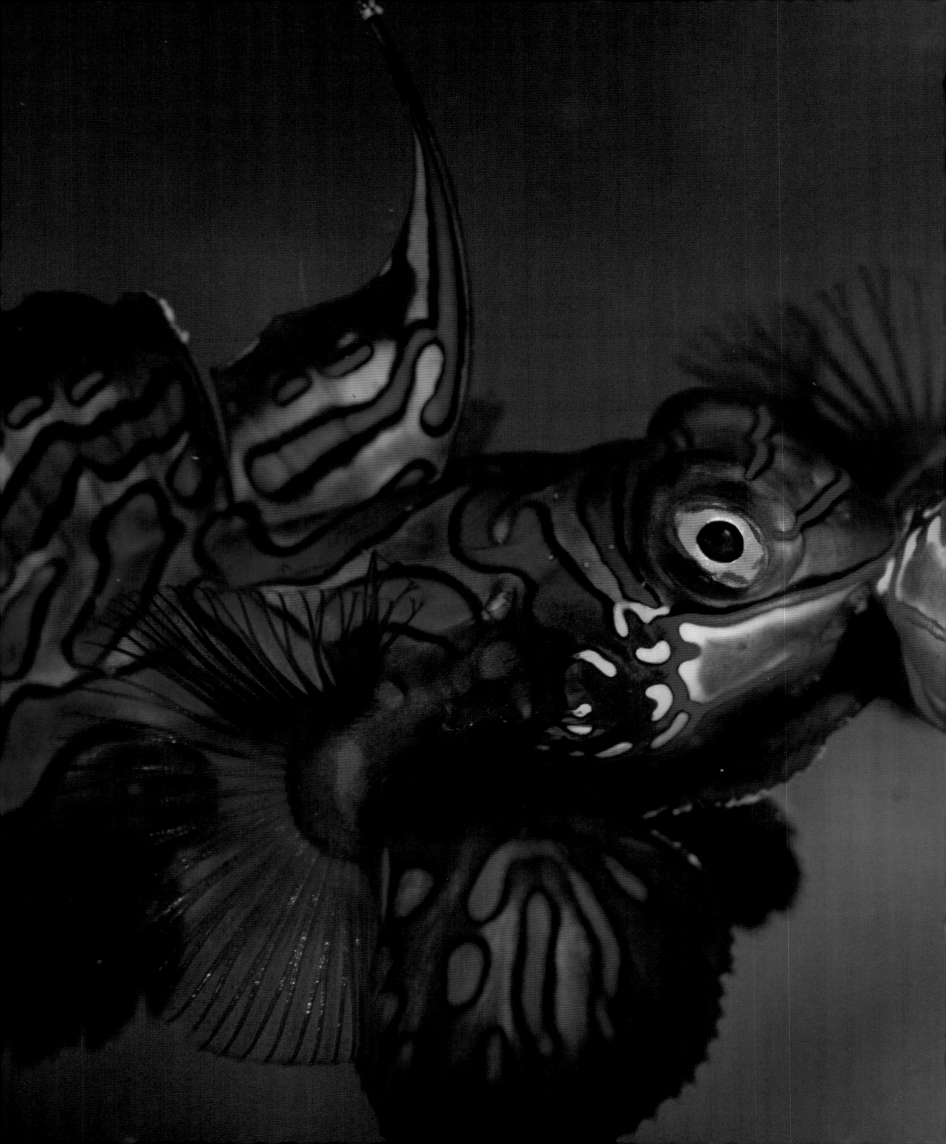

LEFT: Late in the afternoon, two mandarinfish
start to fight for territory, because neither can
find mating partners
(Manado, Indonesia 2007)

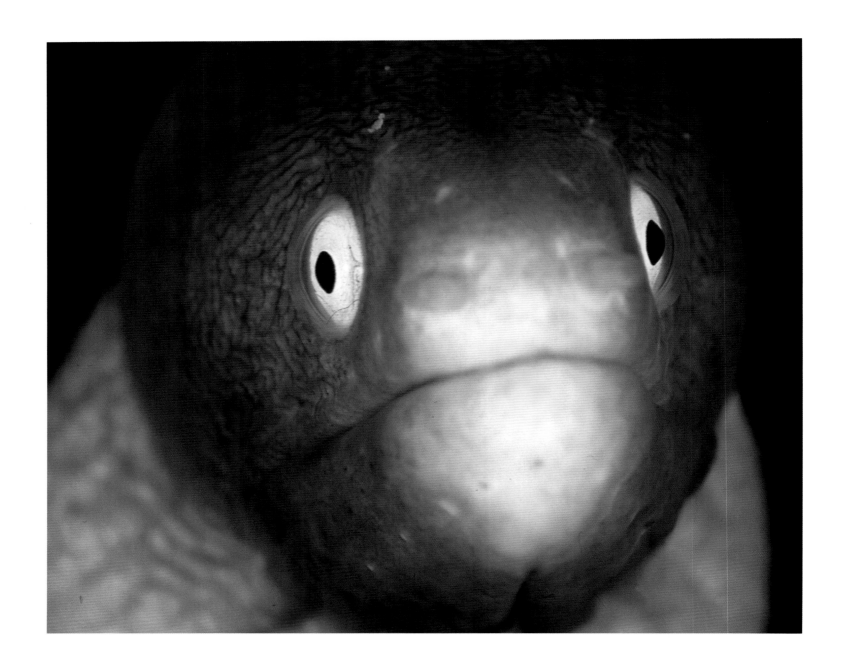

ABOVE: The greyface moray
has eyes like a human's
(Amami-Oshima, Kagoshima, Japan 2001)

TOP RIGHT: A spotted eagle ray digging
in coral rubble in search of prey
(Ari Atoll, the Maldives 2005)

BOTTOM RIGHT: The eye of a trumpetfish
(South Male Atoll, the Maldives 2007)

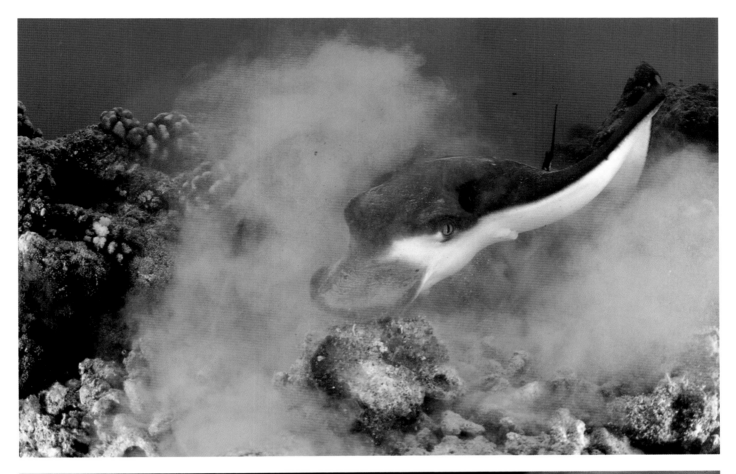

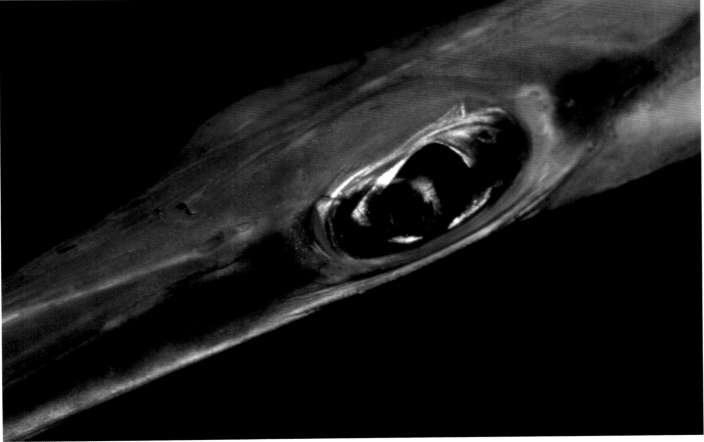

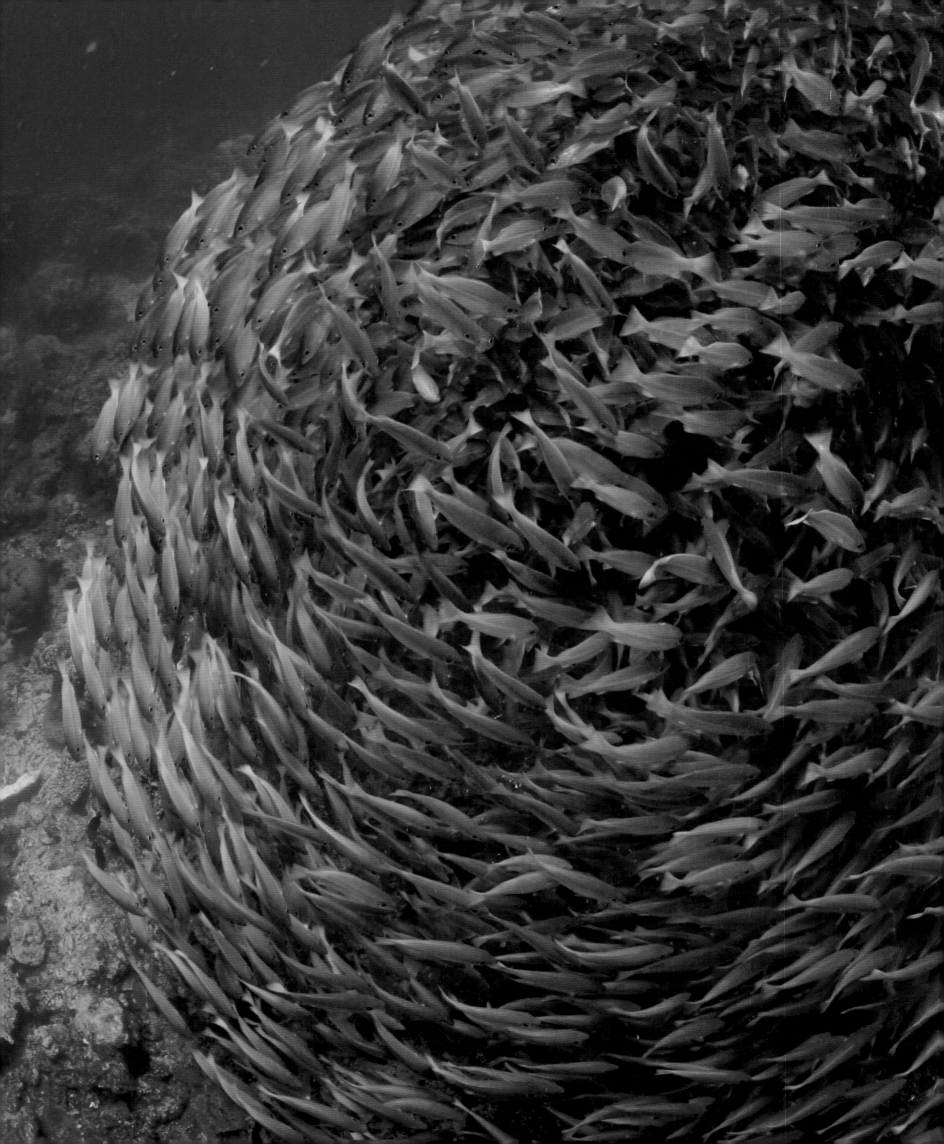

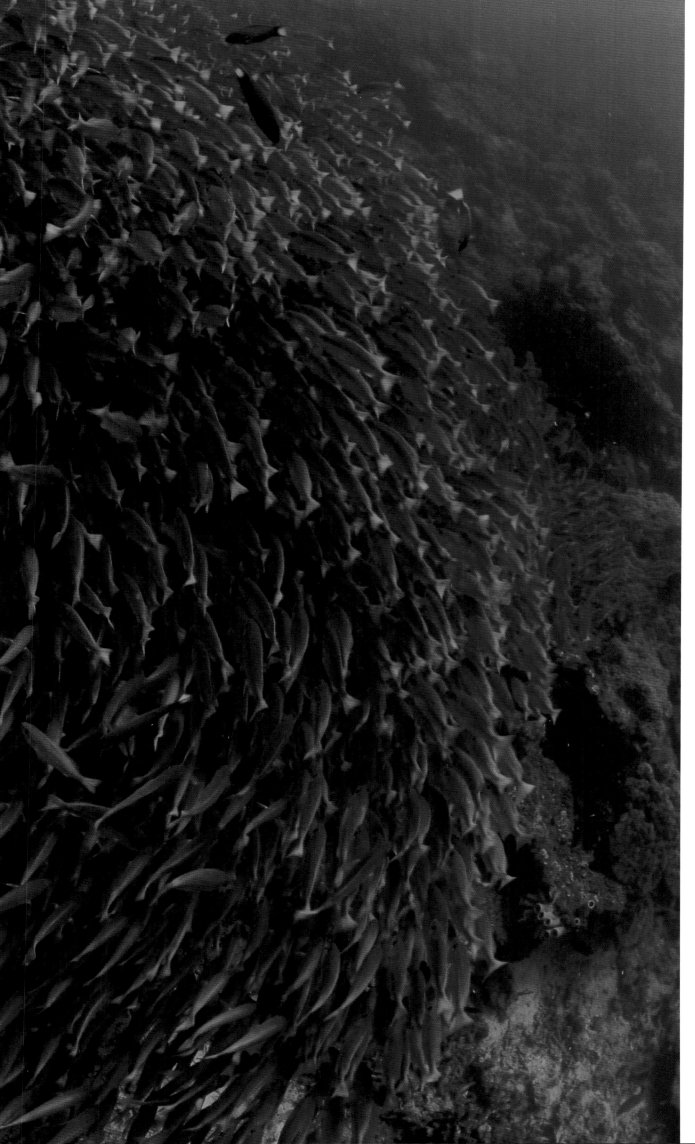

CREATURES

LEFT: A churning ball of gold-striped sea perch
(El Nido, Philippines 2007)

PAGES 134-135: A nudibranch is a
kind of a shellfish without a shell
(Komodo Island, Indonesia 2007)

PAGES 136-137: Nudibranchs like
to eat sea squirt and sponge
(Manado, Indonesia 2006)

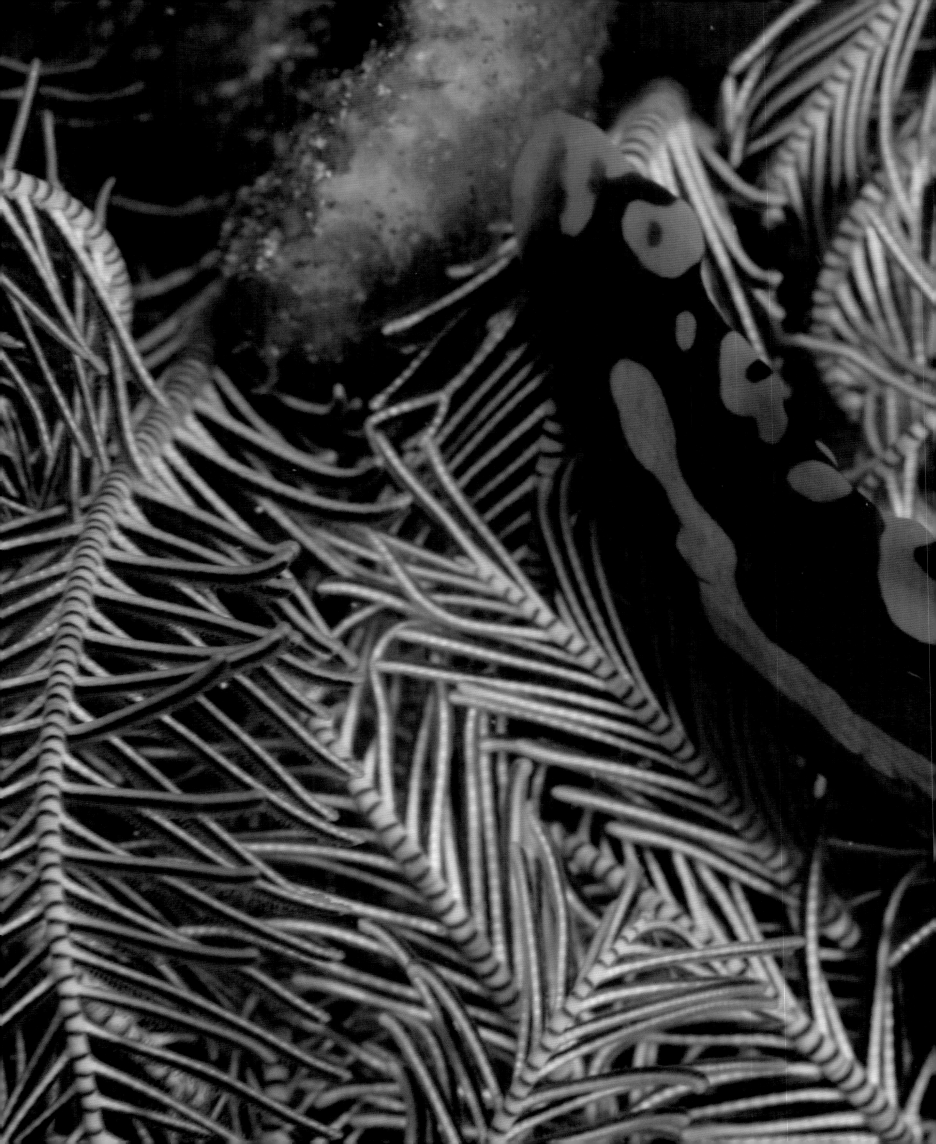

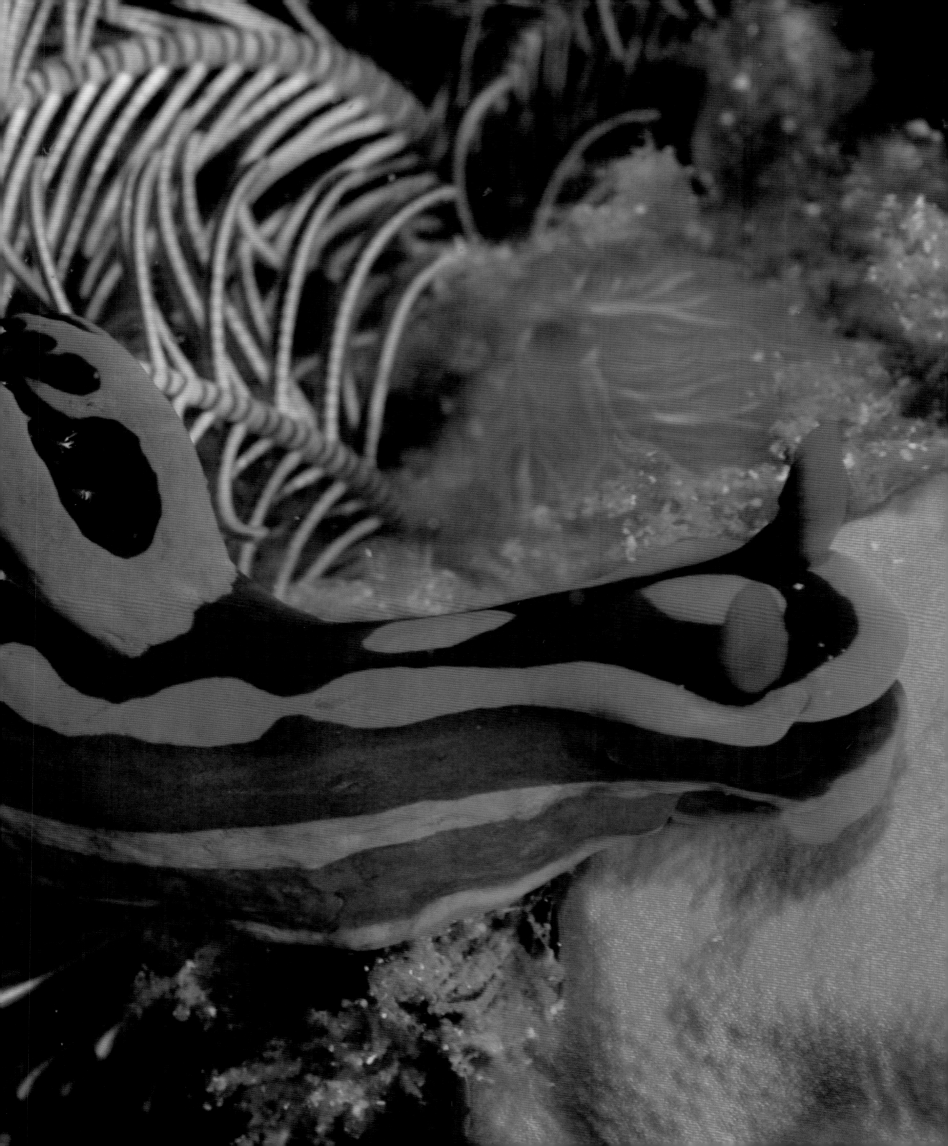

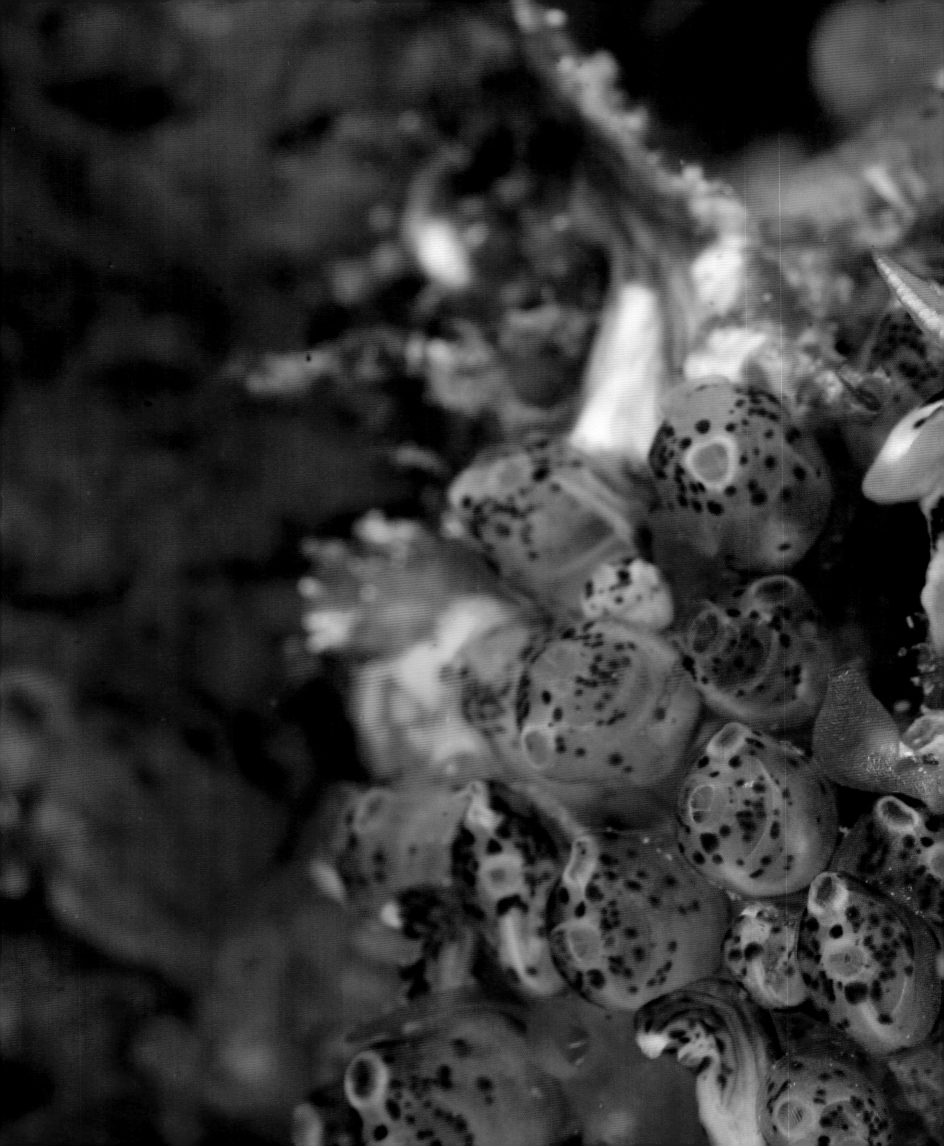

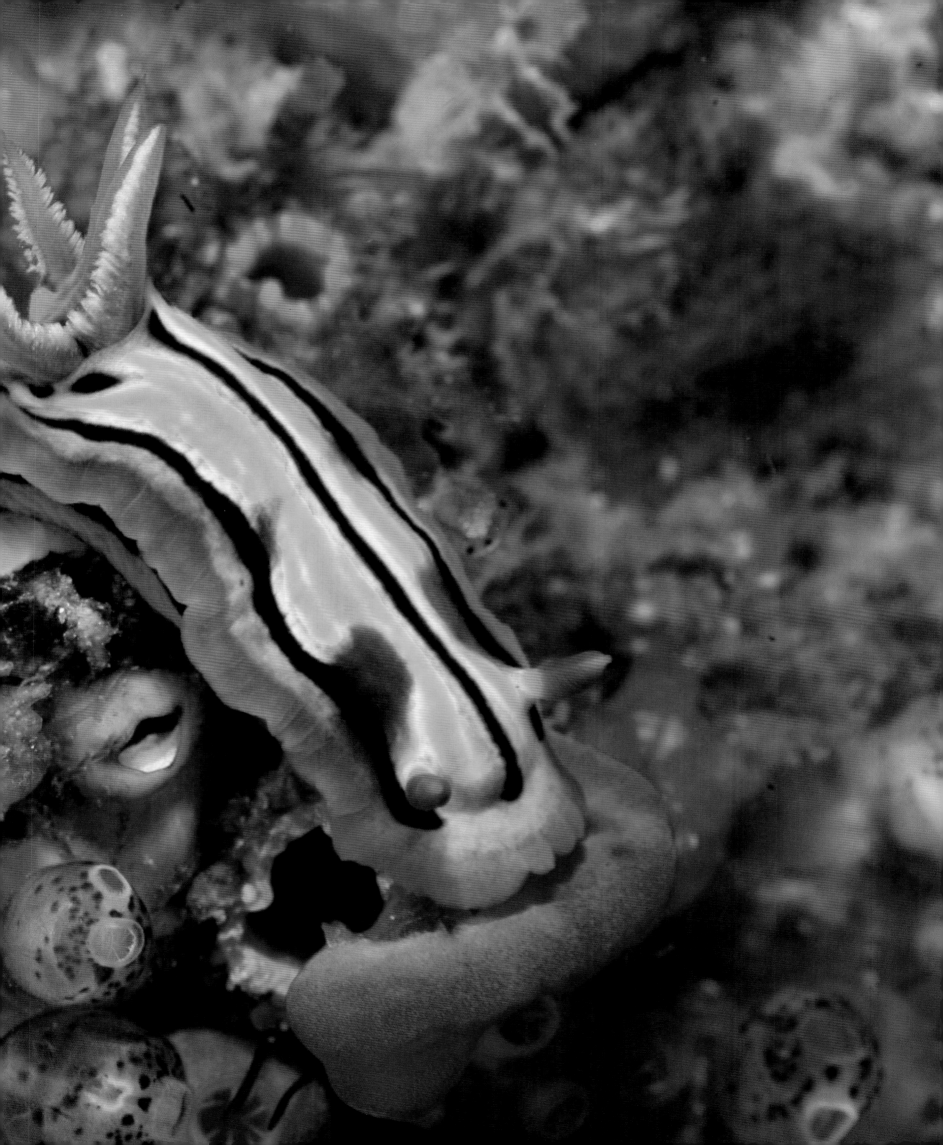

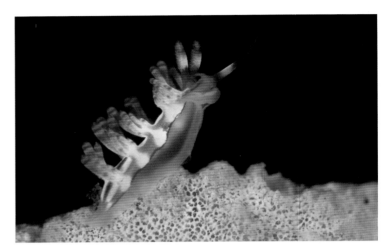
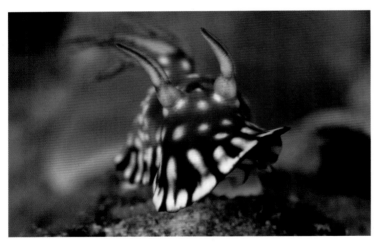

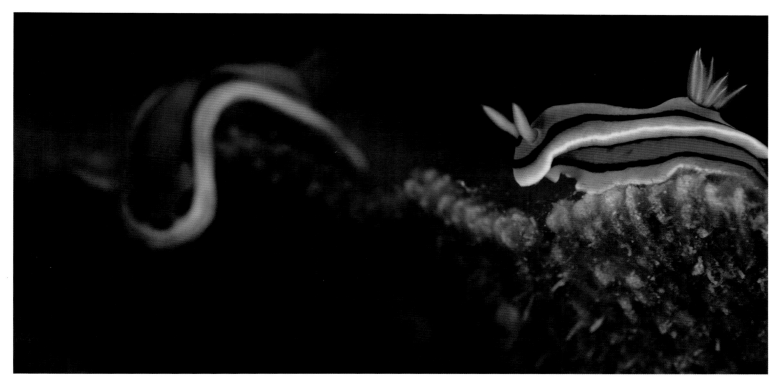

FAR LEFT TOP: A yellow nudibranch.
Chromodoris splendida
(Manado, Indonesia 2005)

FAR LEFT MIDDLE: *Chromodoris splendida*
(Great Barrier Reef, Australia 2002)

FAR LEFT BOTTOM: *Chromodoris magnifica*
(Manado, Indonesia 2003)

LEFT TOP: *Flabellina rubrolineata*
(Manado, Indonesia 2005)

LEFT BOTTOM: *Hypselodoris infucata*
(Manado, Indonesia 2005)

ABOVE: A pair of *chromodoris annae* appear to
be having a conversation, as they look down at
us from above
(El Nido, Philippines 2007)

BOTTOM RIGHT: *Nembrotha purpureolineata*
(Liloan, Philippines 2004)

CREATURES

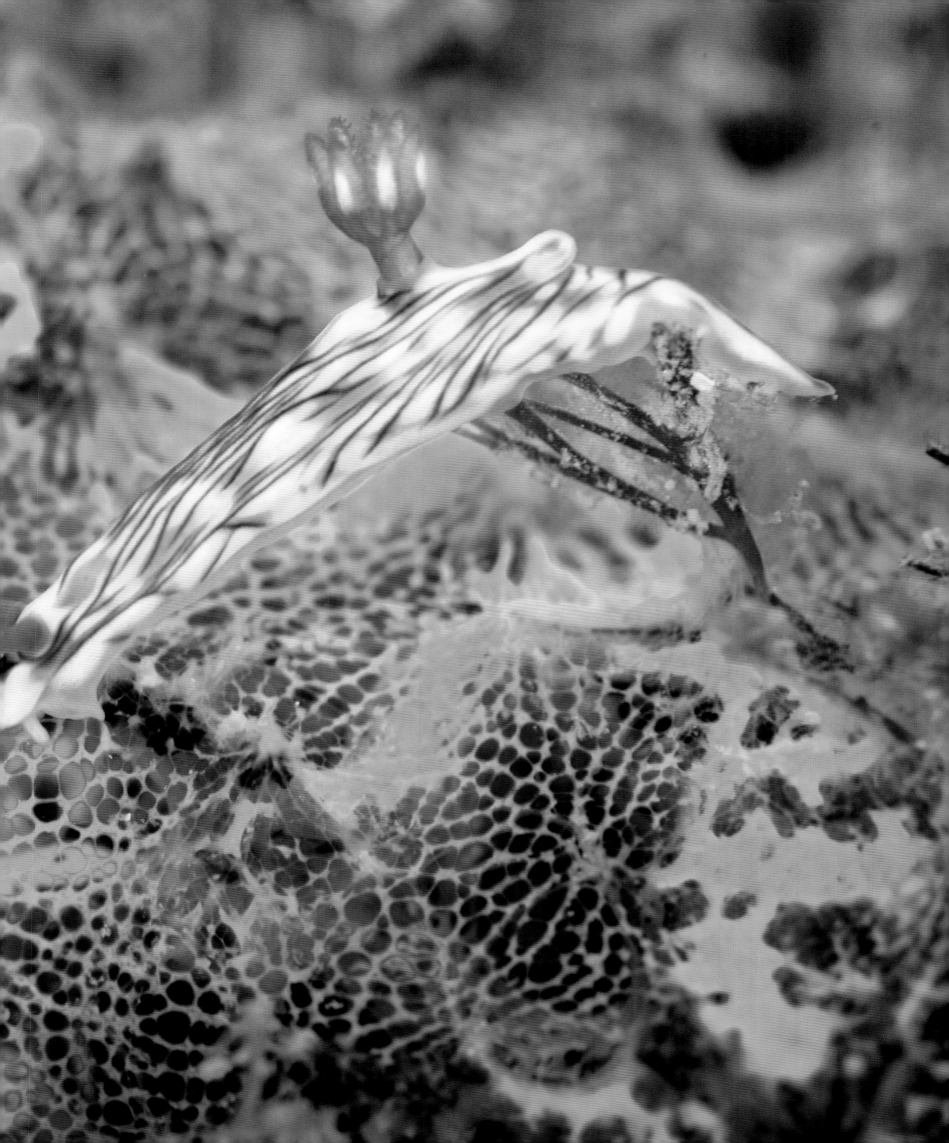

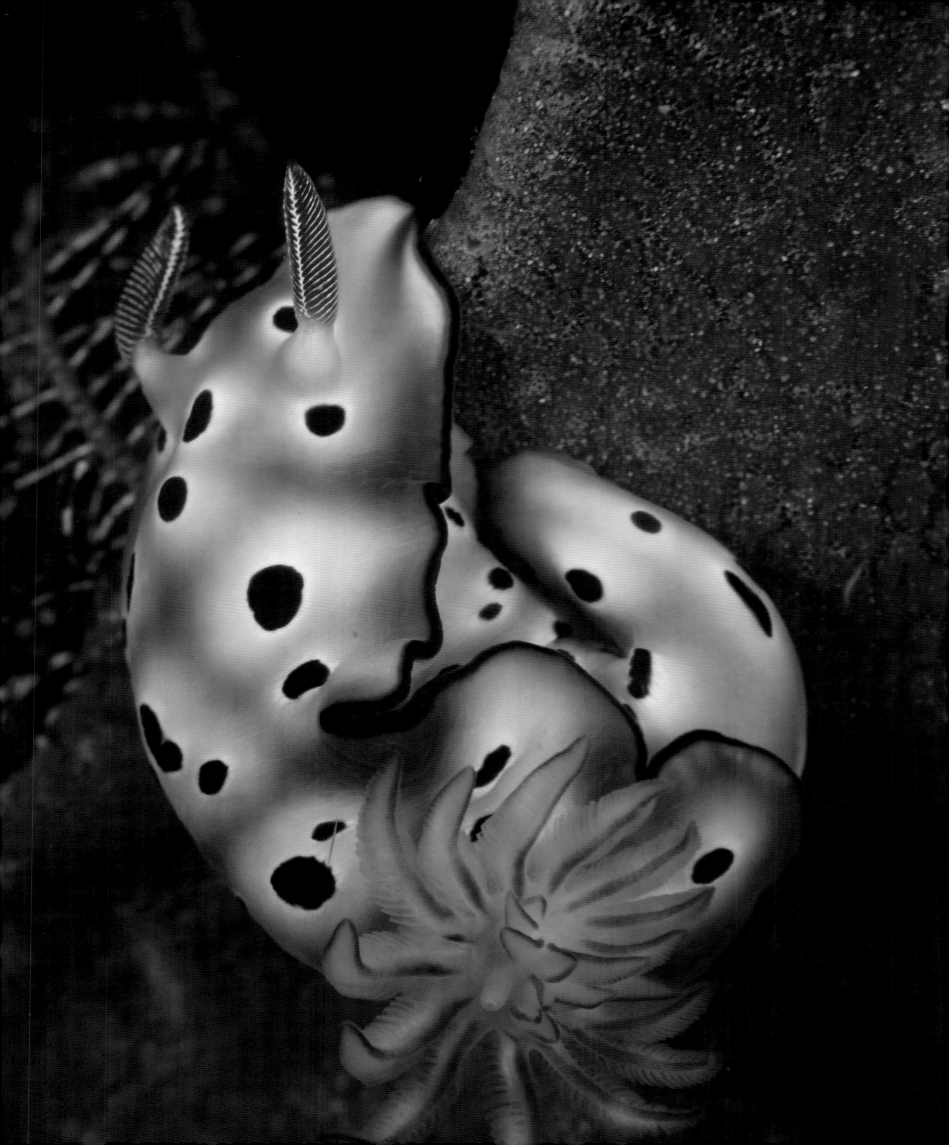

CREATURES

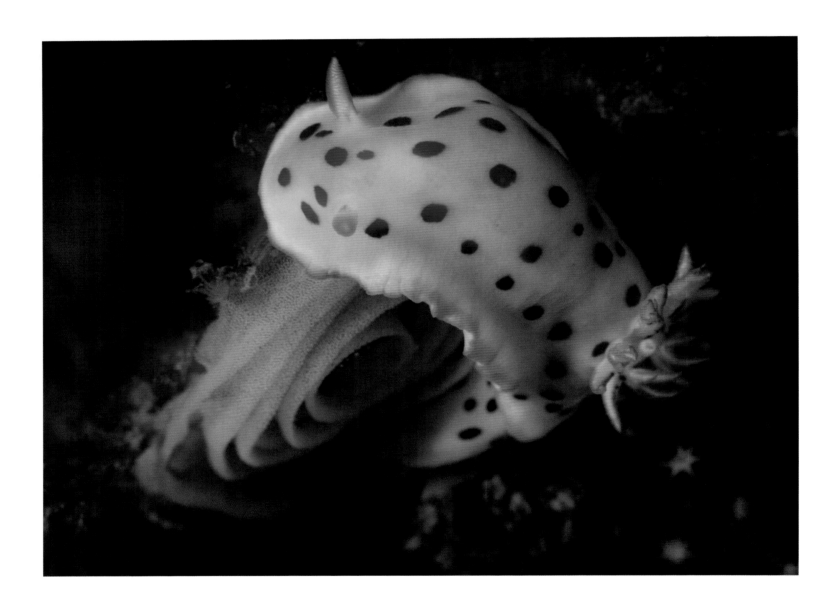

ABOVE: A *chromodoris orientalis* spawns
(Kushimoto, Wakayama, Japan 2007)

ABOVE: A *nembrotha cristata*
appreciates the greenery
(Manado, Indonesia 2006)

PAGES 148-149: A manta
having lunch waves at me
(Palau, Micronesia 2006)

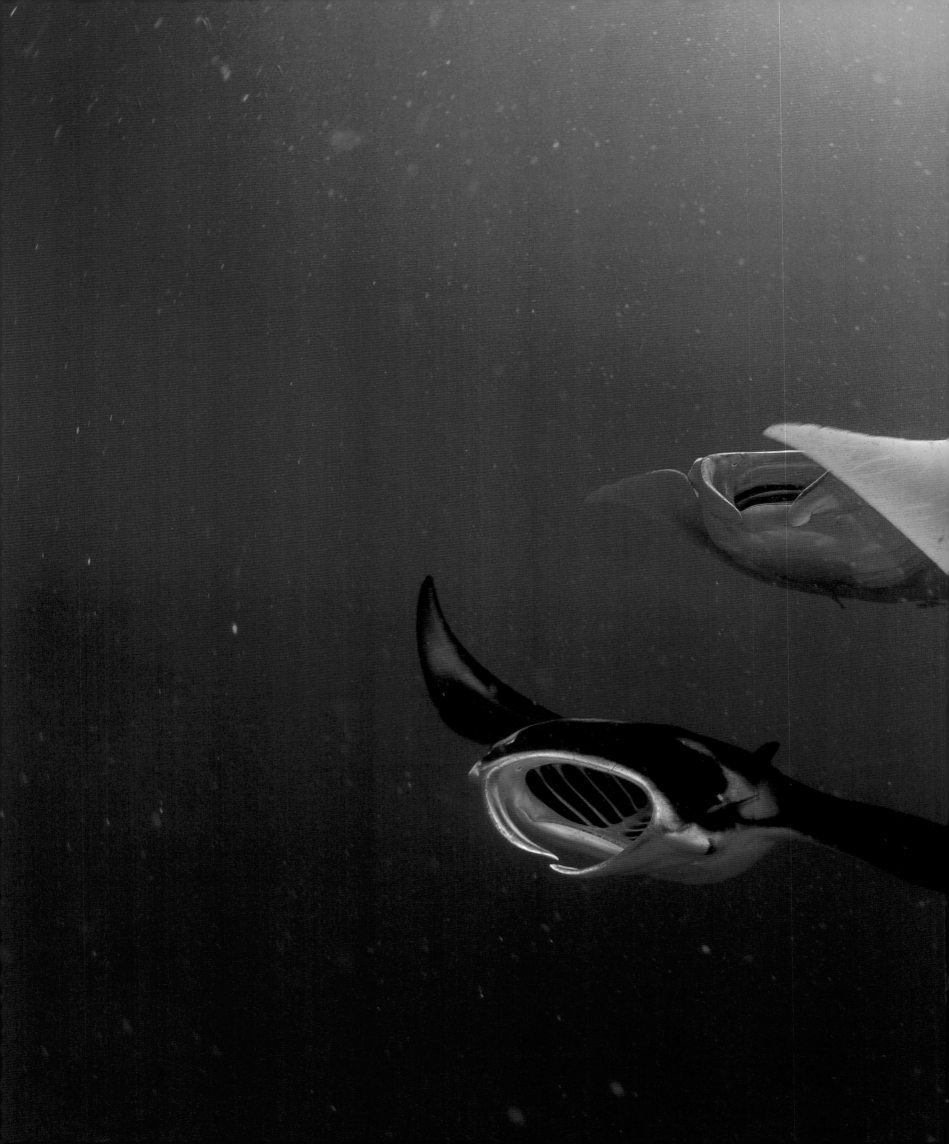

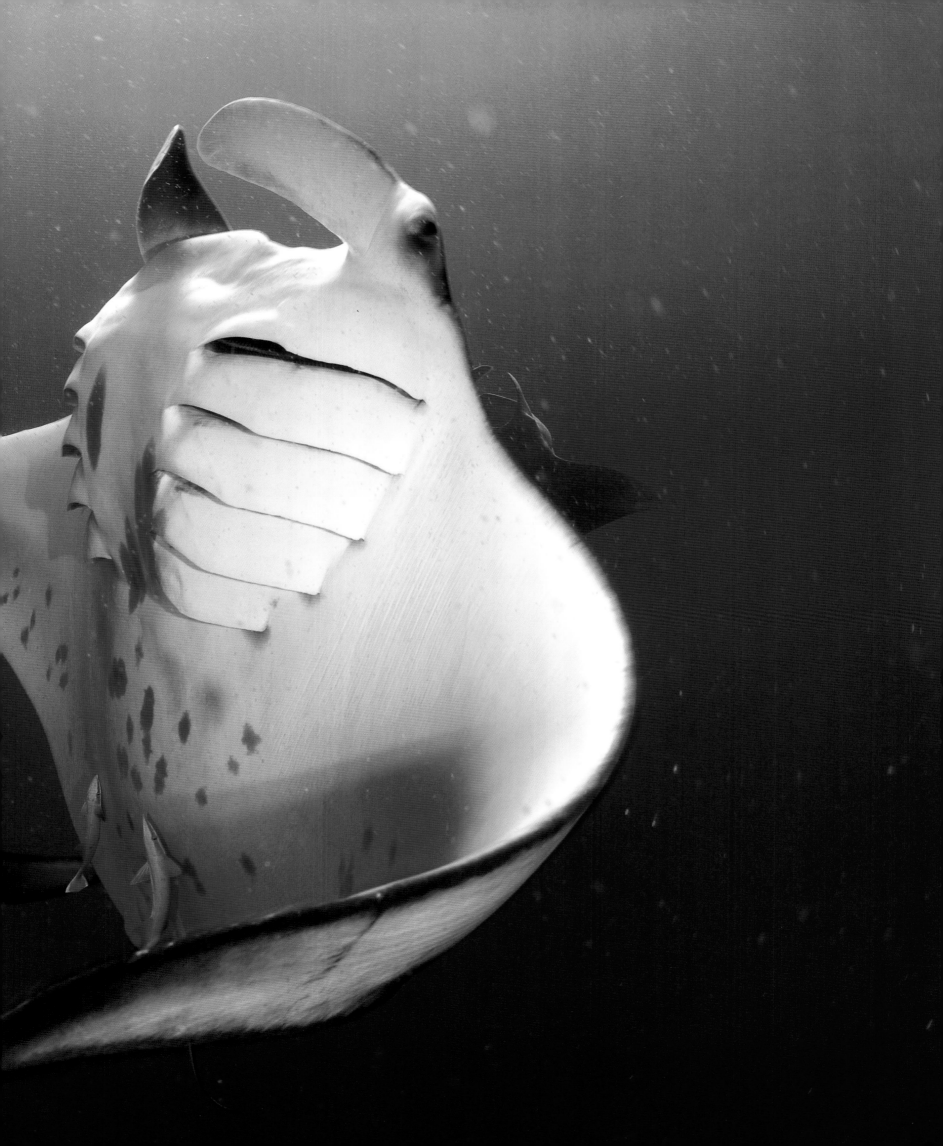

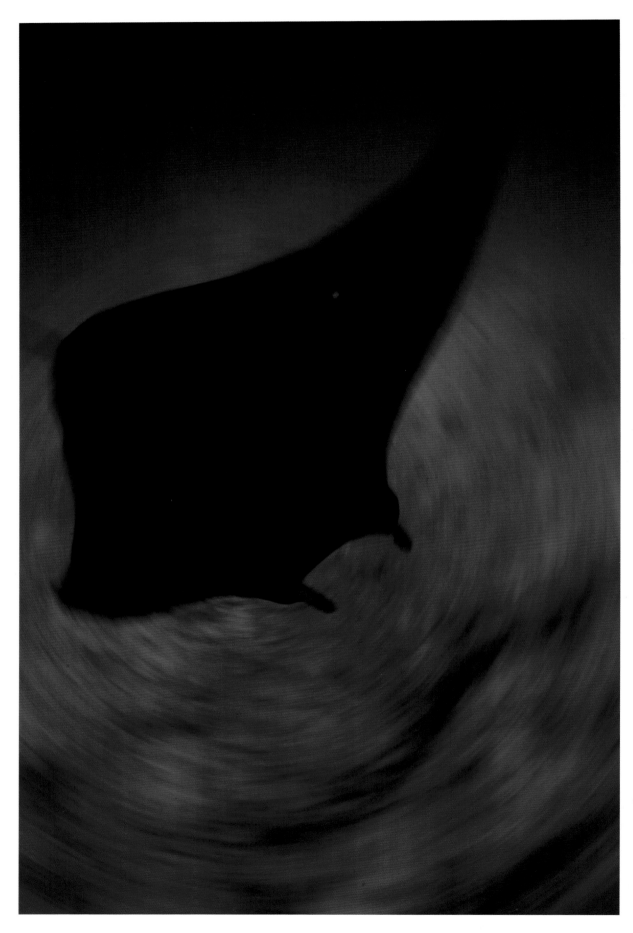

LEFT: A manta waves its
cape as it swims in a whirl
(Noumea, New Caledonia 2005)

RIGHT: It always moves me to encounter
mantas in the endless, open sea
(South Male Atoll, the Maldives 2006)

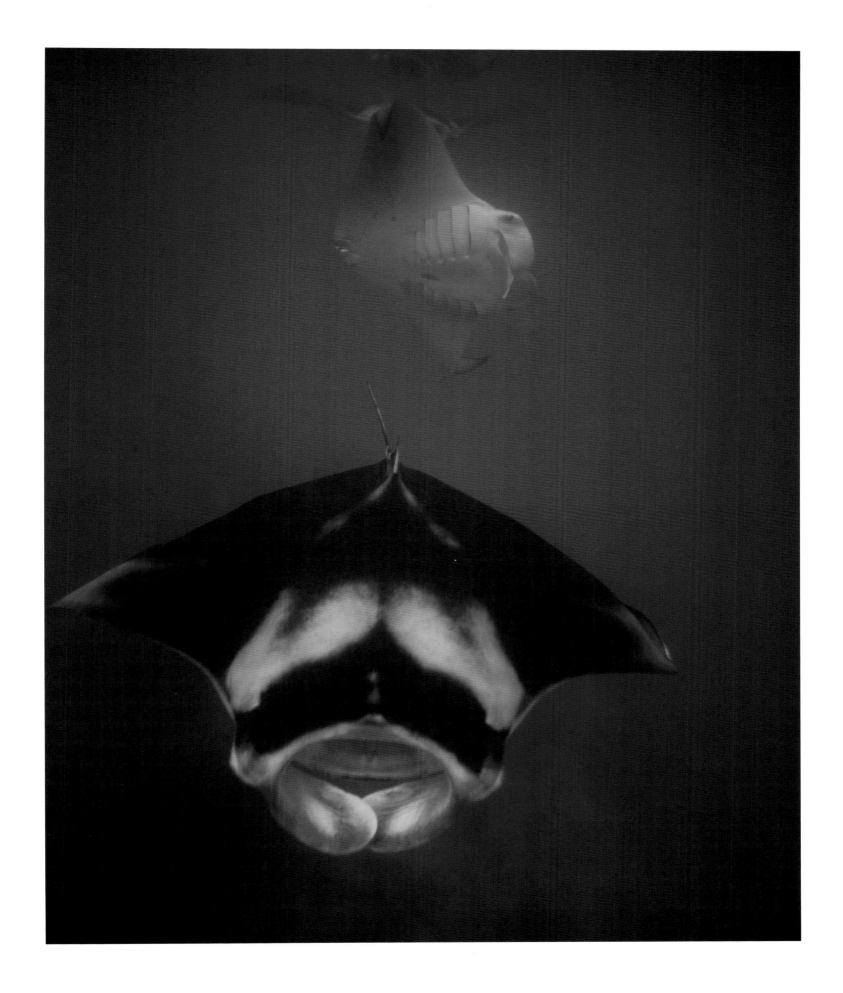

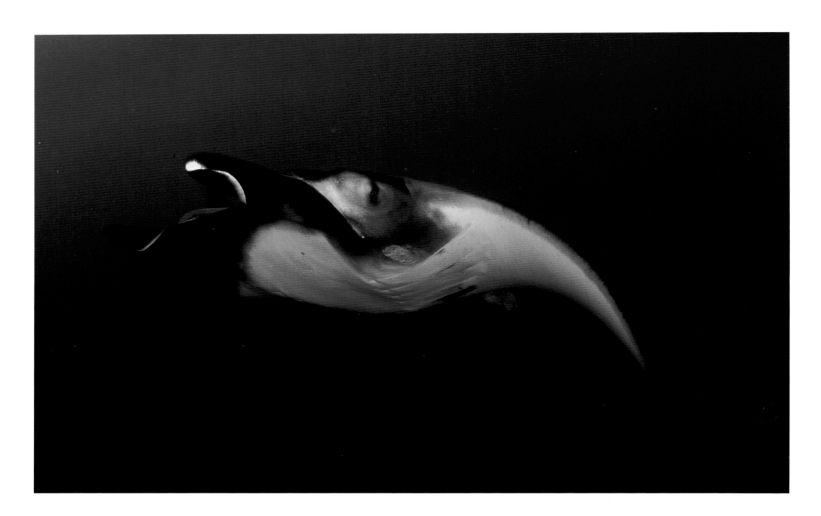

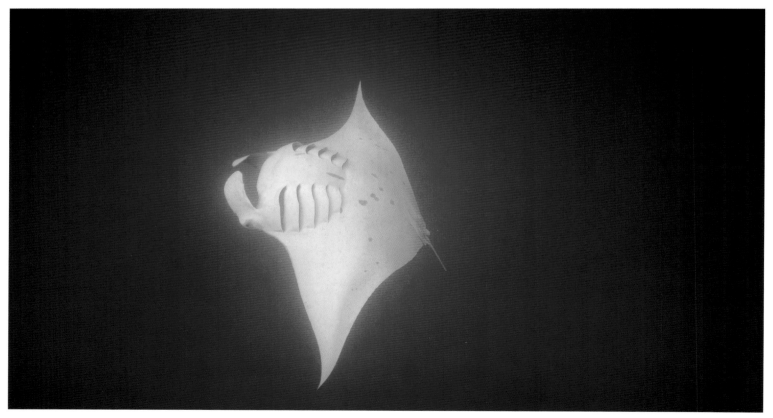

TOP LEFT: A manta flies through the dark blue ocean
(Socorro, Mexico 2001)

BOTTOM LEFT: The divine beauty of a somersaulting manta ray
(South Male Atoll, the Maldives 2006)

TOP RIGHT: The graceful manta ray reflected in the sea's mirrored surface
(Tubbataha, Philippines 2006)

BOTTOM RIGHT: I am engulfed in the shadow of this manta ray's massive wings
(La Paz, Mexico 1998)

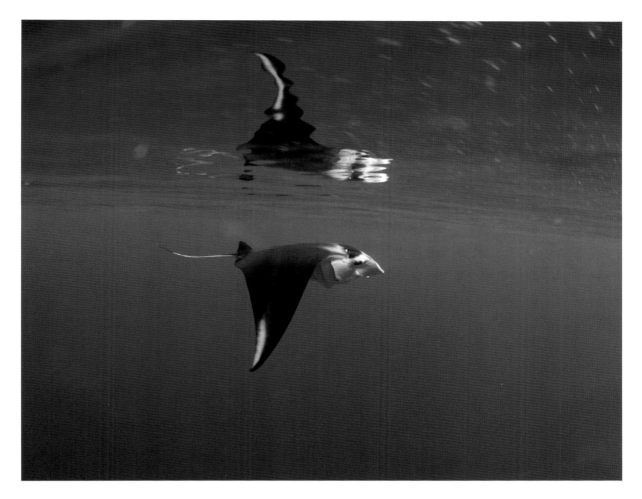

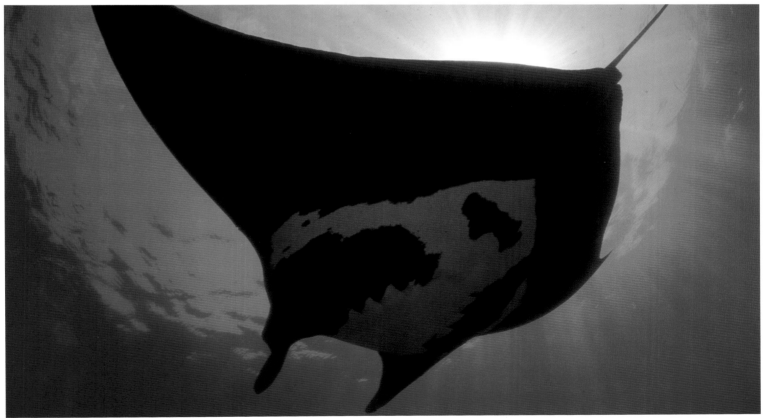

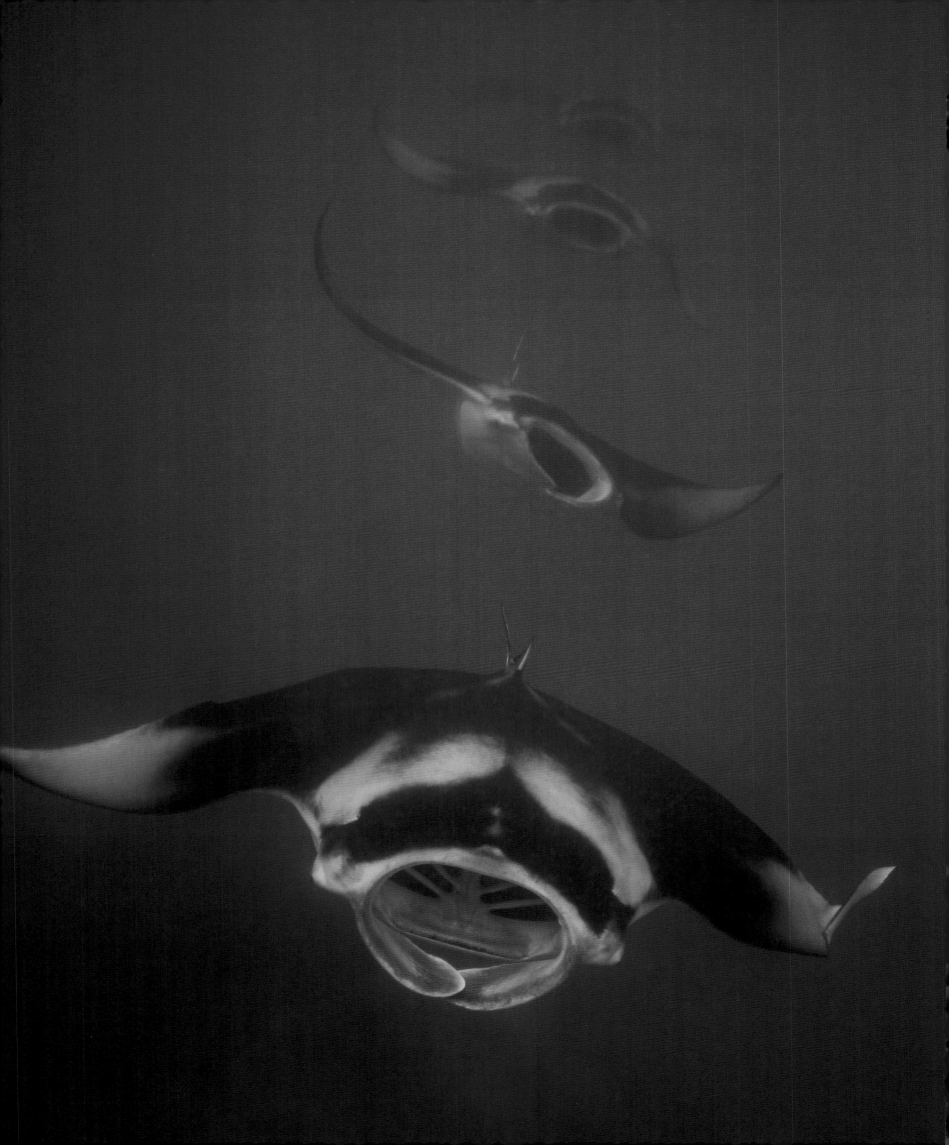

LEFT: Feeding manta rays, flying
in formation, I never tire of this spectacle
(South Male Atoll, the Maldives 2006)

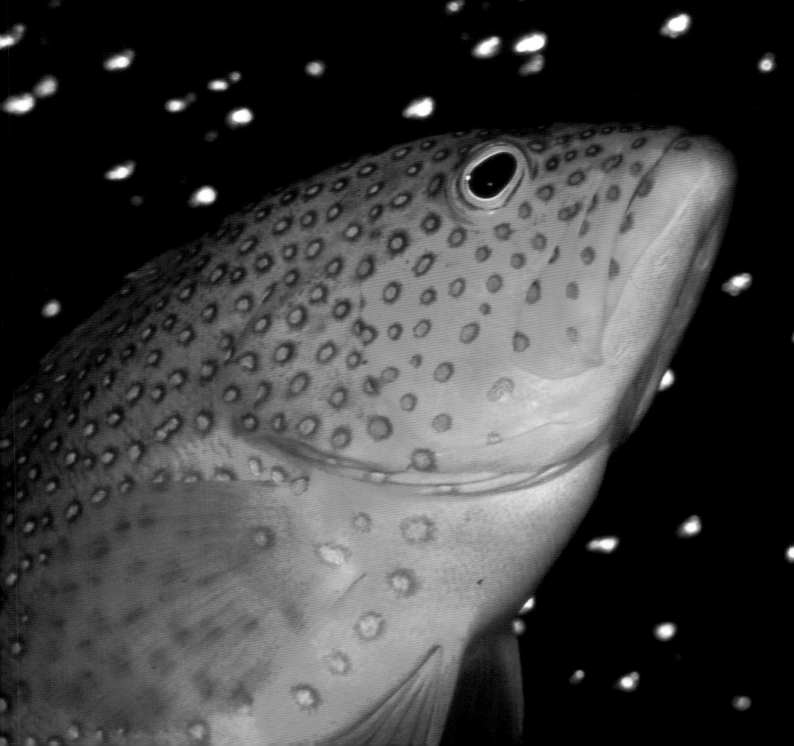

INNER SPACE

The deep blue of the open ocean falls away below me. Hearing only my own slow breathing, I enter a realm of hypnotic tranquillity. Specks of blue plankton the size of rice grains catch the pale light and twinkle like stars in the indigo dark of an early evening sky. In the bottomless blue dusk I feel no pull from gravity; there is no whisper of current and no point of visual reference, nothing that disturbs the illusion to which I now surrender: that I am lost, floating in outer space. I must look skyward to get my bearings but even the sun seems unfamiliar from below the sea: a radially symmetric white circle of light floating on the mirrored surface.

It is said we know more about the surface of the moon than about what lies under the sea. That which is unknown is by definition strange, yet the sheer extent and abundance of difference under the sea may, to an imagination cradled in science fiction, appear more tangibly alien than the cold lifeless expanses that we see through a telescope. It is easy to see compositional similarities that echo throughout nature: the infinitely large is often reflected in the minute, or perhaps it is the other way round. In the eyes of a blotchy swell shark, there is a swirling galaxy that whispers to me of eternity and in it I perceive the enormity of the species' evolution. In the patterns decorating the mantles worn by giant clams, the wise old ones of the reef, I see churning constellations drawn in photosensitive spots. I see alien landscapes in eyes and scales and fins, and in the bodies of the smallest and most insignificant creatures rare and delicate designs that outshine the finest kimono fabric.

It may seem an obvious comparison, but one creature that always reminds me of space is the starfish. Whenever I see the many varieties of starfish scattered on the sea floor and the markings radiating outwards from the centre of their bodies, they really do look to me as if they have just fallen from the sky. In my mind they are transformed into spaceships or aliens as thousands of tiny legs protrude from under their arms, carrying them forward while they suck up the tiny organisms that form a thin membrane on top of the sand.

It was while I worked as a florist that I was awakened to the joy of composition. With each passing day and the changing of the seasons, the blossoms gradually taught me the tangible physical pleasure radiating from deliberate arrangements of colours, shapes and textures. I often think that if I had not discovered marine photography I would have become a florist; I certainly spent more time with the flowers than I did at university. The sensibility that was nurtured among terrestrial blooms makes me seek to capture the breathtaking beauty of inner space.

The vast rocky reefs surrounding Bangka Island in northern Sulawesi, Indonesia, are covered with rare and unique varieties of soft coral creating a beautiful orange, green and yellow carpet of underwater flowers. I can spend hours photographing this reef. It is as magnificent to me as any paintings or sculptures one might see in a gallery or museum. It is one of my favourite places on the planet and I believe deserves World Heritage listing.

Once a year between March and May in the Andaman Sea off Thailand, the water swarms with massive schools of tiny, silvery cardinalfish, all but obscuring the coral reefs. It is breathtaking to plunge into the middle of this swirling multitude, like tiny stars spinning forth from the centre of the Milky Way. When the swarm senses the approach of predatory horse mackerel or sweetlips, it twists and turns as a single entity, suddenly and violently changing direction to avoid attack. They glitter and fade as their bodies catch and lose the sunlight, creating a beautiful yet disorienting strobe effect. It is like being surrounded by thousands of shooting stars. If I look closely at each tiny transparent body, I see in its insignificant viscera the beating heart of life and through it I feel I know the true nature of the universe. I have seen and photographed torrents of fish in many locations throughout the world. How lucky am I, to be able to wish upon so many shooting stars.

LEFT: A blue-spotted rockcod looks up at the stars (South Male Atoll, the Maldives 2007)

PAGES 158-159: A hawksbill turtle swims through the dark sea (South Male Atoll, the Maldives 2006)

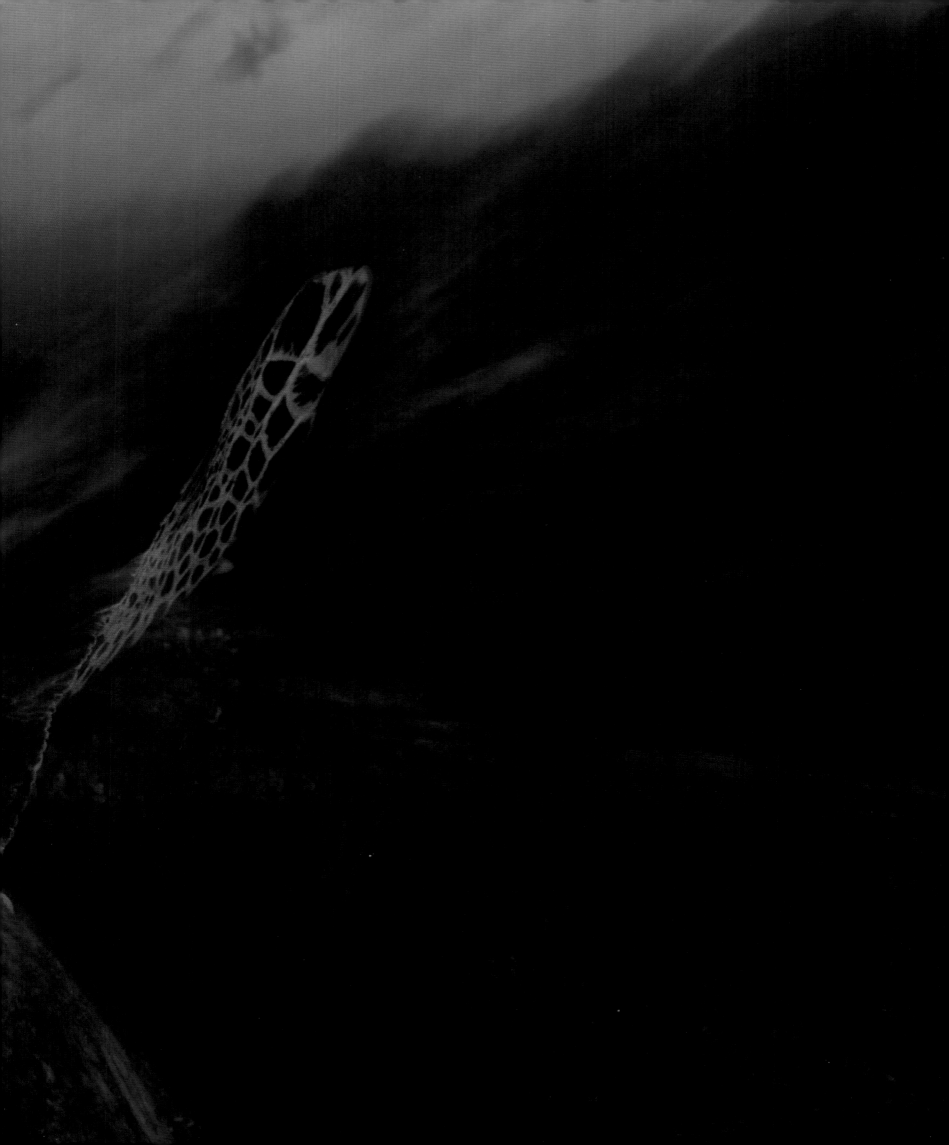

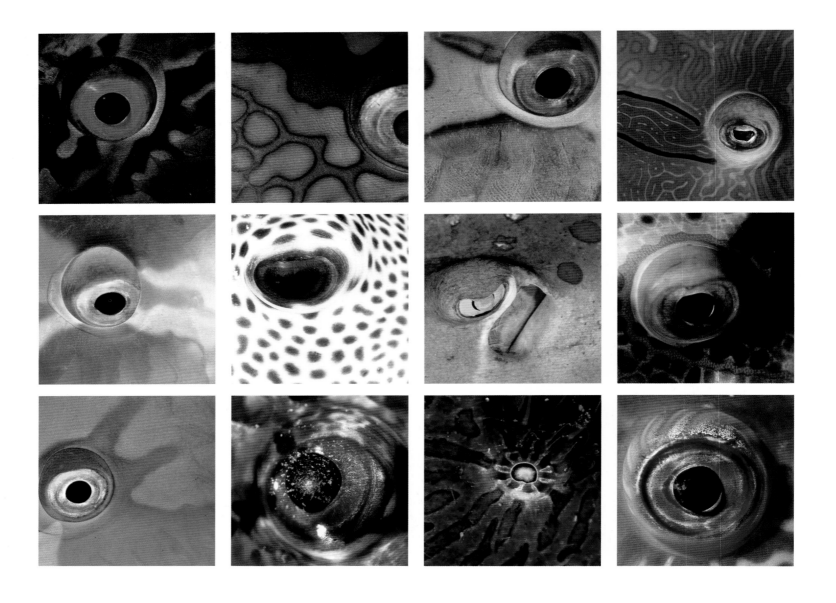

ABOVE: Fish eyes: beautiful and bewildering

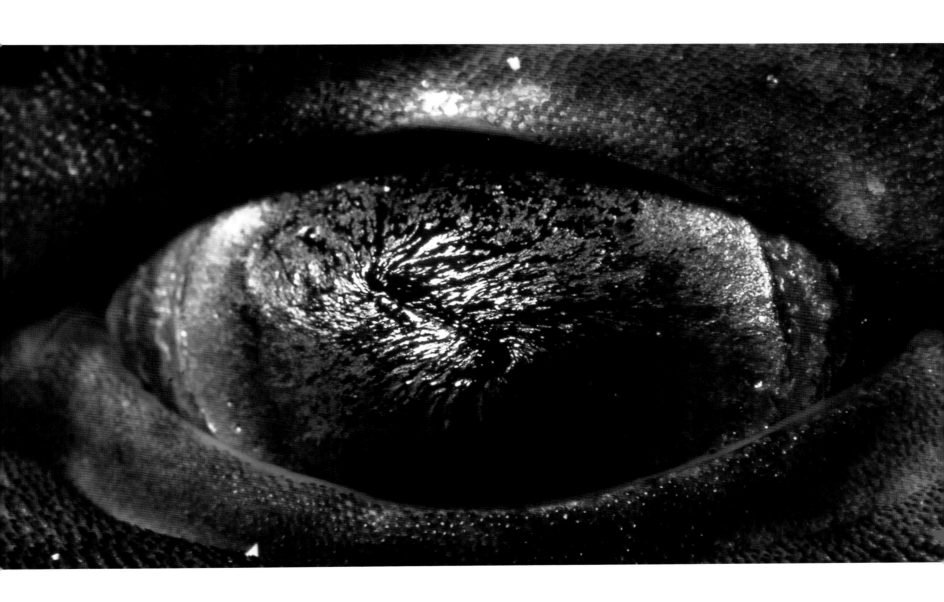

ABOVE: The eye of a blotchy
swell shark; in it I see eternity in the
form of a swirling galaxy
(Izu, Shizuoka 1996)

PAGES 162-163: The strange-looking
barbels of a tasselled wobbegong
(Raja Ampat, Indonesia 2007)

PAGES 164-165: Coral looks
and blooms like flowers
(Manado, Indonesia 2006)

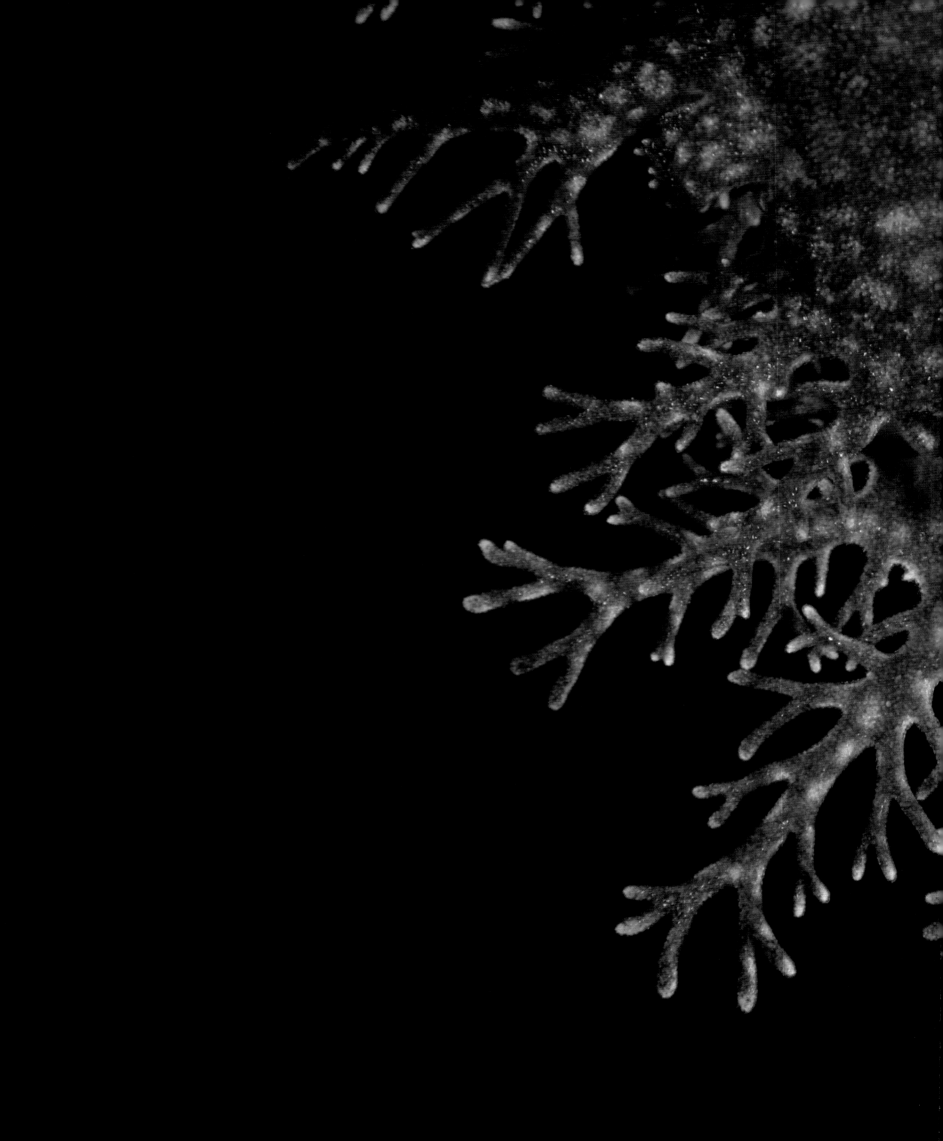

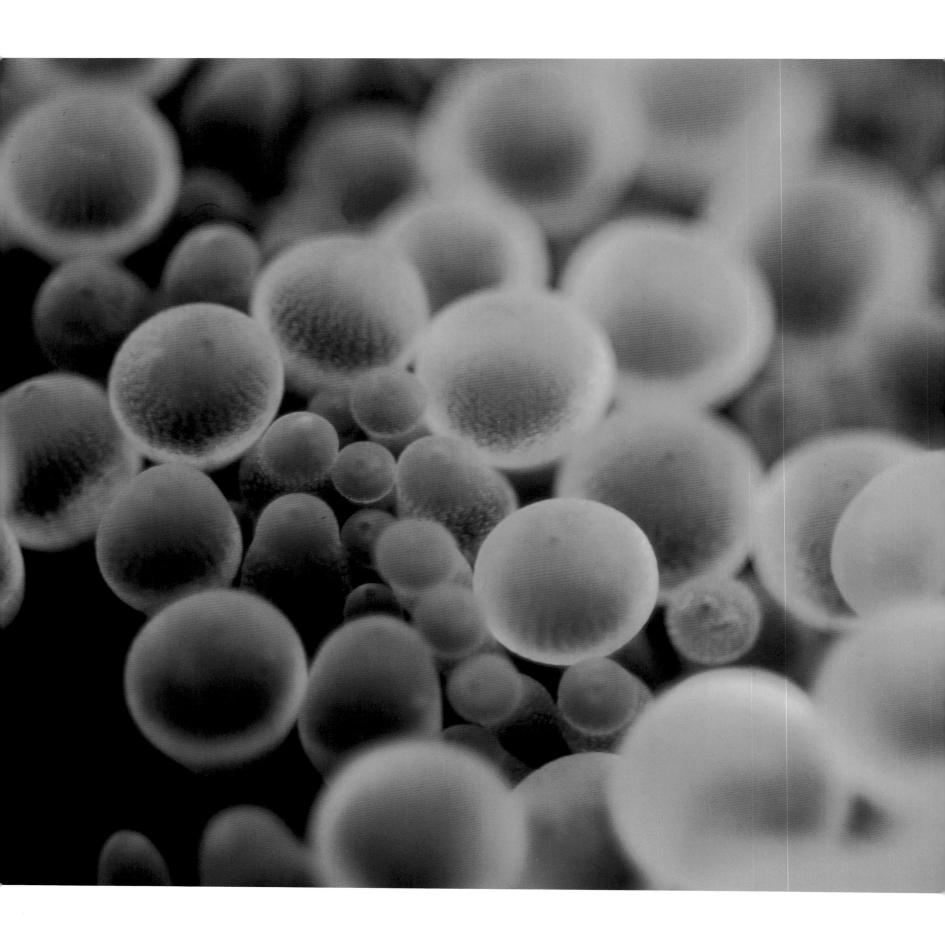

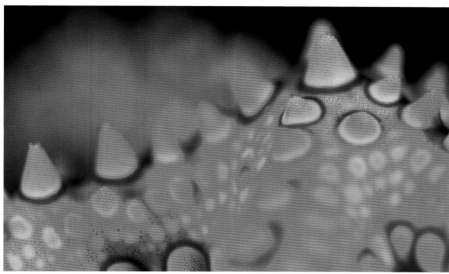

FAR LEFT: The tentacles of the sea anemone are as beautiful as dewdrops (Yonaguni, Okinawa, Japan 2003)

TOP LEFT: This starfish looks like a volcano (Manado, Indonesia 2004)

MIDDLE LEFT: Mushroom coral have beautiful colours and body patterns (South Male Atoll, the Maldives 1997)

BOTTOM LEFT: The surface of a threespot angelfish (South Male Atoll, the Maldives 1997)

PAGES 168-169: The velvety oral disc of a sea anemone (Manado, Indonesia 2004)

PAGES 170-171: The mantle of a giant clam; just like beautifully lit stained glass (Manado, Indonesia 2006)

TOP RIGHT: The body pattern of
the map puffer is just like a maze
(South Male Atoll, the Maldives 1997)

MIDDLE RIGHT: The surface of the emperor
angelfish reminds me of kimono fabric
(South Male Atoll, the Maldives 1997)

BOTTOM RIGHT: Indigenous to the Indian
Ocean, collared butterflyfish have a somewhat
Japanese surface pattern
(South Male Atoll, the Maldives 1997)

FAR RIGHT: The intricate pattern
of a redbreast wrasse's surface
(Manado, Indonesia 2006)

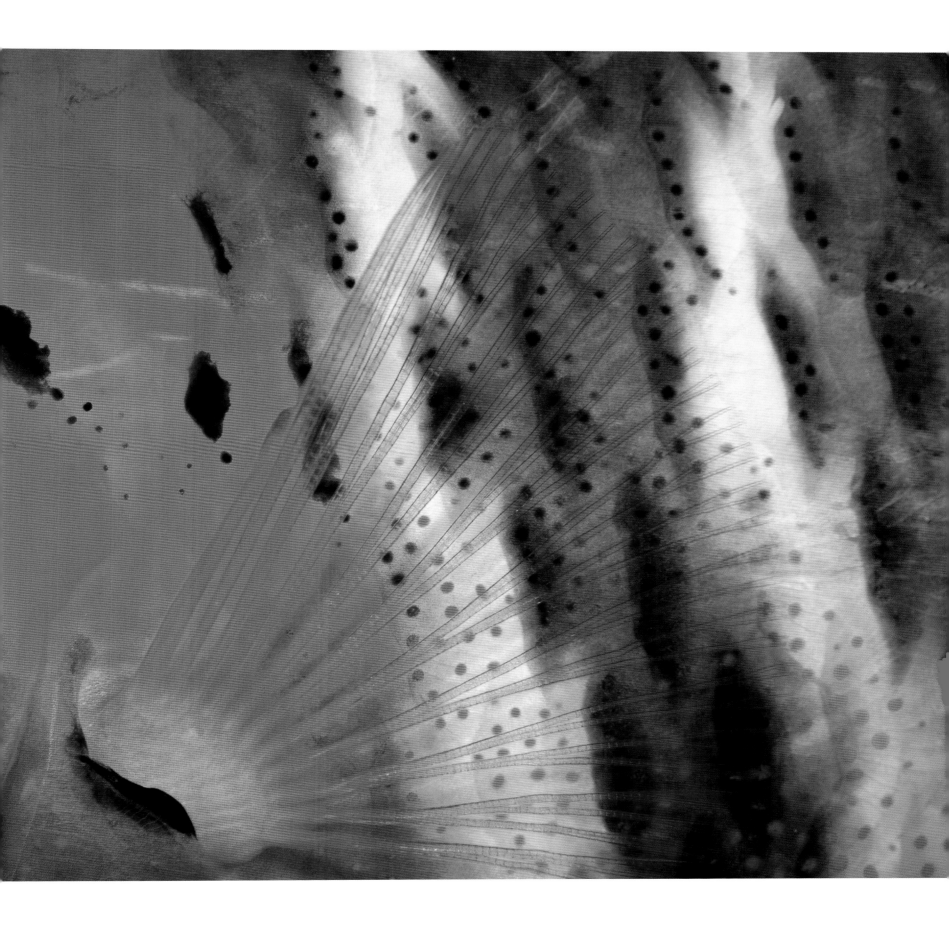

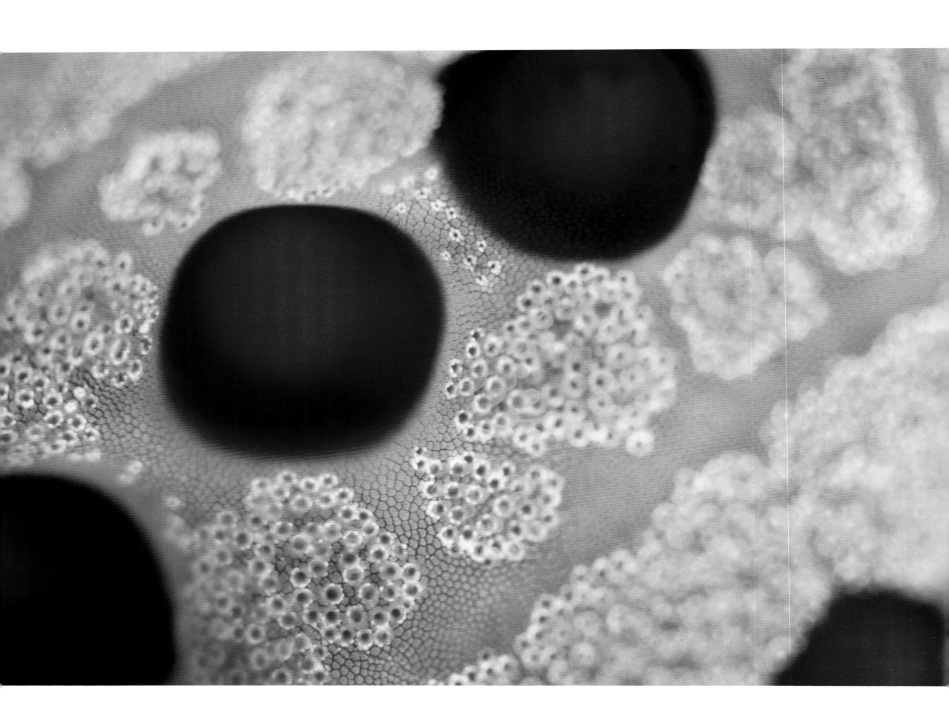

ABOVE: The surface of this starfish
reminds me of an elaborate cake
(Manado, Indonesia 2004)

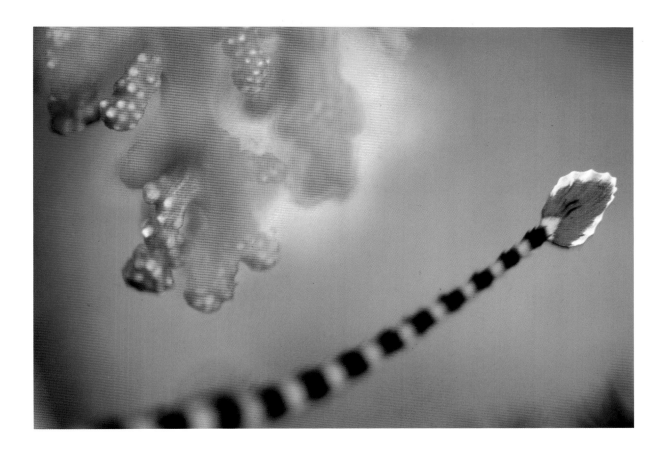

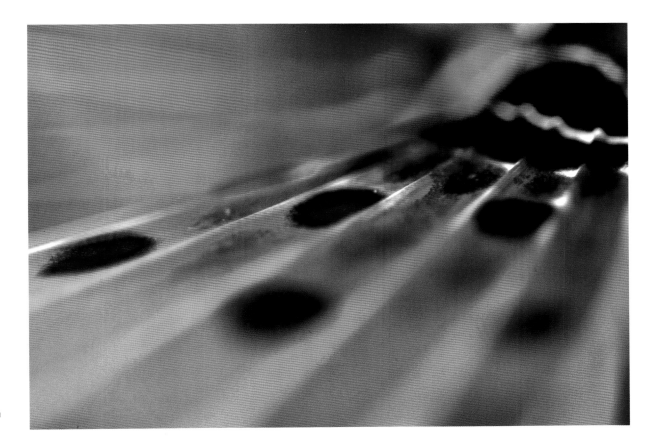

TOP RIGHT: The tail of a banded pipefish (Manado, Indonesia 2005)

BOTTOM RIGHT: The attractive colour and design of the fin of a ragged-finned lionfish (Manado, Indonesia 2005)

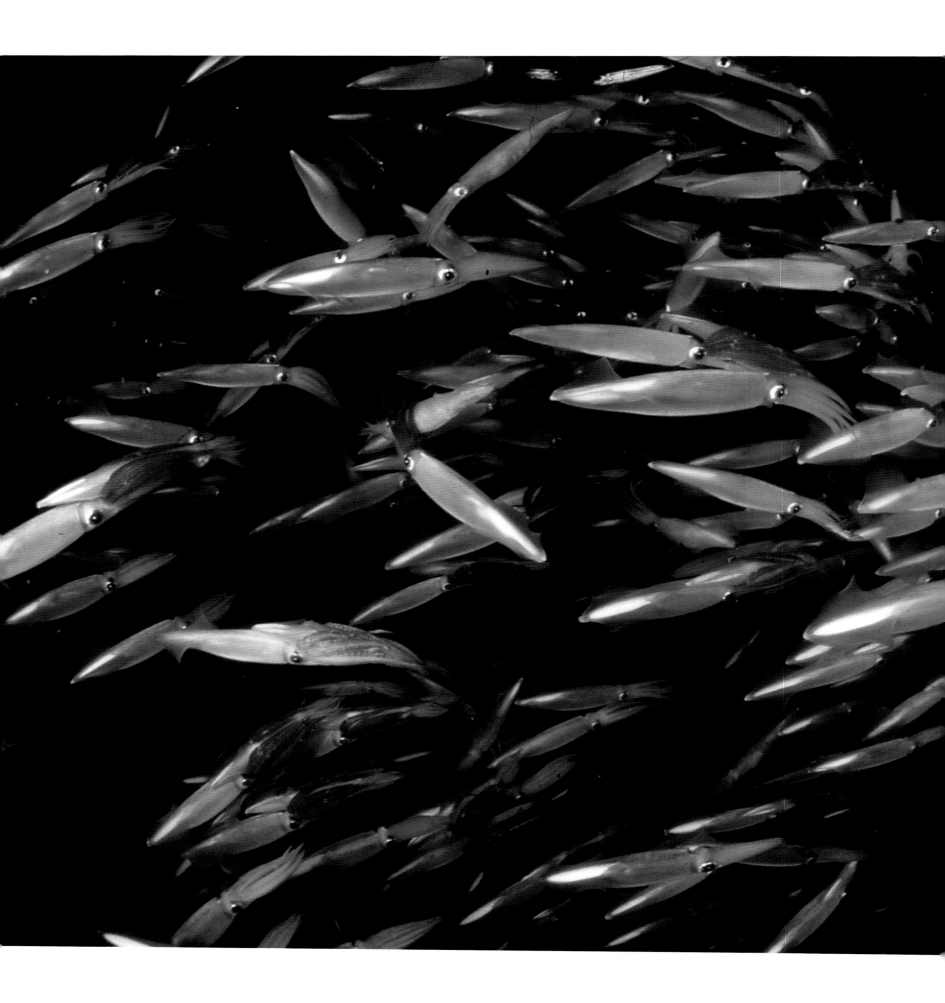

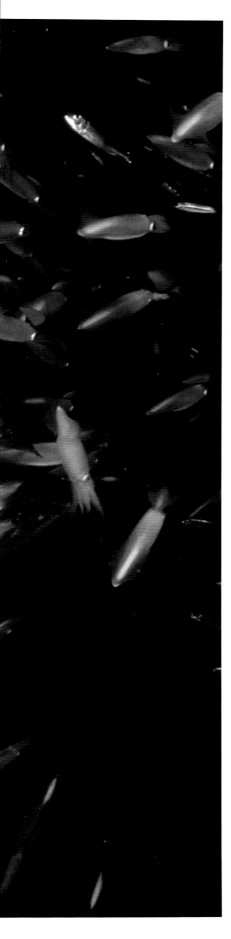

LEFT: The tentacles of the opal squid turn red when schooling in mating season, so that they look like thousands of candles slipping through the sea
(California, USA 2000)

TOP RIGHT: This sea squirt looks like an open-mouthed one-eyed Mickey Mouse
(Manado, Indonesia 2005)

MIDDLE RIGHT: Like the branches of a weeping cherry blossom tree: this is soft coral
(Kavieng, Papua New Guinea 2003)

BOTTOM RIGHT: Purple feather worms blossoming in the sand like windmills catching the tide
(Izu, Shizuoka, Japan 1995)

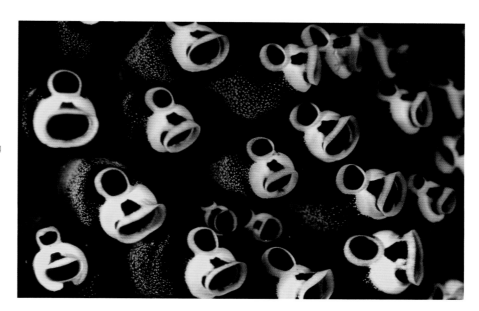

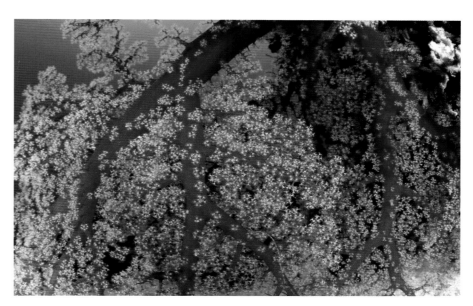

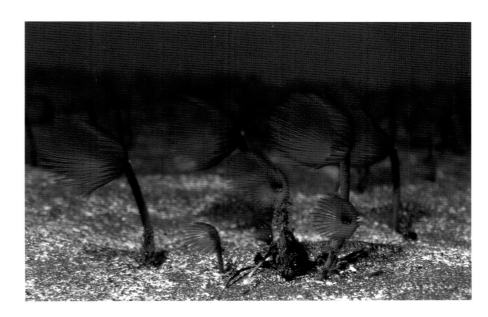

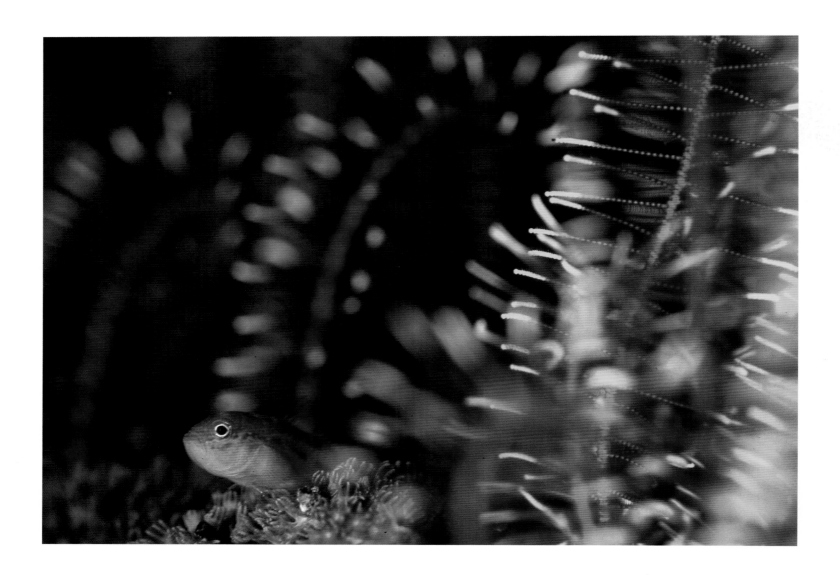

ABOVE: A goby nestles under
a flood of light (a feather star)
(Bohol, Philippines 2005)

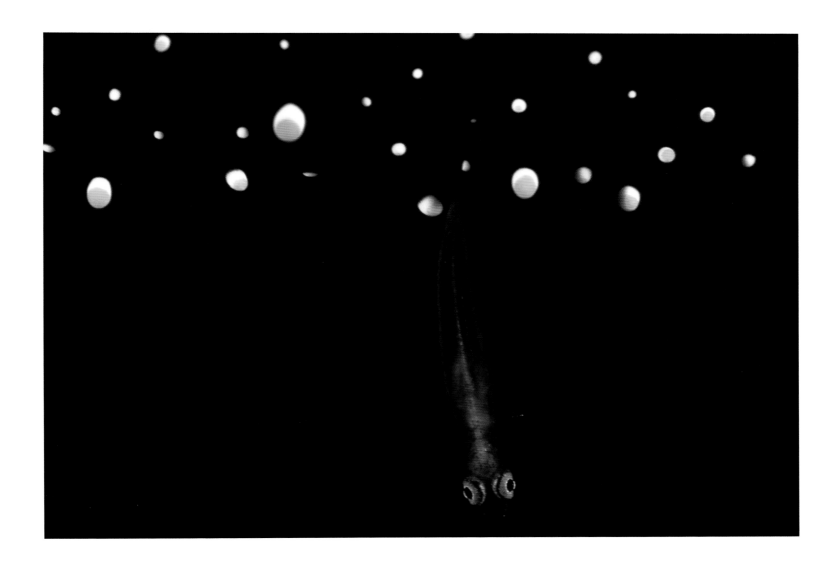

ABOVE: Under a starry sky (the mantles
of cowries), a translucent coral goby
(Andaman Sea. Thailand 2003)

LEFT: The geometric pattern
of the napoleonfish
(South Male Atoll, the Maldives 2007)

TOP RIGHT: The tentacles of the
bleached sea anemone glow bewitchingly
(Yonaguni, Okinawa, Japan 2003)

MIDDLE RIGHT: Soft coral have
a soft and charming style
(Manado, Indonesia 2004)

BOTTOM RIGHT: Christmas tree hydroids are
like dewdrops welling up from the earth
(Manado, Indonesia 2004)

FAR RIGHT: Black coral shrimp
cohabit with bright red soft coral
(Motobu, Okinawa, Japan 2003)

PAGES 182-183: A large wheel of sea
anemone glowing under the moonlight
(El Nido, Philippines 2007)

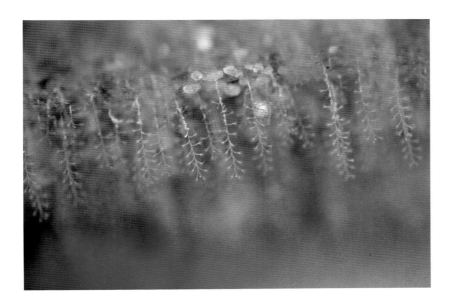

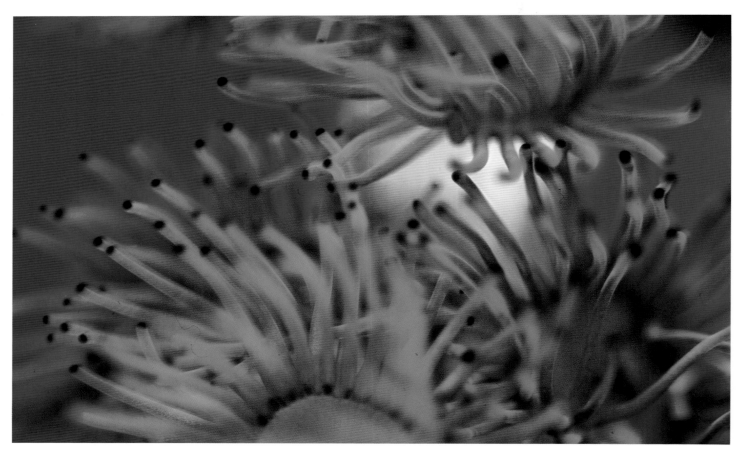

TOP LEFT: The poisonous fire urchin
(*asthenosoma ijimai*), extreme close-up
(Izu, Shizuoka, Japan 1995)

BOTTOM LEFT: Soft coral in fascinating detail
(Manado, Indonesia 2004)

ABOVE: The breast fin of a shortfin turkeyfish
(Manado, Indonesia 2006)

PAGES 186-187: This stalked sea squirt
has a uniquely painted face
(Raja Ampat, Indonesia 2007)

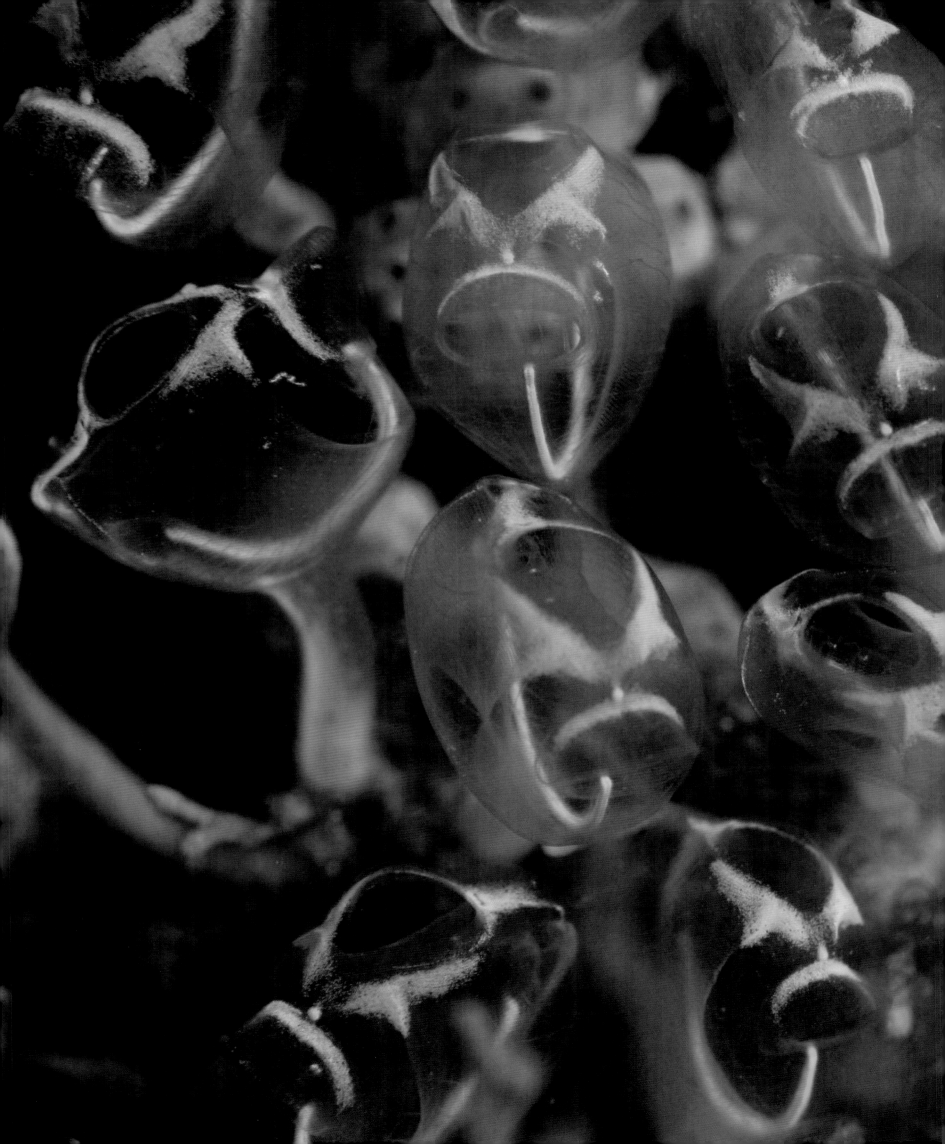

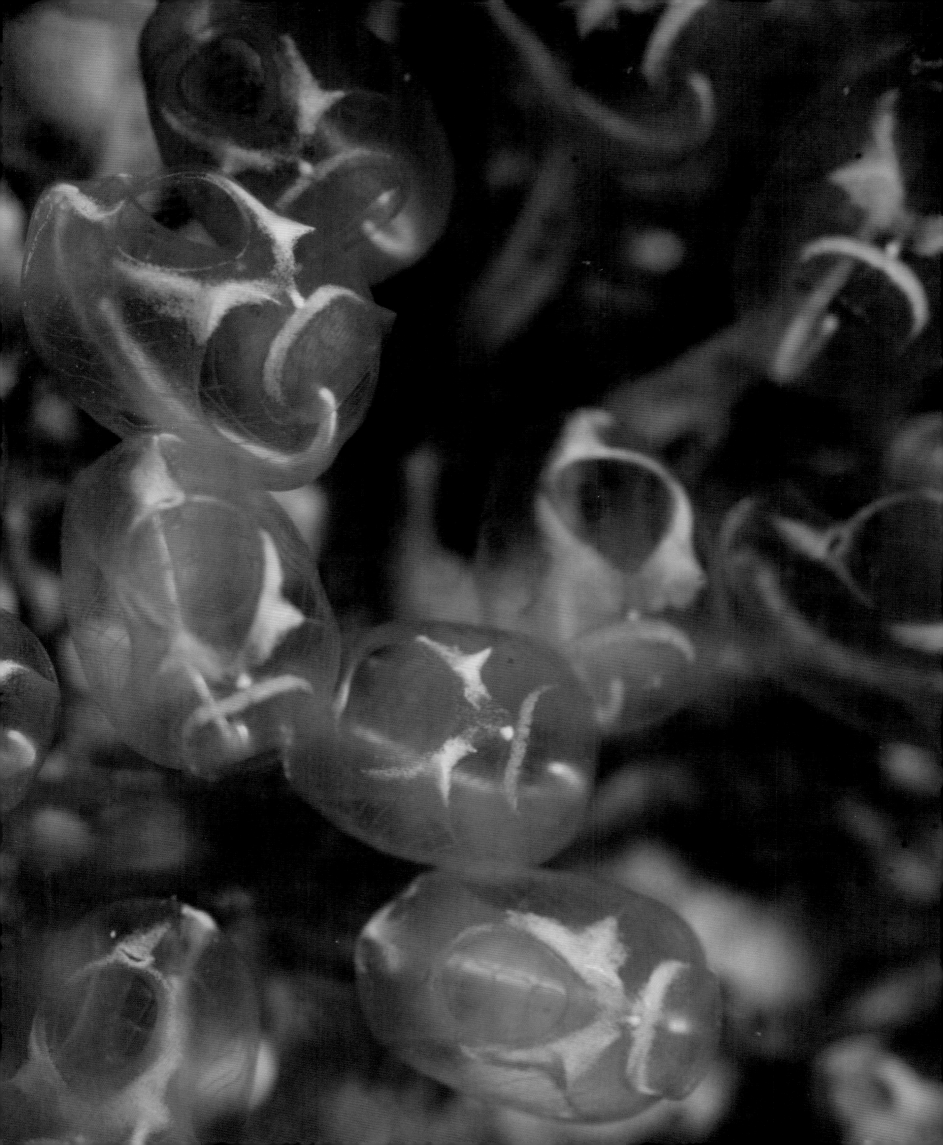

TOP LEFT: The markings of this giant clam look like the paths of celestial bodies (Ile des Pins, New Caledonia 2006)

MIDDLE LEFT: A young damselfish was hiding in the feather stars (Liloan, Philippines 2004)

BOTTOM LEFT: The stalked sea squirt looks like an alien from outer space (Tubbataha, Philippines 2005)

RIGHT: A young map puffer and its uniquely designed body (Manado, Indonesia 2006)

PAGES 190-191: The surface of mushroom coral; it resembles flowing lava or a planetary surface (Manado, Indonesia 2006)

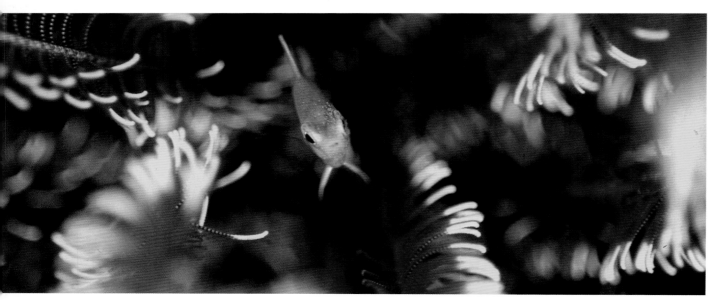

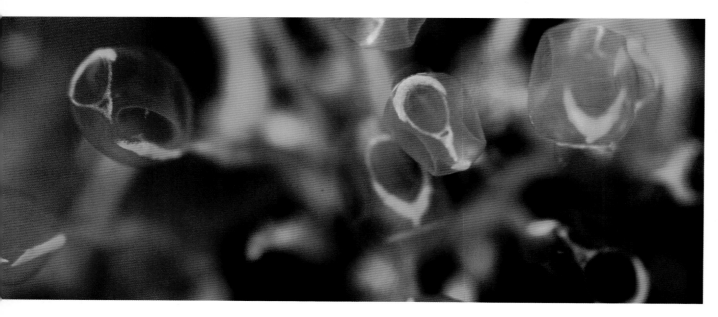

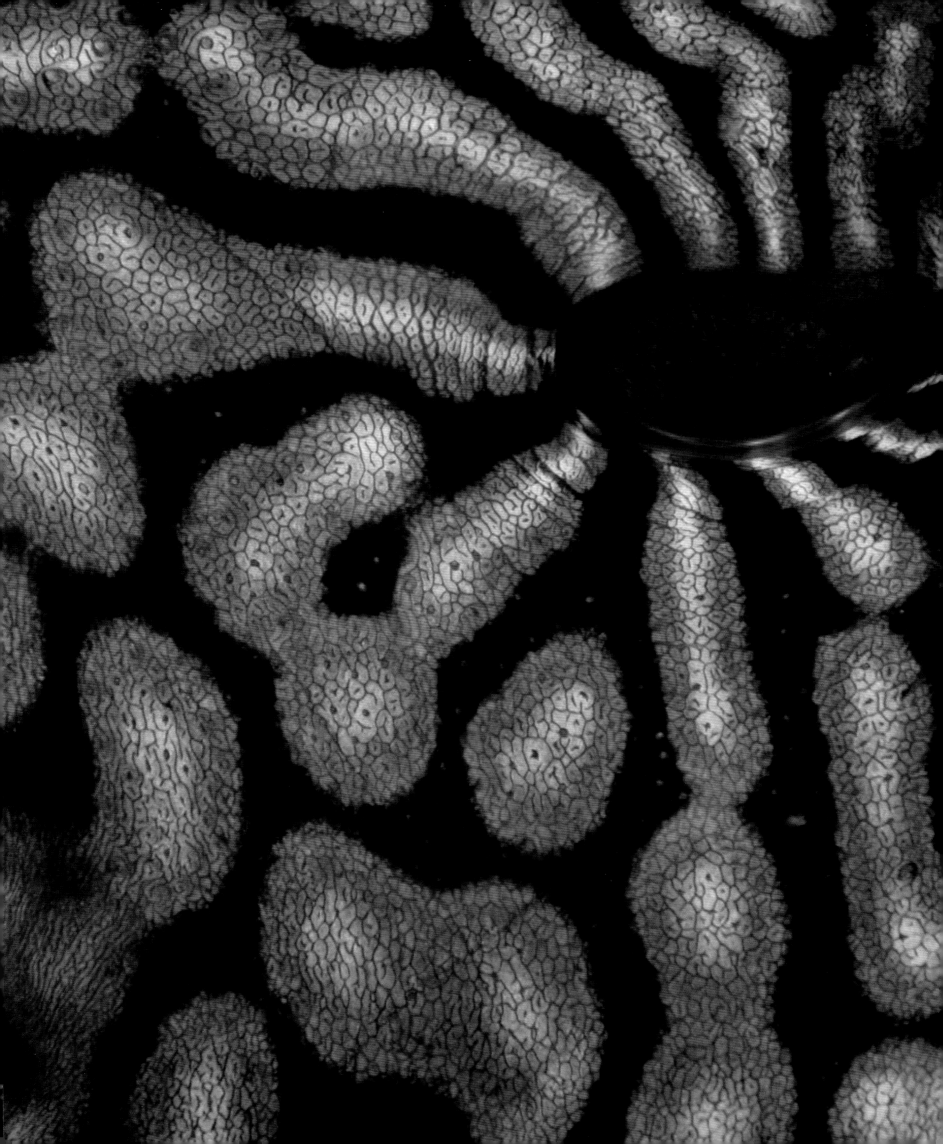

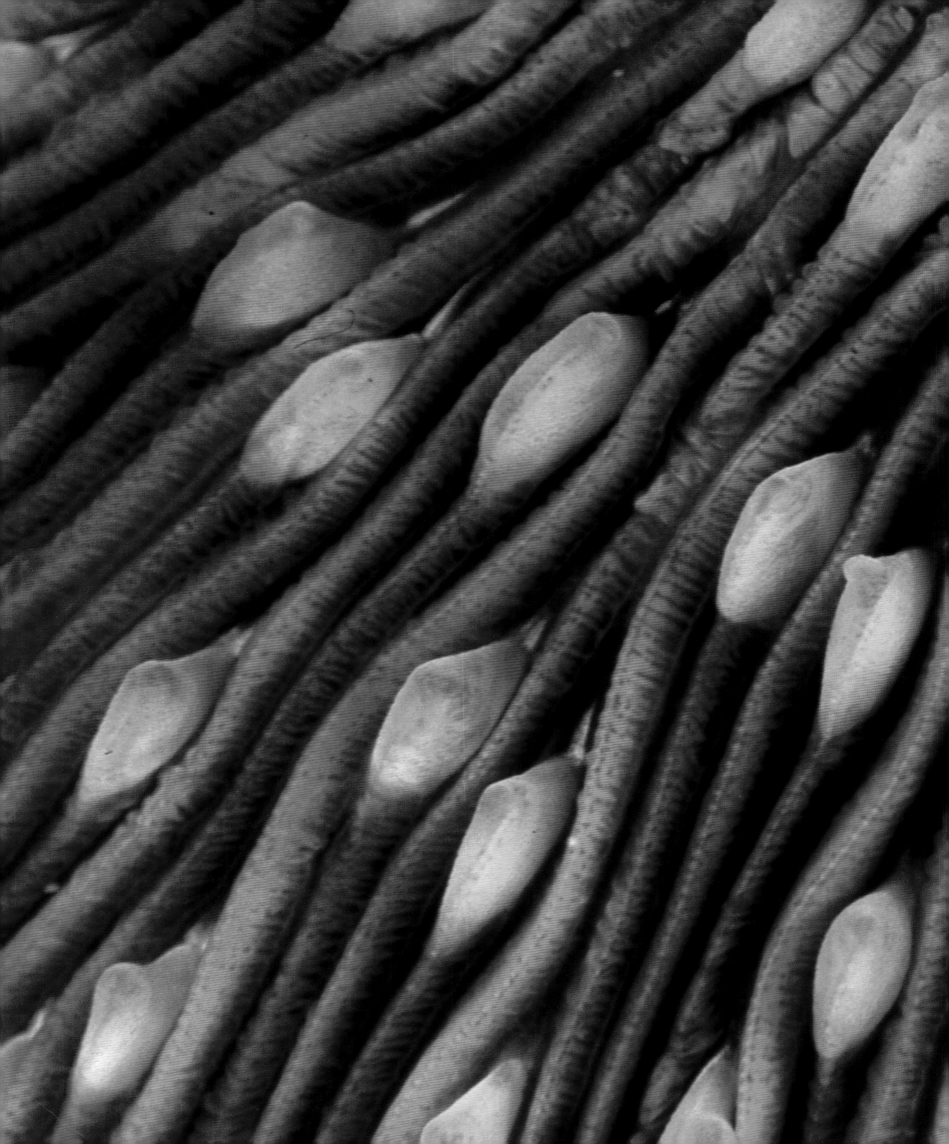

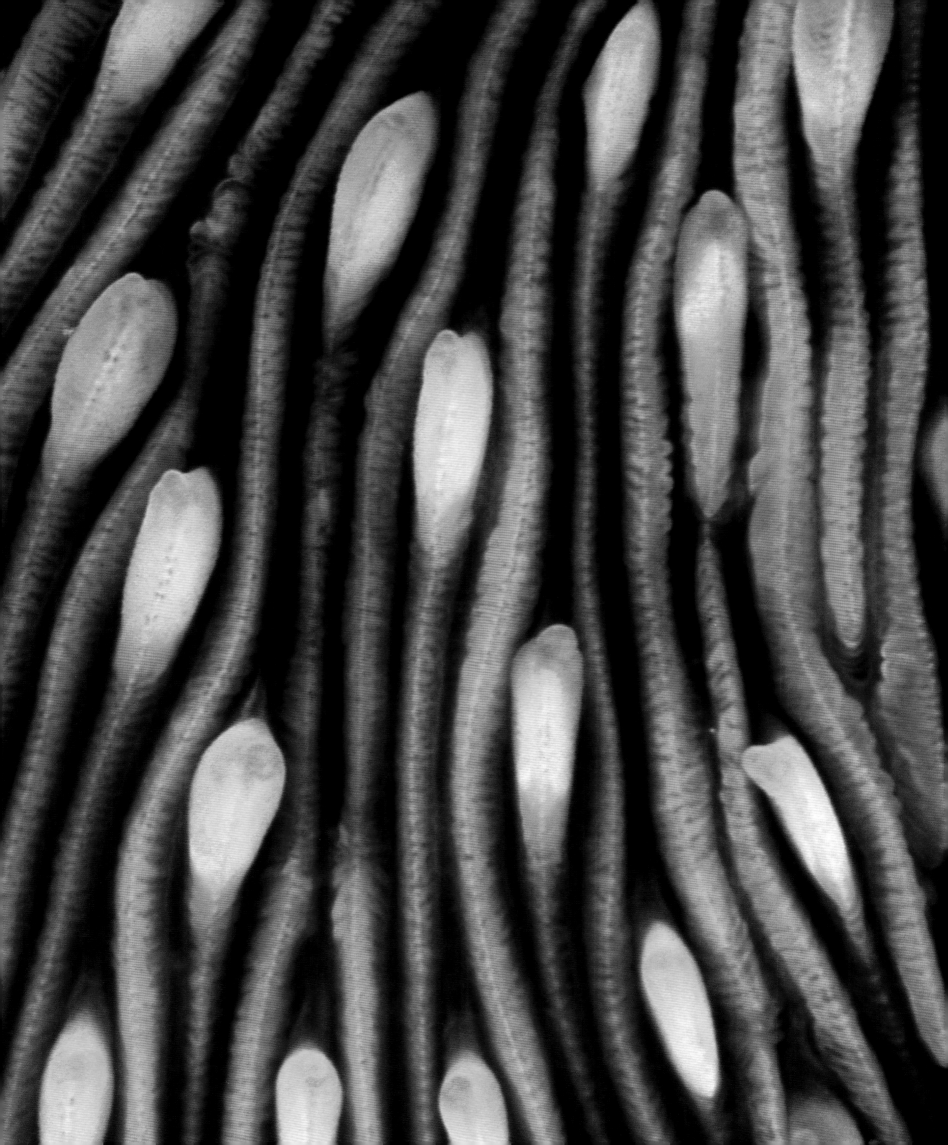

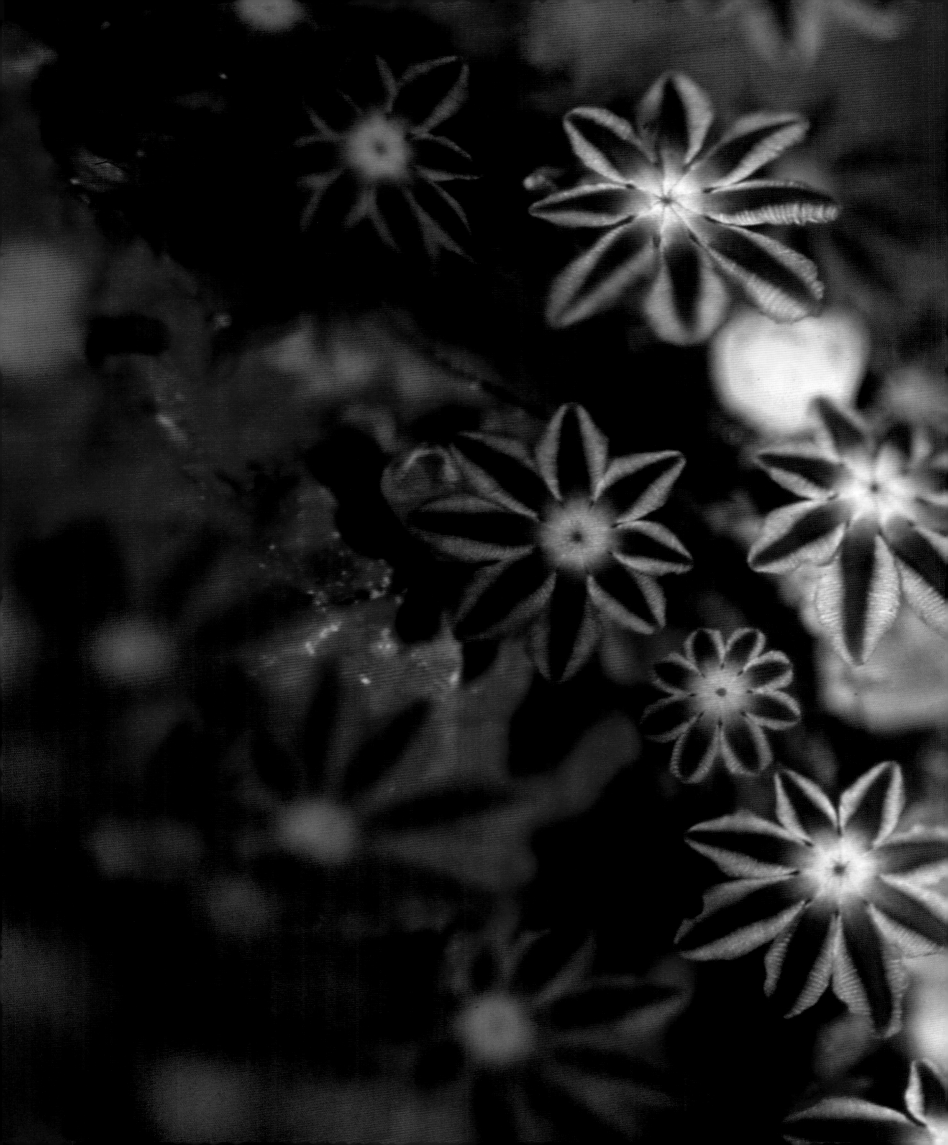

LEFT: A flower patch found
in a corner of the sea
(Tubbataha, Philippines 2005)

PAGES 194-195: A ghost goby
cohabits with soft coral
(Manado, Indonesia 2005)

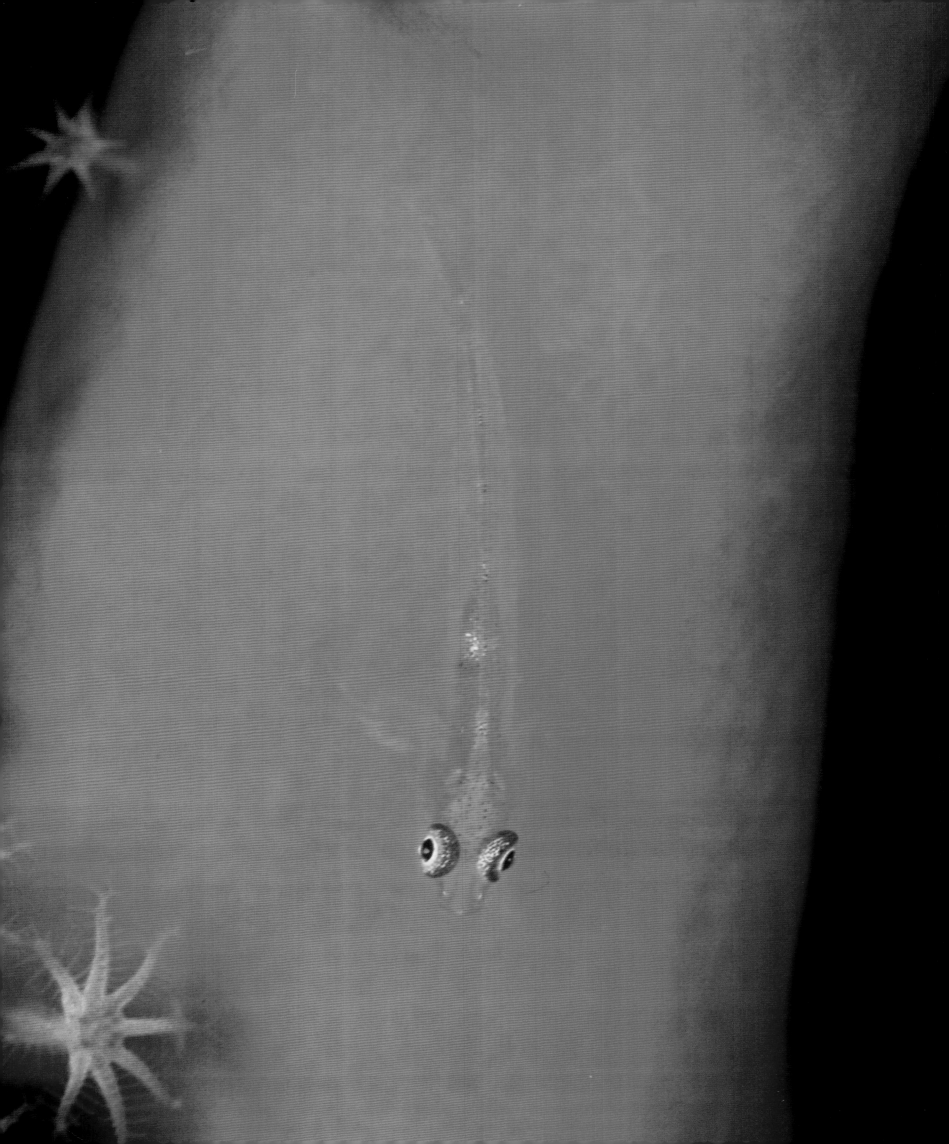

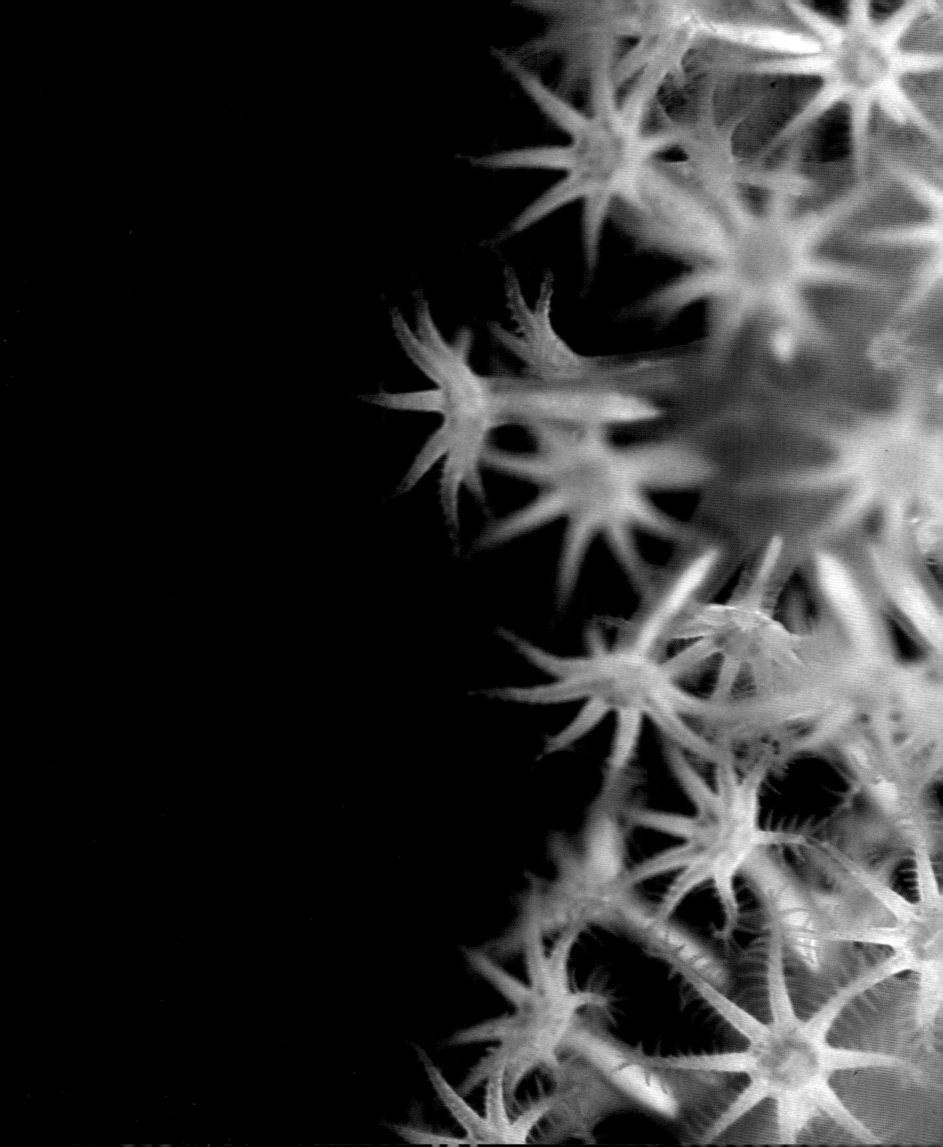

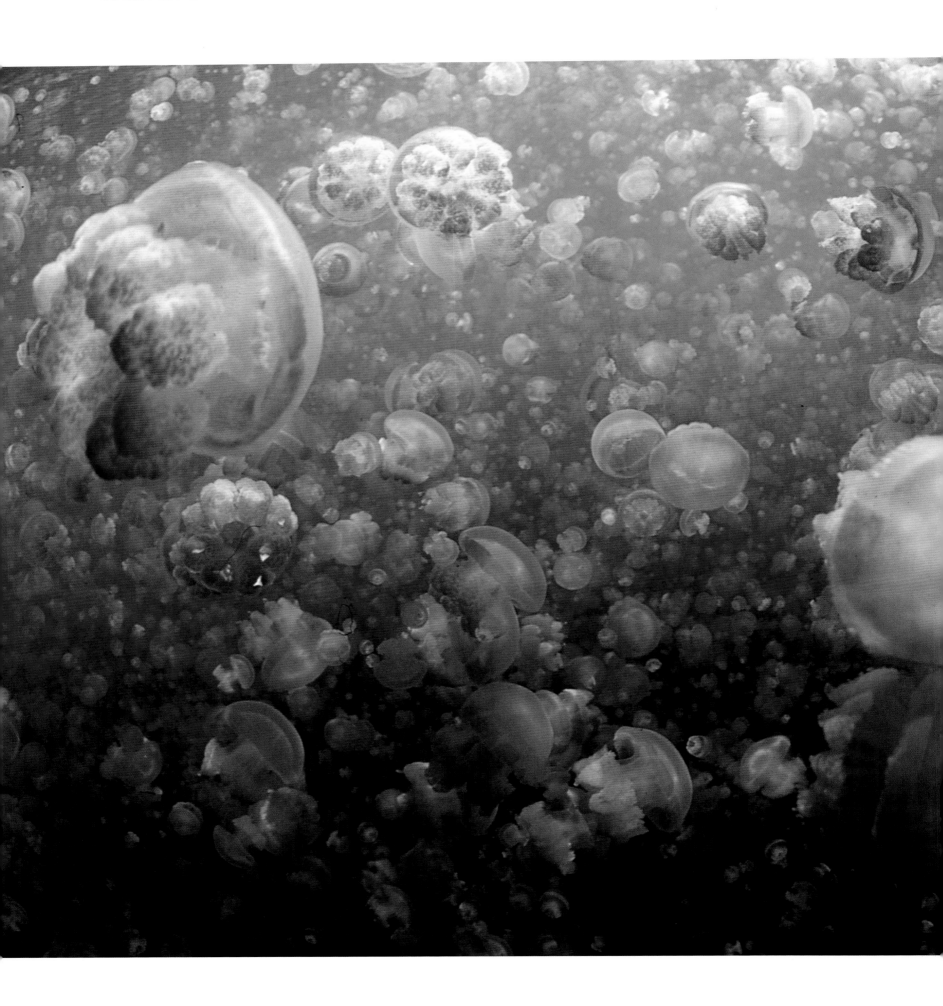

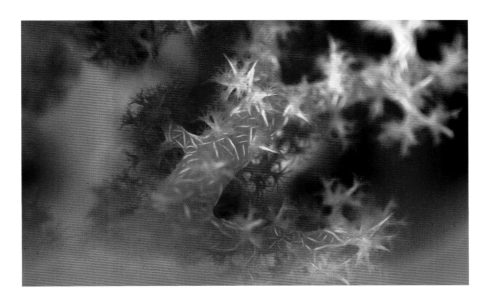

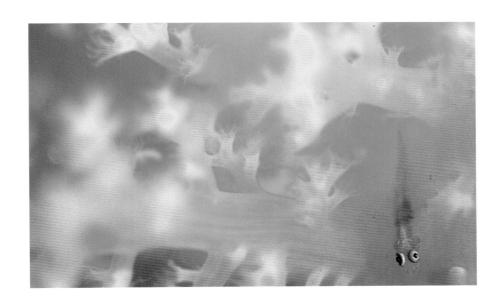

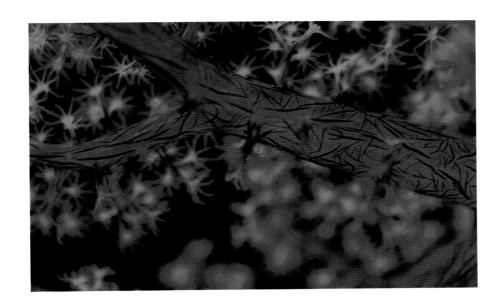

FAR LEFT: Jellyfish Lake is a cosmic space on its own (Palau, Micronesia 2004)

TOP LEFT: Soft coral; the ocean is full of different colours (Manado, Indonesia 2005)

MIDDLE LEFT: A ghost goby lurks behind the soft coral (Manado, Indonesia 2005)

BOTTOM LEFT: Soft corals have the colour of a starry sky (Manus, Papua New Guinea 2003)

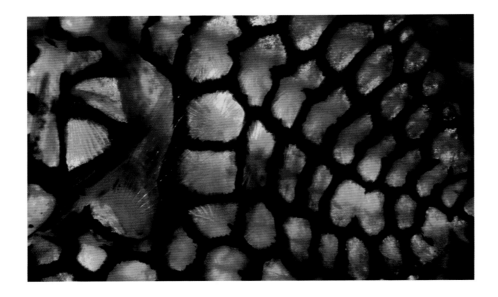

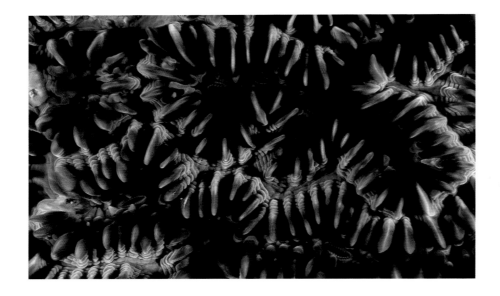

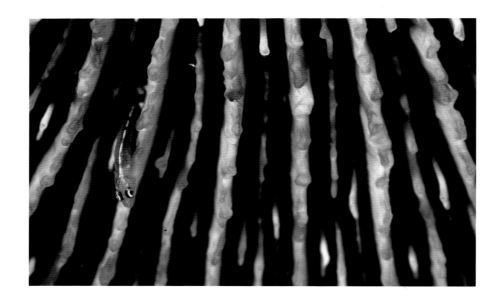

TOP LEFT: The surface of *monocentris japonica*, or the pinecone fish, has a golden shimmer (North Male Atoll, the Maldives 2005)

MIDDLE LEFT: The surface of coral brings to mind a creature from another dimension (South Male Atoll, the Maldives 1998)

BOTTOM LEFT: A Michel's ghost goby nestles up against a black firework (mushroom coral) (Manado, Indonesia 2005)

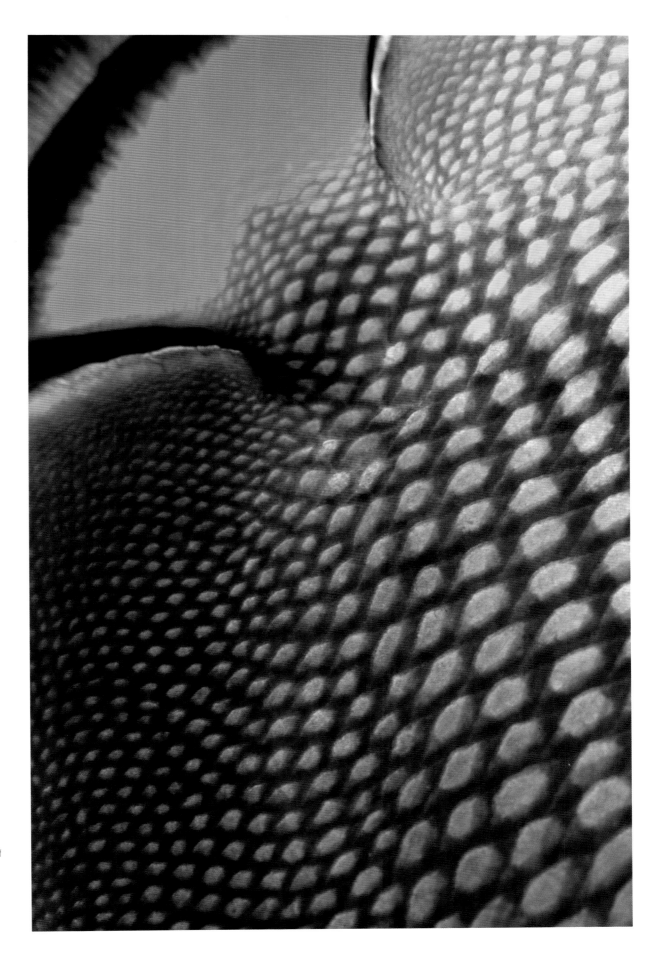

RIGHT: Redtail butterflyfish; the delicacy of each fish's colours is quite remarkable (South Male Atoll, the Maldives 1997)

PAGES 200-201: A forest of feathery soft coral dances with the waves (Manado, Indonesia 2006)

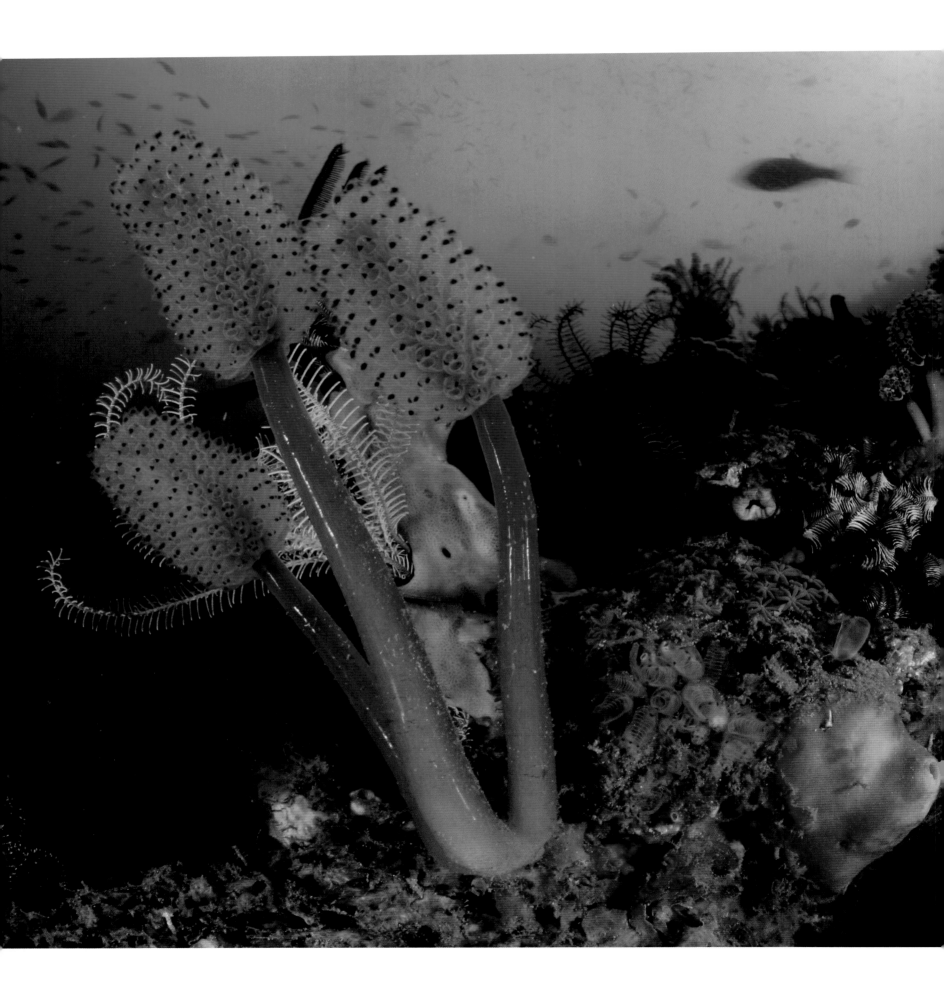

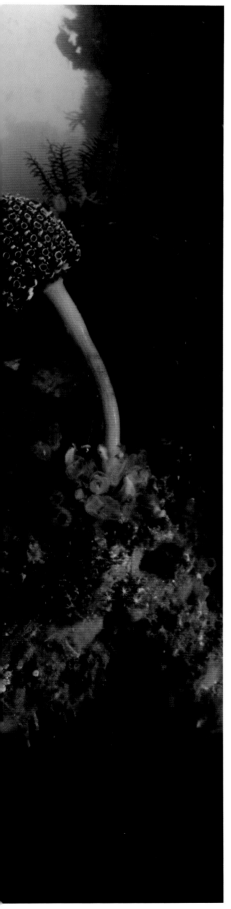

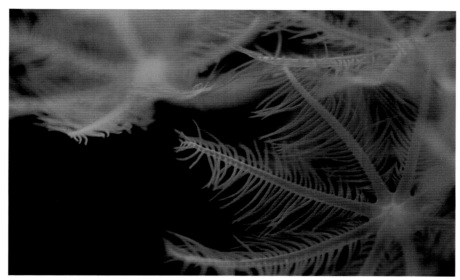

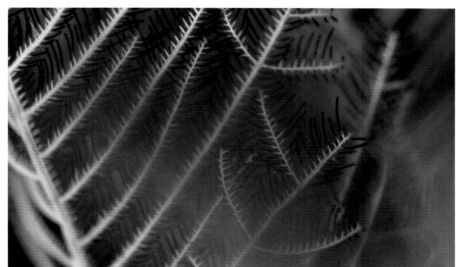

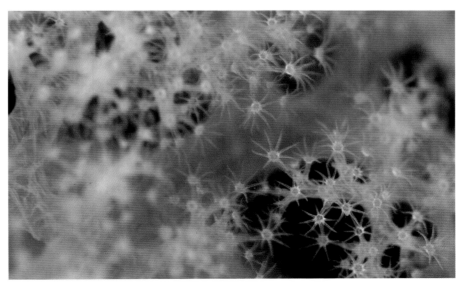

FAR LEFT: I came across this funny-looking sea squirt in the untouched sea of Komodo (Komodo Island, Indonesia 2007)

TOP LEFT: Sea fern (Papua New Guinea 2003)

MIDDLE LEFT: The powerful stingers of a hydroid (Manado, Indonesia 2005)

BOTTOM LEFT: Snowflakes of soft coral (Manado, Indonesia 2005)

PAGES 204-205: A marine bouquet of sea anemones and sea squirts (Manado, Indonesia 2007)

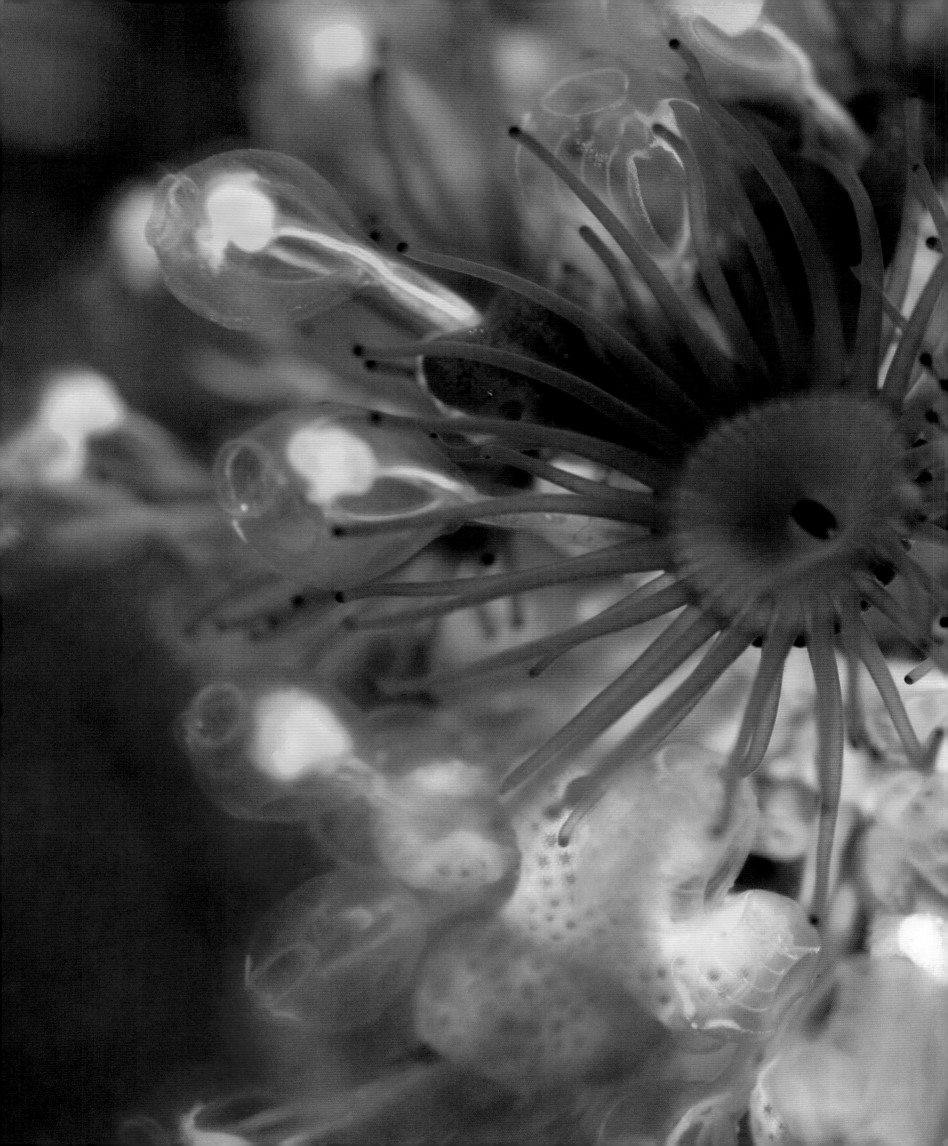

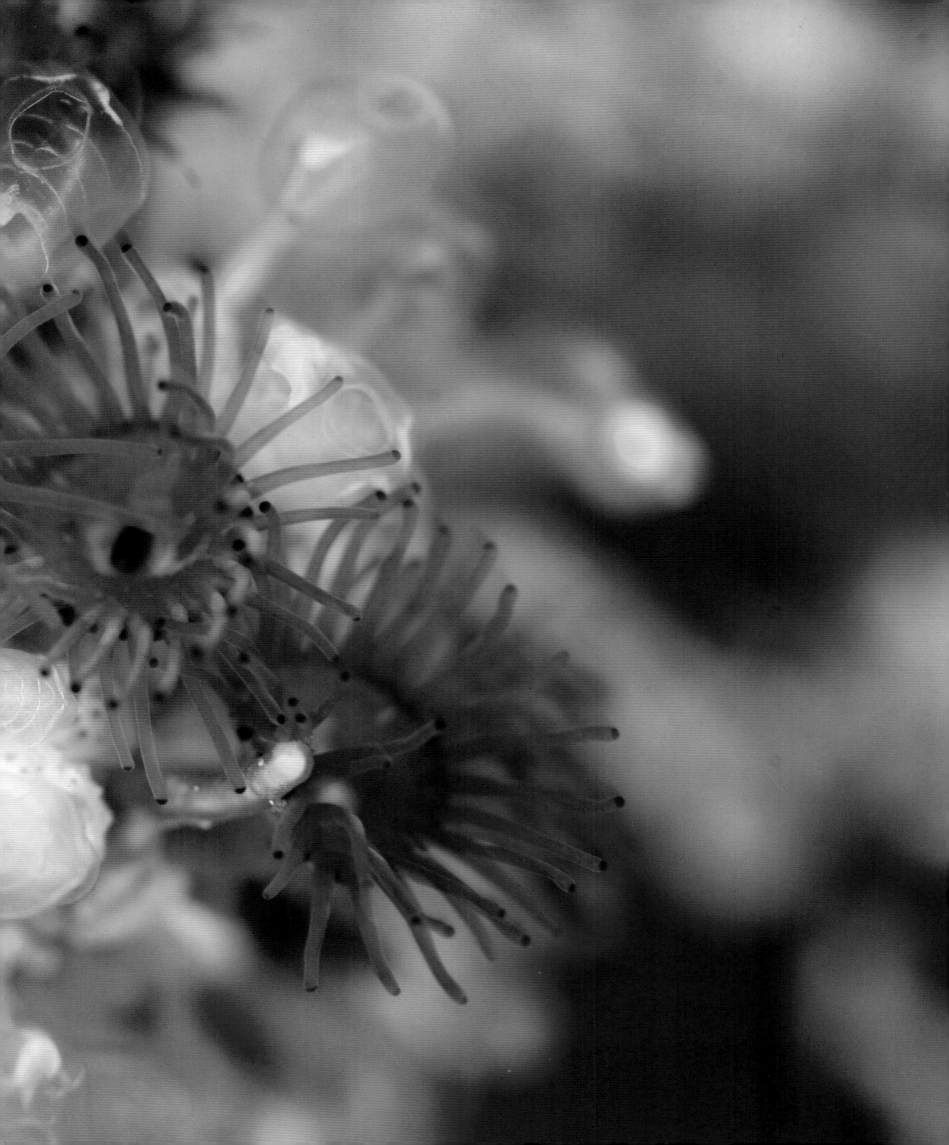

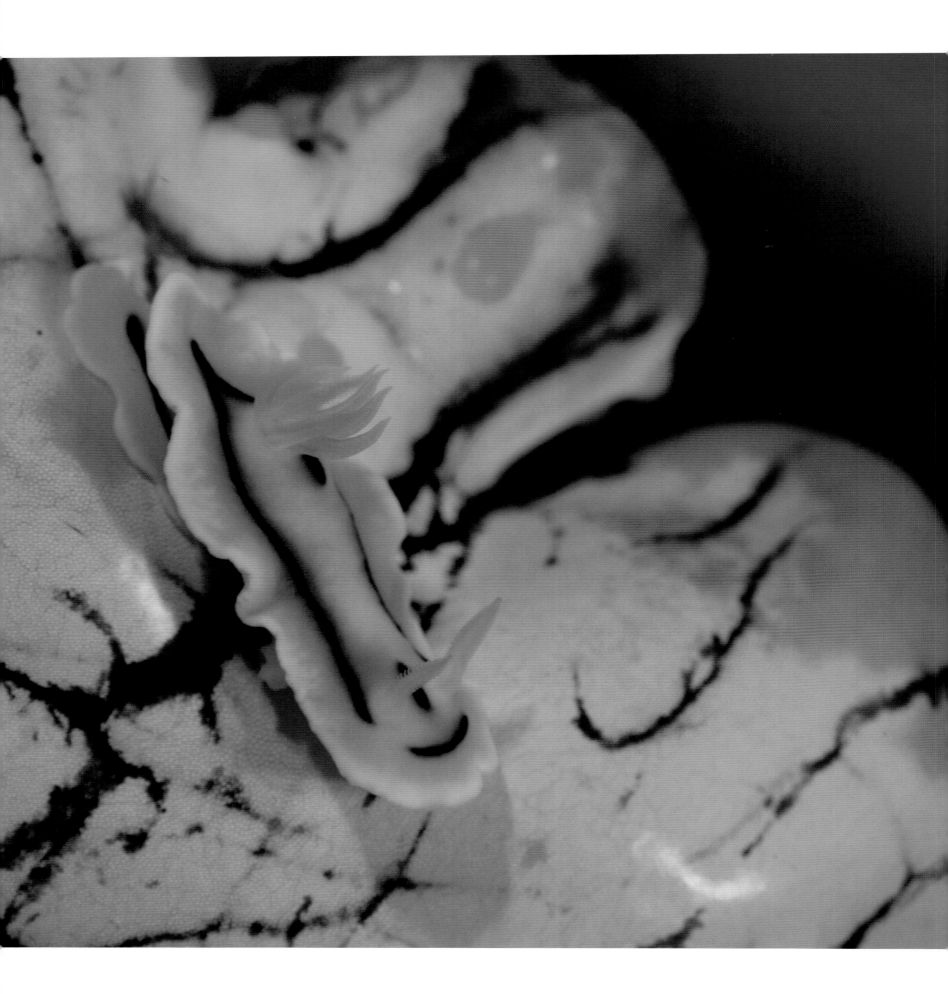

LEFT: *Chromodoris willani* moves slowly on a golden sea squirt (Manado, Indonesia 2006)

BELOW LEFT: The popular and colourful ribbon eel (Raja Ampat, Indonesia 2007)

BELOW RIGHT: A shaded batfish, still with the orange stripe on its face marking it as a juvenile (Raja Ampat, Indonesia 2007)

PAGES 208-209: Sea apples, a kind of sea cucumber, have strong colours and unique shapes (Komodo Island, Indonesia 2007)

PAGES 210-211: The surface of the sea anemone gives a mysterious feeling of outer space (Komodo Island, Indonesia 2007)

PAGES 212-213: The underwater world is full of life and as beautiful as a shower of blossom in spring (Komodo Island, Indonesia 2007)

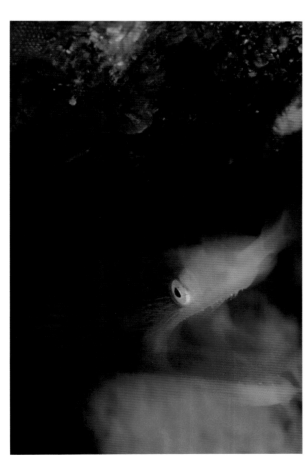

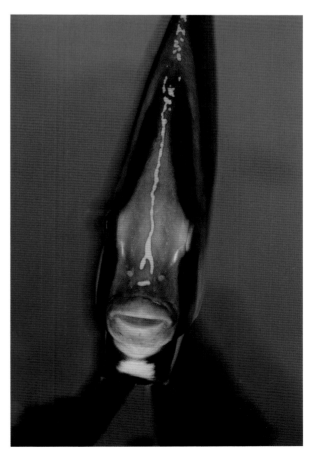

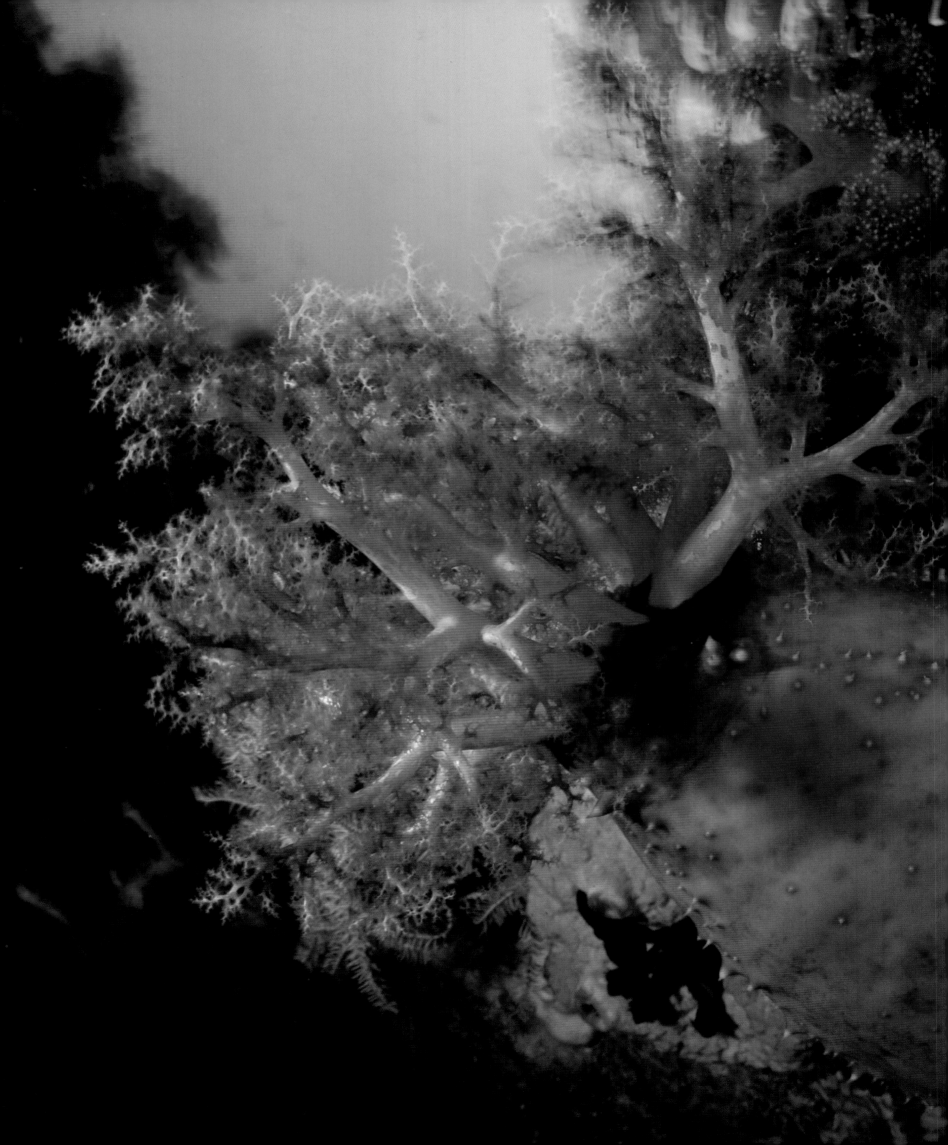

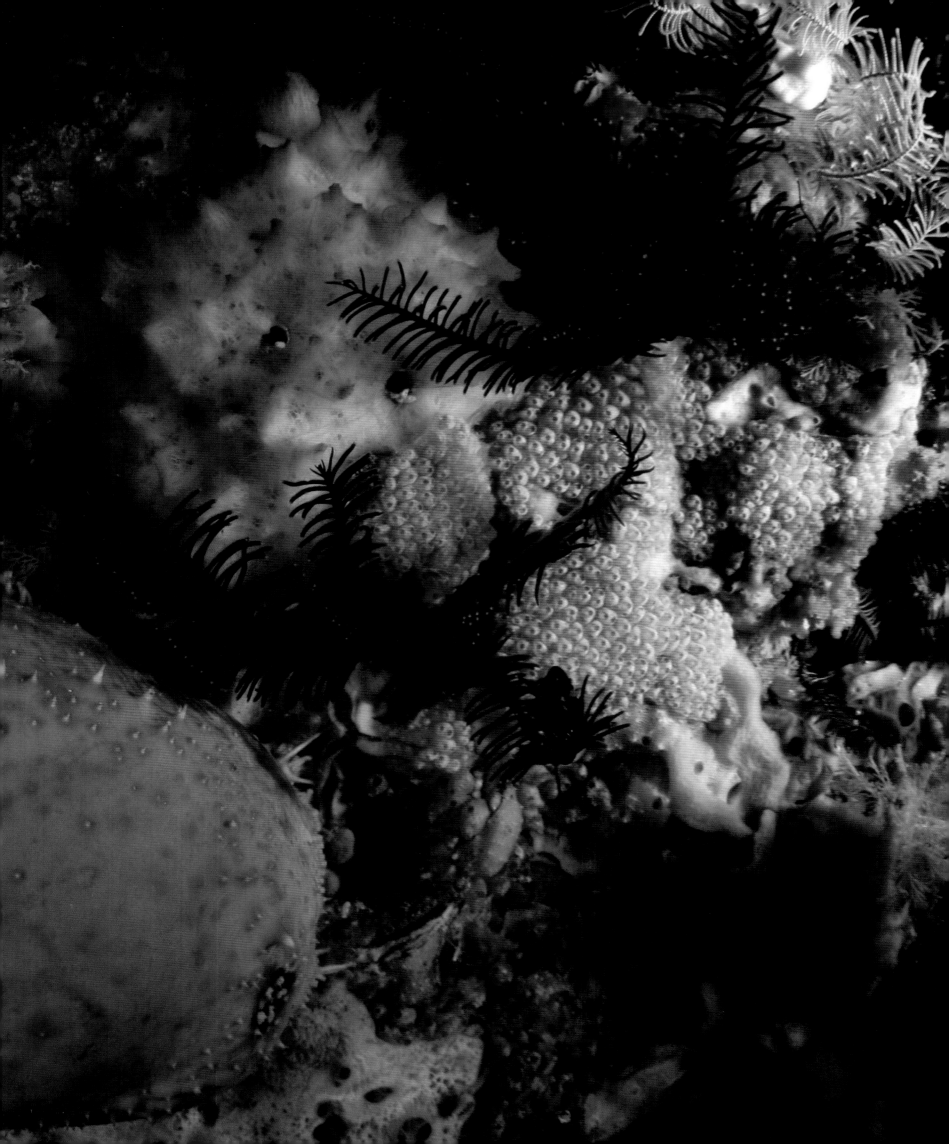

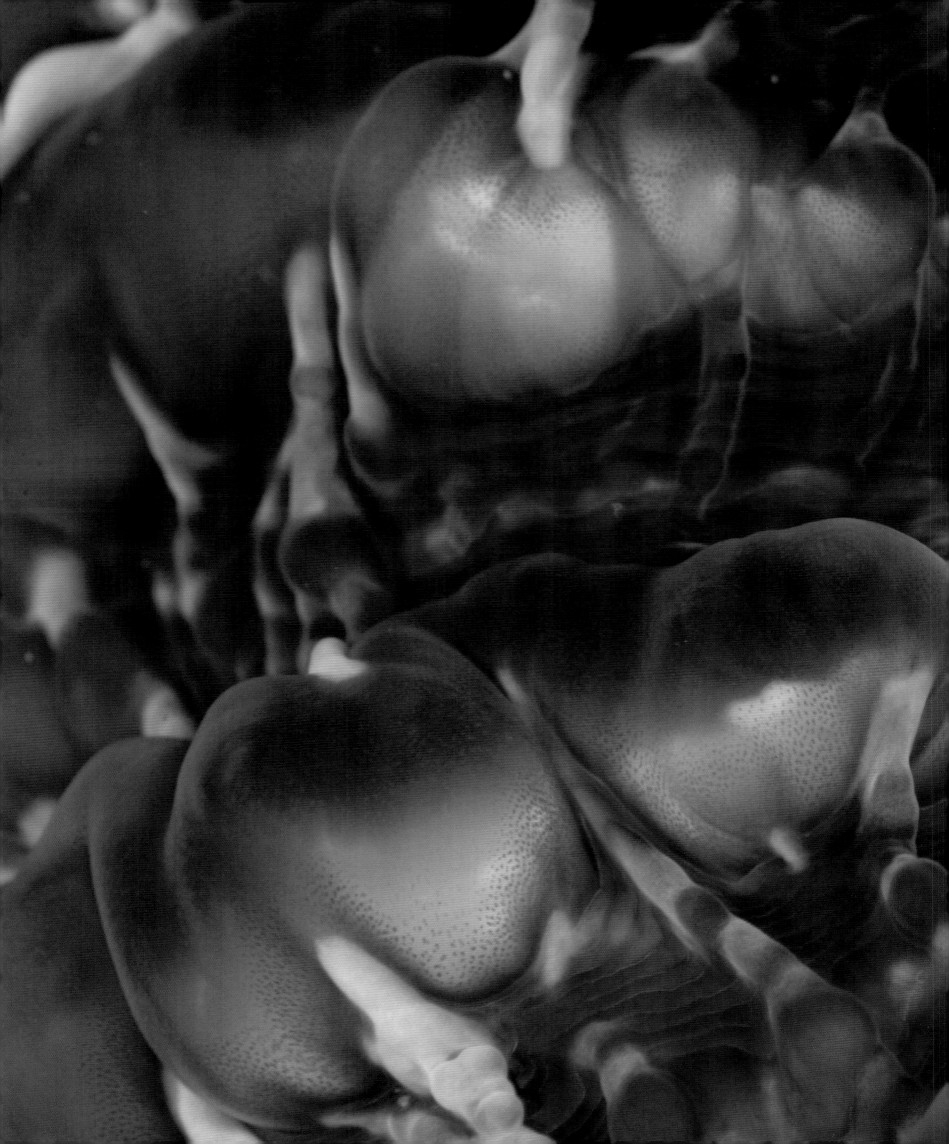

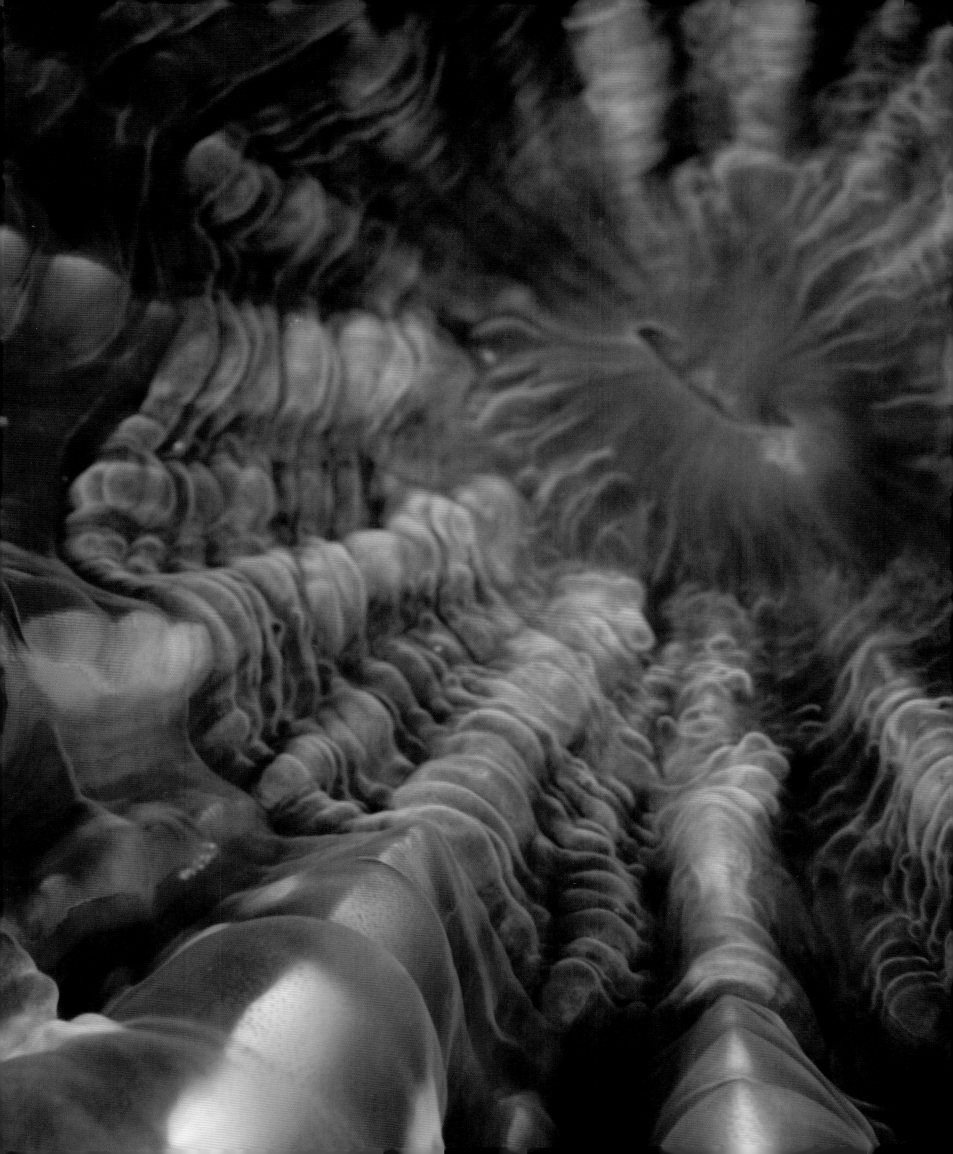

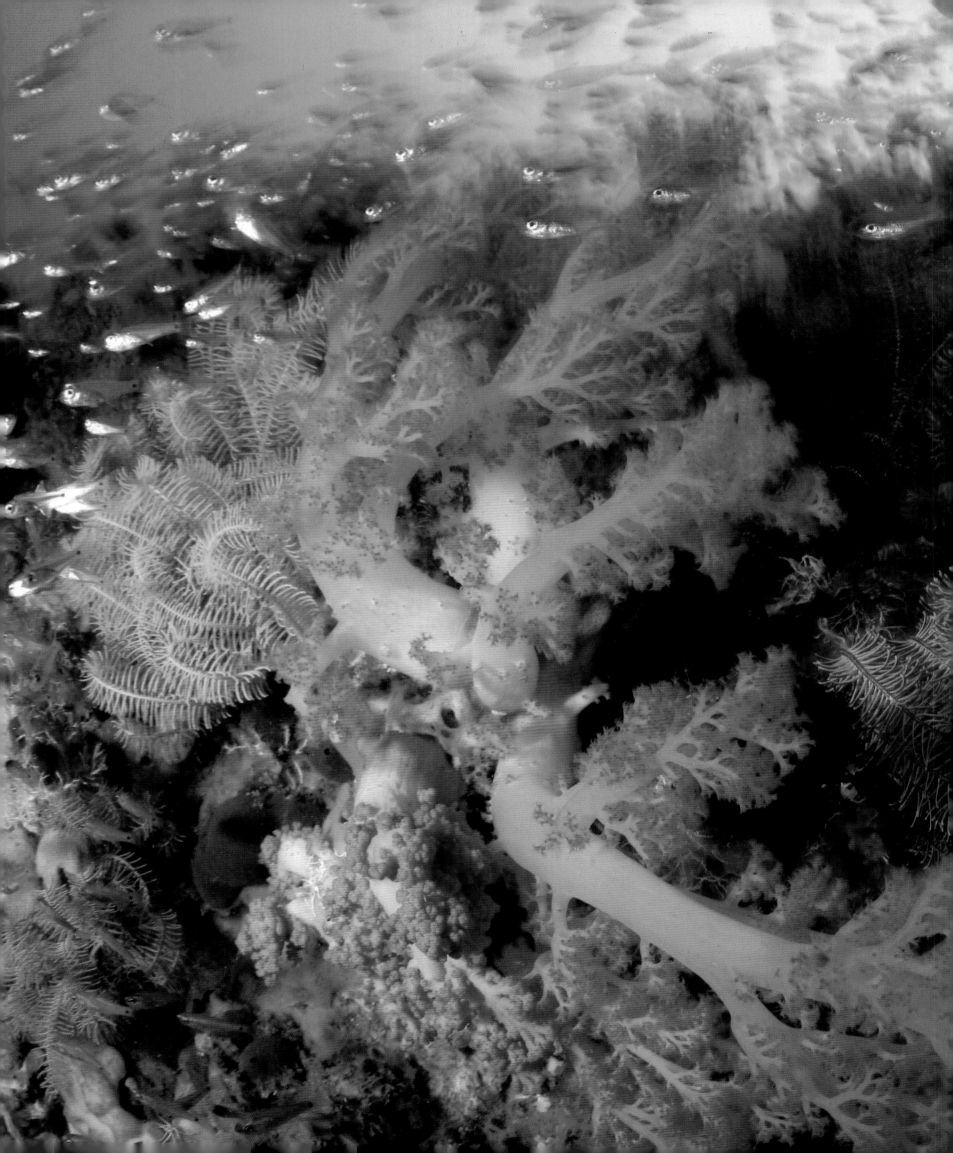

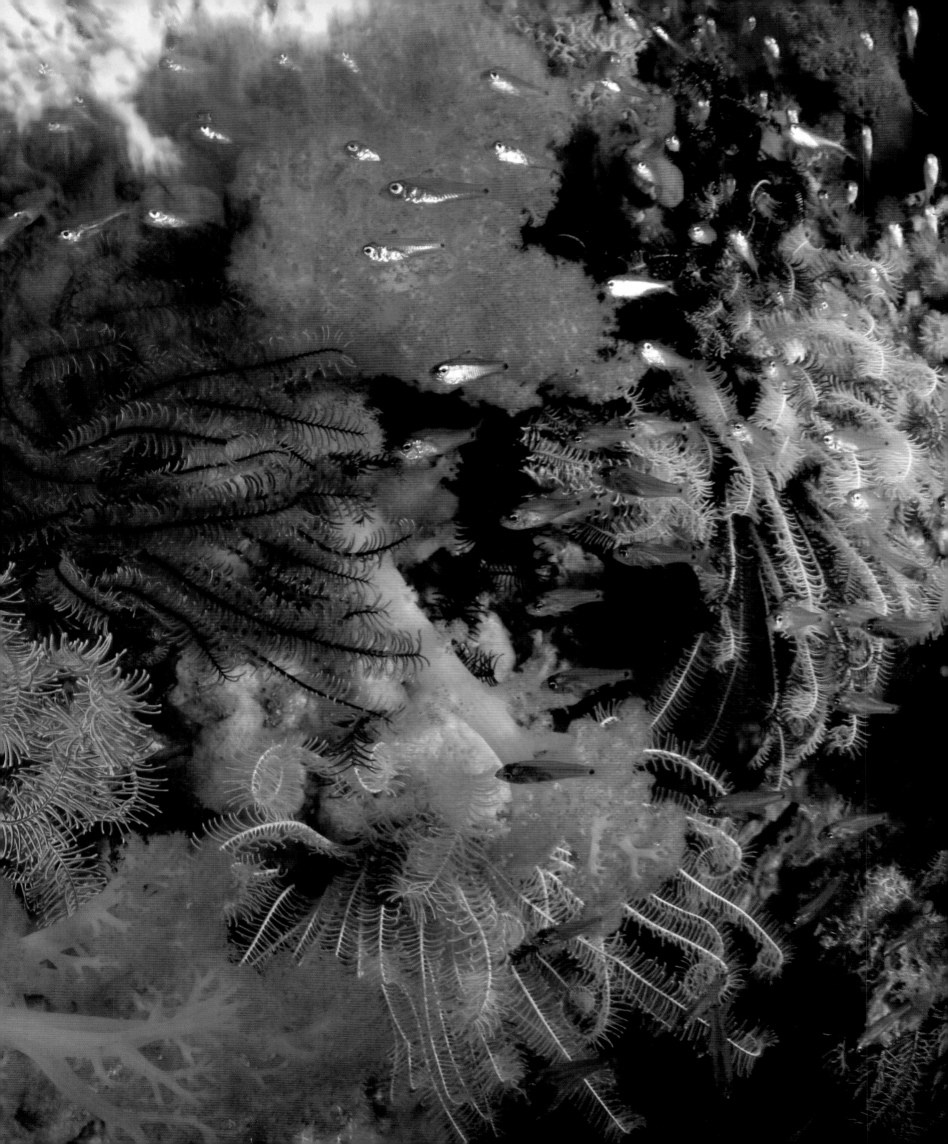

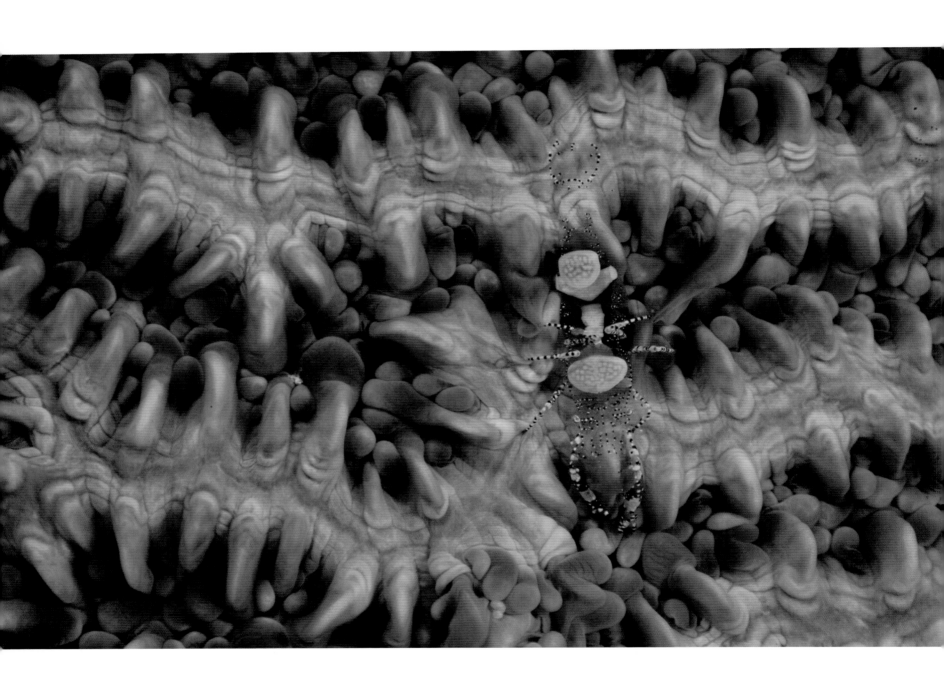

ABOVE: This commensal shrimp is an
alien trying to invade the sea anemone
(Raja Ampat, Indonesia 2007)

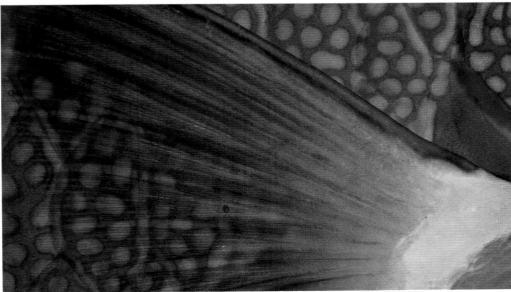

TOP RIGHT: Giant kelp has
air-filled bulbs that allow it to remain
suspended close to the surface
(Monterey, California, USA 1995)

MIDDLE RIGHT: The bewitching
tentacles of a sea anemone
(Kho Tao, Thailand 2006)

BOTTOM RIGHT: The colourful
fins of a red-spotted parrotfish
(South Male Atoll, the Maldives 1996)

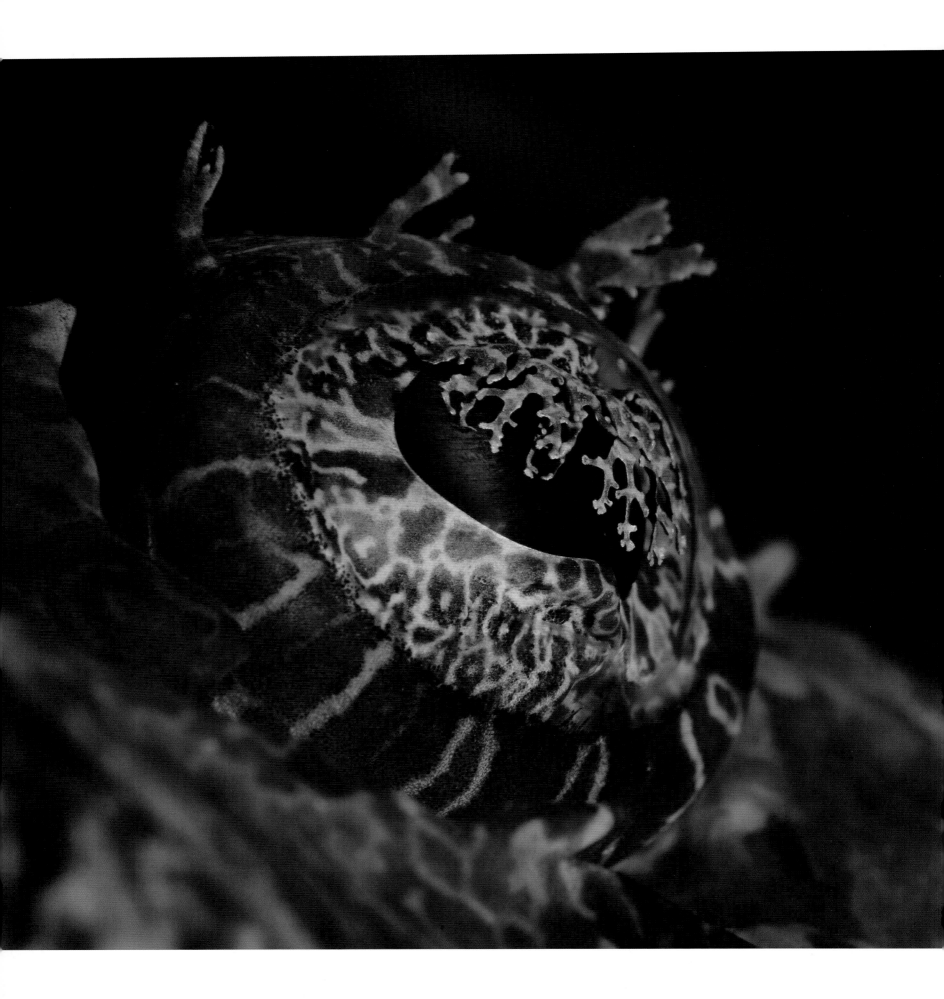

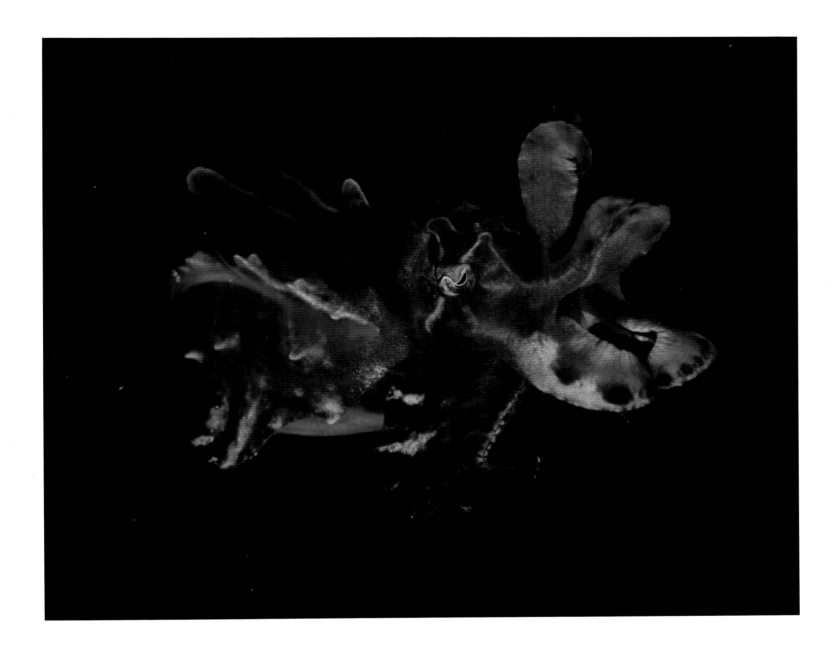

LEFT: The eyes of crocodile fish
staring into the cosmos
(Mabul, Malaysia 2007)

ABOVE: The flamboyant cuttlefish
is constantly changing colour
(Koza, Wakayama, Japan 2007)

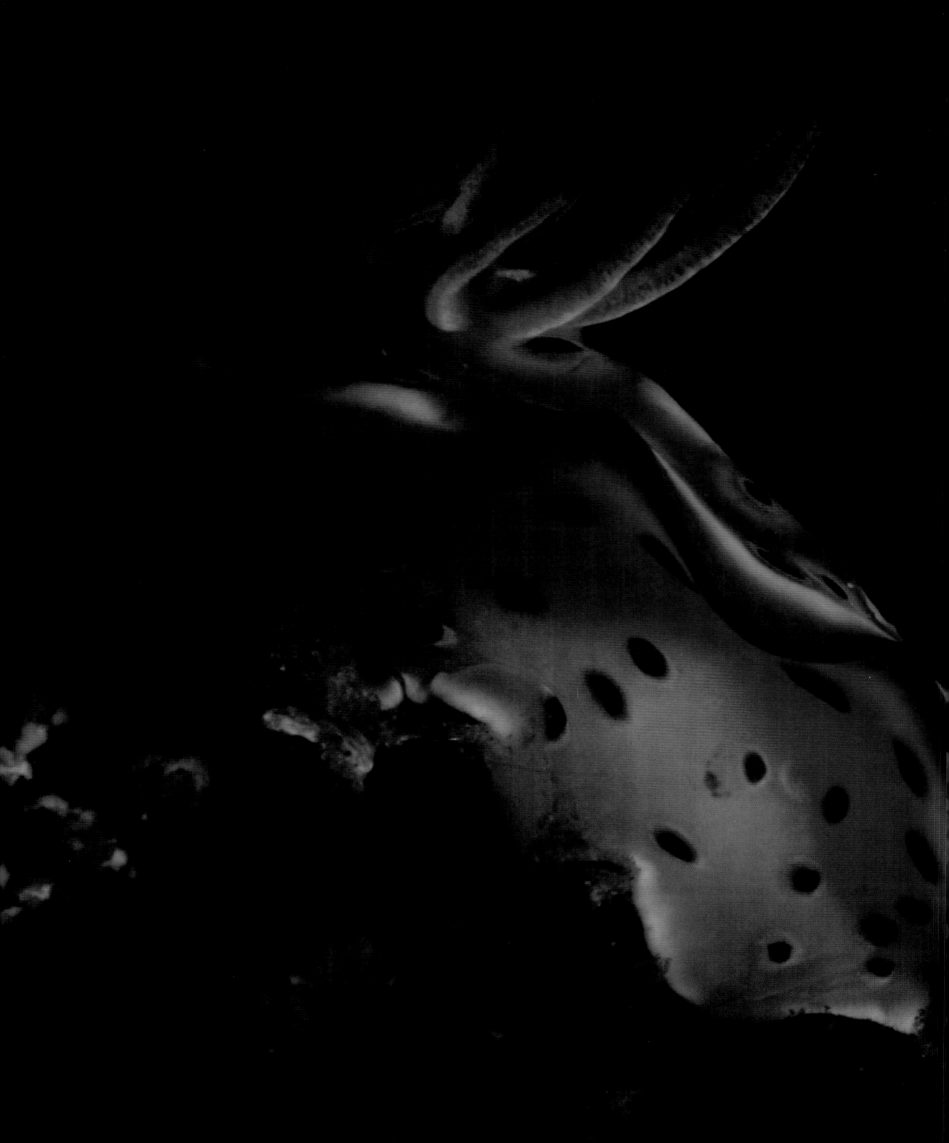

INNER SPACE

LEFT: *Chromodoris kuniei* swims
into the jet-black darkness of the sea
(Manado, Indonesia 2006)

PAGES 220-221: Looking at the mantle of the
giant clam, I am transported into outer space
(Raja Ampat, Indonesia 2007)

PAGES 222-223: The mighty hawksbill
turtle swims through the water
(Raja Ampat, Indonesia 2007)

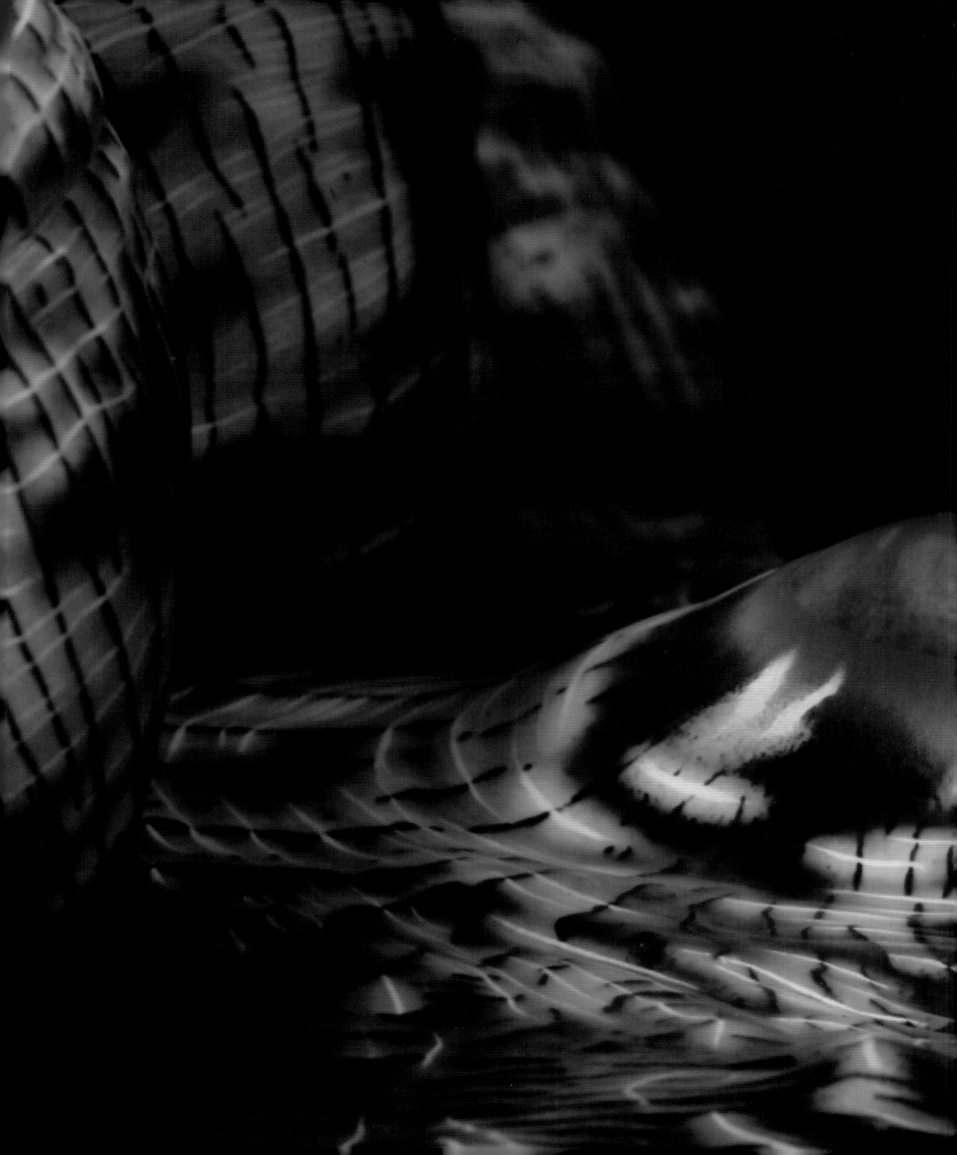

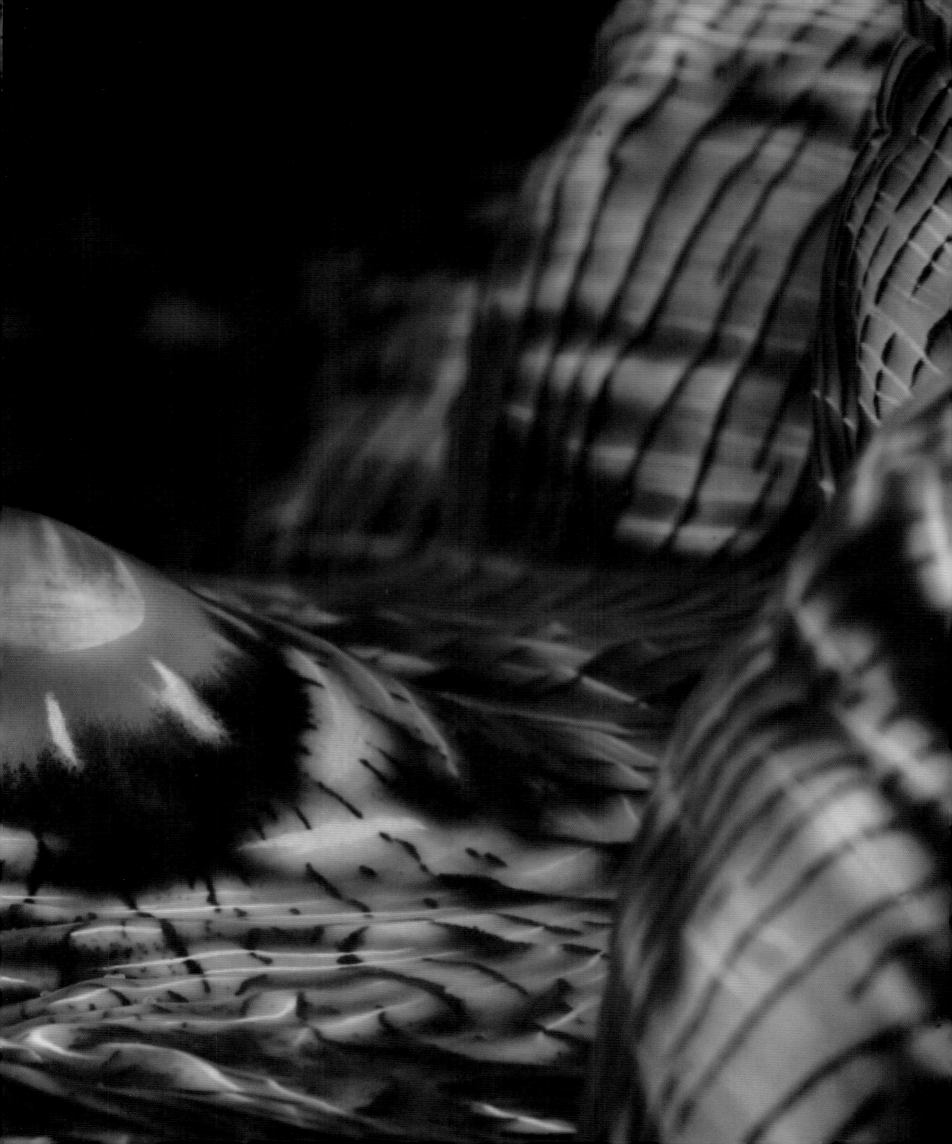

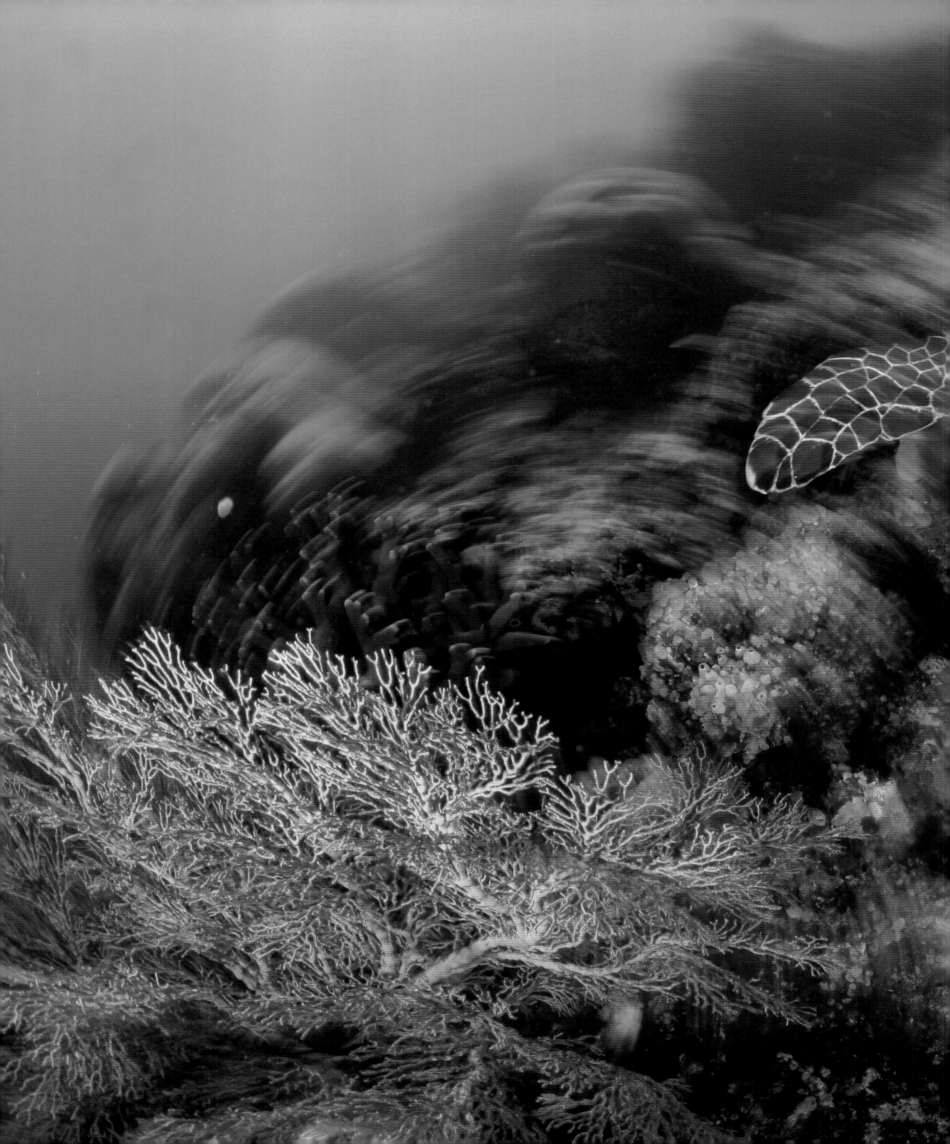

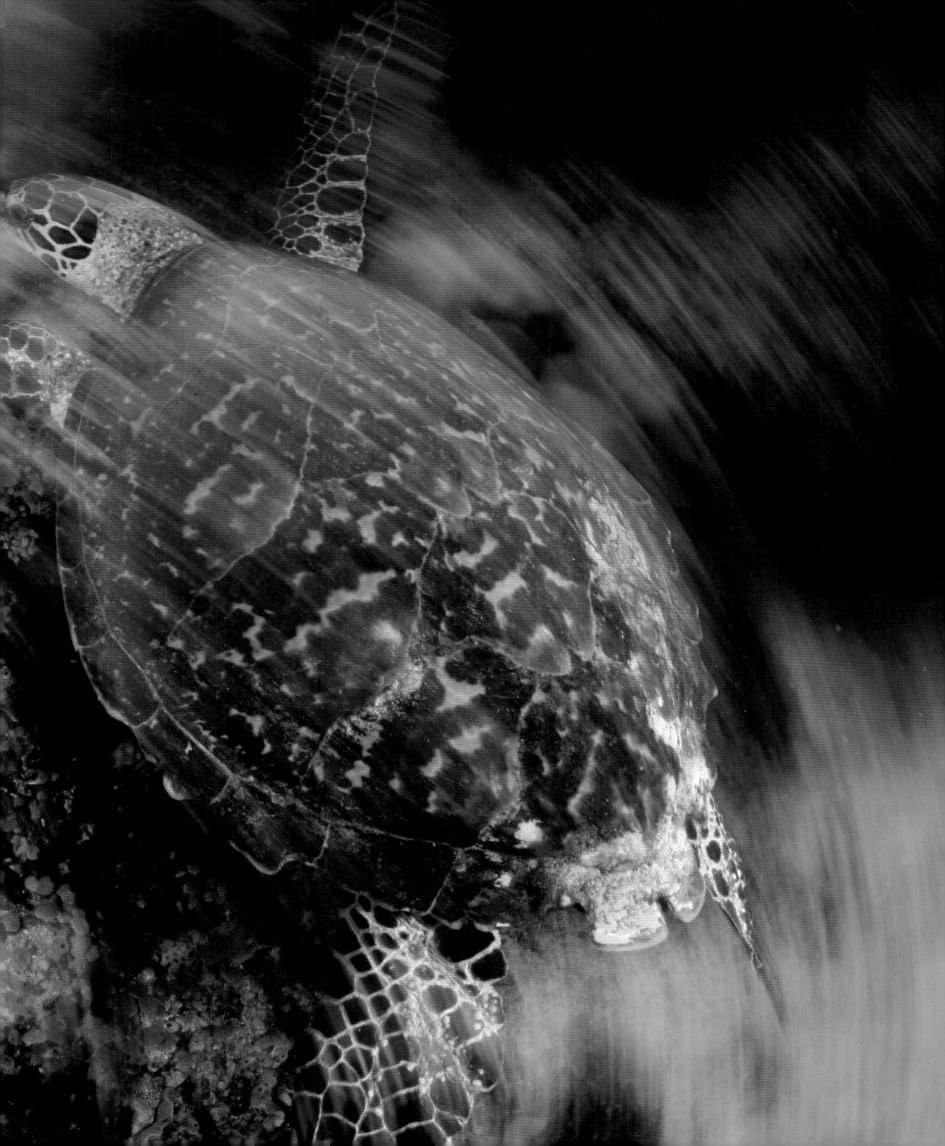

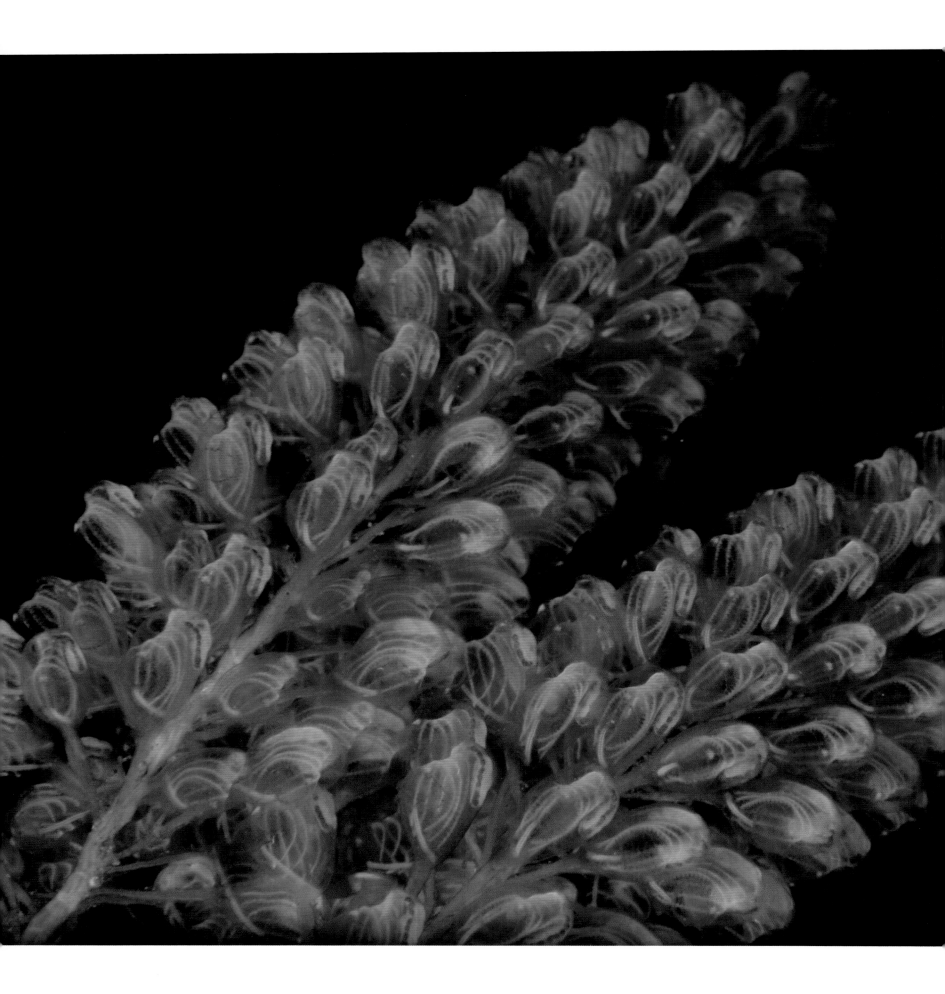

LEFT: A beautiful sea squirt found in a hidden place in Raja Ampat (Raja Ampat, Indonesia 2007)

TOP AND MIDDLE RIGHT: The black spotted boxfish and royal angelfish both have the same colour scheme but in completely different patterns (Manado, Indonesia 2006)

BOTTOM RIGHT: The surface of the sea anemone is like the Andromeda Galaxy; its colours are just mesmerising (Liloan, Philippines 2004)

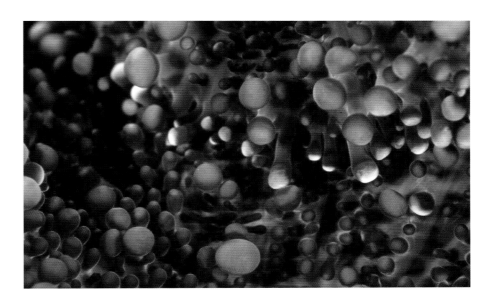

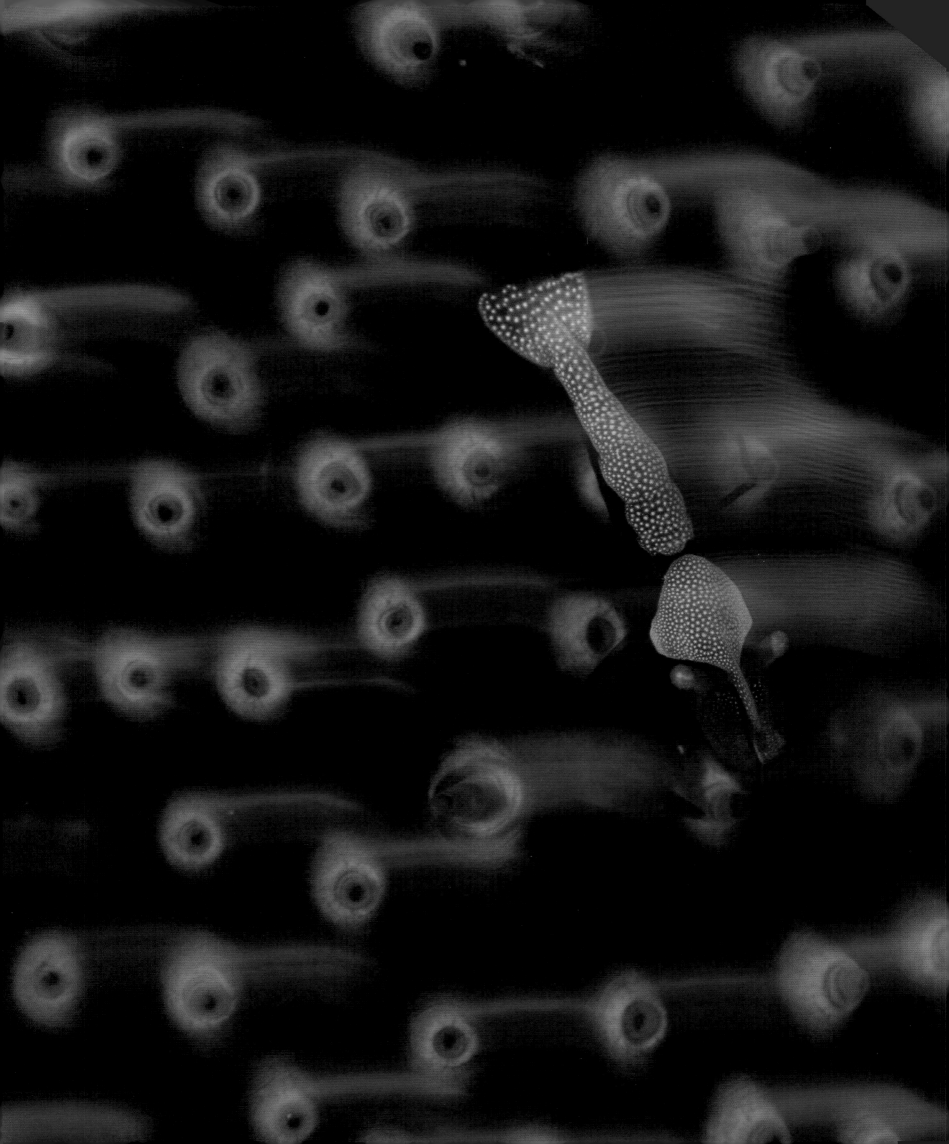

LEFT: This emperor shrimp is
a parasite to the sea cucumber
(Komodo Island, Indonesia 2007)

PAGES 228-229: The breast fin of the red
lionfish is powdered with silver pigment
(Manado, Indonesia 2006)

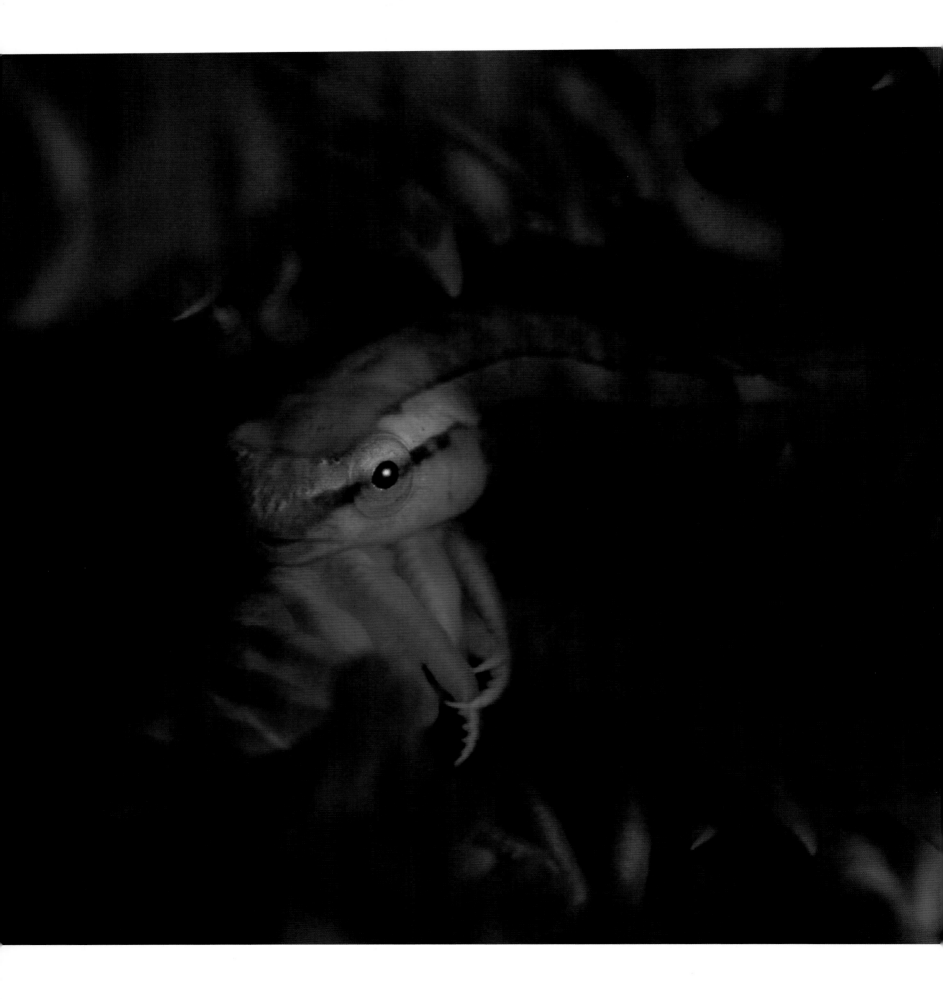

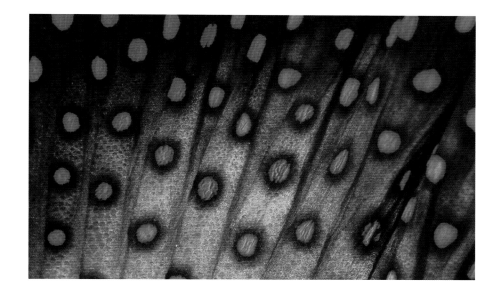

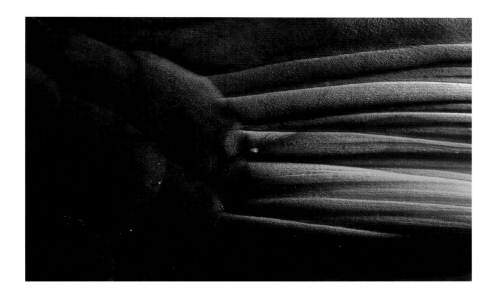

LEFT: A crinoid clingfish
lives off feather stars
(Raja Ampat, Indonesia 2007)

TOP RIGHT: The beautifully dotted
back fin of a peacock hind
(North Male Atoll, the Maldives 2005)

MIDDLE RIGHT: Parrotfish have
tails that are as soft as bird feathers
(North Male Atoll, the Maldives 1996)

BOTTOM RIGHT: The mantles
of giant clams are like mysterious
drawings in the sand
(Manado, Indonesia 2005)

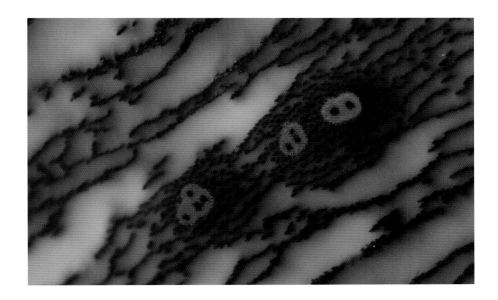

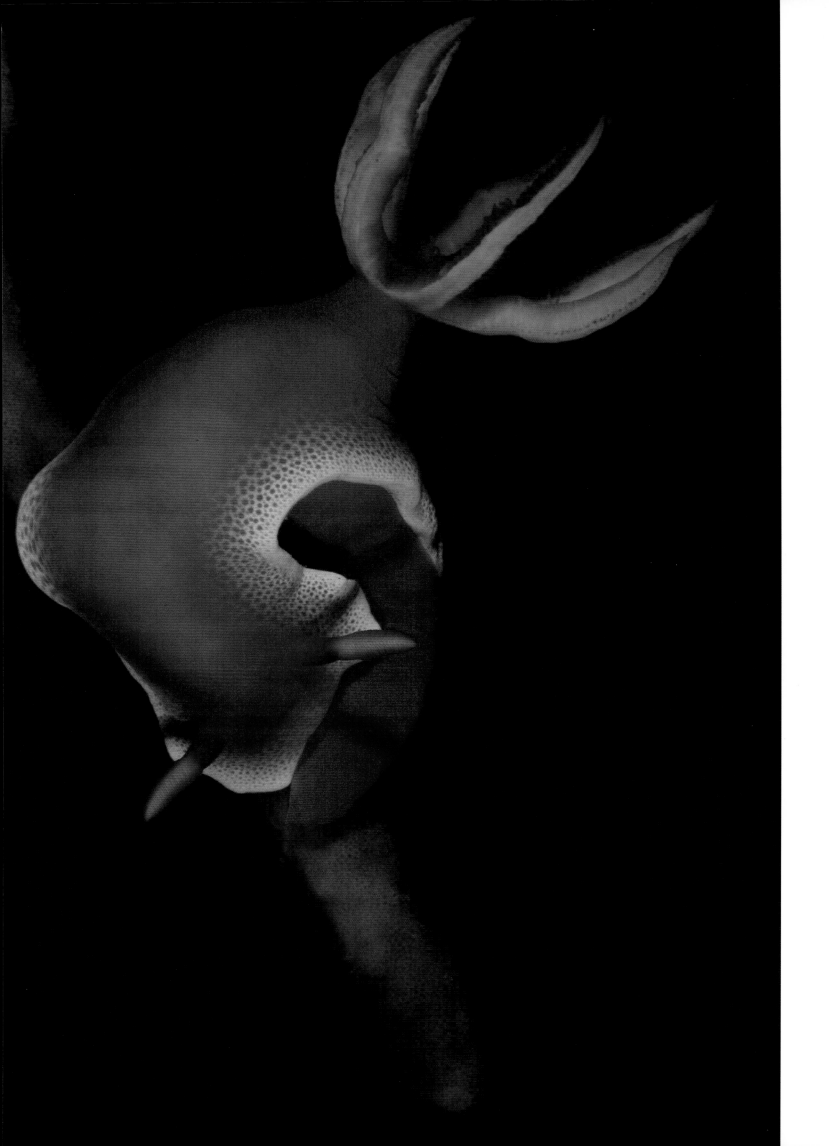

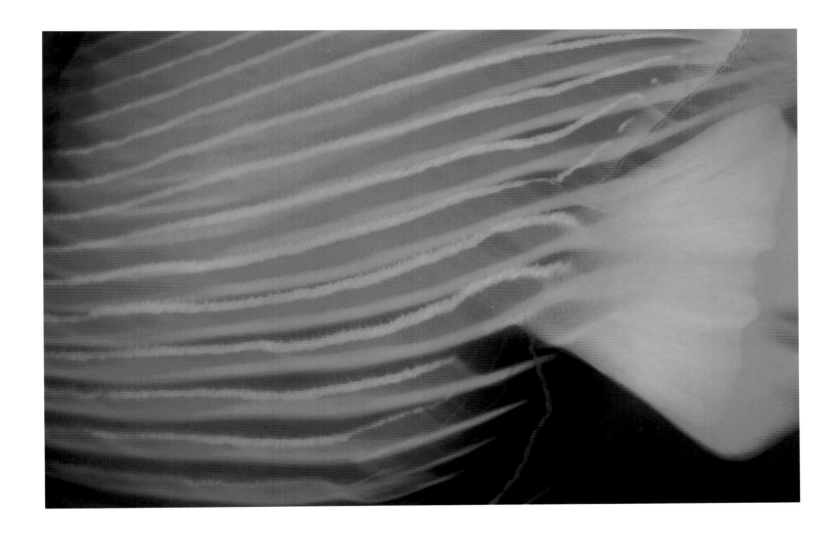

LEFT: A sea slug tries to
hide but its tail is showing
(El Nido, Philippines 2007)

ABOVE: An emperor angelfish
(Raja Ampat, Indonesia 2007)

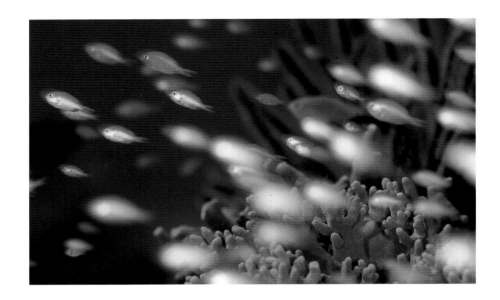

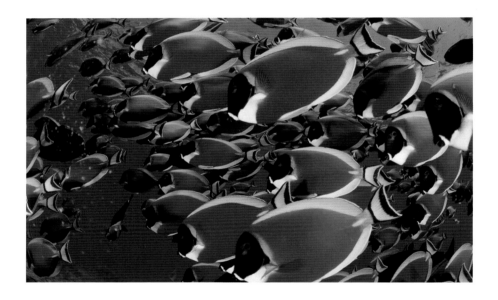

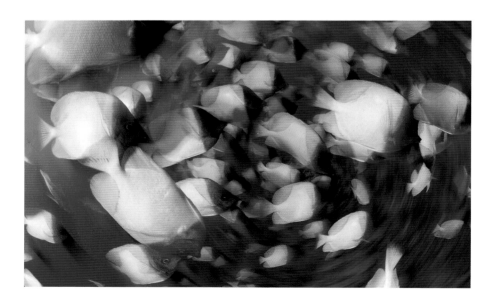

TOP LEFT: A school of blue-green chromis
(Liloan, Philippines 2004)

MIDDLE LEFT: Indigenous to the Indian Ocean,
a school of powder-blue surgeonfish
(North Male Atoll, the Maldives 2004)

BOTTOM LEFT: Obscuring all else,
a massive school of pyramid butterflyfish
(Saipan Micronesia 2003)

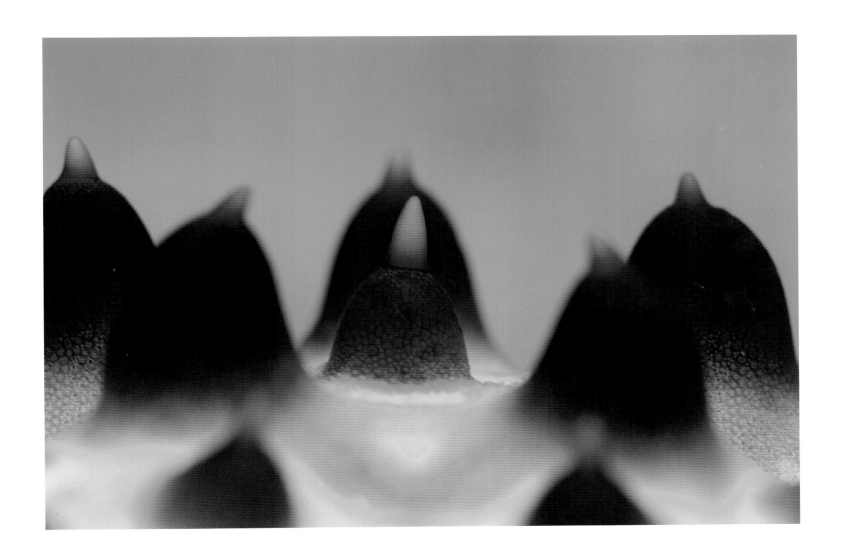

ABOVE: The surface of this starfish
has a pattern like a monster's claws
(Manado, Indonesia 2007)

PAGES 236-237: Banggai cardinalfish are
mouthbrooders, that is to say they protect
their eggs in their mouths until they hatch
(Manado, Indonesia 2007)

PAGES 238-239: The beautiful but
vicious purple-blotched smasher
(Manado, Indonesia 2007)

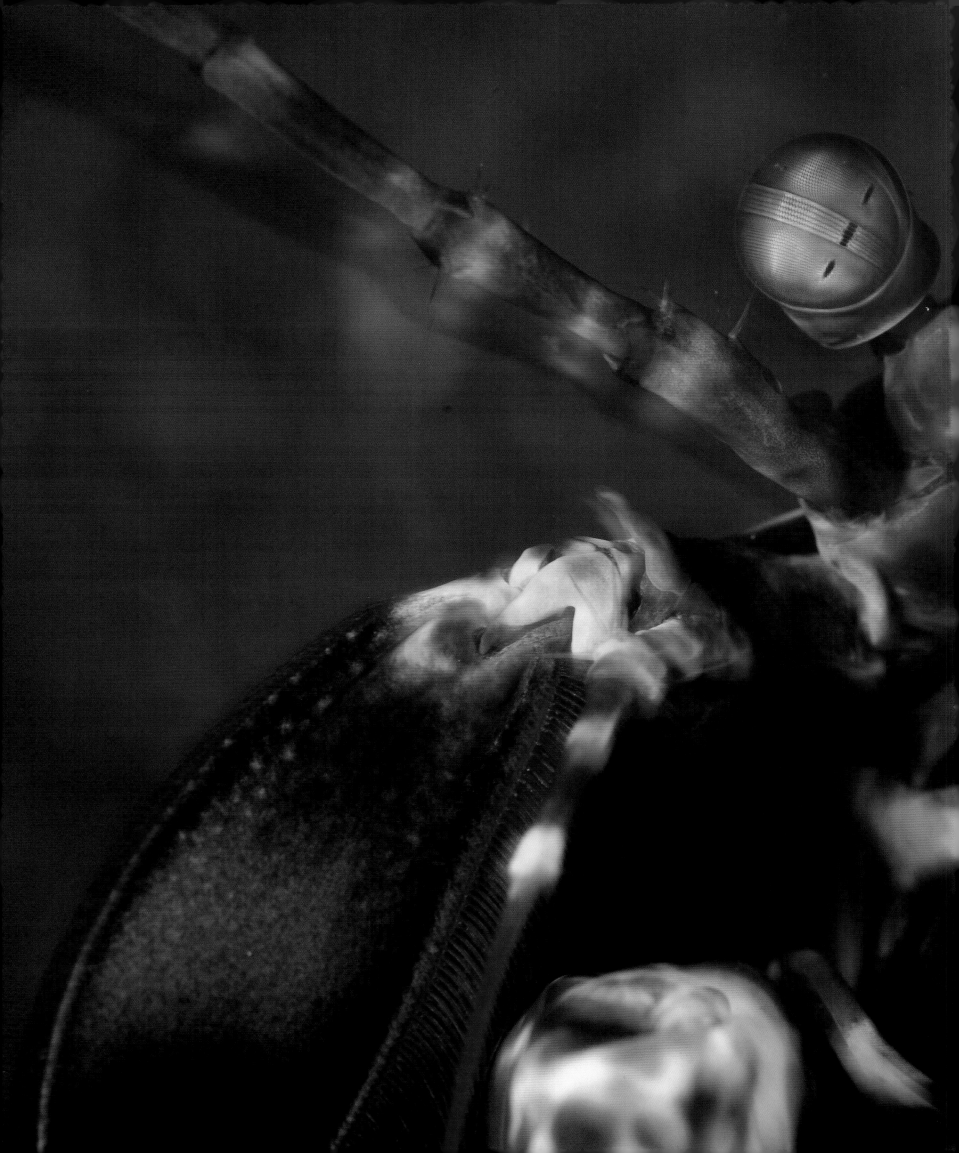

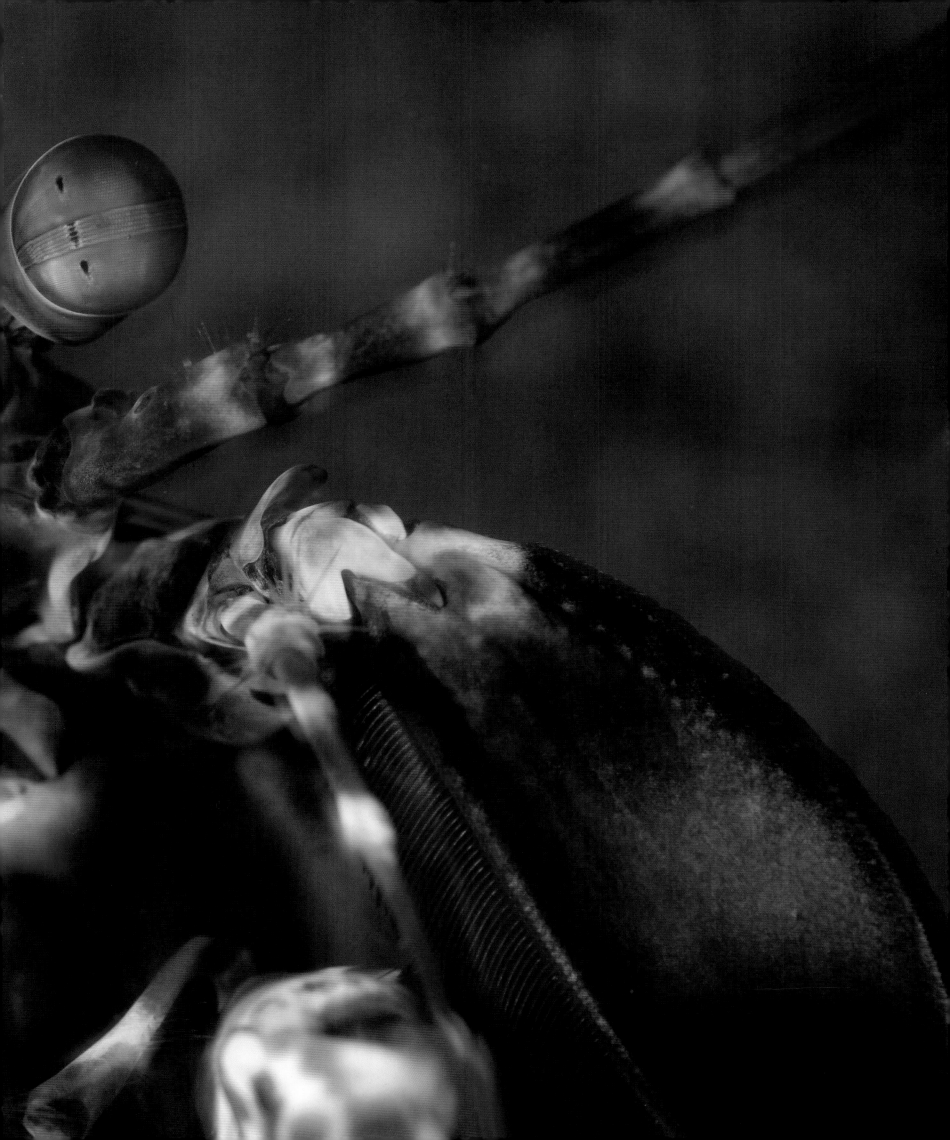

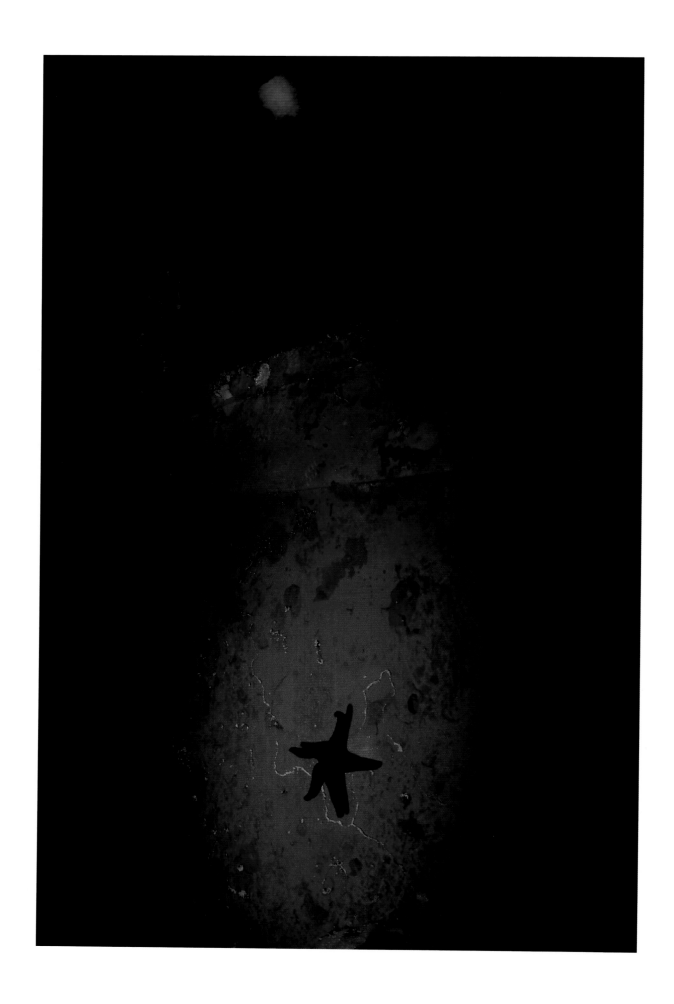

RIGHT: A starfish was hiding
inside the sunken plane
(Marshall Islands, Micronesia 2006)

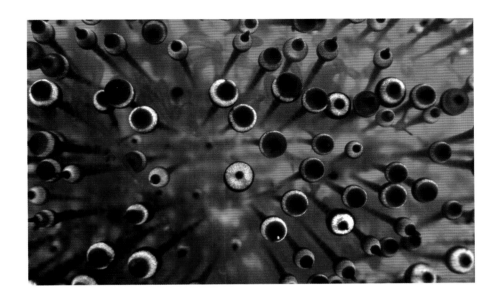

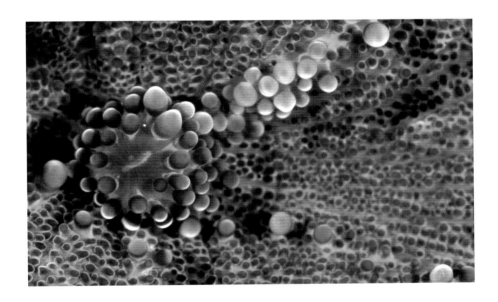

TOP RIGHT: The surface of
a toxic leather sea urchin
(Red Sea, Egypt 2002)

MIDDLE RIGHT: The oral disc
of coral discosoma bryoides
(Liloan, Philippines 2004)

BOTTOM RIGHT: The mantle of a squamosa clam
(Coral Sea, Australia 2002)

PAGES 242-243: The eye of the starry
toadfish is the colour of a green planet
(Manado, Indonesia 2006)

PAGES 244-245: A red-spotted dwarf goby
stands still on the colourful seabed
(Manado, Indonesia 2006)

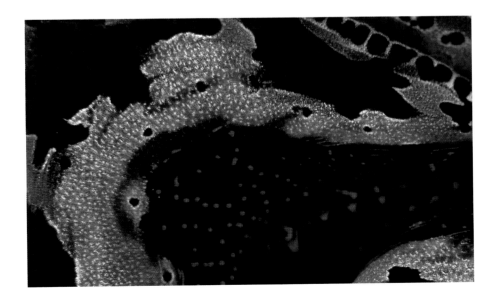

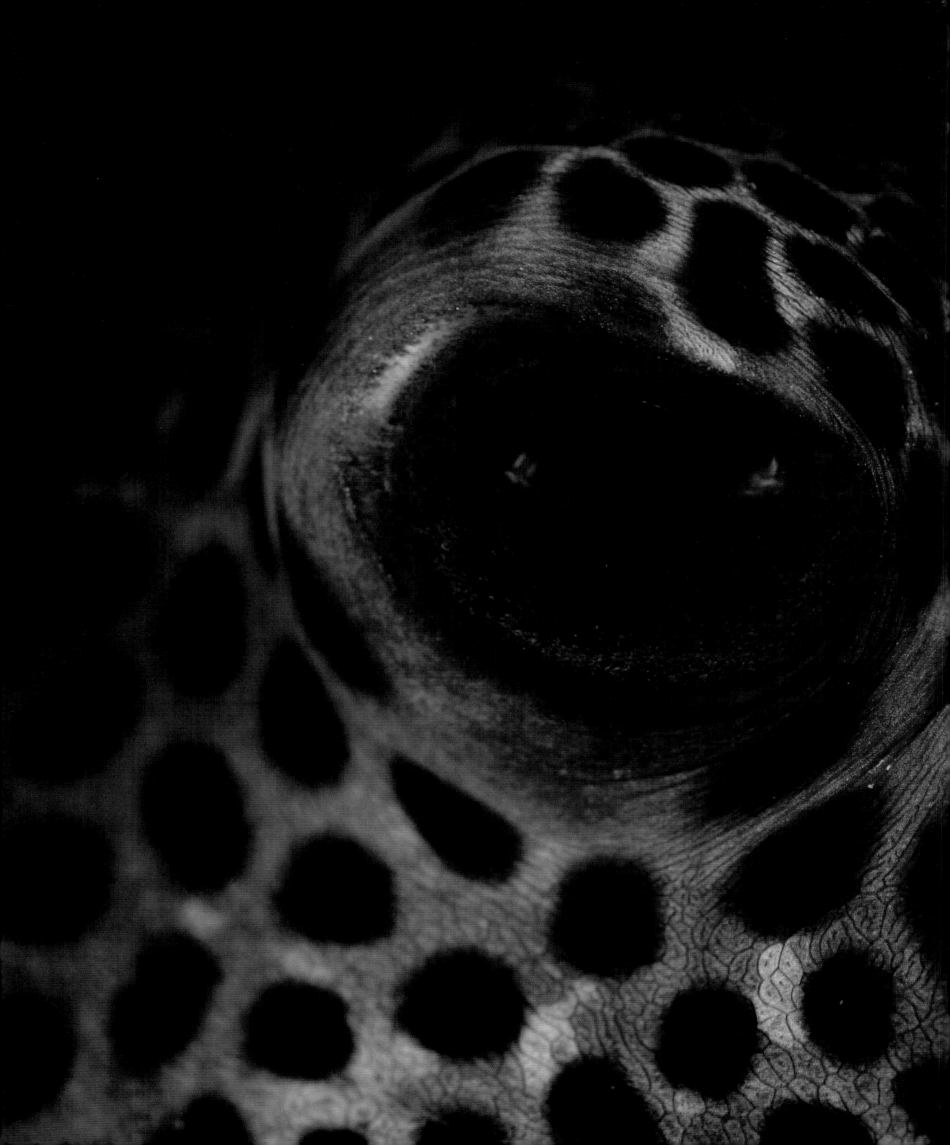

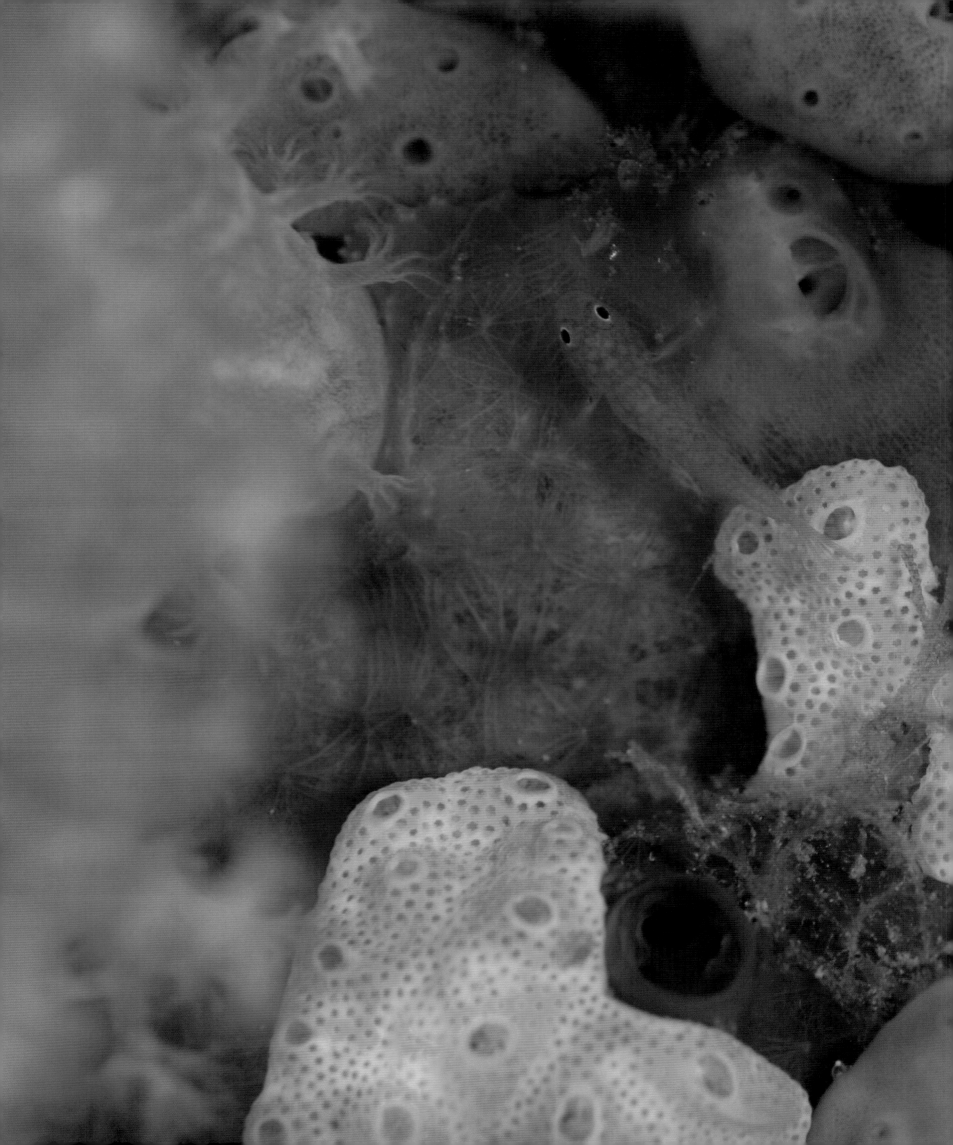

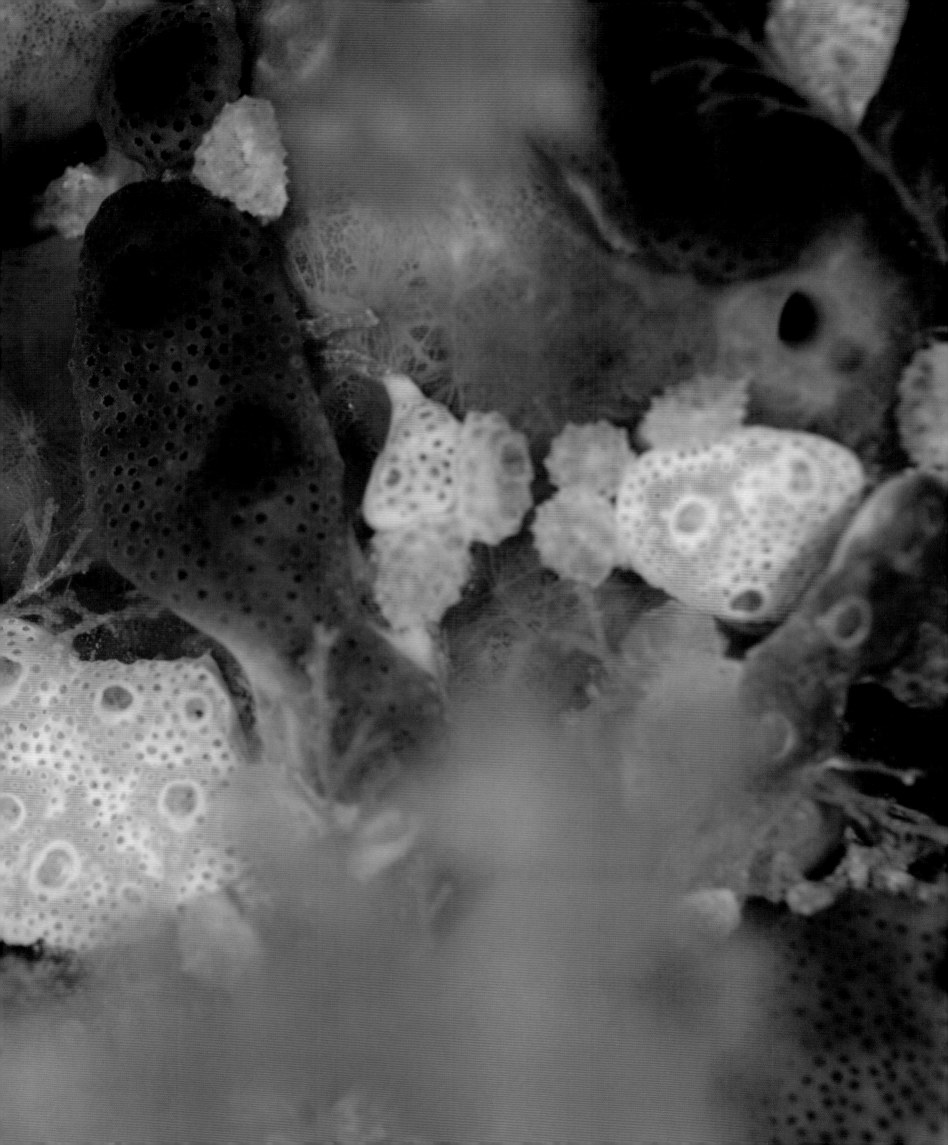

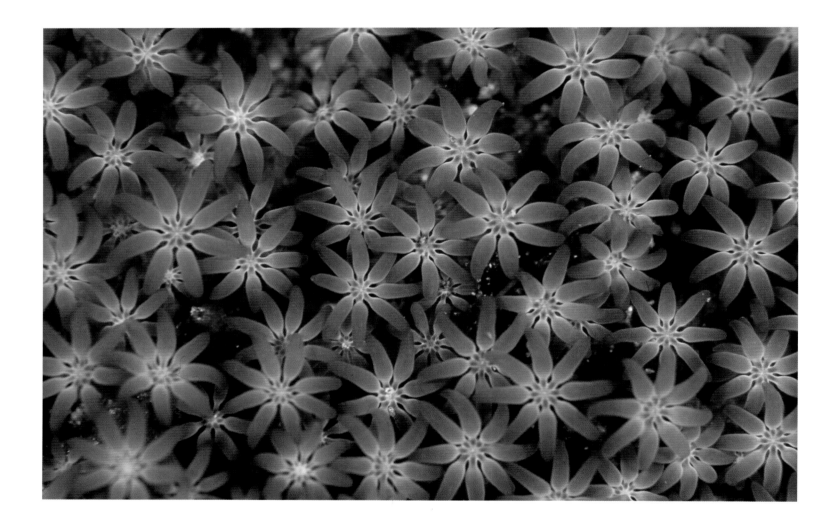

ABOVE: Organ pipe coral: a flower garden
the size of a palm at the bottom of the sea
(Manado, Indonesia 2006)

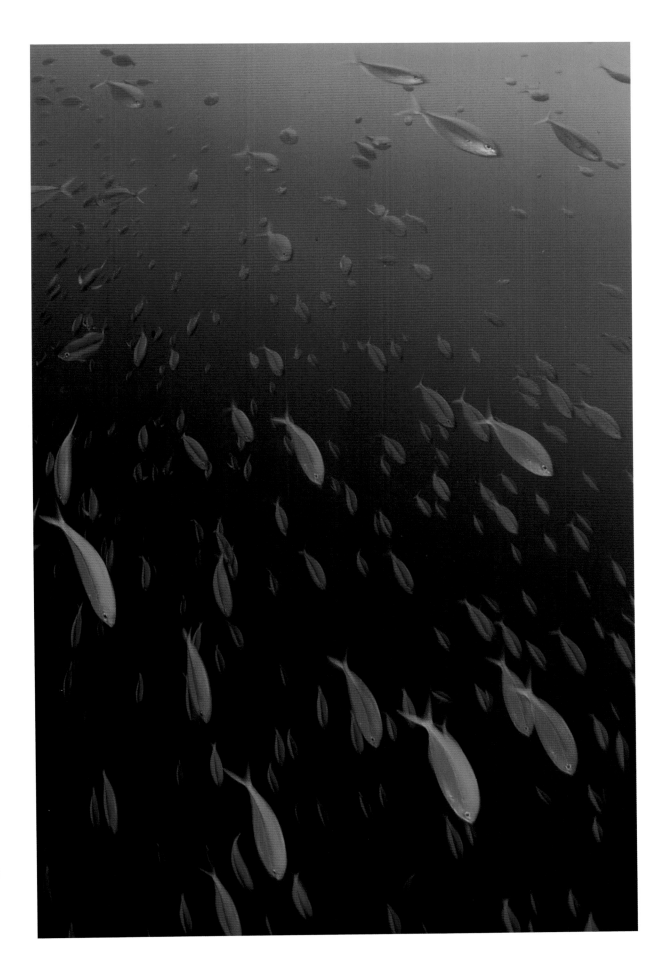

RIGHT: Yellowback fusiliers
(The Maldives 1997)

PAGES 248-249: The full colour of
the soft corals lures me into the
'secret garden' beneath the sea
(Walindi, Papua New Guinea 2003)

PAGES 250-251: The colourful
yellow sweetlips wriggle over the seabed
(Raja Ampat, Indonesia 2007)

PAGES 252-253: A leaf scorpionfish
stares into shooting stars
(Ishigaki Island, Okinawa, Japan 2007)

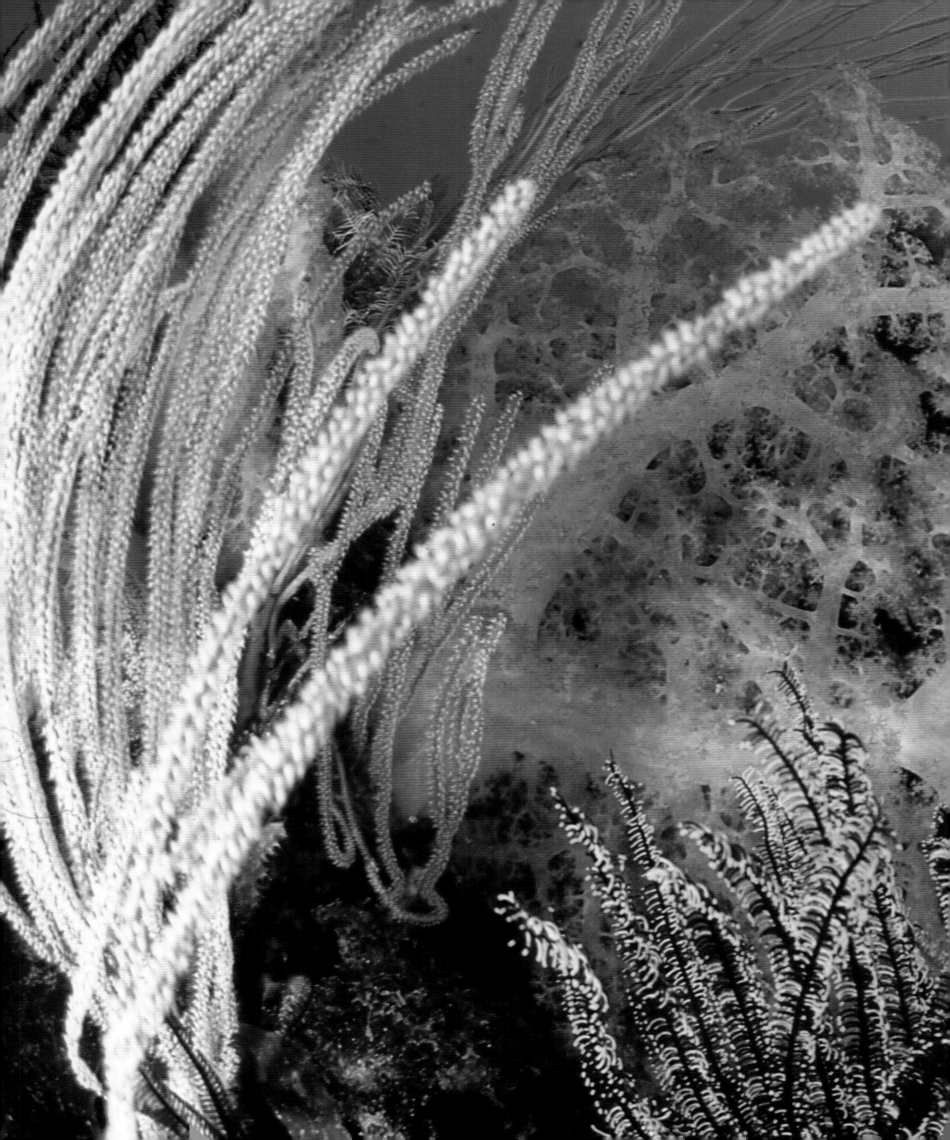

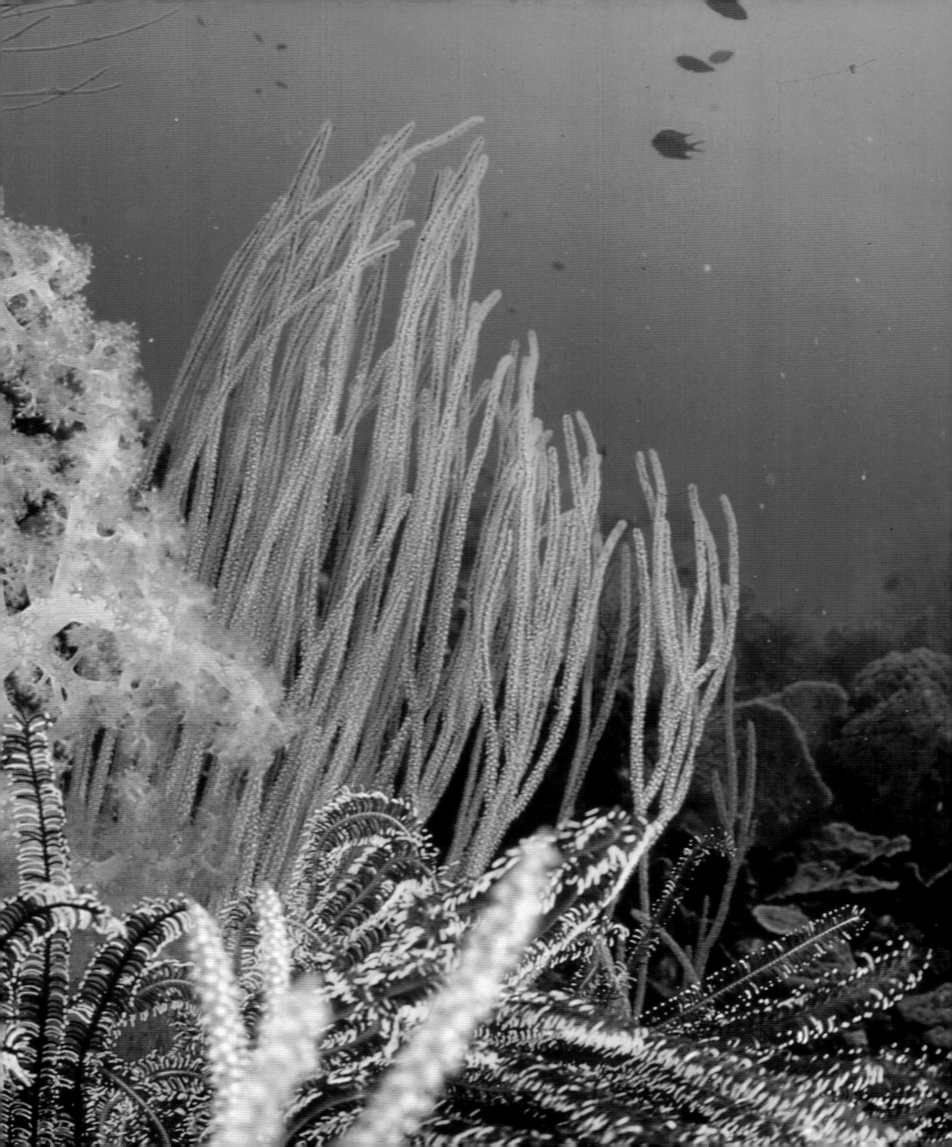

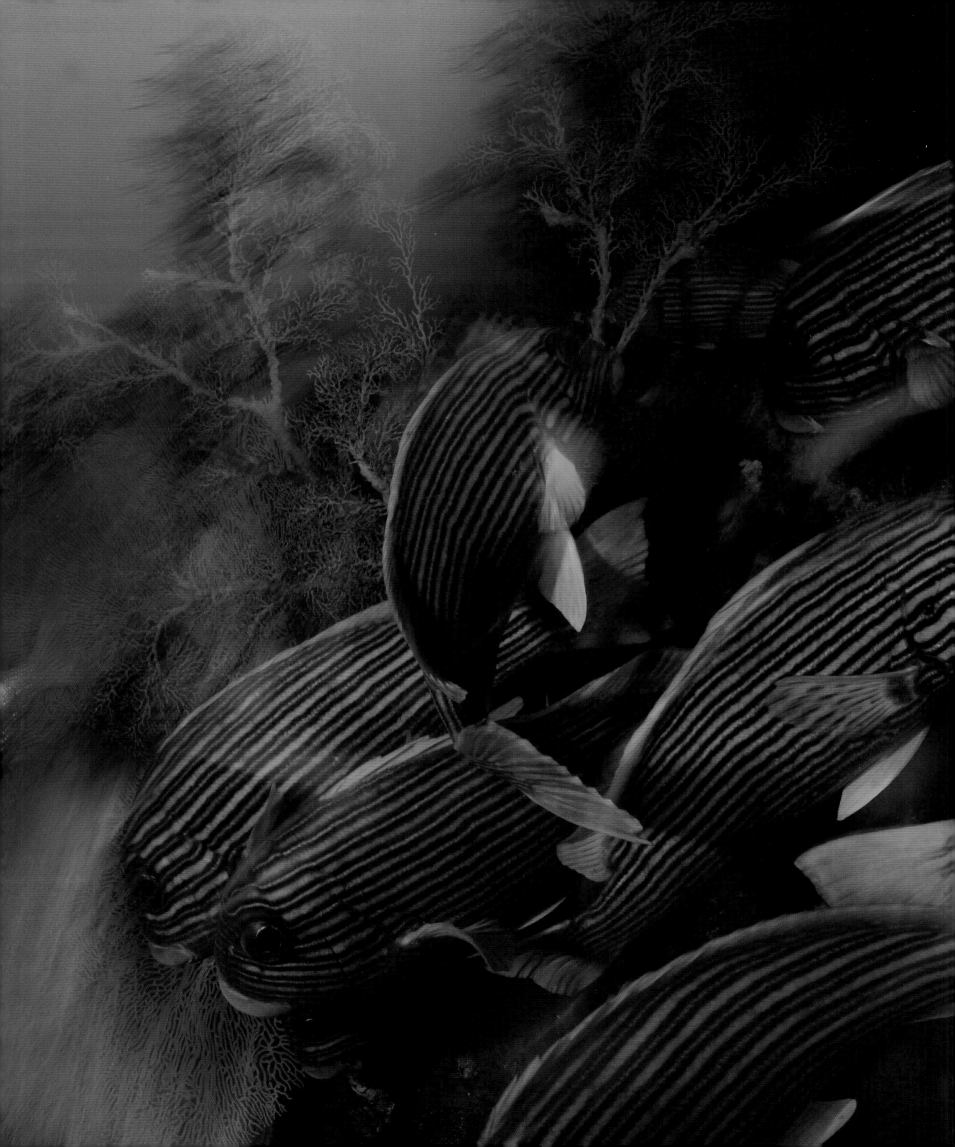

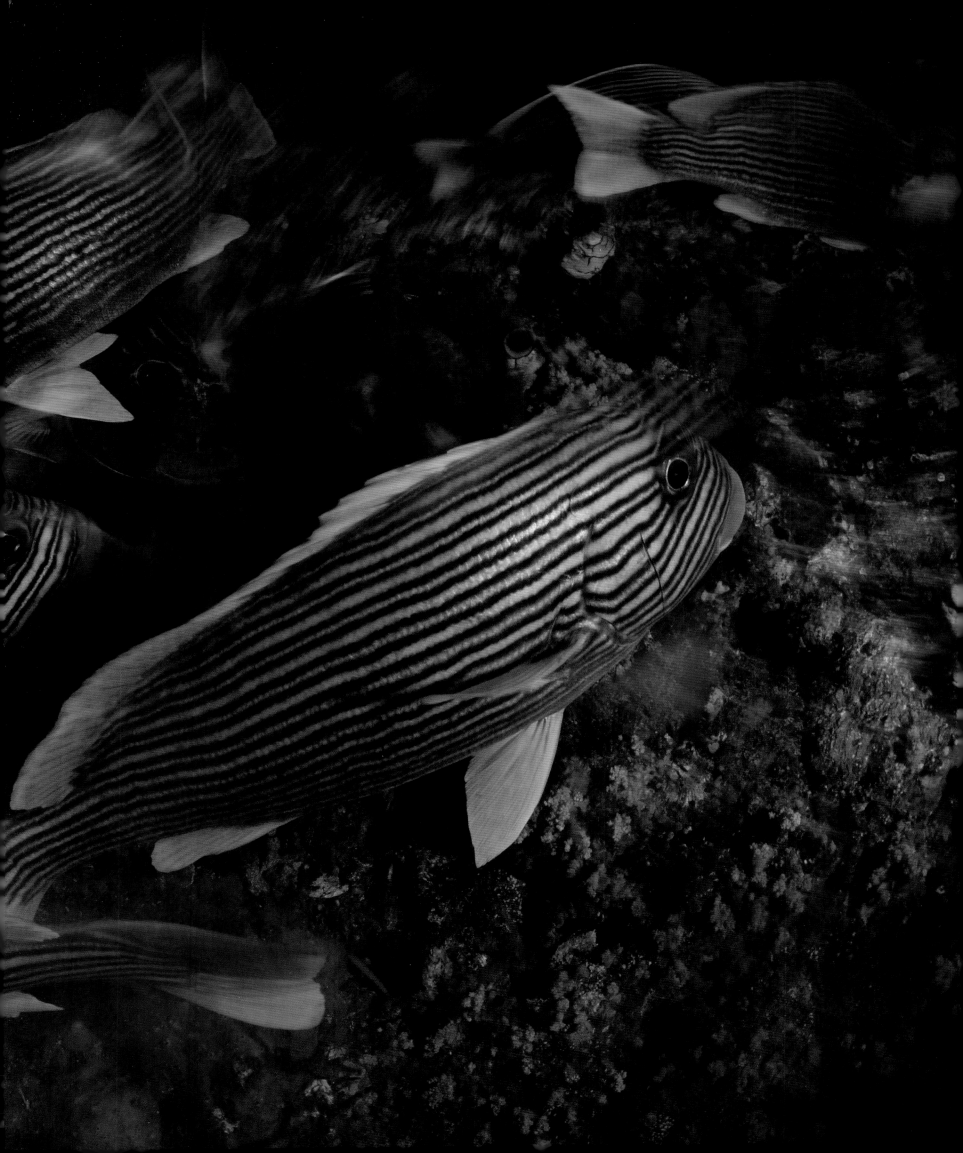

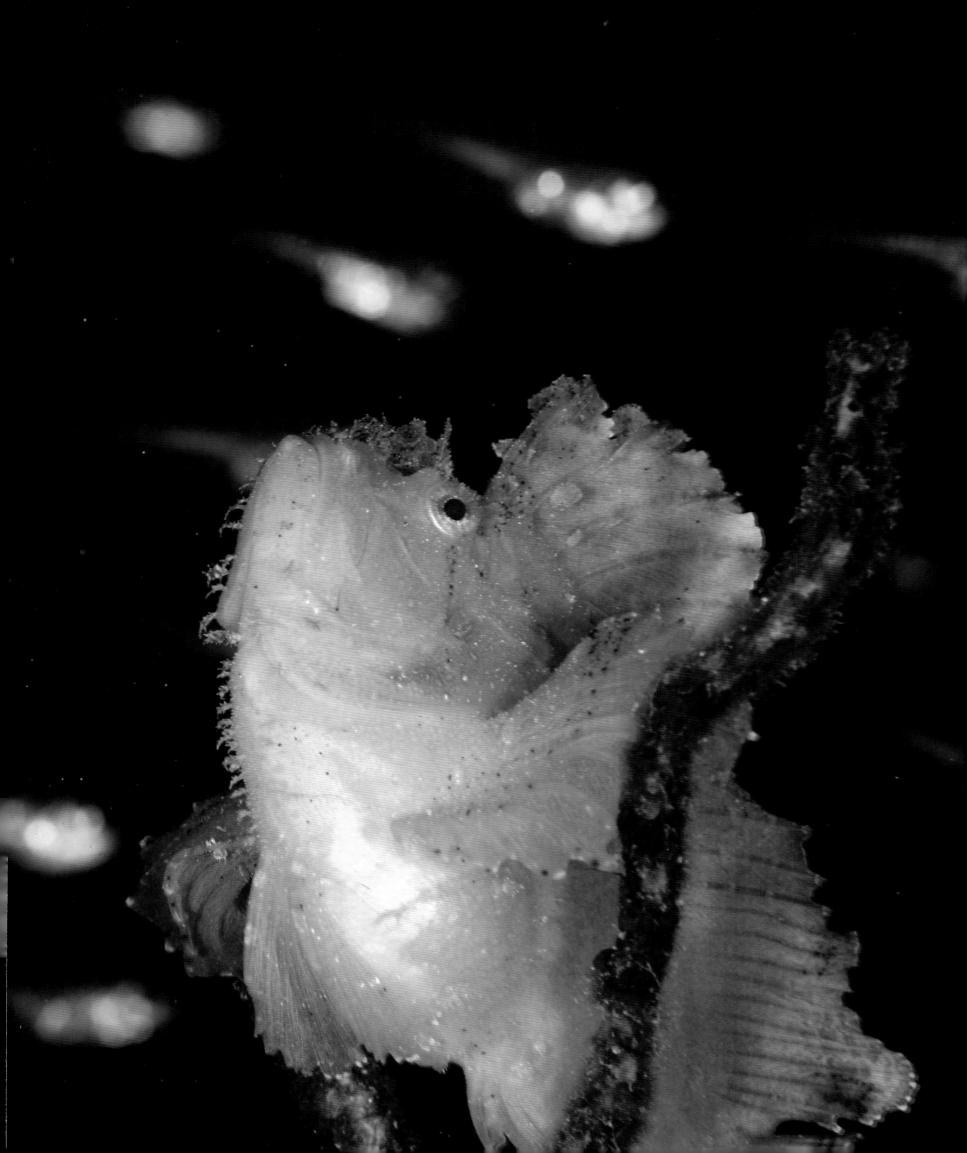

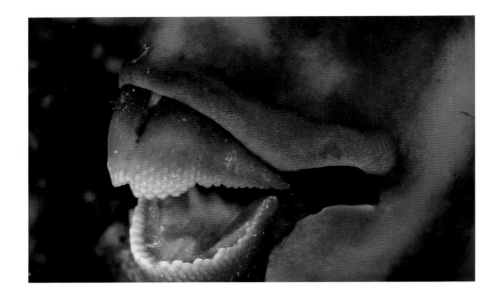

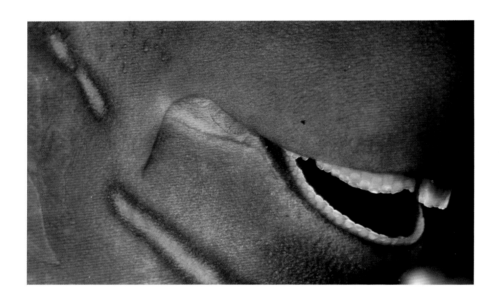

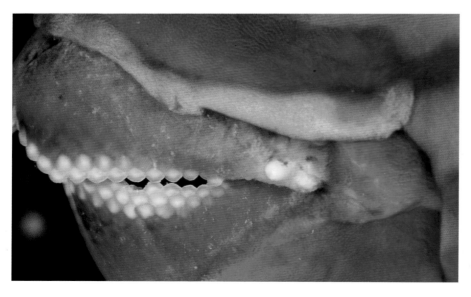

TOP LEFT: This sheephead
parrotfish has a canker
(South Male Atoll, the Maldives 1997)

MIDDLE LEFT: This green-face
parrotfish appears to be smiling
(South Male Atoll, the Maldives 1997)

BOTTOM LEFT: An ember parrotfish,
with its buckteeth!
(South Male Atoll, the Maldives 1997)

RIGHT: A black tipped squirrelfish
gives a somewhat lonely look
(South Male Atoll, the Maldives 2005)

PAGE 256: A green turtle sets
off on a journey into the unknown
(Tubbataha, Philippines 2006)

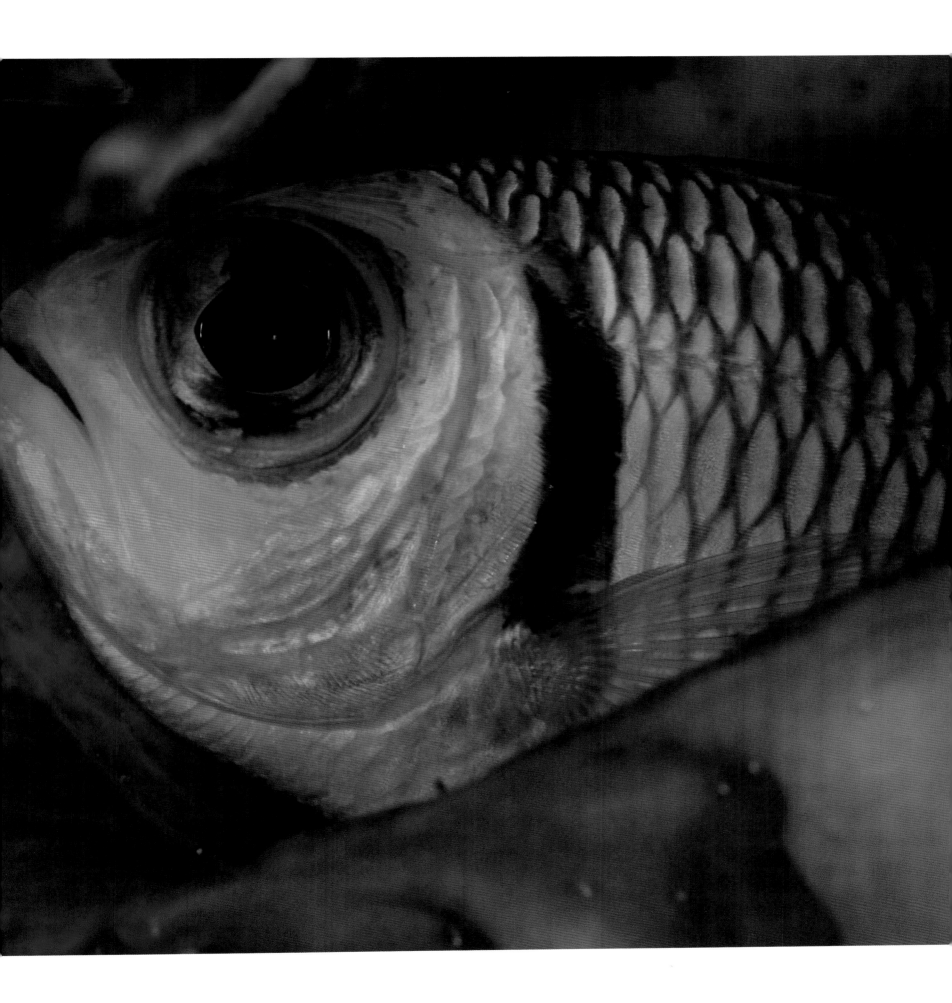

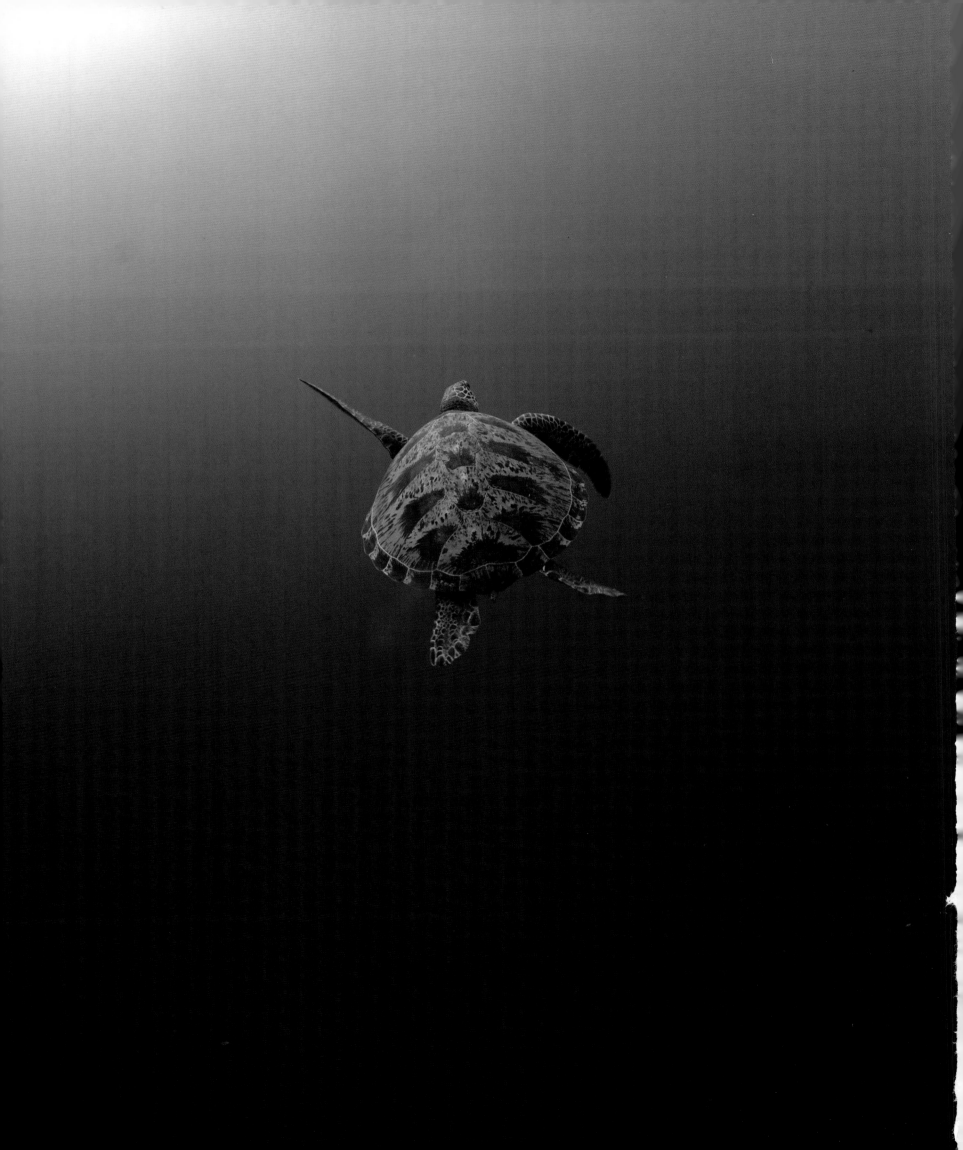

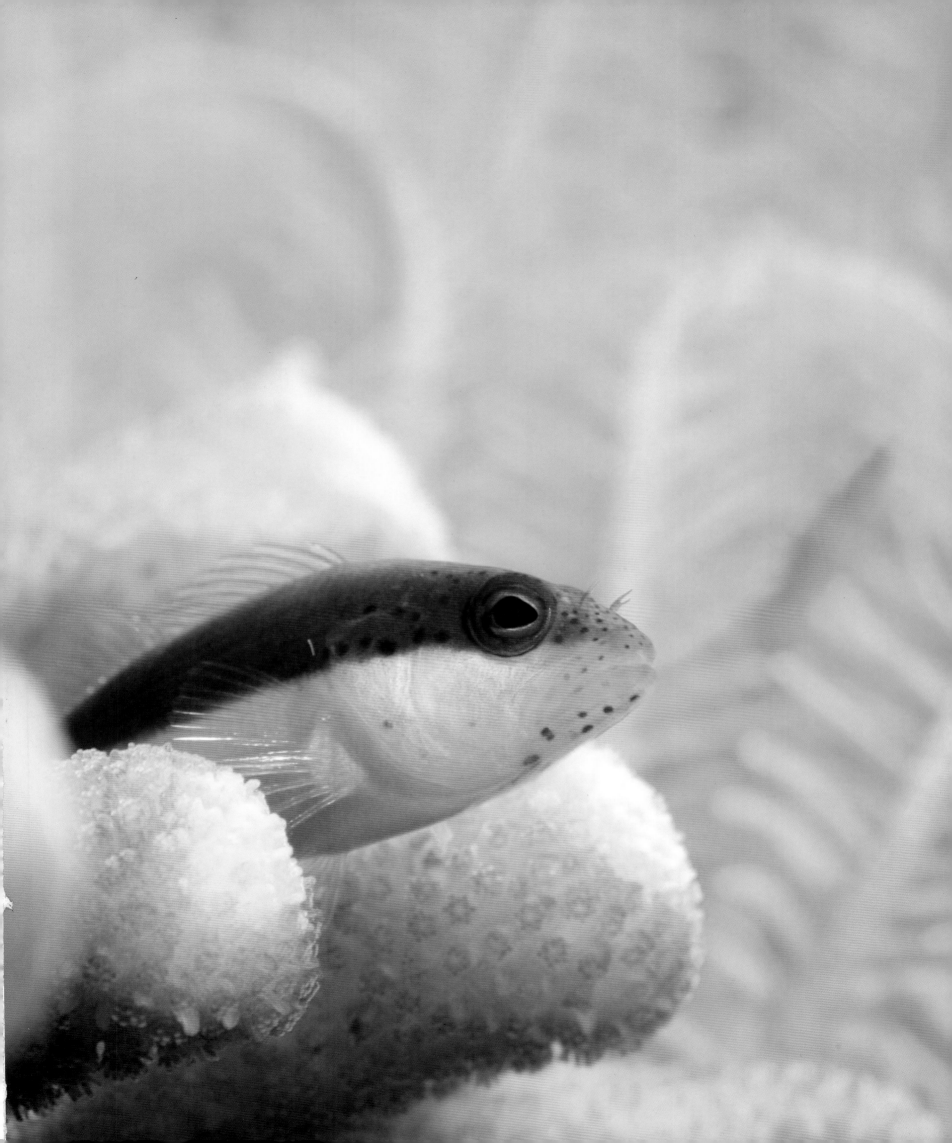